canadian art publications

canadian artists in exhibition
artistes canadiens: expositions
1972·73

roundstone · toronto canada · 1974

Copyright of photographs and illustrations contained herein is vested in most cases in the individual artists or galleries. We have attempted whenever possible to use photographic material supplied by the artists themselves, by their galleries, or by the public institution under whose auspices an exhibition occurred. A minimal fee for each photograph used is payable to artists upon publication.

This publication was created by two Canadian Art Publications projects under the regular Local Initiatives Programme and the Entrepreneurial Group of the Local Initiatives Programme, with the cooperation and assistance of The Round-stone Council for the Arts. The Roundstone Council for the Arts acknowledges with sincere thanks and appreciation the assistance of the Canada Council, the Ontario Arts Council, Bell Canada, Imperial Oil Limited, Alcan Canada Products Limited, Hiram Walker & Sons Limited, Shell Canada Limited and the Consulaat-Generaal der Nederlanden.

Canadian Artists in Exhibition 1972/73 is an educational and cultural publication prepared for general circulation throughout the world. Income from sales of the work is intended to help defray the costs of successive editions. Additional copies may be obtained through The Roundstone Council for the Arts, 546 Richmond Street West, Toronto, Canada M5V 1Y4.

Dans la plupart des cas, les titulaires des droits d'auteur des photographies et illustrations reproduites dans le présent ouvrage sont les artistes ou les galeries. Nous avons tâché, dans toute la mesure du possible, d'utiliser les photographies ou diapositives fournies par les artistes eux-mêmes, leur galerie, leur représentant officiel ou l'institution publique sous les auspices de laquelle telle exposition a eu lieu. Un droit symbolique est versé aux artistes pour toute photographie au moment de la parution.

Le présent ouvrage est une réalisation conjointe de deux projets de Publications d'Art Canadiennes patronnés par le Programme des Initiatives Locales et la section Entrepreneurs du Programme des Initiatives Locales avec la coopération et l'aide du Roundstone Council for the Arts. Ce dernier tient à remercier tout particulièrement de leur aide le Conseil des Arts du Canada, le Conseil des Arts de l'Ontario, Bell Canada, Imperial Oil Limited, Alcan Canada Products Limited, Hiram Walker & Sons Limited, Shell Canada Limited et le Consulat général des Pays-Bas.

Artistes canadiens: Expositions 1972/73 est une publication éducative et culturelle destinée à une distribution mondiale. Le revenu des ventes servira à défrayer la publication des prochains volumes. On obtiendra des exemplaires supplémentaires de l'ouvrage en entrant en contact avec: The Roundstone Council for the Arts, 546 ouest, rue Richmond, Toronto, Canada M5V 1Y4.

Printed in Canada by Herzig Somerville Limited

ISBN 0 919656 00 5
LC 73—91911

CONTENTS:

TABLE DES MATIÈRES:

As I look over these pages, I am struck by the incongruities and omissions. Despite the limitations of a project operated on a basis of voluntary cooperation between ourselves and the country's artists and galleries, we are convinced that this volume is a valuable beginning. As we start work on the next edition, which will cover a one-year period beginning 1 June 1973, we look forward to receiving suggestions and helpful criticism en route.

We are especially grateful for the cooperation and encouragement of the artists, private and public gallery directors and their staffs and officials of public and private agencies who have assisted us with this first effort. Very special thanks must also go to Anne Trueblood Brodzky, Dorothy Cameron, Alan Powell and Doris Shadbolt for their interest and support. I would like to acknowledge the efforts of the following members of the two Canadian Art Publications projects, whose work during the course of the past year has made this book possible: Rodrigo Clement, Carol Eason, Eric Faider, Marion Farrow, Michael Fee, Eillean Ferguson, Janice Gaffe, Denise George, William Gulutzan, Ronald Heydon, Susan Himel, Martin Illingworth, Louise Kerrigan, Marie Lee, Pauline Leung, Gregory Martin, Tony McAuley, Christine Mitchell, Alan Ross, Jerry Rygiel, Loree Steen, Christine Wallace, and Raynald Desmeules (translator).

Bob Burdett, Coordinator

En feuilletant le présent ouvrage, les incongruités et les omissions me frappent à chaque page. Toutefois, malgré les limites que nous ont imposées un projet fondé sur la libre collaboration des artistes et des galeries du pays, nous sommes convaincus que le présent volume constitue un début prometteur. Les travaux préparatoires du second volume, qui recouvrira l'année commençant le 1er juin 1973, sont déjà en cours; nous vous invitons à nous transmettre vos commentaires et vos suggestions.

Nous tenons à exprimer notre gratitude aux artistes, aux directeurs de galeries privées et publiques, à leur personnel ainsi qu'aux représentants officiels des agences d'État et privées qui nous ont apporté aide et encouragement au cours de la préparation du premier volume. Nous tenons à remercier de façon toute particulière Anne Trueblood Brodzky, Dorothy Cameron, Alan Powell et Doris Shadbolt de leur intérêt et de leur appui.

Nous aimerions aussi mentionner les membres des deux projets de Publications d'Art Canadiennes qui ont collaboré à la compilation et à la réalisation de l'ouvrage au cours de l'année qui se termine: Rodrigo Clement, Carol Eason, Eric Faider, Marion Farrow, Michael Fee, Eillean Ferguson, Janice Gaffe, Denise George, William Gulutzan, Ronald Heydon, Susan Himel, Martin Illingworth, Louise Kerrigan, Marie Lee, Pauline Leung, Gregory Martin, Tony McAuley, Christine Mitchell, Alan Ross, Jerry Rygiel, Loree Steen, Christine Wallace et Raynald Desmeules (traduction).

Bob Burdett, Coordonnateur

to the artists, and to the growth of aesthetic experience and expression in Canada • au

PREFACE

Canadian Artists in Exhibition 1972/73 represents a first attempt to create, in capsule form, a general impression of the recent work of artists in Canada. It is intended that subsequent editions would appear annually and would focus on the new work shown in a one-year period beginning each June. Our fundamental purpose in undertaking this effort has been to establish both a permanent record of artistic development in a national context and to make a specific contribution toward stimulating greater public interest in the visual and plastic arts.

Both in its scope and its approach, *Canadian Artists in Exhibition* differs from other kinds of arts publications in that it seeks to be regionally representative, adopts a documentary style and is relatively open in its editorial policy. Although this seems a straightforward approach in theory, it is perhaps one of the most difficult to carry out in practice and poses many more dilemmas for us than would a more selective or thematic policy. Nevertheless, there is something undeniably attractive about the idea of a book in which the most unlikely combination of people may be found rubbing shoulders and though this may mean that we find ourselves dealing with fairly large disparities in the nature and quality of work that is submitted for inclusion, it is doubtful that we would want to modify this concept in any substantial way.

When the original announcement for *Canadian Artists in Exhibition* was issued just eight months ago, the full scope of exhibition activity in Canada was an unknown factor. It was known to be large, but it was difficult to determine how many of the country's ten thousand artists were involved at any one time. We ourselves were using the "exhibition" as a type of filter to help limit the number of artists included in any one edition, painfully aware that a substantial number of artists will exhibit infrequently (if at all) or are working in such a way that they would be unlikely to have much to do with traditional exhibitions at any time.

In the course of assembling this edition, we learned of approximately two thousand seven hundred artists in exhibition in the current year, but much of the information was sketchy or difficult to verify. We issued just under six thousand announcements ourselves (lacking current addresses for an estimated four thousand people), examined nearly seven thousand photographs and slides from over six hundred artists and realized that no single publication or group of publications could hope to cover more than a fraction of the whole. Still we persisted. Although the original plan made provision for including the additional two thousand one hundred artists who had not submitted photographs, we found it impossible to incorporate this information in one volume due to a number of totally unforeseen scheduling problems. Accordingly, a difficult decision was made to concentrate our initial energies on the present pictorial volume and to continue to emphasize the visual aspect of the publication in future editions. However, we must point out that omission of an artist from this volume may have occurred for a variety of reasons. In some cases, artists or galleries may not have wished to participate or were unable to submit photographs for inclusion. In addition, many photographs that were submitted could not be reproduced on technical or editorial grounds (please see opening paragraph of *Basic Information*). On this latter point, the following pages bear witness to the fact that we have attempted to be as fair as possible. We nonetheless ask for the indulgence of all concerned as we work to improve coverage in future years.

Finally, we want to make clear that this edition is by no means the last word on the subject and that inclusion or omission of an artist is not at all meant to be a reflection on the quality of his or her work.

PRÉFACE

Artistes canadiens: Expositions 1972/73 constitue une première tentative de donner, avec la plus grande économie possible, une vue d'ensemble des oeuvres récentes des artistes du Canada. Un tour d'horizon semblable au présent ouvrage devrait paraître chaque année pour illustrer les oeuvres exposées à compter du mois de juin. Le propos qui nous a guidés au cours de la compilation de ce premier ouvrage a été à la fois l'établissement d'un dossier permanent de l'épanouissement artistique à l'échelle nationale et l'apport d'une contribution très particulière à l'avancement de l'intérêt du public pour les choses de l'art visuel et de l'art plastique.

Dans son envergure comme dans son approche, *Artistes canadiens: Expositions 1972/73* s'éloigne des publications artistiques courantes en tentant d'établir une plus grande représentativité régionale, en adoptant un style documentaire et en s'en tenant à une politique éditoriale plutôt ouverte. Alors qu'en théorie cette attitude pourrait sembler de tout repos, en pratique, elle pose plus de dilemmes que ne le ferait une politique plus exclusive ou thématique. Il n'en reste pas moins que l'idée de préparer un ouvrage dans lequel les artistes les plus disparates pourraient se retrouver côte à côte offrait un intérêt indéniable; bien que cette pratique implique une disparité plutôt considérable au niveau de la nature et de la qualité des oeuvres soumises, il est peu probable que nous changions substantiellement d'attitude au cours des prochaines livraisons.

Au moment de l'annonce de la publication d'*Artistes canadiens: Expositions 1972/73* il y a à peine huit mois, personne n'avait une idée précise de l'activité des artistes exposants du Canada. On savait que cette activité était considérable, mais l'on n'aurait pu dire exactement quel pourcentage de nos dix mille artistes voyaient leurs oeuvres exposées. Nous-mêmes, nous nous sommes servis du terme "exposition" comme d'un crible destiné à limiter le nombre des artistes mentionnés dans nos ouvrages, sachant très bien que nous devrions en conséquence laisser de côté, non sans regret, un bon nombre d'artistes qui n'exposent que peu (ou même pas du tout) ou dont les oeuvres, de par leur nature, ne se prêtent pas tellement à l'exposition telle que nous l'entendons généralement.

Au cours de la préparation du présent ouvrage, nous nous sommes rendu compte qu'environ deux mille sept cents artistes ont participé à des expositions au cours de l'année, mais l'information sur laquelle nous nous sommes basés était en bonne partie incomplète et difficile à vérifier. Nous avons fait parvenir un peu moins de six mille formules nous-mêmes (n'ayant pas l'adresse d'environ quatre mille artistes), nous avons passé en revue près de sept mille photographies et diapositives provenant de plus de six cents artistes, nous rendant compte que nulle publication simple ou multiple ne pourrait, avec la meilleure volonté du monde, recouvrir plus d'une fraction de l'ensemble. Nous avons quand même persisté. Bien que, au départ, nous avions l'intention d'inclure au présent volume les deux mille deux cents artistes qui ne nous ont pas fait parvenir d'illustrations de leurs oeuvres, nous avons dû prendre le parti de les mettre de côté pour des raisons d'échéances complètement imprévisibles. Nous avons donc pris la difficile décision de ne tenir compte, dans le présent ouvrage, que des artistes dont nous avions des illustrations et d'en augmenter le nombre au cours des ouvrages qui suivront. Nous tenons toutefois à faire remarquer que l'absence de tel ou tel artiste au présent ouvrage peut tenir à diverses raisons. Dans certains cas, tel artiste ou telle galerie n'aura pas tenu à participer ou n'aura pas été en mesure de nous fournir des photographies. Dans d'autres cas, les illustrations soumises n'ont pu être utilisées pour des considérations techniques ou éditoriales (voir le premier paragraphe des *Renseignements préliminaires*). Sur ce point, nous vous laissons juger par vous mêmes de l'impartialité que nous avons tenté de pratiquer. Nous ne sommes pas sans savoir que ce premier ouvrage est imparfait; nous vous demandons de bien vouloir le consulter en songeant que des livraisons futures seront de bien meilleure tenue. Enfin, nous tenons à indiquer clairement que, dans notre esprit, le présent ouvrage est loin d'être le dernier mot sur les arts plastiques au Canada, et que le fait que tel ou tel artiste y figure ou y brille par son absence ne porte pas le moindre jugement sur la qualité de son oeuvre.

BASIC INFORMATION

This survey is concerned with the recent work of living artists in Canada exhibited during the period 1 June 1972 to 1 June 1973. Works taken from permanent collections or on permanent display, works exhibited in highly mixed shows of potpourri, photography (as such) and crafts (as such) are not normally represented in the survey. Certain exceptions occur, as in the case of special photographic processes, photocollage, woven or assembled "soft sculpture" and ceramic pieces of a non-utilitarian nature, etc.

Entries are arranged alphabetically by name of artist, followed by the art form or forms practiced, birthdate and birthplace, present place of residence, training, principal awards, teaching post if known (or when applicable), list of exhibitions along with illustrations of recent work. The following special usages apply:

MEDIUM: Specific materials used by an artist in the creation of works. Exceptions include printmaking, where processes are listed by name (etching, lithography, silkscreen, etc.), performance-art, mail-art and information environments.

EX–1, EX–2, etc.: One-man/woman show; two-man/woman show, etc.

GROUP: An exhibition of six or more artists.

MAJOR EXHIBITIONS: In order to save repetition of identical information, certain group exhibitions—particularly those organized by public agencies—are listed in greater detail on pages 10 to 14. A titled show (e.g. "SCAN") will often be noted under an artist's group show entry without the usual dates and name of gallery. By referring to the major exhibition index, the exhibition "Survey of Canadian Art Now" will be found listed with name of gallery, dates and participants.

DATES OF EXHIBITIONS: When exact opening and closing dates are known, they are written in the following form: (26 IV–4 VI 73). When only the month is known, it is written (Jan/janv 73).

ALPHABETICAL ORDER: for names beginning with "de" and "De" such as "de Groot", "de Niverville", etc., see "G" and "N" respectively; "Mc" follows "Mac"; artists with pseudonyms are cross-referenced.

PHOTOGRAPHIC CREDITS: In most cases the artists have supplied photographs of their own work. A photograph supplied by a gallery on an artist's behalf is acknowledged, together with the name of the photographer (when known).

RENSEIGNEMENTS PRÉLIMINAIRES

Le présent tour d'horizon porte sur les oeuvres récentes d'artistes canadiens vivants exposées au cours de la période allant du 1er juin 1972 au 1er juin 1973. Les ouvrages faisant partie de collections permanentes ou exposées en permanence, les oeuvres faisant partie d'expositions extrêmement hybrides, la photographie (en tant que telle) et les métiers d'art (en tant que tels) ne trouvent normalement pas place dans le présent ouvrage. On fera cependant exception à cette règle dans le cas de procédés photographiques spéciaux, du photocollage, des "tapisseries sculpturales" tissées ou autres, des objets en céramique sans fin utilitaire, etc.

Les entrées sont données par ordre alphabétique; le nom de l'artiste est suivi de la forme (ou des formes) d'art qu'il pratique, de sa date de naissance, de l'endroit où il est né (dans la plupart des cas), de l'endroit où l'artiste habite présentement et, le cas échéant et si nous disposons des renseignements, de sa formation, de ses principaux prix et honneurs, de l'endroit où il enseigne, d'une liste d'expositions ainsi que d'illustrations d'oeuvres récentes. Voici comment lire le texte:

MEDIUM: Les matériaux utilisés par l'artiste pour la création de ses oeuvres. Dans le cas de la gravure, on se contente de mentionner le procédé (eau-forte, lithographie, sérigraphie, etc.); l'art de représentation, l'art postal, les environnements d'information, etc., sont donnés tels quels.

EX—1, EX—2, etc.: Exposition solo, exposition à deux, etc.

GROUPE: Une exposition collective de six artistes ou davantage.

EXPOSITIONS MAJEURES: Pour éviter la répétition fastidieuse de renseignements, certaines expositions collectives—en particulier les expositions organisées par des agences publiques—sont expliquées plus loin. Les expositions portant un titre (e.g. "Les Moins de 35") paraissent sans dates et sans nom de galerie. On trouvera le nom de la galerie, les dates et le nom des exposants des grandes expositions de la page 10 à la page 14.

DATES DES EXPOSITIONS: Lorsque l'on connaît la date précise du vernissage et de la clôture d'une exposition, on donne le jour, le mois et l'année sous la forme suivante: (1 XII 72—2 I 73). Quand on ne connaît que le mois, la date a la forme suivante: (Jan/janv 73).

ORDRE ALPHABÉTIQUE: On trouvera à la lettre "G" le nom de "de Groot", et à la lettre "N" le nom de "de Niverville", etc.; "Mc" vient après "Mac"; le nom des artistes connus sous un pseudonyme est suivi d'un renvoi au pseudonyme.

SOURCES PHOTOGRAPHIQUES: Dans la plupart des cas, les artistes ont pris eux-mêmes les photographies de leurs oeuvres. Les photographies fournies par une galerie au nom d'un artiste portent le nom de la galerie et celui du photographe (si la photo est signée).

major exhibitions·expositions majeures

When the names of all participants are not known or the information supplied is ambiguous, names are normally omitted. For instance, in shows of an international nature, information was sometimes lacking as to the nationality of particular participants. Style of entry: title of exhibition, followed by the name of the sponsoring institution, the locations and dates of showings and a list of participants.

Dans les cas où nous ne savons pas le nom de tous les participants ou si les renseignements que nous avons sont ambigüs, nous omettons généralement les noms. Par exemple, dans le cas des expositions internationales, il n'était pas toujours facile de déterminer la nationalité de chacun des participants. Les entrées se lisent comme suit: titre de l'exposition, nom de l'institution patronant l'exposition, lieu et dates, nom des participants.

ALBERTA CONTEMPORARY DRAWINGS Edmonton Art Gallery, Edmonton, Alta. (6 IV–30 IV 73).

ARTISTS EXHIBITING/ARTISTES EXPOSANTS: B. Ballachey, D. Barry, B. Bentz, R. Biller-Klein, H. Bres, L.D. Cantine, R. Carmichael, J. Chalke, B. Chapman, P.N. Darrah, E. Diener, A. Clarke-Darrah, L.D. Cromwell, I. Dmytruk, B. Duma, G. Felsberg, S.W. Fisher, V. Foster, J. Funnell, N. Green, S. Haeseker, J.E. Hall, R.C. Guest, D. Haynes, K.J. Hughes, A. Janvier, I. Kerr, J. Knowlton, J. Livermore, T. Manarey, B. Marks, B. McCarroll, C.S. McConnell, J. Moore, J.P. Nourry-Barry, B. Paulson, A. Reynolds, J. Risser, M. Schmill, R. Silvester, R. Sinclair, H. Savage, D. Van Wyk, S. Voyer, D. Whitehouse, H. Wohlfarth, N. Yates.

ANOTHER ELEVEN SASKATCHEWAN ARTISTS Mendel Art Gallery, Saskatoon, Sask. (Dec/déc 72).
ARTISTS EXHIBITING/ARTISTES EXPOSANTS: D. Chester, J. Fafard, M. Forsyth, R. Gomez, B. Kelly, J. Nugent, W. Peterson, J. Poole, R. Shuebrook, L. Walters, R. Yuristy.

ART FOR ALL The Art Gallery of Windsor, Windsor, Ont. (19 XI–26 XI 72).

ARTISTS EXHIBITING/ARTISTES EXPOSANTS: J.M. Alfsen, J. Allsopp, F. Arbuckle, W. Barnes, J.M. Barnsley, H. Beament, J. Beder, L. Bellefleur, D. Bentham, C. Bice, B. Bobak, L. Bouchard, L. Brooks, P. Caron, A.J. Casson, R. Christie, M. Clements, A. Cloutier, A. Collier, G. Coughtry, G. Curnoe, E. Curry, A. Dingle, P. Dobush, A. Drenters, J. Drenters, J. Eaton, Enooky, L.L. Fitzgerald, T. Forrestall, C. Gagnon, J. Gauthier, R. Genn, L. Gilling, P. Goetz, J. Fould, P. Harris, B. Haworth, P. Haworth, R. Hendershot, E. Holgate, R. Holmes, A. Jackson, P. Janes, F. Johnston, J. Jones, T. Kakinuma, W. Kilgour, D. Knowles, J. Korner, N. Kubota, W. Kurelek, P. Lacelin, M. Laliberté, J. Lim, M. MacDonald, T. MacDonald, K. MacDougall, J. MacGregor, R. Markle, W. McElcheran, J. Meredith, J. Morrice, J. Nichols, W. Olgilvie, T. Onley, C. Pachter, W. Perehudoff, R. Pilot, J. Plaskett, M. Rakine, G. Rayner, W. Redinger, J. Roberts, G. Rock, B. Shaw-Rimmington, H. Smith, J. Smith, M. Snow, D. Solomon, J. Stohn, P. Surrey, G. Tremblay, F. Varley, D. Wilson, R. Wilson, W. Winter, J. Wise, M. Wrinch.

ART OF THE CANADIAN ESKIMO Organized by/Organisée par Art Gallery of Ontario. Circulating exhibition/Exposition itinerante.

ARTISTS EXHIBITING/ARTISTES EXPOSANTS: Aliknak, Akourak, Anergna, Ekootak, Eejyvudluk, Jamasie, Juanisialu, Kalvak, Kananginak, Kenojuak, Kiakshuk, Kingmeata, Kugmucheak, Lucy, Lukta, Mummooshoarluk, Oonark, R.A. Oonark, Parr, Pitseolak, Pudlo, Shekoloak, Sheouak, J. Talirunili, Tumira, Ulayu.

THE ART OF THE DANCE Organized by/Organisée par National Ballet Guild of Canada. O'Keefe Centre, Toronto (14 V–19 V 73).

ARTISTS EXHIBITING/ARTISTES EXPOSANTS: A. Blair-Ewart, C. Bonnière, M. Cadot, J. Calleja, E. Champion, J. Culiner, E. Dzenis, M. Ehlert, D. Geden, J. Gould, D. Hannequand, M. Hecht, P. Janes, J. Joel, H. Just, W. Lew, E. Manley, R. Massey, K. Pascal, A. Posa, S. Pushta, M. Raine, H. Rothschild, J. Rosenthal, H. Sabelis, J. Sentbergen, B. Shaw-Rimmington, C. Smith, S. Smith, J. Stone, R. Tuckett, N. Waters, G. Young.

ARTARIO 72 Sponsored by the Ontario Arts Council/Offerte par le Conseil des Arts de l'Ontario. Opened simultaneously in schools, libraries, museums, art galleries, correctional institutions, public buildings, hospitals, meeting halls etc./Vernissage simultané dans les écoles, musées, galeries d'art, écoles de réforme, édifices publics, hôpitaux, centres sociaux etc. (Oct/oct 72).

ARTISTS EXHIBITING/ARTISTES EXPOSANTS: R. Baird, T. Bidner, T. Bieler, J. Boyle, L. de Niverville, M. Drope, K. Eloul, W. Geleynse, A. Handy, M. Hayden, D. Jean-Louis, R. Letendre, J. MacGregor, R. MacKenzie, K. Ondaatje, J. Schyrgens, M. Snow, R. Spiers, T. Urquhart, D. Zander.

ARTFORMS '73 Kitchener-Waterloo Art Gallery, Kitchener, Ont. (7 VI–30 VI 73).

ARTISTS OF THE PROVINCE Cassel Galleries, Fredericton, N.B. (Oct/oct–Nov/nov 72). ARTISTS EXHIBITING/ARTISTES EXPOSANTS: B. Bobak, M. Bobak, M. Donaldson, T. Forrestal, T. Graser, K. Hooper, J. Humphrey, J. Kashetsky, K. McAvity, F. Ross.

ASSOCIATION DES GRAVEURS DU QUEBEC A L'ETABLE Galerie l'Etable, Musée des Beaux-Arts de Montréal/Stable Gallery, Montreal Museum of Fine Arts (11 X–5 XI 72).

ARTISTES EXPOSANTS/ARTISTS EXHIBITING: H. Agerup, P. Ayot, F. Beauvais, J. Benoît, G. Boisvert, M. Charbonneau, L. de Heusch, G. Deitcher-Kropsky, R. Derouin, A. Desmarchais, S. Dumouchel, C. Dupont, J. Fainaru, M. Faucher, S. Gersovitz, L. Genush, R. Giguère, A. Kahn, Y. Lafontaine, S. Lake, E. Landori, R. Langstadt, M. Leclair, C. Leclerc, J. Leroux-Guillaume, L. Marois, M. Marois, D. Moreau, E. Myers, I. Nair, A. Pentsch, N. Petry, E. Proulx, S. Raphael, F. Simonin, T. Steinhouse, H. Tarshis-Shapiro, L. Tremblay, N. Ulrich, R. Venor, B. Van Der Heide, P. Weldon, I. Whittome.

L'ASSOCIATION DES SCULPTEURS DU QUEBEC Centre Culturel de Valcourt, Qué. (Aug/août–Sept/sept 72).

ARTISTES EXPOSANTS/ARTISTS EXHIBITING: M. Aubin, M. Battolini, G. Bergeron, J. Besner, P. Borduas, M. Braitstein, C. Daudelin, I. Fortier, A. Fournelle, R. Giguère, P. Gnass, P. Hayvaert, J. Huet, P. Landry, M. Merola, M. Niffeler, L. Pagé, J. Poliquin, A. Prud'homme, H. Schleh, F. Soucy, F. Sullivan, Y. Trudeau.

BAKER LAKE DRAWINGS Organized by/Organisée par Winnipeg Art Gallery CIRCULATING/ITINERANTE: Winnipeg Art Gallery (15 V–15 VII 72); Vancouver Art Gallery (9 VIII–10 IX 72). ARTISTS EXHIBITING/ARTISTES EXPOSANTS: Anglosaglo, R. Annuktoshe, M. Esa, Karleesuk, M. Kookeeyout, H. Keegooseot, J. Keegooseot, Mummookshoarluk, W. Noah, J. Oonark, S. Tookoome.

BURNABY PRINT SHOW (SIXTH) Sponsored by/Offerte par Burnaby Art Gallery, Burnaby, B.C. Circulated throughout Europe/Circulée à travers l'Europe (1973).

CALGARY GRAPHICS EXHIBITION (13TH ANNUAL) Alberta College of Art Gallery, Calgary, Alta. (26 III–13 IV 73).

ARTISTS EXHIBITING/ARTISTES EXPOSANTS: G.F. Brown, J. Buyers, G. Caiserman-Roth, J.L. Cowin, J.K. Esler, J. Funnell, L.A. Gilkeson, S. Haeseker, J. Hansen, J. Harris, W. Hendershot, C. Hoskinson, T. Howarth, F. Jorgensen, W. Jule, H.M. Kiyooka, J. Livermore, S. Lynn, B. MacIver, J. Manning, D. Marc, M.B. May, B.L. McMullan, M. Mesheau, P.A. Neal, F. Nulf, J. Risser, D. Roberts, K.C. Samuelson, N. Sawai, P. Schmidtz, R. Stanbridge, C.A. Stathacos, S. Tait, G. Ugalde, D. Van Wyk, K.M. Weber, B.D. Wiltshire, R. Yates.

CARSASK (CANADIAN ARTS REPRESENTATION, SASKATCHEWAN SHOW) Organized by/Organisée par Regina C.A.R. Gallery on the Roof, Regina (Feb/févr 73).

ARTISTS EXHIBITING/ARTISTES EXPOSANTS: B.J. Barbour, A. Bleszynski, S.P. Cloutier, A. Deutscher, J. Deutscher, J. Ellemers, V. Faris, P. Godwin, T. Godwin, L. Groome, B. Hone, A. James, B. Kelly, E. Lowe, D. Martin, B. Midmore, C. Mitchell, F. Newman, R. Pawson, C. Quade, C. Samuels, B. Sanders.

CANADIAN CONTEMPORARY EXHIBITION OF PAINTINGS AND SCULPTURE T. Eaton Co. Ltd., Montreal, Que. (summer/été 72).

CANADIAN NATURE ART '72 Sponsored by/Offerte par Canadian Nature Federation. The Provincial Museum and Archives of Alberta, Edmonton (16 VIII–30 IX 72). ARTISTS EXHIBITING/ARTISTES EXPOSANTS: L. Bogaert, H.K. Bowey, C. S. Campbell, D. Dekker, M. Hunter, H. Johnson, P. Karsten, C. Lacy, H.M.A. Schalkwyk, R. Symons, T. Taylor, J. Thomas, C. Tillenius, H.R. White.

8 CANADIAN PRINTMAKERS Organized and circulated by Confederation Art Gallery for the Atlantic Provinces Art Circuit/Organisée et mise en circulation par Confederation Art Gallery pour l'Atlantic Provinces Art Circuit. CIRCULATING/ITINERANTE: Confederation Art Gallery, Charlottetown (May/mai–June/juin 72); Mount St. Vincent Univ, Halifax (May/mai–June/juin 72); Univ Moncton, Moncton, N.B. (Jul/juil–Aug/août 72); Memorial Univ Art Gallery, St. John's, Nfld. (Jul/juil–Aug/août 72); Univ New Brunswick, Fredericton (Mar/mars 73); Acadia Univ, Wolfville, N.S. (Feb/févr 73). ARTISTS EXHIBITING/ARTISTES EXPOSANTS: R. Derouin, V. Foster, N. Petry, S. Raphael, D. Sacilotto, R. Savoie, R. Venor, A. Wong.

CANADIAN PRINTMAKERS EXHIBITION London Public Library and Art Museum, London, Ont. (1972). ARTISTS EXHIBITING/ARTISTES EXPOSANTS: S. Gersovitz, M. Jakobow, H. Norrington, L. Zurosky.

CANADIAN PRINTMAKERS SHOWCASE 1972 (FOURTH ANNUAL) Carleton Univ, Ottawa (Oct/oct 72).

ARTISTS EXHIBITING/ARTISTES EXPOSANTS: R. Achtemicuk, S. Allard, D. Andrew, H. Ariss, F. Bain, B. Banerjee, P. Bates, L. Benic, D. Besant, H. Bettinville, T. Bidner, A. Bieler, M. Bienvenue, J. Bird, D. Blackwood, J. Brodie, G. Caiserman-Roth, Canada Banners Co., P. Caryi, V. Clark, M. Colton, J. Cowin, H. Cragg, R. Crack, S. Crack, A. Dickson, J. Dickson, B. Drummond, S. Dumouchel, K. Eloul, J. Esler, R. Foulger, S. Gersovitz, R. Giguère, B. Goodwin, T. Gore, J. Gouin, G. Guerin, B. Hall, L. Harris, C. Heywood, C. Hoskinson, K. Hunt, J. Jenicek, F. Jorgensen, C. Juarez, N. Keehn, C. Kerwin, H. Kiyooka, B. Kloezeman, R. Langstadt, D. Larson, T. Lau, W. Leathers, R. Letendre, B. Linssen, S. Maki, J. Manning, B. Maycock, K. McFall, M. Morissey-Clayton, E. Myers, F. Nulf, K. Ondaatje, T. Onley, E. Ouchi, E. Porter, S. Raphael, L. Reid, D. Roberts, D. Sacilotto, D. Samila, H. Savage, R. Savoie, N. Sawai, C. Schiffleger, A. Shimizu, H. Siebner, R. Silvester, L. Simons, G. Smith, J. Snow, T. Steinhouse, R. Swartzman, Taira, S. Tait, H. Tarshis-Shapiro, P. Tétreault, C. Tisari, R. Venor, B. Wainwright, D. Ward, K. Weber, R. Whitlock, J. Will, C. Williams, T. Wilson, A. Wong, H. Woolnough.

CANADIAN WEST COAST HERMETICS Organized by/Organisée par Fine Arts Gallery, Univ B.C. CIRCULATING/ITINERANTE: Fine Arts Gallery, Univ B.C. (9 1–27 I 73); Canadian Cultural Centre, Paris (15 III–14 IV 73). Circulated throughout Europe after presentation in Paris/Présentée à travers l'Europe à commencer par Paris. ARTISTS EXHIBITING/ARTISTES EXPOSANTS: G. Foisy, G.L. Nova, G. Simpson, D. Uu, E. Varney, J. Wise.

CERAMIC OBJECTS Organized by/Organisée par Art Gallery of Ontario. CIRCULATING/ITINERANTE: Art Gallery of Ontario, Toronto (29 III–23 IV 73); New York Cultural Center, New York (15 VI–20 VII 73). ARTISTS EXHIBITING/ARTISTES EXPOSANTS: M. Ariss, R. Bozak, V. Cicansky, G. Cournoyer, M. Davis, J. Fafard, G. Falk, D. Gilhooly, A. James, M. Keepax, M. Levine, J. Thornsbury.

CERAMICS SHOW—STUDIO WEST University Art Gallery and Museum, Univ Alberta (4 XII–22 XII 72). ARTISTS EXHIBITING/ARTISTES EXPOSANTS: R. Blackmore, R. Douglas, D. Green.

CONTEMPORARY PROFESSIONAL QUEBEC ARTISTS (THIRD ANNUAL EXHIBITION) Viger Main Hall, Dawson College, Montreal (5 IV–17 IV 73).

ARTISTS EXHIBITING/ARTISTES EXPOSANTS: I. Ballon, M. Boyanner, R. Briansky, L. de Heusch, J. Fox, E. Garnaise, S. Jackson, H.W. Jones, P. Landsley, H. Mayerovitch, J. Prezament, A. Prud'homme, M. Reinblatt, G. Caiserman-Roth, R. Savoie, L. Scott, M. Scott, T. Steinhouse, L. Studham, P. Studham, P. Surrey.

CONTEMPORARY TAPESTRY AND WEAVING EXHIBITION Mido Gallery, Vancouver (12 XI–2 XII 72). ARTISTS EXHIBITING/ARTISTES EXPOSANTS: I. Burg, D. Field, F. Henderson, J. Jakobow, R. Naumann, L. Powell, J. Staniszkis.

DECEMBER CHOICE Morrison Art Gallery, St. John, N.B. (4 XII–23 XII 72).

ARTISTS EXHIBITING/ARTISTES EXPOSANTS: M. Allain, B. Bobak, R. Campbell, T. Campbell, H. Chiasson, F. Coutellier, M. Donaldson, K. Eldridge, T. Forrestall, G. Goguen, T. Graser, L.P. Harris, J. Kashetsky, D. Legassick, C. McAvity, R. Percival, C. Picard, C. Pratt, M. Pratt, F. Ross, R. Savoie, D. Silverberg, P. Skalnik, E. Willar, F. Willar, A. Wylie, K. Watson.

DIRECTOR'S CHOICE Edmonton Art Gallery, Edmonton, Alta. (Nov/nov 72). ARTISTS EXHIBITING/ARTISTES EXPOSANTS: D. Bentham, R. Biller Klien, D. Chester, E. Diener, I. Dmytruk, D. Knowles, V. Owen, W. Perehudoff.

DIVERSITY Organized by/Organisée par Norman Mackenzie Art Gallery, Regina. CIRCULATING/ITINERANTE: Edmonton Art Gallery (15 IX–15 X 72); Norman Mackenzie Art Gallery (27 X–26 XI 72).

ARTISTS EXHIBITING/ARTISTES EXPOSANTS: P. Ayot, D. Bolduc, Y. Cozic, T. Forrestall, P. Fournier, P. Hutner, J. MacGregor, R. Martin, J. Noel, J. Palchinski, B. Parsons, C. Pratt, D. Rabinowitch, W. Redinger, M. Ristvedt, H. Saxe, G. Smith, M. Snow, E. Zelenak.

ESTIVAL '72 Galerie Espace, Montréal (31 V–30 IX 72). ARTISTES EXPOSANTS/ARTISTS EXHIBITING: G. Bergeron, E. Brodkin, R. Cavalli, S. Daoust, H. Franklin, J. Huet, W. Jarnuskiewieck, R. Jones, D. Juneau, S. Lewis, F. Richman.

EXPOSITION D'ART DES FRANCO-ALBERTAINS Organisée par/Organized by La Fédération des Femmes Canadiennes Françaises. Salon d'Exposition, Collège Universitaire St-Jean, Edmonton (17 II–4 III 73). ARTISTES EXPOSANTS/ARTISTS EXHIBITING: H. Baril, M. Champagne, J. Giroyard, S. Hébert, M. Lemay, B. Mercier, Y. Morin, M. Pahud, M. Royer, C. Szaaszkiewicz, L. Tremblay, R. Wilson.

EXPOSITION DES SCULPTURES MODERNES Musée du Québec, Québec (3 VIII–27 VIII 72). ARTISTES EXPOSANTS/ARTISTS EXHIBITING: E. Allaire, J. Bélanger, J. Gasse, P. Julien, J.-M. Lajoie.

FEMMES-PEINTRES DU QUEBEC Centre Maisonneuve, Montréal (22 III–22 IV 73).

FREDERICTON ARTISTS Univ New Brunswick Art Centre, Fredericton, N.B. (1 IV–15 IV 73).

ARTISTS EXHIBITING/ARTISTES EXPOSANTS: G. Bailey, R. Bailey, P. Baldwin, M. Bustin, M. Campbell, W. Collicott, J. Coy, G. Duffie, G. Dugay, E. Ferguson, E. Fredericks, C. Gibson, J. Hall, M. Hashey, E. Hughes, M. Hughson, A.F. Knight, A. Machin, E. Manuel, M. McNair, M.E. Miller, B. Morrison, U. Ozerdem, N. Picketts, D. Price, M. Ross, M. Sargeant, R. Spicer, D. Wilson, E. Wright.

GRAFIK 72/73 Organized by/Organisée par Art Gallery of Ontario CIRCULATING/ITINERANTE: Art Gallery of Ontario, Toronto (Oct/oct 72); Pauline Johnson Collegiate Institute, Brantford (Oct/oct 72); Kitchener Public Library, Kitchener, Ont. (Nov/nov 72); Cobourg Art Gallery, Cobourg, Ont. (Dec/déc 72); Sir Sanford Fleming College, Peterborough, Ont. (Mar/mars 73); Humber College of Art, Toronto (Apr/avril 73); College of Education, West End Art Gallery, Montreal (May/mai 73). ARTISTS EXHIBITING/ARTISTES EXPOSANTS: R. Derouin, V. Foster, N. Petry, S. Raphael, D. Sacilotto, R. Savoie, R. Venor, B. Wainwright, I. Whittome, A. Wong.

GRAPHEX I Art Gallery of Brant, Brantford, Ont. (8 III–29 III 73).

ARTISTS EXHIBITING/ARTISTES EXPOSANTS: T. Allison, D. Andrew, W. Bachinski, E. Baker, T. Beament, D. Besant, M. Bevelander, R. Bikkers, B. Bobak, J. Brodie, D. Carr, A. Cetin, G. Chu, F. Coutellier, M. Curry, M. Davies, A. Dickson, J. Drutz, A.M. Duff, J.K. Esler, T. Gallie, S.V. Gersovitz, S. Glanville, J. Gouin, B. Hall, J. Hansen, J. Harris, D. Hartman, C. Hoskinson, K. Hunt, F. Jones, W. Jule, T. Lapierre, B. Linssen, J. Noestheden, H. Worrington, H. Oberheide, P. Osicka, E. Ouchi, R. Owen, S. Oxley, D. Paquette, R. Pottruff, G. Rayner, D. Rifat, W. Ross, A. Shimizu, J. St. Denis, K.O. Tamasaukas, G. Treibner, J. Van Damme, D. Vermeulen, J. Ward, K.M. Weber, S. Webster, A. Weinstein, J. Wilkinson, T. Wilson, D. Wright, R. Yates, W. Zimmerman, L. Zurosky.

GRAPHISME Bibliothèque centrale de prêt du Saguenay-Lac-Saint-Jean, Alma, Qué. En circulation dans les municipalités affiliées à la Bibliothèque centrale de prêt du Saguenay-Lac-Saint-Jean pour une période de six mois à partir de novembre 1972/Circulated throughout the municipalities associated with the central library of Saguenay-Lac-Saint-Jean for a period of six months beginning November 1972.

ARTISTES EXPOSANTS/ARTISTS EXHIBITING: G. Boisvert, K. Bruneau, S. Dumouchel, G. Fiore, M. Fortier, R. Giguère, J. Hurtubise, A. Jasmin, Joanisialu, P. Lacroix, R. Lacroix, S. Lewis, A. Monpetit, A. Pellan, R. Pichet, J. Tarilunili, A. Trèze, B. Wainwright, R. Wolfe.

IMAGE BANK POSTCARD SHOW (1971–1974) Organized by Michael Morris and Alvin Balkind and circulated by The National Gallery of Canada/Organisée par Michael Morris et Alvin Balkind et circulée par La Galerie nationale du Canada. CIRCULATING/ITINERANTE: Fine Arts Gallery, Univ B.C., Vancouver (5 X–28 X 72); Rothmans Art Gallery, Stratford, Ont. (15 XI–15 XII 72); Dunlop Art Gallery, Regina (1 VII–30 VII 72); Galerie d'art, Univ Moncton, Moncton, N.B. (1 I–31 I 73).

INFORMATION AND PERCEPTION Organized by/organisée par Ontario College of Art, Toronto (24 III–23 IV 73). ARTISTS EXHIBITING/ARTISTES EXPOSANTS: R. Barrios, W. Cowell, K. Finlayson, M.R. Hadfield, R. Hill, R. Robinson, G. Snelling, V. Tangredi, C. Wagner.

INTERNATIONAL GRAPHICS Organized by/Organisée par Art Gallery of Ontario, Toronto.

ARTISTS EXHIBITING/ARTISTES EXPOSANTS: W. Bachinski, T. Beament, R. Blackwood, R. Derouin, R. Lacroix, J.T. Mattingly, B. Winwright.

JEUNES PEINTRES QUEBECOIS McGill Univ, Montréal (28 VII–29 VII 72). ARTISTES EXPOSANTS/ARTISTS EXHIBITING: F. Bouchard, L. Brien, S. Caladaru, L. Dazé, D. Demers, L. Gauthier, M. Jolicoeur, P. Lambert.

A JUNE SHOW Dunlop Art Gallery, Regina (3 VI–25 VI 72).

ARTISTS EXHIBITING/ARTISTES EXPOSANTS: D. Bentham, M. Bolen, R. Christie, V. Cicansky, J. Cowin, R. Cowley, S. Day, J. Ellemers, J. Fafard, M. Forsythe, A.S. Gallus, H. Hamm, B. Hone, M. Hone, J. Jessop, B.L. Kelly, D. Knowles, M. Lawrence, E. Lindner, L. Malach, W. Mulcaster, B. Newman, F. Nulf, W. Peterson, J. Poole, Hansen-Ross Pottery, C. Prescott, C. Samuels, J. Thornsberry, L. Walters, P. Wiens, R. Yuristy, M. Zora.

KINGSTON SPRING EXHIBITION Agnes Etherington Art Centre, Kingston, Ont. (14 V–11 VI 72).

ARTISTS EXHIBITING/ARTISTES EXPOSANTS: D. Allen, D. Andrew, E. Bartram, D. Bentham, C. Birt, R. Bolt, R. Bayer, R. Cattell, I.C. Harris, Y. Cozic, M. Curry, A. Davenport, M. Davies, H. Dunsmore, B. Emilson, G. Forgie, D. Foster, G. Fraser, V. Frenkel, J. Frick, S. Gersovitz, L. Gilkeson, J. Gordaneer, J. Gouin, S. Haeseker, B. Hall, J. Hall, L. Harris, C. Hayward, W. Hendershot, M. Hirschberg, T. Hodgson, A. Horsfall, T. Howorth, K. Hunt, R. Jenkins, F. Jorgensen, N. Kafadarow, P. Lacroix, R. Lafrenière, L. Levinsohn, G. Lorcini, D. Mabie, G. MacDonald, R. Mackenzie, J. Martin, I. McKim, P.G. O'Brien, B. Parsons, W. Perehudoff, S. Raphael, G. Russell, J. Sadler, H. Schreier, B. Siegel, R. Sinclair, E. Smith, R. Spiers, B. St. Clair, V. Tolgesy, R. Van de Peer, R. Winkler, C. Woods, L. Workman, E. Yerex, D. Zander.

THE LEGEND OF ASESSIPPI Winnipeg Art Gallery (18 VIII–27 IX 72). ARTISTS EXHIBITING/ARTISTES EXPOSANTS: The Ophthalmia Co. of Inglis, Man.: L. Anthony, J. Clark, K. Clark, B. Duncan, T. Howorth, R. Hrabec, W. Lobchuk, Don Proch, Doug Proch, B. Wilkinson, M. Wineman.

LITHOGRAPHS I Organized by Nova Scotia College of Art & Design, Halifax, and circulated by The National Gallery/Organisée par Nova Scotia College of Art & Design, Halifax, et mise en circulation par La Galerie nationale. CIRCULATING/ITINERANTE: Robert McLaughlin Gallery, Oshawa, Ont. (1 V–18 VI 72); Fine Arts Gallery, Univ B.C., Vancouver (1 VII–15 VIII 72); Confederation Art Gallery, Charlottetown, P.E.I. (1 IX–30 IX 72); Nova Scotia College of Art & Design, Halifax.

ARTISTS EXHIBITING/ARTISTES EXPOSANTS: V. Acconci, J. Baldessari, D. Bolduc, J. Chambers, G. Curnoe, F. Dallegret, G. Davis, J. Bibbets, G. Ferguson, D. Graham, A. Green, J. Griefen, P. Kelly, G. Kennedy, S. Lewitt, K. Lochhead, A. McKay, H. MacKenzie, B. MacLean, G. Molinari, R. Murray, D. Oppenheim, B. Parsons, P. Pearlstein, G. Rayner, R. Rymar, M. Snow, N. E. Thing Co. Ltd. (I. Baxter), J. Wieland.

LITHOGRAPHS II Organized by Nova Scotia College of Art & Design, Halifax, and circulated by The National Gallery/Organisée par Nova Scotia College of Art & Design, Halifax, et mise en circulation par La Galerie nationale. CIRCULATING/ITINERANTE: Centre Culturel Canadien, Paris (15 V–15 VI 72); Winnipeg Art Gallery, Winnipeg (15 VIII–15 IX 72); Nova Scotia College of Art & Design, Halifax.

ARTISTS EXHIBITING/ARTISTES EXPOSANTS: (See/Voir **LITHOGRAPHS I**).

MANITOBA MAINSTREAM Organized by The National Gallery of Canada/Organisée par La Galerie nationale du Canada CIRCULATING/ITINERANTE: Moose Jaw Art Museum, Moose Jaw, Sask. (1 XII–31 XII 72); Mount St. Vincent Univ, Halifax (15 I–15 II 73); Stewart Hall, Pointe-Claire, Que. (1 III–31 III 73); Art Gallery of Greater Victoria (15 IV–15 V 73); Mendel Art Gallery, Saskatoon (1 VI–30 VI 73).

ARTISTS EXHIBITING/ARTISTES EXPOSANTS: T. Allison, J. Allsopp, S. Anderson, R. Archambeau, J. Beardy, D. Odjig Beavon, N. Nebee, A. Bering, N. Bjelejac, E. Bournes, K. Chernavitch, G. Crawford, K. Creed, E. Cringan, E. Dimock, R. Erickson, I. Eyre, K. Fitzrandolph, D. Fleming, J. Gerrick, M. Grant, M. Harris, M. Horn, T. Howorth, L. Ittinuar, E. Jonasson, N. Kostyshyn, I. Kristensen, R. Lafrenière, J. Lambert, L. Leatherdale, W. Leathers, G. Lewkowich, W. Lobchuk, D. Lucas, R. Mansfield, G. Manson, K. Martin, L. McHugh, B. Mulaine, D. Mutchmor, P. Panton, A. Paquette, D. Perkins, G. Petersen, C. Porath, D. Proch, D. Reichert, S. Repa, A. Riller, B. Rothwell, O. Rudd, H. Russell, R. Sakowski, R. Sifton, L. Sissons, J. Stewart, S. Taniwa, T. Tascona, E. Vitins, J. Waddell, E. Warkov, P. Wheeler, R. Williams, H. Wong, S. Wright, V. Zarins.

MASTER OF VISUAL ARTS '72 CIRCULATING/ITINERANTE: Art Gallery and Museum, Univ Alberta, Edmonton (Sept/sept 72); Marquis Gallery, Univ Saskatchewan, Regina (13 XI–1 XII 72); College of Art, Nelson, B.C. (12 II–25 II 73); Univ Laval, Québec (4 IV–16 IV 73); Univ Calgary, Calgary (30 IV–14 V 73); Univ Waterloo, Waterloo, Ont. (Oct/oct 73). ARTISTS EXHIBITING/ARTISTES EXPOSANTS: R. Beer, R. Chenier, I. Cook, J. Freeman, L. Whitford.

MASTERS OF THE SIXTIES CIRCULATING/ITINERANTE: Edmonton Art Gallery, Edmonton (4 V–4 VI 72); Winnipeg Art Gallery, Winnipeg (15 VI–15 VII 72); David Mirvish Gallery, Toronto (27 VII–19 VIII 72).

METIERS D'ART Centre Culturel Canadien, Paris (mai/May 73). ARTISTS EXHIBITING/ARTISTES EXPOSANTS: I. Chiasson, L. Desmarchais, M. de Passillé, L. Perrier, Y. Sylvestre, R. Wolfe.

LES MOINS DE 35 Présentée simultanément à/Presented simultaneously at Centre Saidye Bronfman, Montréal; La Galerie de la S.A.P.Q., Montréal; La Casa Loma, Montréal; Galerie Espace, Montréal; Galerie Média, Montréal; Musée du Québec, Québec; Pavillon Pierre Boucher, Univ Québec à Trois-Rivières (22 I–4 II 73).

ARTISTES EXPOSANTS/ARTISTS EXHIBITING: M. Adam, M. Allard, S. Allard, P. Angers, D. Archambault, P. Archambault, M. Beaule, J. Bédard, R. Bédard, R. Belley, C. Bengle, J. Bergeron, Y. Bergeron, A. Bernard, M. Bernatchez, R. Blouin, G. Boisvert, M. Bonneau, P. Bouchard, R. Bouchard, G. Boucher, M. Boudreau, G. Boulet, R. Bourdeau, P. Bourdon, D. Briand, F. Brière, D. Bujold, L. Busch, P. Candille, G. Cantieni, A. Caron, J. Champagne, M. Champagne, S. Charbonneau, M. Chene-Belzile, M. Clermont, S. Cohen, P. Cordier, J. Côté, R. Courcy, J. Couture, Y. Cozic, F. Dallaire, M. D'Amour, J. Danio, T. Dean, J. De Heusch, L. De Heusch, M. De La Fouchardière, J. De Lavalle, P. Denault, R. Desautels, G. Deschenes, D. Desilets, A. Deslongchamps, A. Desmarchais, H. Dion, C. Doray, M. Doyon, A. Dubois, A. Dupont, M. Dupont, E. Dupré, S. Duranceau, S. Durand, J. Durguerian, M. Dussault, G. Dietcher-Kropsky, N. Elliot-Ledoux, A. Epaule, M. Faucher, L. Favretti, K. Feldman, A. Forrest, M. Forgues, P. Fortin, A. Fournelle, P. Fraser, J. Frigon, P. Fugère, M. Gagné, Y. Gagner, F. Gagnon, J. Gasse, P. Gaudreau, S. Gauthier, L. Gauthier-Mitchell, P. Gélino, P. Genest, R. Gervais, A. Gilbert, M. Gillon-Tremblay, C. Gisalita, A. Godbout, Michel Goulet, Michèle Goulet, P. Granche, J. Guillemette, F. Harrison, M. Haslam, J. Jacmain, M. Jean, J. Jenicek, S. Jephcott, C. Jirar, J. Keromnes, C. Knudsen, M. Kostman, L. Labbé, M. Labbé, P. Lacelin, J. Lacroix, C. Laflamme, M. Lafleur, M. Lalonde, L. Lambert, L. Lanaro-Burnett, M. Landry, G. Lapointe, F. Larivée, R. Lauzon, Lau Tim Yum, E. Lebel-Lacerte, M. Leclair, S. Ledoux, L. Leduc, L. Lemieux, M. Lépine, L. Lessard, J. Lévesque, S. Levin,

(LES MOINS DE 35)
S. Levy, W. Litwack, L. Llewellyn, M. Lussier, P. Lussier, S. Macabée, J. Marchessault, Y. Marcotte, C. Mauffette, S. Michel, P. Migliaccio, G. Mihalcean, J. Milot, P. Monat, A. Mongeau, C. Mongrain, O. Moyen, G. Nadeau, M. Noël, N. Ouimet, A. Pagé, Y. Paré, Mimi Parent, Murielle Parent, G. Pedneault, A. Pelletier, M. Pelletier, R. Pelletier, A. Picard, J. Pigeon, D. Poirier, M. Poirier, S. Plantenga, S. Poulin, I. Riopel, D. Roberge, A. Robert, P. Robert, P. Rousseau, R. Rousseau, M. Roy, M. Rubenstein, L. Ruel, C. Ryan, G. Saint-Laurent Turcotte, Sandessin, N. Schwartz, J. Séguin, B. Simard, S. Simard, F. Steinberg, L. Sylvain, P. Tétreault, R. Thibert, G. Tibo, S. Tousignant, Toy, D. Tremblay, N. Tremblay-Chamberland, D. Trudel, J. Trudel, N. Ulrich, D. Vaillancourt, J. Vallières, P. Valois, B. Van Der Heide, R. Walker, I. Whittome, J. Ziger, F. Zirowski, G. Zuker.

MORBUS—A RITUAL Organized by/Organisée par Ernest W. Smith, Director, Dalhousie Art Gallery. Dalhousie Univ Art Gallery, Halifax (3 IV—22 IV 73). ARTISTS EXHIBITING/ARTISTES EXPOSANTS: J. Greer, D. Haigh, T. Johnson, G. Metson, B. Parsons.

NATURE SASKATCHEWAN Saskatoon Public Library Gallery, Saskatoon, Sask. (2 X—21 X 72).

NECAFEX: NEW CANADIAN ART EXHIBITION Organized by/Organisée par Cosmopolitan Club, Toronto. St. Lawrence Centre for the Arts, Toronto (5 XI—13 XI 72).

ARTISTS EXHIBITING/ARTISTES EXPOSANTS: A. Babitsch, R. Bolt, A. Boszin, G. Condy, L. Frachetti, K. Glaz, H. Gofforth, L. Guderna, H. Hoenigan, J. Hovadik, C. Kerwin, E. Koniuszy, M. Levytsky, J. Marosan, H. Menjolian, H. Novakiwsky, C. Novakiwsky, A. Nulitis, L. Oesterle, J. O'Sik, G. Otto, M. Pavlinak, J. Pivetta, J. Saarniit, G. Salvatore, I. Szebenyi, R. Thepot, O. Timmas.

NEW BRUNSWICK ARTISTS Cassel Galleries, Fredericton, N.B. (13 II—17 III 73). ARTISTS EXHIBITING/ARTISTES EXPOSANTS: B. Bobak, M. Bobak, R. Butler, K. Cameron, N. Cody, J. Corey, F. Coutellier, M. Donaldson, T. Graser, J. Green, C. Hale, L. Harris, A. Harwood, M. Hashley, M. Hughson, H. Kashetsky, J. Kashetsky, M. MacIntyre, J. Maxwell, C. McAvity, D. McKay, J. Mornell, C. Nicholson, M. Pacey, E. Paterson, R. Percival, E. Pulford, F. Ross, G. Schaap, P. Skalnik, P. Smith, H. Swedersky, B. Tolle, F. Willar.

NORTHERN SASKATCHEWAN JURIED EXHIBITION Organized by/Organisée par Northern Saskatchewan Chapter of the Canadian Arts Representation. Saskatoon Public Library Gallery, Saskatoon (27 II—25 III 73).

ARTISTS EXHIBITING/ARTISTES EXPOSANTS: D. Bentham, J. Boyd, B. Boyer, R. Christie, R. Cowley, M. Forsyth, H. Grenkie, K. Hardy, E. Hull, B. Johnsrude, M. Keelan, D. Knowles, L. Koehn, J. Korpan, M. Malkin, W. Mulcaster, W. Perehudoff, D. Sawchen, R. Shuebrook, F. Stehwien, J. Thornsbury, B. Warnock, M. Wawra, O. Young.

OPERATION MULTIPLE Galerie Espace, Montréal (31 V—30 IX 72). ARTISTES EXPOSANTS/ARTISTS EXHIBITING: G. Bergeron, R. Cavalli, C. Daudelin, L. Dupuis, I. Fortier, H. Franklin, W. Fuhrer, R. Giguère, W. Jarnuskiewieck, R. Mitchell, G. Smith, Y. Trudeau.

PACK SACK ITINERANTE/CIRCULATING: La Galerie d'art de l'Université de Sherbrooke (juin/June—juil/Jul 72); Bibliothèque Centrale de prêt du Saguenay-Lac-Saint-Jean (févr/Feb 73). ARTISTES EXPOSANTS/ARTISTS EXHIBITING: P. Ayot, L. Bissonnette, G. Boisvert, Y. Cozic, J. Noel, F. Simonin, R. Wolfe.

LE PANORAMA DE LA CREATIVITE CONTEMPORAINE AU CANADA Ontario Science Centre, Don Mills, Ont. (juin/June 72).

PAINTERS ELEVEN McIntosh Gallery, Univ Western Ontario, London, Ont. (1 X—22 X 72).

LES PEINTRES DU SAGUENAY Galerie d'Art Benedek-Grenier, Québec (5 V—26 V 73).

ARTISTES EXPOSANTS/ARTISTS EXHIBITING: D. Angers, G. Barbeau, H. Beck, C. Dufour, G. Hébert, J. Lacroix, J. Lambert, G. Moisan, H. Montgrain, A. Ouellet, B. Simard, M. Tanguay, G. Tay, E. Tremblay, L. Tremblé, A. Villeneuve.

PLASTIC FANTASTIC London Public Library, London, Ont. (8 IX—1 X 72).

ARTISTS EXHIBITING/ARTISTES EXPOSANTS: R. Allen, I. Baxter, T. Bieler, Z. Blazeje, R. Brousseau, Y. Cozic, F. D'Allégret, G. Gladstone, A. Handy, M. Hayden, D. Jean-Louis, A. Jolicoeur, P. Kolisnyk, H. Leroy, L. Levine, J.-P. Mousseau, J. Noel, G. Nolte, W. Redinger, H. Saxe, J. Smith, J. Stohn, G. Toppings, J. Wieland, E. Zelenak.

PRAIRIE SCULPTURE Univ Saskatchewan, Saskatoon (Oct/oct 72).

PROCESS Sponsored by the/Offerte par la Women's Committee of the London Public Library and Art Museum. London Public Library, London, Ont. (6 IV—30 IV 73). ARTISTS EXHIBITING/ARTISTES EXPOSANTS: Anglosaglo, Annuktoshe, P. Ayot, A. Benjamin, R. Bikkers, B. Bobak, A. Colville, G. Curnoe, K. Danby, J. Dickson, H. Dunsmore, J.K. Esler, C. Gagnon, Y. Gaucher, S. Haeseker, C. Hoskinson, F. Jorgensen, Kenojuak, C. Knudson, R. Lacroix, R. Letendre, D. Milne, G. Molinari, Mungita, M. Noah, W. Noah, K. Ondaatje, T. Onley, Oonark, J. Palchinski, A. Pellan, W. Phillips, C. Pratt, J.-P. Riopelle, W. Ross, Seegova, G. Smith, J. Snow, R. Swartzman, E. Tellez, H. Town, J. Wheeler.

REALISM: EMULSION AND OMISSION Organized by/Organisée par Agnes Etherington Art Centre, Kingston, Ont. CIRCULATING/ITINERANTE: Agnes Etherington Art Centre, Kingston, Ont. (19 IX—22 X 72); Art Gallery of the Univ of Guelph, Guelph, Ont. (8 XI—4 XII 72). ARTISTS EXHIBITING/ARTISTES EXPOSANTS: J. Boyle, C. Breeze, J. Chambers, G. Curnoe, J. Fafard, G. Falk, M. Favro, General Idea, D. Gilhooly, J. Gouin, J. Hall, C. Hogenkamp, J. Leonard, M. Prent, G. Smith, N. E. Thing Co. Ltd., W. Vazan, R. Young.

REGINA CERAMICS NOW Dunlop Art Gallery, Regina, Sask. (9 XII 72—7 I 73). ARTISTS EXHIBITING/ARTISTES EXPOSANTS: M. Bolen, V. Cicansky, J. Fafard, R. Gomez, B. Hone, A. James, M. Levine, P. Wiens.

DE REVES ET D'ENCRE DOUCE Organisée par/Organized by Guy Girard, Montréal ITINERANTE/CIRCULATING: Bibliothèque nationale du Québec (3 X—29 X 72); Univ Montréal (24 XI—31 XI 72); Musée de Rimouski, Rimouski, Qué. (déc/Dec 72); Bibliothèque du Collège Notre-Dame, Montréal (4 XII—8 XII 72); Univ Sherbrooke, Sherbrooke, Qué. (févr/Feb 73); Stewart Hall Art Gallery, Centre Culturel de Pointe Claire, Qué. (10 IV—28 IV 73); Lorient, France (5 IV—10 IV 73); Morlaix, France (10 IV—15 IV 73); Saint-Brieux, France (16 IV—21 IV 73); Vannes, France (24 IV—28 IV 73); Quimper, France (29 IV—3 V 73); St. Nazaire, France (4 V—10 V 73); Grenoble, France (26 V—4 VI 73); Centre d'art des Jeunesse Musicales, Orford, Qué. (juin/June 73). ARTISTES EXPOSANTS/ARTISTS EXHIBITING: M. Bertrand, C. Bourgeois, I. Desjardins, R. Dumais, S. Girard, C. Léonard, R. Poirier.

SASKATCHEWAN ARTS BOARD COLLECTION OF WATERCOLOURS AND DRAWINGS Saskatoon Public Library (Jan/janv 73). ARTISTS EXHIBITING/ARTISTES EXPOSANTS: R. Cowley, S. Day, J. Ellemers, C. Enright, T. Fenton, A. Gallus, G. Hogg, R.N. Hurley, C. James, L. Koehn, D. Knowles, L. Lamont, M. Lawrence, E. Lindner, L. Malach, A. McKay, J. Sures, R.D. Symons, L. Walters.

SCAN (SURVEY OF CANADIAN ART NOW) Vancouver Art Gallery (27 IX—29 X 72). ARTISTS EXHIBITING/ARTISTES EXPOSANTS: L. Abrams, J.L. Adams, G. Angliss, R. Arsenault, C. Babcock, M. Banks-May, D. Barnett, P.M. Bates, J. Bédard, O. Benazon, D. Bentham, T.M. Bidner, B. Bissett, Z. Blazeje, R. Bonderenko, J. Boyle, R.M. Bozak, R. Brousseau, T. Burrows, Canada Art Writers, R.R. Carmichael, B. Caruso, Chuck Stake Enterprises, P.M. Clarke, C. Dahl, J. Darais, C. Dikeakos, D. Druick, H. Dunsmore, R.W. Eastcott, N. Edell, D. Elliott, D. Ellis, G. Falk, H. Feist, C. Fisher, G.P. Forgie, D. Foster, J.W. Fraser, J. Frick, Galactic Research Council, T. Gallie, I. Garrioch, D. Gill, Göert-Sawatski, D. Gordon, T. Graff, A. Green, N.N. Green, J. Grey, B. Hall, J. Hall, M. Hayden, C. Hayward, D.S. Henderson, M. Hirschberg, D. Holyoak, J. Hoogstraten-Campbell, J.A. Hooper, E.J. Hughes, Insurrection Art Co., B. Jones, R. Jordan, F. Jorgensen, D. Kas-Mazalek, B.L. Kelly, K. Kelly, R. Retman, E.P. La Borie, R. Lafrenière, M. Levine, D. Mabie, D. McCarthy, A.M. MacLennan, T. MacLennan, W.M. May, B. Maycock, R. Moppett, The No Bullshit Bloor Boys, P.G. O'Brien, Pacific Rim Consciousness, S. Palchinski, R. Poulon, R. Prince, S. Raphael, H. Rappaport, G. Rice, E. Roth, B. St. Clair, G. Simpson, A. Smith, R. Stanbridge, A. Stevenson, S. Swibold, R. Taylor, W. Toogood, E. Varney, W. Vazan, A. Whitlock, S. Wildman, J. Willer, N. Yates, R. Young, N. Yuen.

SCULPTORS' SOCIETY OF CANADA GROUP SHOW CIRCULATING/ITINERANTE: Toronto-Dominion Centre, Toronto (15 X—3 XI 72); Scarborough College, Scarborough, Ont. (5 XI—27 XI 72). ARTISTS EXHIBITING/ARTISTES EXPOSANTS: I. Blogg, A. Boszin, E. Cox, W. Falkenberg, A. Filipovic, R. Green, G. Hill, M. Kastner, E. Koniuszy, A. Kopmanis, W. Lawrence, J. Lim, W. McElcheran, S. Michel-Harlander, J. Marosan, M. Marx, K. Nice, A. Nieuwland, L. Oesterle, M. Podgrabinszki, J. Raine, V. Rosenzweig, K. Schmallfuss, R. Sisler, A. Stappels, J. Szablowski, L. Temporale, S. Ulbricht, D. Wilson, I. Zebenyi, R. Zellermeyer.

SCULPTURE OF THE INUIT: MASTERWORKS OF THE CANADIAN ARCTIC/LA SCULPTURE CHEZ LES INUIT: CHEFS-D'OEUVRE DE L'ARCTIQUE CANADIEN Organized by/Organisée par Canadian Eskimo Arts Council. CIRCULATING/ITINERANTE: Vancouver Art Gallery; Les Grand Palais, Paris; National Museum, Copenhagan; British Museum, London; Pushkin Fine Arts Museum, Moscow; The Hermitage, Leningrad; Musée des Beaux-Arts de Montréal; National Gallery, Ottawa (17 V–17 VI 73). ARTISTS EXHIBITING/ARTISTES EXPOSANTS: J. Aculiak, P. Ahlooloo, Akeeah, Akeeaktashuk, M. Amarook, Amidilak, D.A. Amittu, Anaija, A. Anaitok, J. Angnako, K. Angootikjuak, P. Anigliak, G. Annanak, O. Apsaktauk, T. Arlutnar, T. Arnayuinnar, Ashevak, J. Atok, Audla, M. Aupilarjuk, Axangayuk, L. Echalook, Eeleeseepee, Eeteeguyakjuak, P. Ekidlak, D. Ekoota, Eli, Eliassiepik, Elijassigpik, Elizabeth, Epirk, T. Erkoolik, D. Hagiolok, A. Igaiju, Igjookhuak, B. Iguptaq, B. Ikkuma, J. Inukpuk, P. Inukshuk, J. Irkok, M. Issirkrut, Iyola, Joanassie, Jonanassi, Jya, N. Kablutsiak, Kabubawokota, Kadojuak, D. Kagvik, Kaka, B. Kakagon, J. Kakee, F. Kallooar, E. Kanagna, Kananginak, I. Kataq, M. Katoo, J. Kaunak, John Kavik, Johnassie Kavik, Kenojuak, Kiakshuk, Kiawak, J. Kingeelik, Caroline Kittosuk, Charlie Kittosuk, Kogalik, Konak, K. Koodluarlik, Kooparpik, Kopergualook, M. Kopinar, Koughajuke, Kovinaktilliak "C", Kowjakalook, N. Kublutsiak, N. Kudluk, U. Kulluarjuk, L. Kunuk, F. Kupak, Latcholassie, Lukta, V. Arnakingook Makpa, V. Arnasungnark Makpa, A. Mamgark, M. Manaipik, Manno, Mannuk, Markosie, Miki, Moses, V. Mummookshoarluk, Munnurme "A", E. Nanook, H. Napartuk, S. Nassak, A. Nastapoka, K. Natsiapik, I. Neooktook, Niviaksiak, A. Niviaxie, C. Niviaxie, E. Nootaraloo, M. Nugyugalik, P. Nuktialuk, M. Nuyaitok, L. Ohaytok, F. Oogark, Oopik, S. Oothooyuk, Oshooweetook "B", I.Q. Padlayat, J. Pangnatk, Pauta, Piluardjuk, L.A. "Smith" Pirti, M. Pissuyui, J. Polik, A. Poy, Pudlo, Pukka, Qirluaq, Saggiak, Sheeookjuk, J. Shimout, Shoovagar, D. Simaotik, Simigak, Simonee, Smimayook, Suetakak, Syollie, J. Talirunili, F. Tartuk, L. Tasseor, G. Tattener, Tavitee, S. Tegodlerrak, E. Tikeayak, Tiktak, D. Tiktala, M. Tooktoo, P. Toolooktook, Tudlik, M. Tungilik, S. Tunilik, T. Ugjuk, E. Utuyak, M. Uyaoperk, S. Weetaltuk, Willie, Yassic.

SIMPSONS CENTENNIAL EXHIBITION OF SASKATCHEWAN ART Regina (3 X–14 X 72).

SOCIETY OF CANADIAN ARTISTS 5TH JURIED SHOW Eaton's Fine Art Gallery, Toronto (5 X–18 X 72). ARTISTS EXHIBITING/ARTISTES EXPOSANTS: L. Guderna, E. Phillips, H. Sabelis.

SOCIETY OF CANADIAN PAINTER-ETCHERS AND ENGRAVERS Ontario Institute for Studies in Education, Toronto (5 I–31 I 73).

SOCIETY OF CANADIAN PAINTER-ETCHERS AND ENGRAVERS 56TH ANNUAL EXHIBITION London Public Library, London, Ont. (1 XI–29 XI 72).

STAND BACK YOU FOOLS! Burnaby Art Gallery, Burnaby, B.C. (4 IV–29 IV 73). ARTISTS EXHIBITING/ARTISTES EXPOSANTES: D. Crocker, R. Foulger, L. Magor, N. McGovern, C. Thompson, C. Winch.

STEPHEN GREENE'S WORKSHOP Edmonton Art Gallery. ARTISTS EXHIBITING/ARTISTES EXPOSANTS: A. Clarke-Darrah, D. Elliot, H. Feist, B. Forseth, M. Mulcaster, V. Owen.

SOUTHWEST 33 Art Gallery of Windsor, Windsor, Ont. (4 II–28 II 73).

ARTISTS EXHIBITING/ARTISTES EXPOSANTS: L. Anderson, C. Bates, R.W. Beneteau, L. Beresnevicius, K. Bezaire, R. Bonderenko, B.E. Brown, T. Calzetta, S.E. Collacott, J. De Angelis, A. Duck, C.J. Finn, T. Fraser, J. Garland, F.K. Gustin, T. Holownia, M. Karlik, D.W. Knight, J. Krawczyk, W.C. Law, Jr., D. Loaring, G.Y. Masson, N. Milstein, D. Murray, H. Noestheden, J.T. Noestheden, B. Pestich, R. Robinson, C. Rolston, A. Rossini, D. Roy, J. St. Denis, G. Scott, D.W. Smith, J. Szilva, M. White, C. Williams, E. Yerex.

A SUMMER SHOW Saskatoon Public Library Gallery (3 VII–15 VII 73).

ARTISTS EXHIBITING/ARTISTES EXPOSANTS: M. Aadland, H. Baillod, G. Fisher, H. Grenkie, C. Hume, N. Hymers, J. Lodoen, D. Quintal, M. Rivard, E. Soonias, A. Swiatecki, A. Tokarchuk, S. Tokarchuk, R. Wright, Sister S. Zunti.

THEATRE ARTS WORKS Organized with the assistance of The National Gallery/Organisée avec l'aide de La Galerie nationale. CIRCULATING/ITINERANTE: Confederation Centre Art Gallery, Charlottetown; Trajectory Gallery, London, Ont.; Edmonton Art Gallery; Alberta College of Art, Calgary. ARTISTS EXHIBITING/ARTISTES EXPOSANTS: G. Falk, A. Gilbert, T. Graff, E. Klassen, J. Malmberg, G. Prodanluk.

THOMAS MORE ASSOCIATES ANNUAL EXHIBITION OF ART Place Ville Marie, Royal Bank Bldg., Montreal (3 XI–18 XI 72).

TORONTO PAINTING: 1953-1965/LA PEINTURE TORONTOISE 1953-1965 Organized by The National Gallery/Organisée par La Galerie nationale. CIRCULATING/ITINERANTE: National Gallery, Ottawa (15 IX–15 X 72); Art Gallery of Ontario, Toronto (10 XI–10 XII 72).

ARTISTS EXHIBITING/ARTISTES EXPOSANTS: D. Burton, J. Bush, O. Cahen, G. Coughtry, P. Fournier, G. Gladstone, H. Gordon, R. Gorman, R. Hedrick, T. Hodgson, G. Iskowitz, L. Levine, A. Luke, J. Macdonald, R. Markle, R. Mead, J. Meredith, K. Nakamura, G. Rayner, W. Ronald, M. Snow, M. Teitelbaum, H. Town, T. Urquhart, J. Wieland, W. Yarwood.

TWO NATIONS—SIX ARTISTS Organized by/Organisée par Moorhead State College, Moorhead, Minn. CIRCULATING/ITINERANTE: Moorhead State College Center for the Arts Gallery, Moorhead, Minn. (26 III–20 IV 73); Centennial Concert Hall, Winnipeg (30 IV–25 V 73). ARTISTS EXHIBITING/ARTISTES EXPOSANTS: C. Brodie, D. Flynn, M. Harris, J. Kielkopf, R. Mansfield, T. Tascona.

UKRAINIAN-CANADIAN GRAPHIC ARTISTS EXHIBITION Univ Montréal (Mar/mars 73).

WATERCOLOUR PAINTERS FROM SASKATCHEWAN/AQUARELLISTES DE LA SASKATCHEWAN Organized by The National Gallery/Organisée par La Galerie nationale. CIRCULATING/ITINERANTE: Moose Jaw Art Museum, Moose Jaw, Alta. (15 V–15 VI 72); Burnaby Art Gallery, Burnaby, B.C. (1 VII–31 VII 72); Rothmans Art Gallery, Stratford, Ont. (15 VIII–15 IX 72); Dunlop Art Gallery, Regina (14 X–5 XI 72). ARTISTS EXHIBITING/ARTISTES EXPOSANTS: R. Cowley, R. Hurley, D. Knowles, E. Lindner, R. Symons.

WEST '71 Organized by/Organisée par The Edmonton Art Gallery CIRCULATING/ITINERANTE: Glenbow-Alberta Institute, Calgary (1 VII–1 VIII 72).

ARTISTS EXHIBITING/ARTISTES EXPOSANTS: G. Bailey, B. Ballachey, R. Beer, D. Bentham, H. Bres, G. Brown, S. Campbell, R. Carmichael, R. Chenier, D. Chester, R. Christie, A. Clarke-Darrah, I. Cook, A. Cooke, I. Dmytruk, B. Drummond, M. Enns, A. Esler, J. Esler, G. Eversole, W. Fairbairn, H. Feist, N. Fiertel, J. Forbes, V. Foster, J. Freeman, J. Grabuin, M. Grayson, G. Guerin, G. Guillet, S. Haeseker, John Hall, Joyce Hall, V. Hammock, D. Haynes, H. Hicks, B. Jacobs, M. Jones, F. Jorgensen, W. Jule, J. Kay, H. Kiyooka, D. Knowles, R. Kostyniuk, D. Lieberman, J. Lindsay, T. Manarey, R. Mansfield, B. McCarroll, C. McConnell, D. McVeigh, J. Mitchell, B. Neinish, D. Oakley, K. Ohe, B. O'Neil, V. Owen, G. Peacock, P. Peacock, W. Perehudoff, B. Pratt, D. Roberts, R. Sakowski, G. Seeckts, R. Sen, R. Silvester, R. Sinclair, M. Sowdon, V. Thierfelder, J. Thornsbury, K. Thurlbeck, G. Tosczak, M. Travers, S. Vadnai, L. Von Scheliha, S. Voyer, J. Vriesen, M. Wawra, L. Whitford, J. Will, M. Will, T. Wilson, R. Yuristy, P. Zielke.

WESTERN CANADA Gallery 1640, Montreal (3 III–31 III 73). ARTISTS EXHIBITING/ARTISTES EXPOSANTS: A. Bell, J. Esler, G. Guerin, D. Harvey, H. Kiyooka, W. Leathers, K. Van der Ohe, E. Ouchi, J. Snow.

WESTERN ONTARIO EXHIBITION (33RD ANNUAL) London Public Library and Art Museum, London, Ont. (5 V–5 VI 73). ARTISTS EXHIBITING/ARTISTES EXPOSANTS: J. Andreisse, H.P. Baillie, B. Bauman, D. Bellamy, R. Benner, T. Benner, T.M. Bidner, R. Bonderenko, D. Bonham, P. Borowsky, R.M. Bozak, L. Brighton, R. Burke, A. Calzetta, M. Chow, K. Ferris, A. Garwood, J. Gillies, D. Gordon, B. Ling, V. Lougheed, B. Maycock, J. Maycock, H. Noestheden, N. Oman, P. Osicka, P. Ottenbrite, K. Posliff, J. St. Denis, V. Sturdee, G. Wright, R. Zarski.

WINNIPEG UNDER 30 The Winnipeg Art Gallery, Winnipeg, Man. (17 XI–18 XII 72). ARTISTS EXHIBITING/ARTISTES EXPOSANTS: J. Allsopp, T. Andrich, R.P. Brunet, B. Caslor, W. Condon, M. Harris, T. Howorth, J.J. Johnson, R. Mansfield.

WOMEN'S WORK Gallery 76, Ontario College of Art, Toronto (16 II–25 II 73).

ARTISTS EXHIBITING/ARTISTES EXPOSANTS: V. Adamovitch, S. Aikins, A. Armstrong, B. Astman, P. Boote, M. Brandt, V. Burgess, M. Campbell, B. Cochrane, P. Dumas, M. Goodman, D. Gordon, E. Greene, J. Griffith, D. Hart, K. Haynes, S. Hillel, J. Ingrao, D. Jarrett, A. Jordan, S. Kelly, I. Ketola, J. Krosnick, B. Laffey, N. Lindsay, S. Martin, S. Merkur, L. Mills, P. Morley, E. Nishihata, S. Nonen, C. Pasternak, J. Perry, A. Powell, J. Sadel, M. Smith, C. Stewart, P. Stren, D. Taylor, C. Timm, D. Turkewitch.

artists
artistes

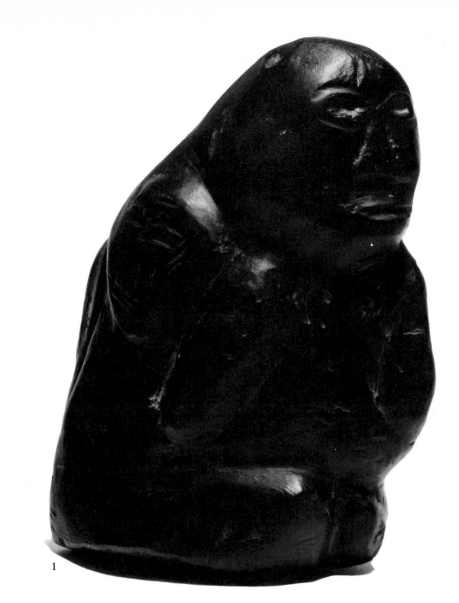

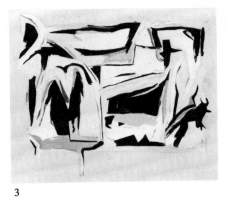

TONY ALLISON (Sculpture, drawing/Sculpture, dessin) 1946, Flin Flon, Man. LIVES/HABITE: Winnipeg TRAINING/FORMATION: Sir John Cass School, London, Eng. AWARDS & HONOURS/PRIX & HONNEURS: State First Award, Hallmark Poster Competition, North Dakota, 1965; First place, Prince Albert Exposition, 1972 MEDIUM: Assemblage, oil, acrylic and plastic paints, ceramic sculpture/Assemblage, peinture à l'huile, à l'acrylique et au plastique, sculpture en céramique.

EX−1: Peoples' Gallery, Winnipeg (Aug/août 72); Plug-In Gallery, Winnipeg (13 XII 72−13 I 73).

GROUP/GROUPE: Prince Albert Art Centre, Prince Albert, Sask. (Aug/août 72); "Sun Centre Show" Winnipeg (July/juil−Aug/août 72); Univ Winnipeg (Feb/févr 73).

JUDITH ALLSOPP (Printmaking, painting, drawing/Gravure, peinture, dessin) 1943, Bartlesville, Oklahoma LIVES/HABITE: Winnipeg TRAINING/FORMATION: Kansas City Art Institute; Univ Kansas School of Fine Arts; Byam Shaw School of Fine Art, London, Eng.; Emma Lake Workshop; Edmonton Art Gallery Workshop AWARDS

AND HONOURS/PRIX ET HONNEURS: Canada Council Arts Bursaries and Travel Grants, 1970,1971/ Bourses et Bourses de Voyage du Conseil des Arts du Canada, 1970,1971.

EX−1: "Judith Allsopp—Recent Paintings" Organized by/organisée par Memorial Univ, St. John's, Nfld.: Beaverbrook Art Gallery, Fredericton, N.B. (June/juin 72); Memorial Univ, St. John's, Nfld. (Jul/juil 72).

GROUP/GROUPE: "Winnipeg Under 30"; "Manitoba Mainstream"; "Manisphere '72"; "Art for All".

1 ANGAKTAGUAK *Black Stone/Pierre noire, 1973 (12")* Photo: Innuit Gallery, Toronto

2 ANGLOSAGLO *Kayaks and Caribou, 1972.* Photo: Innuit Gallery, Toronto

3 ALLSOPP *1972 (32" x 44")*

4 ALLISON *Red Amber Wedge, 1971 (37" x 37")*

MAURICE D'AMOUR (Multi-média, gravure, peinture/Mixed media, printmaking, painting) 1949 HABITE/LIVES: Laval, Qué. FORMATION/TRAINING: Ecole des Beaux-Arts, Montréal MEDIUM: Multi-média, acrylique, sérigraphie/Mixed media, acrylic, serigraphy GROUPE/GROUP: "Les Moins de 35".

TOM ANDRICH (Sculpture) 1945, Winnipeg LIVES/HABITE: Winnipeg TRAINING/FORMATION: Art School, Univ Manitoba MEDIUM: 2–D, 3–D mixed media/multi-média GROUP/GROUPE: Winnipeg Art Gallery, Winnipeg (17 XI–18 XII 72); "Winnipeg Under 30".

ANGATAGUAK (Sculpture) LIVES/HABITE: Baker Lake, N.W.T. EX–2: with/avec **KAVIK**, Innuit Gallery, Toronto (25 III–3 IV 73).

GROUP/GROUPE: Mohawk College, Hamilton, Ont. (Apr/avril 73); "St. Thomas and Elgin Juried Show" St. Thomas, Ont. (Apr/April–May/mai 73); "Graphex 1"; "Canadian Society of Graphic Art" London, Ont. (June/juin 73).

ANGLOSAGLO (Printmaking, drawing/Gravure, dessin) 1895 LIVES/HABITE: Baker Lake, N.W.T. EX–1: "Drawings by Anglosaglo of Baker Lake" Innuit Gallery, Toronto (23 IX–4 X 72); EX–2: "Drawings by Anglosaglo of Baker Lake" with/avec **PARR**, Moss Gallery, London, Eng. (Oct/oct 72) GROUP/GROUPE: "Process"; "Baker Lake Drawings".

LOUIS ARCHAMBAULT (Sculpture, dessin/Sculpture, drawing) 1915, Montréal HABITE/LIVES: St-Lambert, Qué. FORMATION/TRAINING: Ecole des Beaux-Arts de Montréal; Univ Montréal; autodidacte/self-taught PRIX & HONNEURS/AWARDS & HONOURS: Concours Artistique de la Province de Québec, Premier Prix, sculpture, 1948 et Premier Prix, arts appliqués, 1950; Dixième Triennale de Milan, Diplôme, 1954; Commission pour le Pavillon canadien, Bruxelles; Institut Royal d'Architecture du Canada, Médaille des Arts connexes, 1958; Médaille du Centenaire, 1967; Ordre du Canada, 1968/Province of Quebec Arts Competition, First Prize, Sculpture, 1948 and First Prize, Applied Arts, 1950; Tenth Milan Triennale, Diploma, 1954; Commission for the Canadian Pavillion, Brussels; Royal Architectural Institute of Canada, Related Arts Medal, 1958; Centennial Medal, 1967; Order of Canada, 1968 ENSEIGNE/TEACHES: Univ Québec, Montréal MEDIUM: Bois et aluminium peint/Wood and painted aluminum.

EX–1: "Sculptures Urbaines" Musée d'Art Contemporain, Montréal (17 IX–29 X 72) GROUPE/GROUP: "Bertrand Russel Centenary Art Exhibition and Sale" London, Eng.

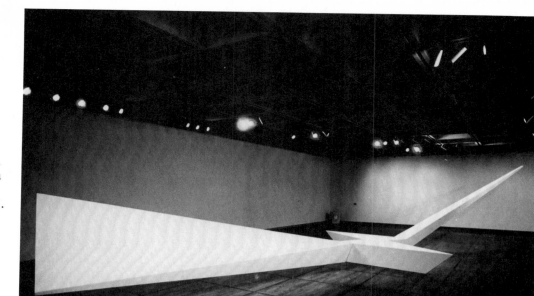

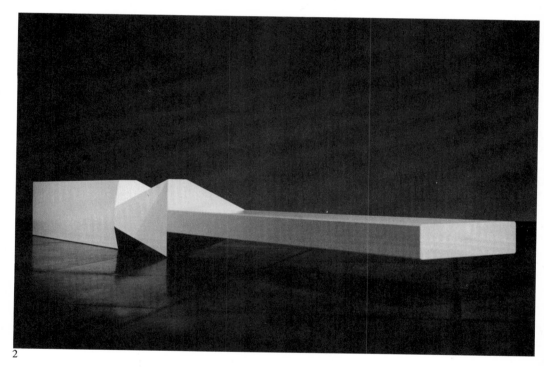

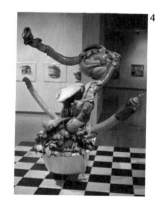

1 L. ARCHAMBAULT *La Flèche, 1972 (60')* Photo: Eloi Archambault (Musée d'Art Contemporain, Montréal)

2 L. ARCHAMBAULT *Modulation No. IV (26')* Photo: Eloi Archambault (Musée d'Art Contemporain, Montréal)

3 D'AMOUR *Life Savers*

4 ANDRICH *Enigmatic in Bathtub, 1972*

PIERRE ARCHAMBAULT (Peinture/Painting) 1943 HABITE/LIVES: Montréal FORMATION/TRAINING: Ecole des Beaux-Arts, Montréal; Institut des Arts Appliqués de Montréal MEDIUM: Huile et acrylique sur aluminium/Oil and acrylic on aluminum.

EX–1: Galerie le Gobelet, Montréal (mai/May–juin/June 72); Ateliers du Vieux Longueuil, Longueuil, Qué. (23 III–1 IV 73).

GROUPE/GROUP: Centre d'Art du Mont-Royal (15 IX - 15 X 72); "Les Moins de 35".

KAROO ASHEVAK (Sculpture) 1941 LIVES/HABITE: Spence Bay, N.W.T. MEDIUM: Whalebone/Os de baleine EX–1: Lippel Gallery, Montréal; Innuit Gallery, Toronto (Mar/mars 73); American Indian Arts Centre, New York (Jan/janv 73) GROUP/GROUPE: "Sculpture/Inuit".

DENIS ASSELIN 1943 HABITE/LIVES: Québec MEDIUM: Acrylique, huile, émail fluorescent/Acrylic, oil, fluorescent enamel EX–3: "Visuels" Univ Laval, Galerie des Arts (21 II–6 III 73)

ERIC ATKINSON (Mixed media/Multimédia) 1928, Hartlepool, Eng. TRAINING/FORMATION: Royal Academy, London TEACHES/ENSEIGNE: Fanshawe College, London, Ont.

EX–1: Morse-Capponi Gallery, Grosse Pointe, Michigan (10 V–7 VI 73)

GROUP/GROUPE "Stratford Summer Show".

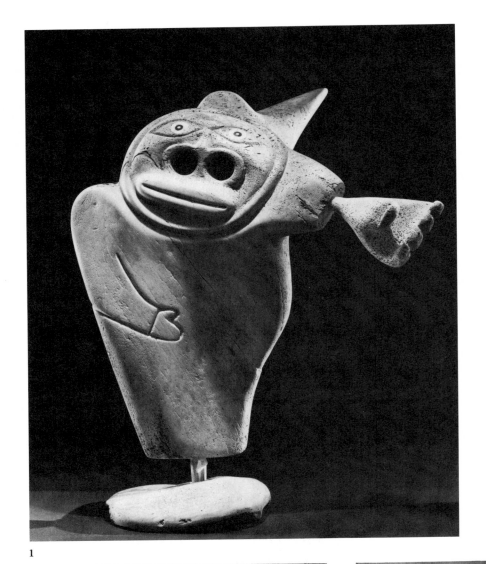

1

2

3

4

5 6

MADELEINE LANGLOIS AUDETTE (Peinture, dessin/Painting, drawing) 1925 HABITE/LIVES: Magog, Qué. FOR-MATION/TRAINING: Musée des Beaux-Arts de Montréal MEDIUM: Encre de Chine, acrylique, huile/India ink, acrylic, oil EX—1: La Galerie d'Art, Univ Sherbrooke (29 X—12 XI 72) GROUPE/GROUP: Club House Piste Blue-Bonnet (janv/Jan 73).

1 ASHEVAK *(19")* Photo: Lippel
 Gallery, Montreal

2 P. ARCHAMBAULT *Correspondance,*
 1973

3 P. ARCHAMBAULT *Vibration I, 1972*

4 ATKINSON *Toltec Procession, 1973*
 (42" x 54")

5 ASSELIN *No. 248, 1972 (60" x 60")*

6 AUDETTE

1

ARTHUR S. BAALAM (Painting/Peinture) 1898 LIVES/HABITE: North Battleford, Sask. TRAINING/FORMATION: Heatherly School of Art, Eng. MEDIUM: Oil, watercolour, collage/Huile, aquarelle, collage.

EX—1: Legion Hall, North Battleford, Sask. (3 VI–4 VI 72); Richmond Arts Centre, Richmond, B.C. (31 VI–27 VII 72).

WALTER BACHINSKI (Drawing, printmaking, sculpture/Dessin, gravure, sculpture) 1939, Ottawa LIVES/HABITE: Guelph, Ont. TRAINING/FORMATION: Ontario College of Art, Toronto AWARDS & HONOURS/PRIX & HONNEURS: Canada Council Grant/Bourse du Conseil des Arts du Canada TEACHES/ENSEIGNE: Univ Guelph.

EX—1: "Walter Bachinski" CIRCULATING/ITINERANTE: Mount St. Vincent Univ, Halifax (Dec/déc 72); Mt. Allison Univ, Sackville, N.B. (Feb/févr 73); Memorial Univ, St. John's, Nfld. (Mar/mars 73); New Brunswick Museum, St. John, N.B. (May/mai 73).

EX—1: Faculty of Fine Art, Univ Guelph, Guelph, Ont. (7 II–28 II 73).

EX—1: "Prints, Drawings and Sculpture" (12 III–15 V 73) CIRCULATING/ITINE-RANTE: St. John's Gallery, Memorial Univ, Nfld. (12 III–1 IV 73); Cornerbrook Gallery Nfld. (12 III–1 IV 73); Grand Falls Gallery, Nfld. (1 V–15 V 73); Gander International Airport, Nfld. (2 V–16 V 73).

GROUP/GROUPE: "XI Biennale of Prints and Drawings" Lugano, Switzerland; "International Printmakers"; "International Graphics"; Graphex I"; "26th Annual Boston Printmakers Exhibition" Boston, U.S.A.

HELEN BAILLIE (Painting/Peinture) LIVES/HABITE: Hamilton, Ont. TRAINING/FORMATION: Ontario College of Art, Toronto; St. Martin's School, London, Eng.; Dundas Valley Art School MEDIUM: Watercolour, gouache, acrylic/Aquarelle, gouache, acrylique.

EX—1: Beckett Gallery, Hamilton, Ont. (12 X–25 X 72).

GROUP/GROUPE: "33rd Annual Western Ontario Exhibition"; "Annual Juried Show" Tom Tomson Gallery, Owen Sound, Ont.; "47th Annual Juried Exhibition" Canadian Society of Painters in Watercolour, O'Keefe Centre, Toronto; "23rd Annual Exhibition of Contemporary Canadian Art" Art Gallery of Hamilton; "Ontario Juried Exhibition" Rodman Hall, St. Catharines, Ont. (Mar/mars 73).

1 BAILLIE *It Depends Which Way You Look, 1973*

2 BAALAM *Saskatchewan Farm Scene (30" x 24")*

3 BACHINSKI *Saturn, 1971*

2

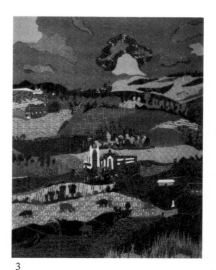

3

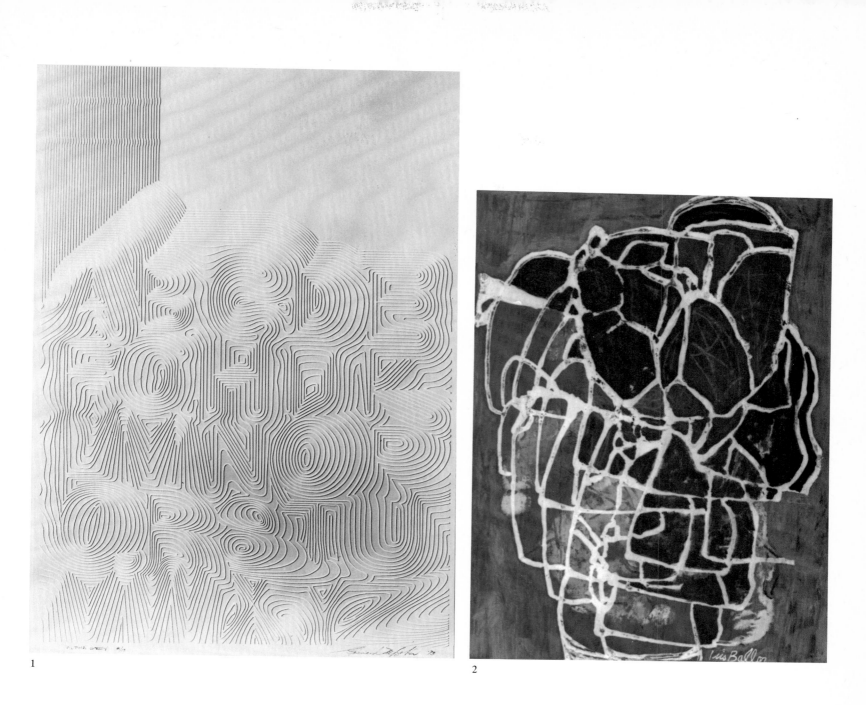

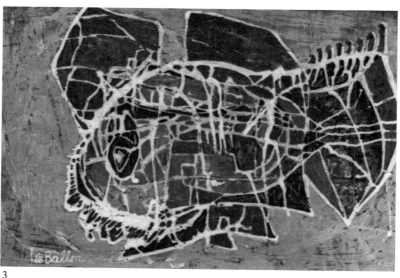

EDWARD M. BAKER (Printmaking/Gravure) 1927, Orangeville, Ont. LIVES/HABITE: Woodstock, Ont. TEACHES/ENSEIGNE: College Ave. Secondary School, Woodstock, Ont. MEDIUM: Serigraphy/Sérigraphie.

EX—2: College Ave. Secondary School, Woodstock, Ont. (May/mai 73).

GROUP/GROUPE: Mohawk College, Hamilton, Ont. (April/avril 73); "St. Thomas and Elgin Juried Show" St. Thomas, Ont. (April/avril - May/mai 73); "Graphex 1"; "Canadian Society of Graphic Art" London, Ont. (May/mai - June/juin 73).

IRIS SHKLAR BALLON (Peinture, gravure/Painting, printmaking) 1937, Montréal HABITE/LIVES: Montréal FORMATION/TRAINING: Autodidacte/Self-taught MEDIUM: Gouache, eau-forte, lithographie, gravure sur bois/Gouache, etching, lithography, woodcut.

EX—1: Waddington Galleries, Montréal (6 XII—22 XII 72).

GROUPE/GROUP: National Council of Jewish Women Exhibition and Sale, Ottawa; Société des Artistes Professionnels du Québec, Dawson College, Montréal (nov/Nov 72); Canadian Society of Painters in Watercolour, 47th Annual Exhibition; Thomas More Associates Annual Exhibition of Art; Gallery 1667, Halifax (déc/Dec 72); Waddington Galleries, Montréal (janv/Jan 73).

1 BAKER *Alpha Grey, 1973*

2 BALLON *Blonde Head, 1972 (22" x 28")*

3 BALLON *Silent Whiskered Fish, 1972*

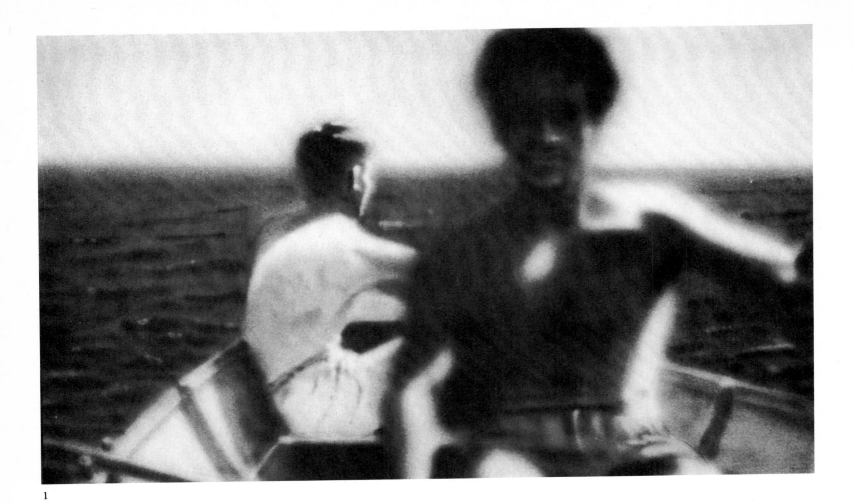

1

DAVID BARNETT (Painting/Peinture) 1933, Cheltenham, Eng. LIVES/HABITE: Rexdale, Ont. TRAINING/FORMATION: Self-taught/Autodidacte AWARDS & HONOURS/PRIX & HONNEURS: Canada Council Grant, 1973/Bourse du Conseil des Arts du Canada, 1973 MEDIUM: Sprayed acrylic/Acrylique vaporisé.

EX—1: "Soft-Focus Realism" Aggregation Gallery, Toronto (4 X—21 X 72).

GROUP/GROUPE: "SCAN"; "Inaugural Exhibition" Aggregation Gallery, Toronto (3 X—21 X 72); "Gallery Artists" Aggregation Gallery, Toronto (24 X—11 XI 72).

RAFAEL BARRIOS TRAINING/FORMATION: Ontario College of Art, Toronto GROUP/GROUPE: "Information and Perception".

FRANK BARRY (Painting, printmaking/ Peinture, gravure) 1913 LIVES/HABITE: Montréal TRAINING/FORMATION: Ealing School of Art, Eng.; Hornsey School of Art, Eng.; Sir George Williams Univ, Montréal TEACHES/ENSEIGNE: Sir George Williams Univ, Montréal MEDIUM: Wood engraving, etching/Gravure sur bois, eau-forte.

GROUP/GROUPE: "Faculty Show" Sir George Williams Univ, Montréal (Oct/oct 72).

2

3

ED BARTRAM (Printmaking/Gravure) 1938, London, Ont. LIVES/HABITE: King City, Ont. TRAINING/FORMATION: Univ Western Ontario, London, Ont.; Univ Toronto TEACHES/ENSEIGNE: Central Technical School, Toronto MEDIUM: Etching/ Eau-forte.

EX—2: With/avec **A. WEINSTEIN**, London Public Library, London, Ont. (Oct/oct 72).

EX—4: "Images: Earth/Water/Sky" with/ avec **B. JORDAN, S. PALCHINSKI, R. SINCLAIR**, Aggregation Gallery, Toronto (19 V - 14 VI 73).

EX—5: "Five Printmakers" with/avec **H. DUNSMORE, M. DAVIES, K. HUNT, S. SINGER**, Aggregation Gallery, Toronto (16 V - 10 VI 72).

GROUP/GROUPE: "Annual Exhibition of Contemporary Canadian Art"; "Inaugural Exhibition" Aggregation Gallery, Toronto (3 X - 21 X 72); "Fifth Annual Christmas Show" Aggregation Gallery, Toronto; "International Graphics".

1 BARNETT *Jim Rowing, 1972 (87" x 55")* Photo: Aggregation Gallery, Toronto

2 BARRY *Many Mansions II, 1972 (6'6" x 3'6" x 3')* Photo: S.A.P.Q., Montréal

3 BARRIOS Photo: Ontario College of Art, Toronto

BASQUE (LEONARD PARENT) (Peinture/
Painting) 1927, Trois-Pistoles, Qué. HA-
BITE/LIVES: Rimouski, Qué. FORMATION/
TRAINING: Autodidacte/Self-taught.

EX—1: "La Peinture du Terroir" Galerie d'Art
Les Gens de Mon Pays, Ste-Foy, Qué. (29 X—
8 XI 72); "La Gaspésie" Galerie L'Art Français,
Montréal (Nov/nov 72); Galerie Colline,
Edmundston, N.B. (24 III—5 IV 73).

EX—3: avec/with **M. CHAMPAGNE, A.
PELLETIER**, Galerie d'Art Les Gens de Mon
Pays, Ste-Foy, Qué. (24 II—8 III 73).

CATHERINE BATES (Peinture, gravure,
sculpture/Painting, printmaking, sculpture)
1934, Windsor, Ont. HABITE/LIVES: Mont-
réal FORMATION/TRAINING: Univ Toronto;
Doon School of Fine Arts; Beal Technical
School, London, Ont.; Baltimore Museum of
Art; Maryland Institute of Art MEDIUM:
Acrylique, sérigraphie, aluminium/Acrylic, seri-
graphy, aluminum.

EX—1: Galerie Pascal, Toronto (28 IV—16 V
73).

GROUPE/GROUP: "56th Annual Exhibi-
tion" Society of Canadian Painter-Etchers
and Engravers, London, Ont.; Montreal
Museum of Fine Arts (juin/June 72); Galerie
1640, Montréal (22 VIII—23 IX 72); Vehi-
cule Art, Montréal (29 XII 72—14 I 73);
"Southwest 33"; "Exhibit 73" Beth Sion
Synagogue, Montréal; "Alumni Exhibition
of Canadian Art" Sir George Williams Univ,
Montréal (28 V—3 VI 73).

1 BARTRAM *Zebra Rock No. 2, 1973*
 (21 1/2" x 27 1/2") Photo: Ayriss
 for Aggregation Gallery, Toronto

2 BASQUE *L'Epinette, 1965 (24" x 36")*

3 C. BATES *Icon, 1973 (13 1/4" x 13 1/4")*

4 C. BATES *Crosses, 1972 (7 1/2" x 7 1/2")*

5 C. BATES *Busing, 1972 (17 1/2" x 3 1/2")*

1

2

3

4

5

1

2

MAXWELL BATES (Painting, drawing, print-making/Peinture, dessin, gravure) 1906, Calgary LIVES/HABITE: Victoria TRAINING/FORMATION: Provincial Institute of Technology and Art, Calgary; Brooklyn Museum Art School, New York MEDIUM: Ink, pencil, woodcut, watercolour, oil, lithography, tempera, oil collage, monoprint, gouache/ Encre, crayon, gravure sur bois, aquarelle, huile, lithographie, détrempe, collage à l'huile, monogravure, gouache.

EX—1: Upstairs Gallery, Winnipeg (10 X—30 X 73); "Maxwell Bates in Retrospect (1921— 1971)" CIRCULATING/ITINERANTE: Vancouver Art Gallery, Vancouver (5 I—28 I 73); Alberta College of Art, Calgary (19 II— 9 III 73); Norman MacKenzie Gallery, Regina (6 IV—4 V 73); Saskatoon Gallery and Conservatory, Saskatoon (28 V—29 VI 73).

PAT MARTIN BATES (Printmaking, sculpture, painting, drawing/Gravure, sculpture, peinture, dessin) St. John, N.B. LIVES/ HABITE: Victoria TRAINING/FORMATION: Académie Royale des Beaux-Arts, Belgique; Institut des Beaux-Arts, Antwerp, Netherlands; Académie de la Grande Chaumière, Paris; Pratt Graphic Centre, New York AWARDS & HONOURS/PRIX & HONNEURS: Grand Award, First Chilean Biennale, Santiago; Nicholas Homyansky Memorial Award; Canada Council Arts Award; Purchase Award, Ljubljana Print Biennale; "Biennialpris" First Norwegian Print Biennale, Crakow, Poland/ Grand Prix, Première Biennale du Chili, Santiago; Prix Commémoratif Nicholas Homyansky; Bourse du Conseil des Arts du Canada; Prix d'achat, Biennale de la Gravure de Ljubljana; "Biennialpris" Première Biennale de la Gravure de Norvège; Prix d'achat, Biennale de la Gravure, Cracovie, Pologne MEDIUM: Etching, lithography, plexiglas/Eau-forte, lithographie, plexiglas.

EX—1: Zan Art Gallery, Victoria (17 V—18 VI 73).

EX—5: "Victoria Perspectives" with/avec **ELSA MAYHEW, BOB DE CASTRO, JACK KIDDER, P.K. IRWIN**, Mido Gallery, Vancouver (7 V—4 VI 72).

GROUP/GROUPE: "4th International Print Biennale" Crakow, Poland (1972); "1st International Print Biennale" Norway; "Black & White International Graphics" Lugano, Switzerland; Neuvième Biennale Internationale d' Art de Menton, France; "2nd International Grafik Biennale" Frechen, Germany; "3rd Argentina Print Biennale"; "SCAN"; "Canadian Printmakers Showcase"; "Women" Burnaby Art Gallery, Burnaby, B.C.; "International Graphics".

1 M. BATES *Road in the Foothills (10" x 17")* Photo: Glenbow-Alberta Institute, Calgary

2 M. BATES *Boy and Workman, 1921 (5 3/4" x 6 3/8")* Photo: Glenbow-Alberta Institute, Calgary

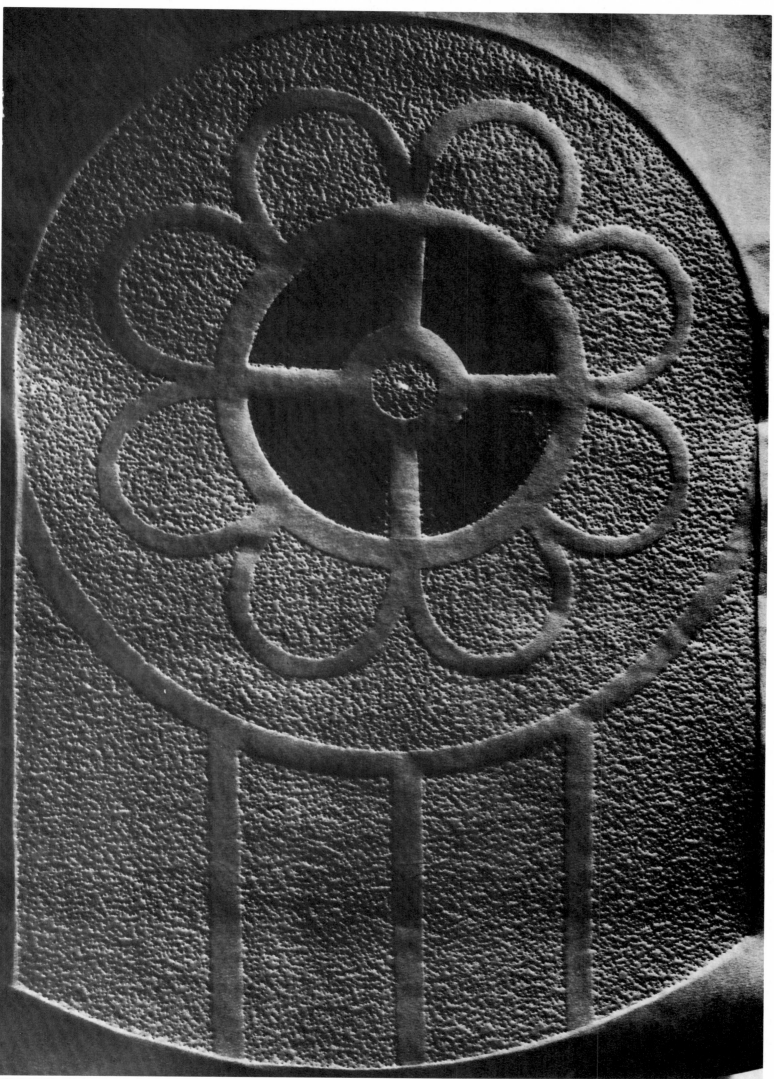

P.M. BATES *Black Rose Window for Rumi (40" x 34")*

1

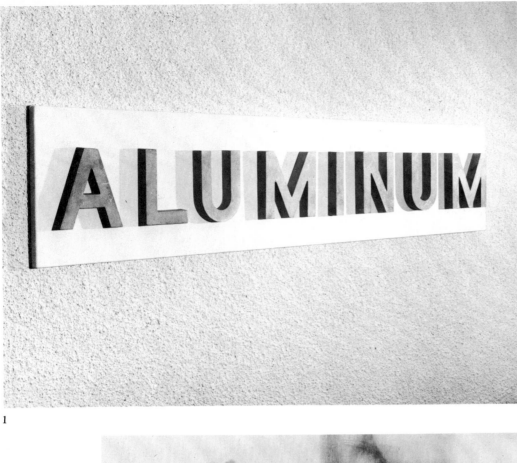

2

3

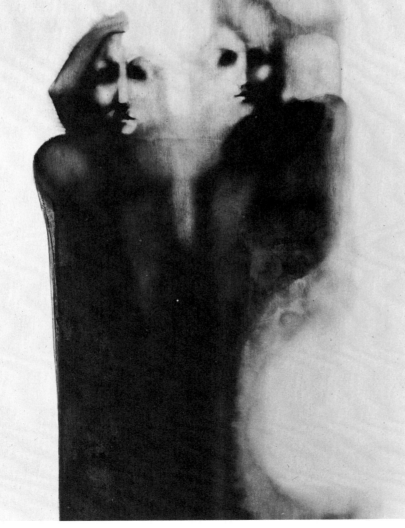

4

JURATE BATURA (Painting/Peinture)
1948 LIVES/HABITE: Toronto TRAIN-
ING/FORMATION: Ontario College of Art,
Toronto MEDIUM: Oil, coloured inks/Huile,
encres de couleur.

EX—1: Gallery 76, Ontario College of Art,
Toronto (18 I–28 I 73).

MALCOLM BATTY (Mixed media, painting/
Multi-média, peinture) 1945, India LIVES/
HABITE: Toronto TRAINING/FORMA-
TION: Cardiff Fine Arts College, Wales ME-
DIUM: Oil on canvas/Huile sur toile.

EX—1: Hart House, Univ Toronto, Toronto
(4 XI–24 XI 72).

GROUP/GROUPE: La Cimaise Gallery, To-
ronto (14 IV–10 V 73).

BONNIE BAXTER (Painting/Peinture)
LIVES/HABITE: Val David, Qué. MEDIUM:
Acrylic, oil/Acrylique, huile EX—2: with/
avec **P. LEMIEUX**, Maison des Arts La Sauve-
garde, Montréal (9 II–12 III 73).

IAIN BAXTER (Printmaking, conceptual/
Gravure, conceptuel) 1937, Middlesborough,
Eng. LIVES/HABITE: Vancouver.

EX—1: "N.E. Thing Co. Ltd." Art Gallery of
York Univ, Toronto (21 III–13 IV 73).

GROUP/GROUPE: "Plastic Fantastic"; "Prints
by Painters of B.C."; "Realism: Emulsion &
Omission"; Carmen Lamanna Gallery, Toronto
(11 VIII–14 IX 72); Nova Scotia College of
Art & Design, Halifax.

1 I. BAXTER *Aluminum, 1968 (52" x 6'1")*
Photo: Carmen Lamanna Gallery, Toronto

2 B. BAXTER Photo: Claude Vallée (La Maison
des Arts La Sauvegarde, Montréal)

3 BATURA *Untitled, 1972*

4 BATTY *Untitled* Photo: La Cimaise Gallery,
Toronto

TIB BEAMENT (Peinture, gravure, tapisseries, dessin/Painting, printmaking, hangings, drawing) 1941, Montréal HABITE/LIVES: Montréal FORMATION/TRAINING: Fettes College, Edinburgh, Scotland; Ecole des Beaux-Arts, Montréal; Academia di Belle-Arti, Rome PRIX & HONNEURS/AWARDS & HONOURS: Premier Prix, batik, Exposition d'Artisanat Canadien, 1967; Prix de Batik, Dimensions Artisanales Canadiennes, 1969; Prix Heinz Jordan, dessin, 1971; Bourse de la Fondation Elizabeth T. Greensheilds, 1971/First Prize, batik, Canada Crafts Exhibition, 1967; Batik Award, Craft Dimensions Canada, 1969; Heinz Jordan Award, for drawing, 1971; Elizabeth T. Greensheilds Foundation Grant, 1971.

GROUPE/GROUP: "56th Exhibition, Society of Canadian Painters, Etchers & Engravers"; "Graphex 1"; "Thomas More Annual Exhibition"; "National Council of Jewish Women, Annual Art Auction" Skyline Hotel, Ottawa; "The Workshop's Collection" GRAFF, Montréal; "Exhibition of Contemporary Canadian Artists" Sir George Williams Univ, Montréal.

JACKSON BEARDY (Painting/Peinture) LIVES/HABITE: Brandon, Man. MEDIUM: Gouache.

EX–3: "Treaty Numbers 23, 287, 1171" with/avec **A. JANVIER, D.O. BEAVON,** Winnipeg Art Gallery, Winnipeg (12 IX - 10 X 72).

DAPHNE ODJIG BEAVON (Painting/Peinture) Manitoulin Island, Ont. LIVES/HABITE: Winnipeg, Man. MEDIUM: Acrylic/Acrylique.

EX–3: "Treaty Numbers 23, 287, 1171" with/ avec **J. BEARDY, A. JANVIER,** Winnipeg Art Gallery, Winnipeg (12 IX–10 X 72).

GROUP/GROUPE: "Manitoba Mainstream".

1 BEAMENT *Roadster, 1972*

2 BEARDY *Origin of the Earth, 1970*
 Photo: Winnipeg Art Gallery

3 BEAVON *Massacre, 1971* Photo:
 Winnipeg Art Gallery

1

2

3

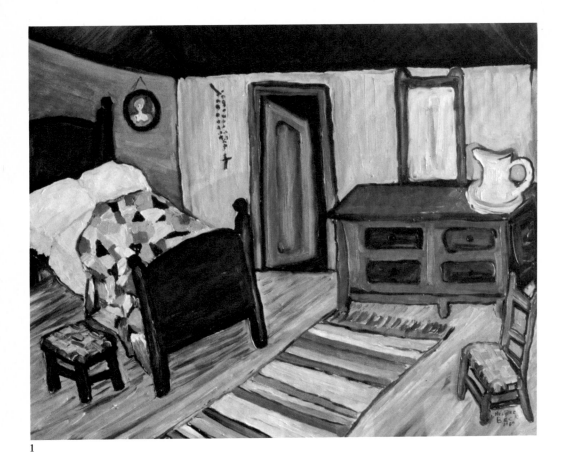

1

3

HELENE BECK (Peinture/Painting) 1930, Jonquière, Qué. HABITE/LIVES: Chicoutimi, Qué. MEDIUM: Huile, acrylique, eau-forte, pastel/Oil, acrylic, etching, pastel EX–2: Centre d'Art de Ste-Foy, Ste-Foy, Qué. (9 III– 24 III 73).

GROUPE/GROUP: "Panorama de la Créativité Contemporaine au Canada"; Hôtel de Ville de Chicoutimi (juin/June–sept/Sept 72); Maison des Arts de Chicoutimi (15 XI–15 XII 72); Centre d'Art de Ste-Foy (févr/Feb 73); Galerie Benedek-Grenier, Québec (5 V–26 V 73).

R. ALLAN BECKLEY (Painting/Peinture) 1947 LIVES/HABITE: London, Ont. TRAINING/FORMATION: H.B. Beal Technical School, London, Ont.; Ontario College of Art, Toronto MEDIUM: Acrylic/Acrylique.

EX–1: Glen Gallery, London, Ont. (21 X– 18 XI 72).

JEAN-THOMAS BEDARD (Dessin, peinture, gravure, multi-média/Drawing, painting, printmaking, mixed media) 1947 HABITE/LIVES: Montréal FORMATION/TRAINING: Univ Montréal; Ecole des Beaux-Arts de Montréal MEDIUM: Gouache, acrylique, encre, sérigraphie, collage, film/Gouache, acrylic, ink, silkscreen, collage, film.

EX–1: Galerie L'Ezotérik, Montréal (27 V– 30 VI 72); Maison Culturelle de Roberval, Qué. (14 VIII–20 VIII 72); "Les Tubuliflores" Galerie L'Ezotérik, Montréal (déc/Dec 72).

GROUPE/GROUP: "SCAN"; "Les Moins de 35"; "Salon des Métiers d'Art".

*** Voir section couleur/ See colour section**

4

1 BECK *Grandma's Room*

2 BEDARD *Le Poisson enraciné, 1972*

3 J.-C. BERGERON *Acadie*

4 BECKLEY

MARCEL BELLERIVE (Gravure, peinture/ Printmaking, painting) 1934, Grand-Mère, Qué. HABITE/LIVES: Montréal FORMA-TION/TRAINING: Ecole des Beaux-Arts de Montréal; Univ Québec MEDIUM: Huiles, monogravures/Oils, monoprints.

EX—1: ITINERANTE/CIRCULATING: Organisée par/Organized by La Fédération des Centres Culturels de la Province de Québec et Le Ministère des Affaires Culturelles; Centre Culturel d'Alma, Qué. (nov/Nov 72); Centre Culturel de Châteauguay, Qué. (janv/Jan 73); Centre Culturel de Trois-Rivières, Qué. (févr/ Feb 73); Centre Culturel de Shawinigan, Qué. (mars/Mar 73); Centre Culturel de Drummond-ville, Qué. (avril/Apr 73); Centre Culturel de Hull, Qué. (mai/May 73).

GROUPE/GROUP: Galerie Libre, Montréal (1972); Pavillon Maison des Arts La Sauve-garde, Terre des Hommes, Montréal (1972); Exposition Grand Prix de Monaco, Monte Carlo (15 XI - 3 XII 72); S.A.P.Q. (7 X - 15 XI 72); Galerie Martal, Montréal (av-ril/April 73).

JEAN-CLAUDE BERGERON (Gravure/ Printmaking) 1941, St-Fortunat, Qué. HA-BITE/LIVES: Touraine, Qué. FORMA-TION/TRAINING: Univ Ottawa; Ecole des Beaux-Arts d'Aix en Provence, France ME-DIUM: Gravure, sérigraphie, lithographie/ Printmaking, serigraphy, lithography.

GROUPE/GROUP: Club Richelieu Laurier, Ottawa (10 XI—12 XI 72); "Les Moins de 35".

1 BELLERIVE *Pommes blanches, 1972 (20" x 26")*

2 BELLERIVE *La Balançoire, 1972 (28" x 44")*

3 BELLERIVE *L'Hiver québécois, 1972 (26" x 20")*

2

1

3

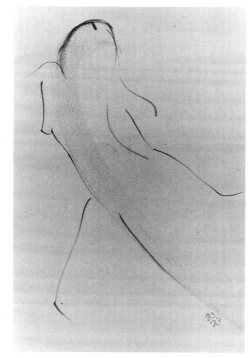

RONALD ARES BERGERON (Peinture/ Painting) 1946, Montréal HABITE/LIVES: Longueuil, Qué. FORMATION/TRAINING: Ecole des Beaux-Arts, Montréal MEDIUM: Email, acrylique, urethane, polyurethane, polymère, métal/Enamel, acrylic, urethane, polyurethane, polymer, metal.

EX—1: Les Ateliers du Vieux-Longueuil, Longueuil, Qué. (19 IV—30 IV 73).

MICHELE BERNATCHEZ (Tapisseries/ Hangings) 1939 HABITE/LIVES: Québec FORMATION/TRAINING: Ecole des Beaux-Arts de Montréal et Québec; Univ Laval, Ste-Foy, Qué. MEDIUM: Tapisserie/Tapestry GROUPE/GROUP: "Tours des Arts" Univ Laval, Qué.; Musée du Québec, Qué. (mars/Mar 73); "Les Moins de 35".

BAIBA BERZIN (Drawing, painting/Dessin, peinture) 1944, Latvia LIVES/HABITE: Saskatoon TRAINING/FORMATION: Ontario College of Art, Toronto.

EX—1: Latvian Federation House, Hamilton (Nov/nov 72); Mendel Gallery, Saskatoon (28 IV—14 V 73).

1 BEVELANDER

2 BEVELANDER

3 BERNATCHEZ *Triton*

4 BERZIN *Untitled, 1973*

5 R. BERGERON *Octopus, 1973 (24" x 24")*

MIEKE BEVELANDER (Drawing, painting/ Dessin, peinture) 1945 LIVES/HABITE: Guelph, Ont. TRAINING/FORMATION: Royal Academy of Art, Netherlands; Univ Guelph, Guelph, Ont. MEDIUM: Pastel, pencil, conté, oil/Pastel, crayon, conté, huile EX—2: Woodstock Art Gallery, Woodstock, Ont. (Aug/août—Sept/sept 72) GROUP/GROUPE: "Graphex 1".

KARL BEVERIDGE (Metalwork/Métal) 1945, Ottawa LIVES/HABITE: Toronto TRAINING/FORMATION: Ontario College of Art, Toronto; New School of Art, Toronto MEDIUM: Metal/Métal GROUP/GROUPE: Carmen Lamanna Gallery, Toronto (11 VIII—14 IX 72).

T. MIKE BIDNER (Printmaking/Gravure) LIVES/HABITE: London, Ont. MEDIUM: Graphics/ graphiques GROUP/GROUPE: "SCAN"; "International Graphics"; "Canadian Printmakers Showcase"; "33rd Annual Western Ontario Exhibition".

GEZA T. BIRO (Painting/Peinture) 1919, Hungary LIVES/HABITE: Montréal TRAINING/FORMATION: Royal Hungarian Academy of Fine Arts MEDIUM: Watercolour, oil, oil tempera/Aquarelle, huile, détrempe à l'huile EX—1: Atelier Biro, Montréal (May/mai 73).

1

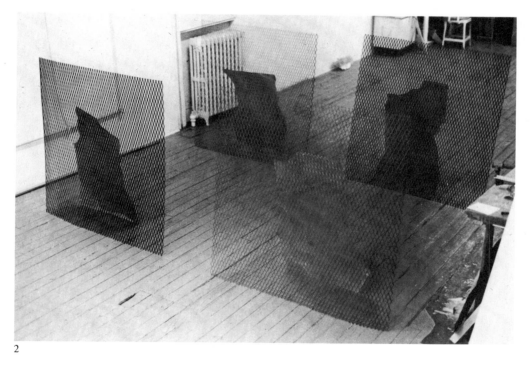

2

3

1 BIDNER

2 BEVERIDGE *B 69212, 1969*
 (9 1/2' x 7' x 4') Photo: Carmen
 Lamanna Gallery, Toronto

3 BIRO

BOLDUC *Harris, 1972 (66" x 81 1/8")* Photo: Carmen Lamanna Gallery, Toronto

BLOORE *Painting "1969" (5" x 7")* Photo: Morris Gallery, Toronto

1

RONALD BLOORE (Painting/Peinture) 1925, Brampton, Ont. LIVES/HABITE: Toronto TRAINING/FORMATION: Univ Toronto; Institute of Fine Arts, N.Y.; Washington Univ, St. Louis TEACHES/ENSEIGNE: York Univ, Toronto.

EX—1: Morris Gallery, Toronto (3 III—17 III 73)

GILLES BOISVERT (Peinture, gravure,dessin/Painting, printmaking, drawing) 1940, Montréal HABITE/LIVES: Montréal FORMATION/TRAINING: Ecole des Beaux-Arts, Montréal MEDIUM: Acrylique, sérigraphie, encre/ Acrylic, silkscreen, ink.

EX—1: "Les Oiseaux" ITINERANTE/CIRCULATING: Galerie Média, Montréal; Gallery 93, Ottawa; Galerie Pascal, Toronto; Musée du Québec, Québec (1972).

EX—1: Organisée par/ organized by la Fédération des Centres Culturels du Québec (1972—73) Le Centre Culturel de Shawinigan, Shawinigan, Qué.

GROUPE/GROUP: "Art 3", Bâle, Suisse; "Association des Graveurs du Québec à l'Etable" Montréal; "Graphisme"; "GRAFF" Centre Culturel Canadien, Paris; "Pack Sack"; "Noël à 99c" Galerie Média, Montréal; "Les Moins de 35"; "Québec Underground".

*** Voir section couleur/ See colour section**

DAVID BOLDUC (Painting, printmaking/ Peinture, gravure) 1945, Toronto LIVES/ HABITE: Toronto TRAINING/FORMATION: Ontario College of Art, Toronto; Museum of Fine Art, Montreal MEDIUM: Acrylic, lithography/Acrylique, lithographie.

EX—1: Carmen Lamanna Gallery, Toronto (10 II—1 III 73); Marlborough-Godard Gallery, Toronto (17 III—12 IV 73).

EX—5: Carmen Lamanna Gallery, Toronto (21 VI—31 VII 72).

GROUP/GROUPE: "Diversity-Canada East" Edmonton Art Gallery & Norman MacKenzie Art Gallery, Regina.

1 BOISVERT *Une Main, 1973 (20" x 26")*

2 BOUCHARD *Sans-titre (12" x 20")*

FRANCINE BOUCHARD (Sculpture, gravure, tapisseries/Sculpture, printmaking, hangings) 1949, Montréal HABITE/LIVES: Montréal FORMATION/TRAINING: Ecole des Beaux-Arts de Montréal; Univ Québec, Montréal MEDIUM: Crayon, encre, sérigraphie, lithographie, monotype, collages, tapisseries, marionnettes/ Pencil, ink, serigraphy, lithography, monotype, collages, tapestries, marionettes.

EX—4: "Exposition-recherche" avec/with **L. DAZE, M. JOLICOEUR, P. LAMBERT**, Galerie Colline, Collège St-Louis-Maillet, Edmundston, N.B. (2 XII - 15 XII 72).

EX—4: Collège d'Alma, St-Jean, Qué (11 IV - 15 IV 73).

GROUPE/GROUP: "Jeunes Peintres Québecois" McGill Univ, Montréal.

2

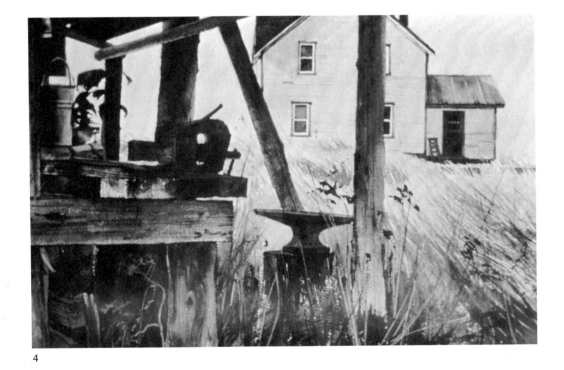

GINETTE BOUCHER (Peinture/Painting)
1944, La Pocatière, Qué. HABITE/LIVES:
Lévis, Qué. MEDIUM: Huile/Oil.

EX−1: Galerie du Palais Montcalm, Québec
(18 IV−29 IV 73).

GROUPE/GROUP: "Les Moins de 35";
Chanteauteuil, Québec (juin/June 72).

1 BOURIGAUT *Sans-titre, 1972 (40" x 42")*

2 BOUCHER *Tiens, de la neige*
Photo: Claire Morel

3 BRADSHAW *Many Moods, 1971 (25" x 36")*

4 BRADFORD *Homestead, 1973*

VICTOR BOURIGAUT (Peinture/Painting)
1941 HABITE/LIVES: Montréal FOR-
MATION/TRAINING: L'Ecole des Beaux-Arts
de Montréal MEDIUM: Acrylique, huile/
Acrylic, oil.

EX−1: Studio 23, St-Sauveur-des-Monts,
Qué. (5 VIII−29 VIII 72); Artlenders,
Montréal (avril/Apr 73).

GROUPE/GROUP: Hadassah November Art
Auction, Montréal (nov/Nov 72); Thomas More
Institute for Adult Education, Montréal (nov/
Nov 72).

KENNETH RAYMOND BRADFORD
(Painting/Peinture) 1936 LIVES/HABITE:
Sault Ste-Marie, Ont. TRAINING/FOR-
MATION: American Academy of Art, Chi-
cago MEDIUM: Watercolour/Aquarelle
EX−3: Walz Art Gallery, Sault Ste-Marie, Ont.
(Apr/avril 73).

NELL M. BRADSHAW (Painting, printmaking/
Peinture, gravure) California LIVES/HABITE:
Victoria MEDIUM: Oil, wood block printing,
collages/Huile, gravure sur bois, collages.

EX−1: "Indian Heritage" Leafhill Galleries,
Victoria (Nov/nov 72).

GERALD BRENDER A BRANDIS (Print-making, drawing/Gravure, dessin) 1942 LIVES/HABITE: Carlisle, Ont. TRAINING/ FORMATION: McMaster Univ, Hamilton, Ont. MEDIUM: Wood engraving, lino cuts, block printed fabric/Gravure sur bois, gravure sur lino, tissu imprimé.

EX–1: Alice Peck Gallery, Burlington, Ont. (29 XI–30 XII 72);

EX–2: with/avec **T. GREGSON**, The Barn, Morrison, Ont. (8 VI–25 VI 72); with/avec **HARRY BRUNT**, Gallery House Sol, George-town, Ont. (16 II–8 III 73).

GROUP/GROUPE: "Annual Exhibition of Contemporary Canadian Artists"; Canadian Arts, Stratford, Ont.; Sarnia Public Library, Sarnia, Ont. (17 VIII–3 IX 72).

1 BRES *Framed Flags Section 2, 1973 (29" x 28")*

2 BRENDER à BRANDIS *Magdalene College, Cambridge, 1972*

3

1

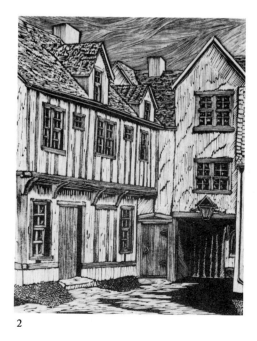

2

4

3 BRISSON *Harmonie, 1973 (16" x 24")*

4 BRES *Land and Sky Ltd., 1972 (42" x 42")*

HENDRIK BRES (Printmaking/Gravure) 1932, The Hague, Netherlands LIVES/HA-BITE: Edmonton TRAINING/FORMA-TION: Self-taught/Autodidacte AWARDS & HONOURS/PRIX & HONNEURS: Canada Council Materials Grant, 1973/Bourse d'achat de matériel, Conseil des Arts du Canada, 1973.

EX–3: with/avec **E. DIENER, A.C. DARRAH**, Edmonton Art Gallery, Edmonton (14 V–4 VI 73).

GROUP/GROUPE: "West '71"; "Alberta Contemporary Drawings".

ALBERTE BRISSON (Peinture, dessin/ Painting, drawing) 1938, Pointe-au-Père, Qué. HABITE/LIVES: Montréal FORMATION/ TRAINING: Musée des Beaux-Arts de Mont-réal MEDIUM: Encre, plume feutre, papier collé, huile, acrylique/ Ink, felt pen, pasted paper, oil, acrylic.

EX–1: Caisse Populaire Notre-Dame-des-Neiges, Montréal (7 III–31 III 73).

GROUPE/GROUP: Salon des Métiers d'Art, Place Bonaventure, Montréal (déc/Dec 72).

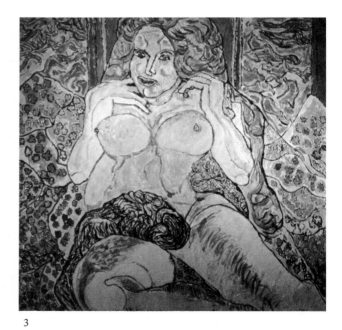

DIANE BRODERICK (Painting, drawing/
Peinture, dessin) 1947 LIVES/HABITE:
Edmonton TRAINING/FORMATION:
Univ Alberta MEDIUM: Mixed media,
acrylic, ink/Multi-média, acrylique, encre.

EX—1: Univ Alberta Gallery, Edmonton
(26 VI—21 VII 72).

*** See colour section/ Voir section couleur**

STEVEN BRODKIN (Peinture/Painting)
1950 HABITE/LIVES: Montréal FOR-
MATION/TRAINING: Ecole des Beaux-
Arts, Montréal.

EX—2: avec/with **C. MEVRIER,** Maison des
Arts La Sauvegarde, Montréal (5 I—5 II 73).

GROUPE/GROUP: Artlenders, Montréal (1 IV—
15 IV 73).

RAYMOND BROUSSEAU (Sculpture, pein-
ture/Sculpture, painting) 1938, Montréal
HABITE/LIVES: St-Lambert, Qué. MEDIUM:
Acrylique, électricité/Acrylic, electricity.

EX—1: Gallery III, Montréal (8 V—8 VI 72);
"Cruciformes" ITINERANTE/CIRCULA-
TING: Musée d'Art Contemporain, Montréal
(18 III—22 IV 73); Grand Théâtre de Québec,
Qué. (18 I—25 II 73).

GROUPE/GROUP: "SCAN"; "Plastic Fan-
tastic".

1

2

3

1 BRODERICK *Hyperbole, 1972*
Photo: Univ Alberta Art Gallery, Edmonton

2 BROUSSEAU *Cruciformes, 1973 (5')*

3 BRODKIN *Invitation, 1972* Photo: Claude
Vallée (La Maison des Arts La Sauvegarde,
Montréal)

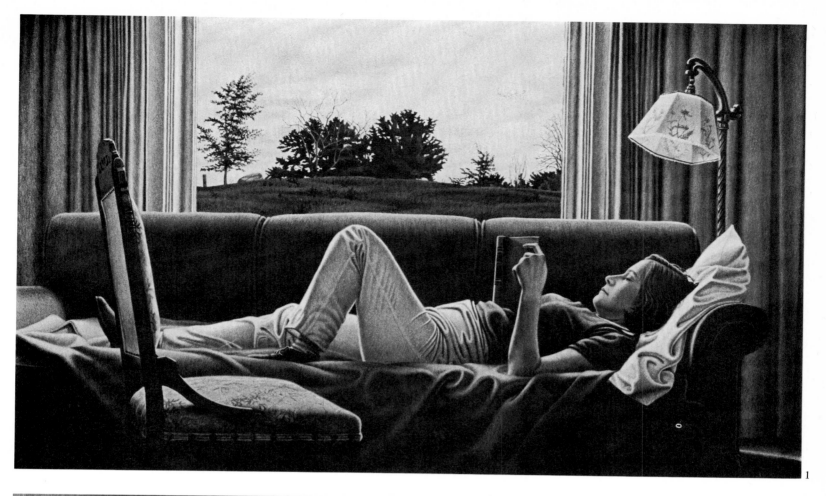

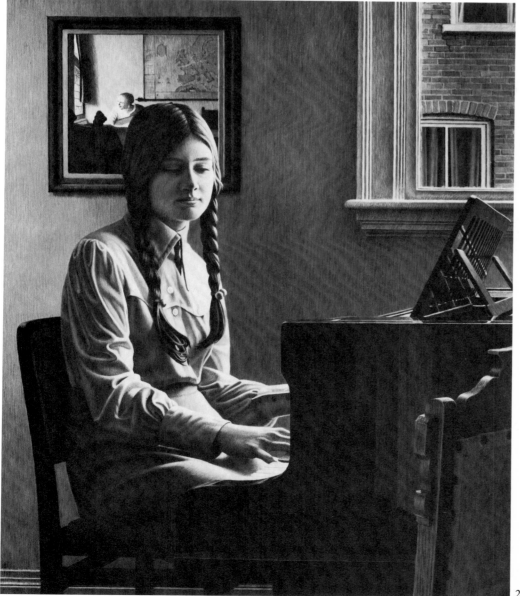

D.P. BROWN (Printmaking, drawing, painting/Gravure, dessin, peinture) 1939 LIVES/ HABITE: Collingwood, Ont. TRAINING/ FORMATION: Mount Allison Univ, Sackville, N.B. MEDIUM: Tempera, silverpoint, ink, serigraphy, pencil/Détrempe, pointe d'argent, encre, sérigraphie, crayon.

EX—1: Dunkelman Gallery, Toronto (27 V— 10 VI 72).

1 BROWN *The Reader, 1970*
2 BROWN *Girl at Piano, 1972*

1

5

1 BURKE *Ms. in Drag, 1972 (3 1/2' x 7')*

2 BURKE *Stars and Stripes Forever, 1973 (4' x 8')*

3 BRUNEAU *La Chimère, 1973 (13" x 20")*

4 BRUNET Premier plan/Foreground: *Mechidol 1417E, 1971 (8' x 2'6" x 2')* Arrière-plan/Background: *Mechidol A-45 (6'6" x 2'2")*

5 BURKE *A Walk in the Park, 1972 (17" x 22")*

2

3

4

KITTIE BRUNEAU (Gravure, peinture/Printmaking, painting) 1929, Montréal HABITE/LIVES: Montréal FORMATION/TRAINING: Ecole des Beaux-Arts, Montréal PRIX & HONNEURS/AWARDS & HONOURS: Bourses du Conseil des Arts du Canada, 1964, 1968; Bourses du Ministère des Affaires Culturelles du Québec, 1965, 1972/Canada Council Grants, 1964, 1968; Quebec Ministry of Cultural Affairs Grants, 1965, 1972 MEDIUM: Eau-forte, acrylique, huile/Etching, acrylic, oil.
GROUPE/GROUP: "Graphisme"; "Exposition de Gravures" Galerie d'Art Benedek-Grenier, Québec; Galerie Pascal, Toronto (avril/April 73); Atelier 68, Montréal (1 V-30 V 73).

RAYMOND PIERRE BRUNET (Métal/Metalwork) 1948, St-Boniface, Manitoba HABITE/LIVES: St-Boniface, Manitoba FORMATION/TRAINING: Univ Manitoba MEDIUM: Métal, bois/Metal, wood EX-1: Centennial Concert Hall, Foyer, St-Boniface, Manitoba (1 VIII-14 VIII 72) GROUPE/GROUP: "Winnipeg Under 30".

REBECCA BURKE (Painting, drawing, printmaking, sculpture/Peinture, dessin, gravure, sculpture) 1946 LIVES/HABITE: London, Ont. TRAINING/FORMATION: Ohio State Univ, Columbus, Ohio MEDIUM: Acrylic, plywood, charcoal/Acrylique, contre-plaqué, fusain.

EX-1: Trajectory Gallery, London, Ont. (7 III-30 III 73).

EX-5: McIntosh Gallery, Univ Western Ontario, London, Ont. (25 X-30 XI 72)

GROUP/GROUPE: "33rd Annual Western Ontario Exhibition".

*** See colour section/ Voir section couleur**

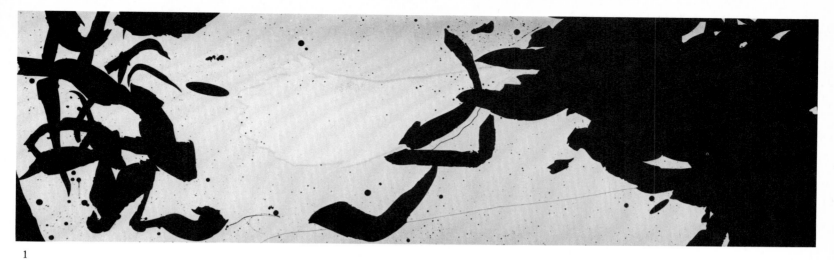

1

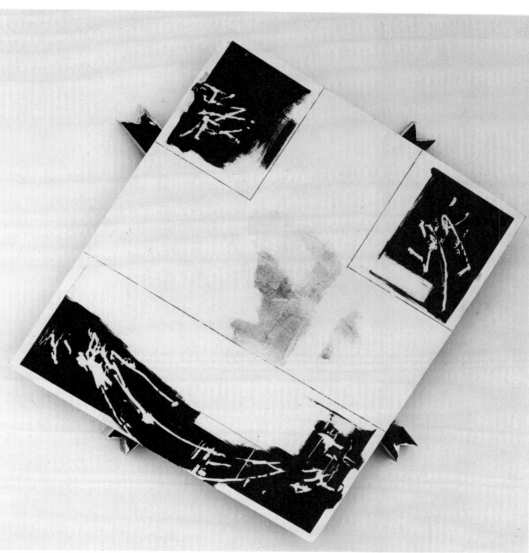

2

DENNIS BURTON (Painting/Peinture) 1933, Lethbridge, Alta. LIVES/HABITE: Toronto TRAINING/FORMATION: Ontario College of Art, Toronto AWARDS & HONOURS/PRIX & HONNEURS: Royal Academy Scholarship; Canada Council Award, 1961, 1968; Canada Council Senior Arts Grant, 1969/ Bourse de l'Académie Royale; Bourse du Conseil des Arts du Canada, 1961, 1968; Bourse de perfectionnement du Conseil des Arts du Canada, 1969. TEACHES/ENSEIGNE: New School of Art, Toronto MEDIUM: Acrylic, ink, collage/ Acrylique, encre, collage.

EX—1: Isaacs Gallery, Toronto (15 XI— 5 XII 72) GROUP/GROUPE: "Toronto Painting 1953-1965".

3

LESLIE BUSCH (Peinture/Painting) 1943, Los Angeles, U.S.A. HABITE/LIVES: Montréal FORMATION/TRAINING: Chovinard Art Institute, Calif.; California State Univ ENSEIGNE/TEACHES: Dawson College, Montréal MEDIUM: Huile/Oil GROUPE/ GROUP: "Les Moins de 35".

1 BURTON *Vajjav, 1972 (36" x 20")* Photo: Lyle Wachovsky for Isaacs Gallery, Toronto

2 BURTON *Table Top Swivel, 1972 (24" x 21" x 5")* Photo: Lyle Wachovsky for Isaacs Gallery, Toronto

3 BUSCH *Map of California No. 2, 1972*

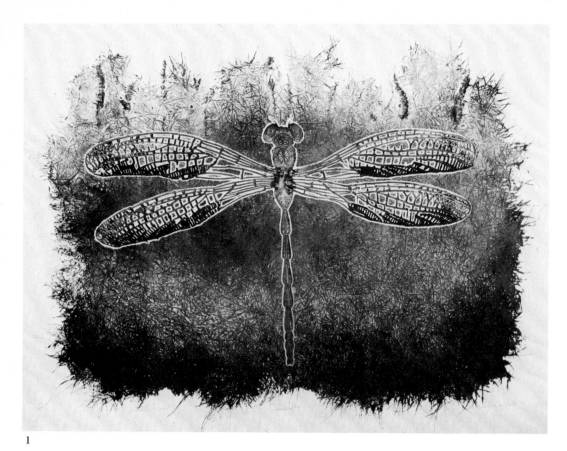

1

2

3

4

MIEKE CADOT (Mixed media/Multi-média) 1938, Amsterdam, Netherlands LIVES/HABITE: Toronto TRAINING/FORMATION: Kunstoefening School of Art, Arnheim, Netherlands MEDIUM: Papier mâché, fiberglass/ Papier mâché, fibre de verre.

EX—1: "Dolls" La Cimaise Gallery, Toronto (June/juin 72).

GROUP/GROUPE: La Cimaise Gallery, Toronto (14 IV—10 V 73).

* **Voir section couleur/ See colour section**

ROBERT HAMPTON CALDWELL (Painting, drawing/Peinture, dessin) 1945 LIVES/ HABITE: Ottawa TRAINING/FORMATION: Vancouver School of Art, Vancouver; Ontario College of Art, Toronto MEDIUM: Watercolour, pencil, pen/Aquarelle, crayon, encre.

EX—1: Gallery 76, Toronto (8 — 17 XII 72)

GROUP/GROUPE: "Student Exhibition" Ontario College of Art, Toronto.

DAVID CAMPBELL (Printmaking, painting/ Gravure, peinture) 1949, Toronto LIVES/ HABITE: Toronto TRAINING/FORMATION: Ontario College of Art, Toronto MEDIUM: Relief etchings, bronze reliefs, watercolour/ Eau-forte en relief, reliefs en bronze, aquarelle.

EX—1: La Cimaise Gallery, Toronto (3 III—22 III 73)

GROUP/GROUPE: La Cimaise Gallery, Toronto (14 V—10 V 73).

CANADA BANNERS COMPANY (SHIRLEY RAPHAEL and ROBERT VENOR) LIVES/ HABITE: Montréal MEDIUM: Banners/ Banderoles.

EX—1: CIRCULATING/ITINERANTE: Mount St. Vincent Univ, Halifax (May/mai—June/juin 72); Memorial Univ Art Gallery, St. John's, Nfld. (Jul/juil—Aug/août 72); Acadia Univ Art Gallery, Wolfville, N.S. (Feb/févr 73).

EX—1: Gallery West, Buffalo, N.Y., U.S.A. (Jul/juil 72); Van Straaten Gallery, Chicago, Ill., U.S.A. (Nov/nov 72); Musée de Québec, Qué. (10 V—18 VI 73).

1 CAMPBELL *Damsel Fly*
 Photo: La Cimaise Gallery, Toronto

2 CAMPBELL *Dodo Bird (16" x 20")*
 Photo: La Cimaise Gallery, Toronto

3 CANADA BANNERS

4 CALDWELL *Nude Couple with Green Pillow, 1971 (15" x 18")*

1

2

3

PATRICK CANDILLE (Peinture, gravure/ Painting, printmaking) 1939, Royan, Charente Maritime, France HABITE/LIVES: Montréal FORMATION/TRAINING: Ecole Nationale Supérieure des Beaux-Arts de Paris; Académie Julian, Paris; Académie de la Grande Chaumière, Paris; Académie Populaire, Paris MEDIUM: Acrylique, huile/Acrylic, oil.

GROUPE/GROUP: "Les Fleurs" La Caisse Populaire, Ste-Thérèse, Qué. (juin/June 72); "Les Moins de 35"; "Jacob ou la Persuasion" Galerie Weiller, Paris (4 VII–30 IX 72); "Nous Vivons Avec" Institut National d'Education Populaire, Marly-le-Roi, France (29 XI–28 XII 72); "à jour" Galerie Dupannier, Paris (mars/March 73).

GRAHAM CANTIENI (Peinture, dessin/Painting, drawing) 1938, Albury, Australia HABITE/LIVES: Sherbrooke, Qué. FORMATION/TRAINING: Prahran Technical College; Univ Melbourne; Royal Melbourne Institute of Technology, Melbourne, Australia MEDIUM: Huile, gouache, encre/Oil, gouache, ink.

EX–1: Wells Gallery, Ottawa (27 VI–18 VII 72); McIntosh Gallery, Univ Western Ontario, London, Ont. (29 XI–17 XII 72); Centre Culturel de Sherbrooke, Sherbrooke, Qué. (11 II–4 III 73); "Exposition Graham Cantieni" Rothman's of Pall Mall Canada Ltd., Sherbrooke, Qué. (17 IV–30 V 73).

EX–2: "Beaudoin et Cantieni" avec/with **F.H. BEAUDOIN**, une exposition itinérante organisée par le Ministère des Affaires Culturelles du Québec et La Fédération des Centres Culturels du Québec (1972-73)/ A circulating exhibition organized by the Quebec Ministry for Cultural Affairs and La Fédération des Centres Culturels du Québec (1972-73).

GROUPE/GROUP: "Les Moins de 35".

1 CANDILLE *Femme Fleur, 1971 (89" x 76")*

2 CANTIENI *Cosmological Theme Variation 273*

3 CANTIENI *Orionis XI, 1971 (68" x 68")*

1

JEAN CARIS (Peinture, dessin/Painting, drawing) 1934 HABITE/LIVES: St-Jacques de Montcalm, Qué. FORMATION/TRAINING: Ecole des Beaux-Arts, Paris, France; Ecole des Beaux-Arts, Liège, France MEDIUM: Huile, encre, fusain/Oil, ink, charcoal.

EX–1: "L'Amour" Univ Montréal, Grand Salon du Centre Communautaire, Montréal, Qué. (5 XII–14 XII 72)

1 CARMICHAEL *Fantasy of a Simple Man, 1968 (30" x 72")*

2 CARTER *Not in Bloom, 1970*

ROBERT-RALPH CARMICHAEL (Painting, drawing/Peinture, dessin) 1937 LIVES/HABITE: Edmonton TRAINING/FORMATION: Ontario College of Art MEDIUM: Oil, acrylic, watercolour, ink, pencil/Huile, acrylique, aquarelle, encre, crayon.

EX–1: "The Temptation of Aquarius" CIRCULATING/ITINERANTE: Winnipeg Art Gallery, Winnipeg (8 VI - 24 VII 72); Peter Whyte Gallery, Banff, Alta. (1 IX - 30 IX 72); Glenbow Art Gallery, Calgary (7 X–5 XI 72).

GROUP/GROUPE: "Alberta Contemporary Drawings"; "West '71"; "SCAN".

ARLETTE CARREAU-KINGWELL (Hangings, printmaking/Tapisseries, gravure) 1917, Montréal LIVES/HABITE: Montréal TRAINING/FORMATION: Ecole des Beaux-Arts de Montréal; Saidye Bronfman Centre; Affaires Culturelles, Holback Slot Ladegaard, Denmark MEDIUM: Batik, collage, acrylic/Batik, collage, acrylique.

EX–2: with/avec **OTTO BOHM**, Galerie L'Art Français, Montréal (14 IV–2 V 73) GROUP/GROUPE: Town Municipal Library, Mount Royal, Montréal (Dec/déc 72); Montréal Museum of Fine Arts (Nov/nov 72).

2

IAN CARR-HARRIS (Painting/Peinture)
1941, Victoria LIVES/HABITE: Toronto
TRAINING/FORMATION: Queen's Univ,
Kingston, Ont.; Univ Toronto; Ontario
College of Art, Toronto MEDIUM: Painted
wood/Bois peint.

EX–1: A Space, Toronto (7 XI–25 XI 72).

EX–3: with/avec **ROBERT FONES,
COLETTE WHITTEN**, Carmen Lamanna
Gallery, Toronto (16 IX–5 X 72).

GROUP/GROUPE: "Kingston Spring Exhi-
bition"; "Group Exhibition" Carmen Lamanna
Gallery, Toronto (14 XII–28 XII 72).

HARRIET MANORE CARTER (Painting,
printmaking/Peinture, Gravure) 1929, Grand
Bend, Ont. LIVES/HABITE: Hamilton
TRAINING/FORMATION: H.B. Beal Tech-
nical School, London, Ont.; Dundas Valley
School of Fine Art, Ont. MEDIUM: Etching,
watercolour, acrylic/Eau-forte, aquarelle,
acrylique.

EX–1: CIRCULATING/ITINERANTE:
Nancy Poole's Studio, Toronto (14 X–28 X
72); Nancy Poole's Studio, London, Ont.
(25 XI–8 XII 72)

GROUP/GROUPE: "Annual Exhibition of
Contempory Canadian Art"; "Ontario Society
of Artists One Hundredth Annual Open
Exhibition".

BARBARA CARUSO (Painting, drawing,
printmaking/Peinture, dessin, gravure) LIVES/
HABITE: Toronto TRAINING/FORMATION:
Ontario College of Art, Toronto AWARDS &
HONOURS/PRIX & HONNEURS: Aviva Art
Award, Graphics, 1971; Canada Council Visual
Arts Bursaries, 1971, 1972, 1973, 1974/Prix
Artistique Aviva, Graphique; Bourses du Conseil
des Arts du Canada, 1971, 1972, 1973, 1974
MEDIUM: Acrylic, pencil, serigraphy/Acrylique,
crayon, sérigraphie.

EX–1: Gadatsy Gallery, Toronto (17 III–
30 III 73); Pollock Gallery, Toronto (20 V–
7 VI 73).

GROUP/GROUPE: "40th Annual Ex-
hibition of the Canadian Society of Graphic
Art" McIntosh Gallery, Univ Western On-
tario, London, Ont. (4 V - 3 VI 73); SCAN.

1 CARR-HARRIS *Fred, 1972 (54"x 22-1/2"x 22-1/2")*
 Photo: La Maison des Arts La Sauvegarde, Montréal

2 CARUSO *Colour Lock, 2nd Series, no. 16 (72"x 72")*

3 CARREAU-KINGWELL *Graffiti, 1972 (40"x 40")*

4 CARIS *La Force, 1970 (20"x 24")*

45

1

3

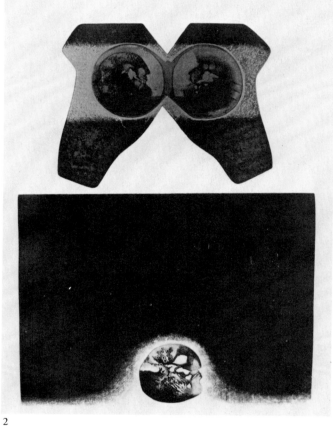

2

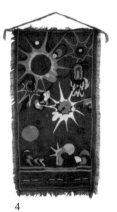

4

1 CAVALLI *Chant d'Automne (50")*

2 CETIN *Universe I*

3 CATTELL *Time Part: Orchard Edge (30" x 38")*

4 CAVAEL *Abstract 5*

GEORGE CASPROWITZ (Painting, print-making/Peinture, gravure) 1940, Los Angeles LIVES/HABITE: Vancouver TRAINING/FORMATION: School of Art and Architecture, Univ Oregon MEDIUM: Acrylic on shaped canvas, serigraphy/Acrylique sur toile taillée, sérigraphie.

EX–1: Glenbow Art Gallery, Calgary (23 V–11 VI 72)

EX–2: with/avec **B. WEST**, Galerie Allen, Vancouver (Oct/oct 72)

GROUP/GROUPE: "Group of Seven" Galerie Allen, Vancouver (29 XI–22 XII 72); "Vancouver Group Show" Galerie Allen, Vancouver (1 III–24 III 73).

RAY CATTELL (Painting/Peinture) 1921, Birmingham, Eng. LIVES/HABITE: Toronto AWARDS & HONOURS/PRIX & HONNEURS: Watercolour Award, Third Toronto Outdoor Show, 1963; Honour Award, Royal Canadian Academy, 1964; Hadassah Prize, 1965; Honour Award, Canadian Society of Painters in Watercolour, 1965, 1970, 1972/Prix d'aquarelle, Troisième Exposition en Plein Air, Toronto, 1963; Prix d'Honneur, Académie Royale du Canada, 1964; Prix Hadassah, 1965; Prix d' Honneur, Canadian Society of Painters in Watercolour, 1965, 1970, 1972 MEDIUM: Oil, acrylic, watercolour/Huile, acrylique, aquarelle.

EX–1: Drian Galleries, London, Eng. (18 IX–6 X 72); Gallery Moos, Toronto (3 III–22 III 73). GROUP/GROUPE: "Canadian Society of Painters in Watercolour"; "Aviva Art Show" Toronto (April/avril 73); "Annual Exhibition of Contemporary Canadian Art".

JACKIE CAVAEL (Mixed media, painting, ceramics, printmaking, drawing/Multi-média, peinture, céramique, gravure, dessin) 1955, Hamilton TRAINING/FORMATION: Self-taught/Autodidacte MEDIUM: Oil, acrylic, silkscreen, ink, cord, macramé, wax/Huile, acrylique, sérigraphie, encre, corde, macramé, cire.

EX–1: Reos Art Gallery, Hamilton, Ont. (15 II–15 III 73).

EX–5: with/avec: **W. NUDDS, R. NUDDS, I. LINTON, S. SCHNEIDER**, Reos Art Gallery, Hamilton, Ont. (15 VIII–15 XI 72);

GROUP/GROUPE: McMaster Univ, Hamilton, Ont.

ROGER CAVALLI (Sculpture) 1930, Liézey-Gerardmer (Vosges), France HABITE/LIVES: St-Jovite, Qué. FORMATION/TRAINING: Autodidacte/Self-taught PRIX & HONNEURS/AWARDS & HONOURS: Premier Prix, Exposition Provinciale du Québec, 1959; Premier Prix, Salon Panoramique de Montréal, 1962, 1963; Premier Prix, Sculpture, et Deuxième Prix, Dessin, Concours National d'Art, Québec, 1966/First Prize, Quebec Provincial Exhibition, 1959; First Prize, Panoramic Exhibition, Montreal, 1962, 1963; First Prize, Sculpture and Second Prize, Drawing, National Competition, Quebec, 1966 MEDIUM: Marbre, granit, pierre/Marble, granite, stone.

EX—1: Galerie Artlenders, Westmount, Qué. (4 XI–18 XI 72); Galerie d'Art Benedek-Grenier, Québec (16 XI–26 XI 72); Galerie L'Apogee, Québec (30 III–26 IV 73).

GROUPE/GROUP: "Estival '72".

ANTON CETIN (Drawing, painting, printmaking/Dessin, peinture, gravure) 1936, Yugoslavia LIVES/HABITE: Toronto TRAINING/FORMATION: School of Applied Arts, Academy of Fine Art, Zagreb, Yugoslavia EX—1: Theatre in Camera, Toronto (9 IX–16 IX 72) GROUP/GROUPE: "Fourth International Graphic Biennial" Krakow, Poland; "Graphex 1".

MERTON FRANCIS CHAMBERS (Hangings, ceramics/Tapisseries, céramique) 1929, Exeter, Ont. LIVES/HABITE: Toronto TRAINING/FORMATION: Ontario College of Art, Toronto AWARDS & HONOURS/PRIX & HONNEURS: Henry Birks Medal, 1957; T. Eaton Co. Ltd. Travelling Scholarship, 1957; Silver Medal, Third International Ceramic Exhibition, Prague, 1972; Second Prize, Fountains-Monuments Contest, Montréal, 1965; Second Prize, Manitoba Design Institute Souvenir Contest, 1965; Canada Council Arts Fellowship, 1967/Médaille Henry Birks, 1957; Bourse de Voyage T. Eaton Co. Ltée, 1957; Médaille d'Argent, Troisième Exposition Internationale de la Céramique, Prague, 1962; Deuxième Prix, Concours Fontaines-Monuments, Montréal, 1965; Deuxième Prix, Concours de Souvenir, Manitoba Design Institute, 1965; Bourse de travail libre du Conseil des Arts du Canada, 1967 MEDIUM: Batik on canvas/Batik sur toile.

EX—1: Albert Campbell Branch, Scarborough Public Libraries, Toronto (1 XI–11 XII 72); Woodstock Art Gallery, Woodstock, Ont. (2 II–28 II 73); Algonquin College, Ottawa (12 III–30 III 73).

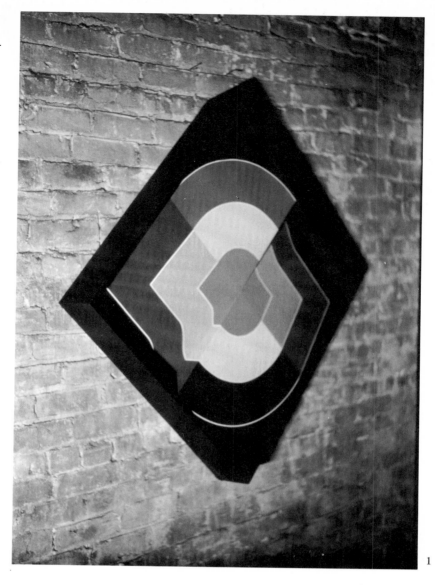

1

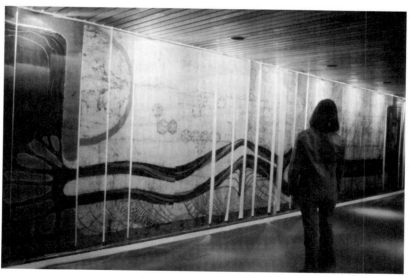

2

1 CASPROWITZ *To Be or Not to Be (30" x 30")*

2 CHAMBERS *Inland Waters Batik (8' x 50')*

1

3

4

2

JEAN-SERGE CHAMPAGNE (Sculpture)
1945 HABITE/LIVES: Montréal FORMA-
TION/TRAINING: Ecole des Beaux-Arts de
Montréal PRIX & HONNEURS/AWARDS &
HONOURS: Bourse du Ministère des Affaires
Culturelles du Québec, 1972/Quebec Ministry
for Cultural Affairs Grant, 1972 MEDIUM:
Bois, corde/Wood, cord GROUPE/GROUP:
"Les Moins de 35"; Galerie Jolliet, Québec,
Qué. (oct/Oct 72).

MICHEL CHAMPAGNE (Peinture, gravure/
Painting, printmaking) 1940, Montréal HA-
BITE/LIVES: Québec City, Qué. FORMA-
TION/TRAINING: Institut des Arts Appliqués
de Montréal; Univ Laval, Québec; Ecole des
Beaux-Arts, Québec PRIX & HONNEURS/
AWARDS & HONOURS: Deuxième Prix de
gravure à l'Exposition provinciale de Québec,
1963; Quatrième Prix de gravure à l'Expo-
sition provinciale de Québec, 1965, 1966/
Second Prize, Prints, Quebec Provincial Ex-
hibition, 1963; Fourth Prize, Prints, Quebec
Provincial Exhibition, 1965, 1966 MEDIUM:
Huile, sérigraphie/Oil, serigraphy.

EX—1: La Chasse-Galerie, Toronto (12 X—
3 XI 72).

EX—3: avec/with **ANDRE PELLETIER,
BASQUE**, Galerie d'Art les Gens de Mon
Pays, Ste-Foy, Qué. (24 II—8 III 73)

GROUPE/GROUP: "Les Moins de 35".

LUC A. CHARETTE (Sculpture, peinture/
Sculpture, painting) 1952 HABITE/LIVES:
Edmundston, N.B. FORMATION/TRAIN-
ING: Collège St-Louis-Maillet, Edmundston,
N.B. MEDIUM: Bois, plastique, métal,
pierre, bronze, plâtre, acrylique, aquarelle,
papier aluminium/Wood, plastic, metal, stone,
bronze, plaster, acrylic, watercolour, aluminium
foil.

EX—3: Galerie Colline, Edmundston, N.B.
(17 II—2 III 73).

JOHN CHARNETSKI (Painting/Peinture)
1935 LIVES/HABITE: Nanaimo, B.C.
TRAINING/FORMATION: Univ Washing-
ton, Seattle MEDIUM: Polyester resins/
Résines de polyester GROUP/GROUPE:
Zan Art Gallery, Victoria, B.C. (17 V -
18 VI 73).

1 M. CHAMPAGNE *Sauvagerie automnale (22" x 28")*

2 J.S. CHAMPAGNE *4 Fois 10*
 Photo: Galerie Jolliet, Québec

3 CHOW *Girl on Keefer Street*
 Photo: Exposition Art Gallery, Vancouver

4 CHICOINE *La Maison de Jos, 1969 (32" x 40")*
 Photo: Pierre Henry

1

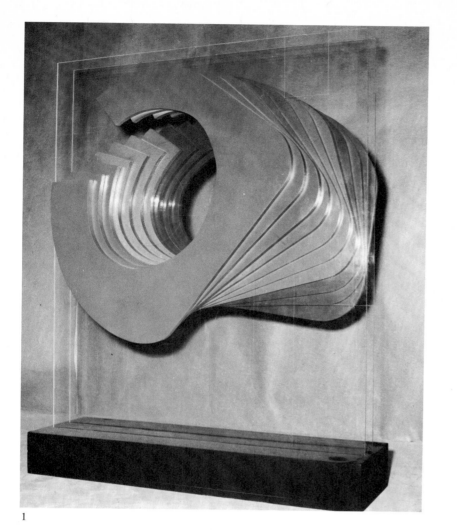

3

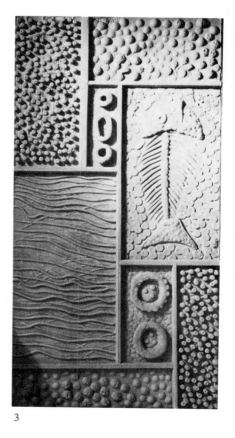

2

LOUIS CHARPENTIER (Peinture/Painting) 1947, Montréal HABITE/LIVES: Edmundston, N.B. FORMATION/TRAINING: Ecole des Beaux-Arts, Montréal; Univ Québec, Montréal MEDIUM: Collages en polymère, encre/Polymer collages, ink.

EX—1: "Travaux Récents" La Maison du Notaire, Trois-Pistoles, Qué. (18 V—30 V 73).

GROUPE/GROUP: Concours du Premier Ministre du Québec, Québec (juin/June 72); "Formoptic"; Galerie de la S.A.P.Q., Montréal (oct/oct 72); "Les Artisans Coopvie".

OWEN CHICOINE (Peinture/Painting) 1916 HABITE/LIVES: Mont St-Hilaire, Qué. FORMATION/TRAINING: Montréal Museum of Fine Arts, Montréal MEDIUM: Huile/Oil.

EX—1: La Chasse-Galerie, Toronto (9 XI—24 XI 72)

EX—2: Avec/with **FABLO**, La Galerie d'Art Les Deux B, St-Antoine-sur-Richelieu, Qué. (16 IX—15 X 72).

RAYMOND CHOW (Painting/Peinture) TRAINING/FORMATION: Univ B.C. MEDIUM: Acrylic/Acrylique.

EX—1: "In and Out of Windows" Exhibition Art Gallery, Vancouver (8 II—21 II 73).

1 CHARETTE *Fusion Stabile No. 1*
 Photo: Galerie Colline, Edmondston, N.B.

2 CHARPENTIER *Les Givres verts, 1972*

3 CHARNETSKI *Untitled*
 Photo: Zan Art Gallery, Victoria

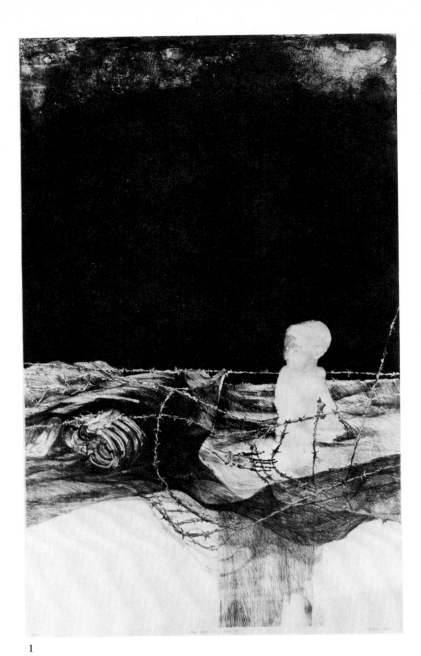

1

GENE CHU (Printmaking/Gravure) 1936
LIVES/HABITE: Guelph, Ont. TRAINING/
FORMATION: Ontario College of Art, Toronto;
Art Students League of New York; Claremont
Graduate School, California, U.S.A. MEDIUM:
Lithography (zinc, stone, aluminium), etching,
woodcut/Lithographie (zinc, pierre, aluminium),
eau-forte, gravure sur bois.

EX—1: "A Printmaker and His Prints" The Tom
Thomson Memorial Gallery, Owen Sound, Ont.
(3 XI—26 XI 72); De Cordova Museum, Lincoln,
Mass. (18 III—20 III 73).

GROUP/GROUPE: "Graphex 1"; "Interna-
tional Graphics"; "56th Annual Exhibition"
Society of Canadian Painter—Etchers and En-
gravers"; "The Boston Printmakers 25th An-
niversary Exhibition" Boston, U.S.A.; McLaugh-
lin Library, Guelph, Ont. (7 II—28 II 73).

FRANK CICANSKY (Sculpture) LIVES/HA-
BITE: Regina MEDIUM: Wood/Bois EX—3:
"Windmills, Wagons and Railroads" with/avec:
F. MOULDING, W. McCARGAR, Dunlop Art
Gallery, Regina (10 II—4 III 73).

1 CHU *The Cage of Eternity, 1973*
(31 3/4" x 20 1/4")

2 CLARKE *The Drunkards, 1971*

3 COLLACOTT *Girl in a Red Bathing Suit*
(4' 10" x 3' 6")

4 CICANSKY *Installation shot/Photo de l'exposi-
tion* Photo: Dunlop Art Gallery, Regina

3

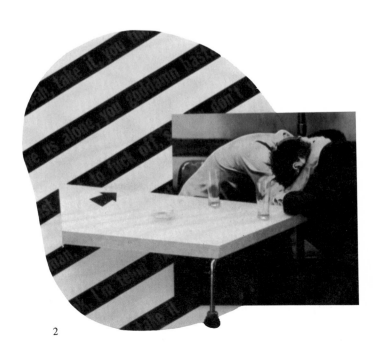

2

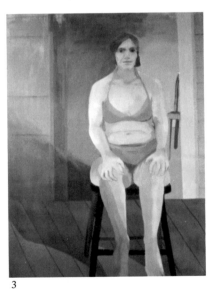

4

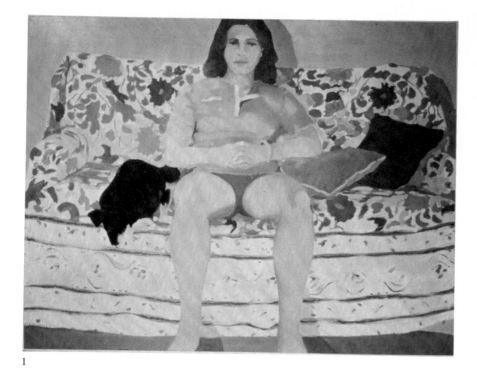

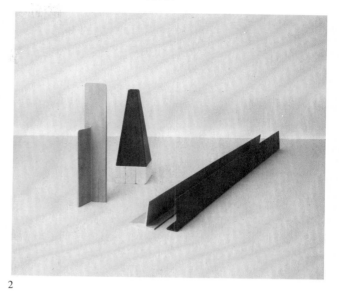

PETER M. CLARKE (Painting/Peinture) 1940 LIVES/HABITE: Ottawa TRAINING/ FORMATION: Self-taught/Autodidacte MEDIUM: Mixed media/Multi-média GROUP/GROUPE: "SCAN".

*** See colour section/ Voir section couleur**

MONICK CLERMONT (Peinture/Painting) 1942, Lévis, Qué. HABITE/LIVES: Montréal FORMATION/TRAINING: Ecole des Beaux-Arts de Québec; Institut des Arts Appliqués, Montréal; Univ Québec, Montréal MEDIUM: Huile/Oil.

GROUPE/GROUP: "Les Moins de 35"; Centre d'Art l'Oie Blanche, Montmagny, Qué. (14 IX 72—14 I 73); "Femmes Peintres du Québec" Centre Maisonneuve, Montréal (22 III—22 IV 73).

SUSAN COLLACOTT (Painting, print-making/Peinture, gravure) 1948 LIVES/HA-BITE: Windsor, Ont. TRAINING/FORMA-TION: Northern Illinois Univ; Univ Windsor MEDIUM: Silkscreen, oil, lithography/Séri-graphie, huile, lithographie.

EX—1: "Girl in a Red Bathing Suit" Northern Illinois Univ (Dec/déc 72).

GROUP/GROUPE: "Southwest 33"; Lake-shore League, Northwestern Univ, Chicago (Apr/avril 73); Newman Center, Dekalb, Illinois (Apr/avril 73).

*** See colour section/ Voir section couleur**

ROBIN COLLYER (Sculpture, printmaking/ Sculpture, gravure) 1949, London, Eng. TRAINING/FORMATION: Ontario College of Art MEDIUM: Aluminum, steel, wax, copper, bricks, brass, corrugated cardboard, silkscreen/Aluminium, acier, cire, cuivre, briques, laiton, carton gaufré, sérigraphie.

EX—2: with/avec: **TOM DEAN,** Carmen Lamanna Gallery, Toronto (7 X—26 X 72)

3

1 DE COURSEY *Elevators, 1972*

2 COURNOYER *Abécédaire*

3 COUGHTRY *Water Figure No. 8, 1973*
 (72" x 60") Photo: Isaacs Gallery, Toronto

4 COTE Photo: La Chasse-Galerie, Toronto

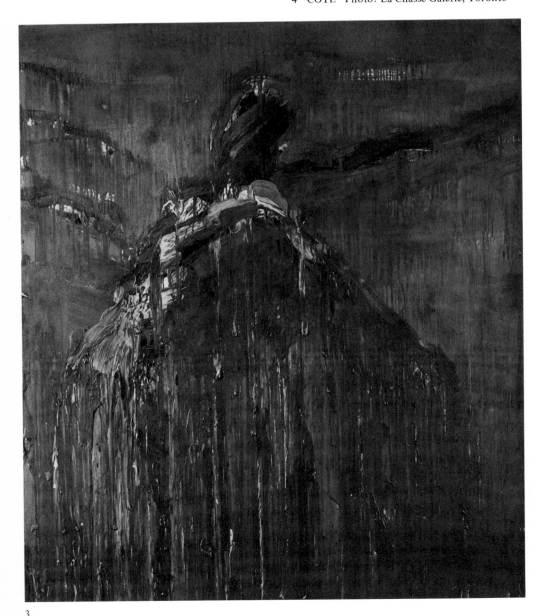

TONY COOPER (Painting/Peinture) 1950,
England TRAINING/FORMATION: Ontario
College of Art MEDIUM: Oil/Huile EX–4:
Carmen Lamanna Gallery, Toronto (16 IX–5
X 72)

MARY CORNEILLE (Painting/Peinture)
1917 LIVES/HABITE: Victoria MEDIUM:
Oil/Huile EX–3: with/avec: **LES HARPER,
HYSLOP INGHAM**, Art Gallery of Greater
Victoria, Victoria (14 XI–26 XI 72)

LUCIE COTE (Peinture, sculpture/Paint-
ing, sculpture) Montréal HABITE/LIVES:
Montréal MEDIUM: Acrylique, métal
soudé/ Acrylic, welded metal.

EX–1: Centre d'Art de Cowansville, Cowans-
ville, Qué. (8 XII–28 XII 72); Institut Co-
opératif Desjardins, Lévis, Qué. (10 I–10 V
73); La Chasse-Galerie, Toronto (23 II–9 III
73); Galerie d'Art de la Caisse Populaire
Laurier, Sherbrooke, Qué. (15 XI 72–10 I 73).

EX–3: avec/with **NICOLE ELLIOT-LEDOUX,
JACQUES POISSON**, La Maison des Arts La
Sauvegarde, Montréal (13 X–13 XI 72)

GRAHAM COUGHTRY (Painting/Peinture)
1931, St-Lambert, Qué. LIVES/HABITE:
Ibiza, Spain/Espagne AWARDS & HONOURS/
PRIX & HONNEURS: First Prize, Winnipeg
Show, 1957, 1962; First Prize, Montreal Spring
Show, 1958; Guggenheim International Award,
1958; Vancouver Art Gallery Prize, 1962; Can-
ada Council Award; Canada Council Fellow-
ship/Premier Prix, Winnipeg Show, 1957, 1962;
Premier Prix, Exposition du Printemps à Mon-
tréal, 1958; Prix international Guggenheim,
1958; Prix de la Vancouver Art Gallery, 1962;
Bourse du Conseil des Arts du Canada; Bourse
de travail libre du Conseil des Arts du Canada
MEDIUM: Oil/Huile.

EX–1: "New Paintings–Water Figure Series"
Isaacs Gallery, Toronto (22 III–10 IV 73).

GROUP/GROUPE: "Art for All"; "Toronto
Painting"; Gallery Five–Six–Seven, Toronto
(May/mai 73); Musée Régional de Rimouski,
Rimouski, Qué. (28 V–17 VI 73).

GEORGET COURNOYER (Peinture, sculpture, céramique/ Painting, sculpture, ceramics) 1931 HABITE/LIVES: Montréal FORMATION/TRAINING: Ecole des Beaux-Arts, Montréal; Univ Québec, Montréal; Institut des Arts Appliqués, Montréal ENSEIGNE/TEACHES: CEGEP du Vieux-Montréal MEDIUM: Poterie, sculpture en céramique/ Pottery, ceramic sculpture.

GROUPE/GROUP: "Ceramic Objects"; Victoria and Albert Museum, Londres, Angleterre (7 VI–23 VII 72); Nerolium Hall, Vallauris, France (20 VII–20 VIII 72); Musée International de la Céramique, Faenza, Italie (23 VII–8 X 72); Confederation Art Gallery and Museum, Charlottetown, P.E.I. (mai/May 73).

INGER DeCOURSEY (Painting/Peinture) 1931, Camrose, Alta. LIVES/HABITE: Saskatoon TRAINING/FORMATION: Univ Alberta MEDIUM: Oil, acrylic, watercolour, encaustic/Huile, acrylique, aquarelle, encaustique.

EX–1: St. Thomas More Gallery, Saskatoon (1 I–31 I 73)

FRANCIS COUTELLIER (Tapisseries, dessin, peinture/ Hangings, drawing, painting) 1945, Namur, Belgique/Belgium HABITE/LIVES : Moncton, N.B. FORMATION/TRAINING: Ecole d'Art de Mardesous; Ecole Nationale Supérieure d'Architecture et des Arts Visuels de Bruxelles, Belgique ENSEIGNE/TEACHES: Univ Moncton, Moncton, N.B. MEDIUM: Collage, acrylique, sérigraphie, crayon, tapisserie/Collage, acrylic, serigraphy, pencil, tapestry.

EX–2: "Coutellier - Skalnik" avec/with **P. SKALNIK** , William Ganong Hall, Univ Nouveau-Brunswick, St-Jean, N.B. (22 X - 4 XI 72).

EX–3: Rothman's of Pall Mall Canada Ltée, Moncton, N.B. (19 III - 6 IV 73).

GROUPE/GROUP: Phoenix Galleries, Charlottetown, P.E.I. (26 III–14 IV 73); "Graphex I" Morrison Gallery, St-Jean, N.B. (2 X–14 X 73); "Les Six de Moncton" Galerie Colline, Edmundston, N.B. (22 IX–30 IX 72); "New Brunswick Artists"; "December Choice".

2

1 CORNEILLE *Imp,* 1972

2 COURNOYER *Veterinarian's Bag*

3 COOPER *Fluctuation,* 1972 *(66 3/4" x 90")* Photo: Carmen Lamanna Gallery, Toronto

4 COUTELLIER

3

1

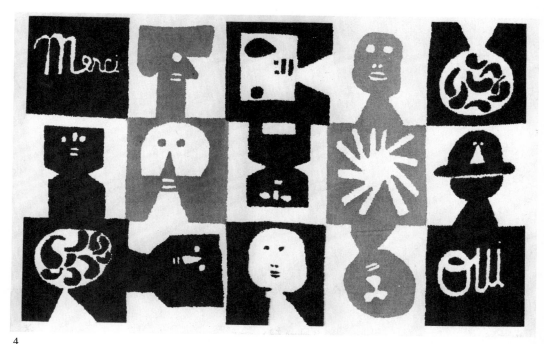

4

AILEEN COWAN (Sculpture, Painting/ Sculpture, Peinture) 1926, Toronto LIVES/HABITE: Toronto TRAINING/ FORMATION: Three Schools, Toronto MEDIUM: Bronze, iron, acrylic/Bronze, fer, acrylique.

EX—1: Diogenes International Galleries, Athens, Greece (23 VI–8 VII 72); Commerce Court, Toronto (14 I–14 II 73).

GROUP/GROUPE: Penell Gallery, Toronto (15 II–7 III 73).

WAYNE COWELL GROUP/GROUPE: "Information and Perception" Ontario College of Art, Toronto (24 III–23 IV 73).

1 COWELL *Figured Ground, 1973 (8' x 5')*

2 COWAN *Dante (14")*

3 COZIC *5 Pieds .2 les Yeux bleus! , 1973 (77" x 64 1/2" x 57")* Photo: Carmen Lamanna Gallery, Toronto

YVON COZIC (Sculpture, conceptuel/Sculpture, conceptual) 1942, Clermont-Ferrand, France HABITE/LIVES: Longueuil, Qué. FORMATION/TRAINING: Ecole des Beaux-Arts de Montréal PRIX & HONNEURS/ AWARDS & HONOURS: Bourses du Conseil des Arts du Canada, 1969, 1970, 1971/Canada Council Grants, 1969, 1970, 1971 MEDIUM: Styrofoam, vinyle, fourrure artificielle, corde, masonite, etc./Styrofoam, vinyl, fake fur, string, masonite, etc.

EX—1: "Les Chenilles" Galerie Média, Montréal (28 II - 10 III 73); "Toucher" Galerie Jolliet, Québec (27 III–15 IV 73); "Les 15 Premiers Jours de la Vie d'Eustache" Galerie Média, Montréal (mai/May 73).

EX—1: "Vêtir ceux qui sont nus" Itinérante dans toute la Province de Québec/Circulating throughout the province of Quebec (nov/Nov–déc/Dec 72).

EX—2: "Cozic and DeLavalle" avec/with **JEAN-MARIE DELAVALLE**, Organisée par la Galerie Nationale/Organized by The National Gallery, Ottawa ITINERANTE/ CIRCULATING: Fine Art Gallery, Univ British Columbia (5 VII - 16 VII 72); La Galerie Nationale/National Gallery, Ottawa (15 XI - 15 XII 72); York Univ Art Gallery, Toronto (28 II - 16 III 73).

EX—4: avec/with **REINHARD REITZEN-STEIN, JEAN-MARIE DELAVALLE, TOM DEAN**, Carmen Lamanna Gallery, Toronto, (14 IV - 3 V 73).

GROUPE/GROUP: "Les Moins de 35"; "Kingston Spring Exhibition"; "Diversity"; "Plastic Fantastic"; "Noël à 99c" Galerie Média, Montréal; "Pack-Sack" Bibliothèque Centrale de Prêt, Alma, Qué (févr/Feb 73)

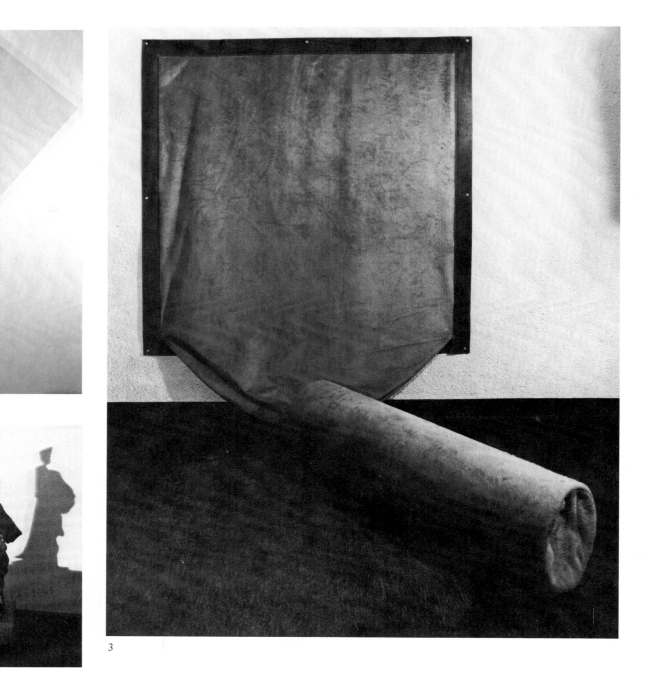

1

2

3

LARRY D. CROMWELL (Drawing/Dessin)
LIVES/HABITE: Calgary GROUP/GROUPE:
"Alberta Contemporary Drawings".

JUDY CURRELLY (Painting/Peinture)
1946, Toronto LIVES/HABITE: Toronto
TRAINING/FORMATION: Ontario College of
Art, Toronto AWARDS & HONOURS/PRIX &
HONNEURS: "Best of Show" Award, Young
Canadian Artists Show, Toronto, 1970; Canada
Council Arts Bursary, 1972/"Prix d'excellence"
Exposition des Jeunes Artistes Canadiens,
Toronto, 1970; Bourse du Conseil des Arts du
Canada, 1972 MEDIUM: Silkscreen, acrylic/
Sérigraphie, acrylique.

EX–1: "Paintings" Erindale College, Univ
Toronto (18 XII 72 - 3 I 73).

EX–3: "Three Toronto Artists" with/avec
CHRISTOPHER BIRT, **JOHN STREET**,
McLaughlin Gallery, Oshawa, Ont. (4 IV -
29 IV 73).

DON CURLEY (Painting, drawing/Peinture,
dessin) 1940, Halifax LIVES/HABITE:
Halifax TRAINING/FORMATION: Nova
Scotia College of Art; Mount Allison Univ;
Pratt Univ, Art Students League; Columbia
Univ, New York MEDIUM: Oil/Huile.

EX–3: Galerie Moos, Montréal (31 III–12
IV 73).

2

3

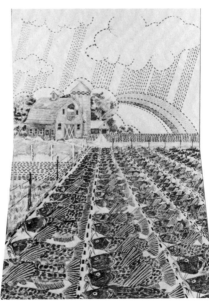

1

1 CROMWELL *Bullhead Farm* Photo:
 Edmonton Journal

2 COZIC *D'Amour tendre, 1973 (5 1/2' x
 14" x 18")* Photo: Carmen Lamanna
 Gallery, Toronto

3 CURELLY *Crescendo*

4 CURLEY *The Ladies of Petticoat Lane*

4

1

GREG CURNOE (Painting, drawing, print-making/Peinture, dessin, gravure) 1936, London, Ont. LIVES/HABITE: London, Ont. TRAINING/FORMATION: Beal Technical School, London, Ont. MEDIUM: Watercolour, collage/Aquarelle, collage.

EX–1: "Greg Curnoe" Isaacs Gallery, Toronto (24 I–13 II 73).

GROUP/GROUPE: "Lithographs 1"; "Annual Exhibition of Contemporary Canadian Art"; "Process"; "Art for All"; "Realism: Emulsion & Omission".

1 CURNOE *Zeus 10 Speed, 1972* Photo: Isaacs Gallery, Toronto

2 CURNOE *Clockings: Timed July 21/69, Stamped Jan. 27/72* Photo: Isaacs Gallery, Toronto

2

CURNOE *View from a Window above the Double Doors in the West Wall, 1971* Photo: Isaacs Gallery, Toronto

DIANA DABINETT (Painting, hangings/
Peinture, tapisseries) 1943, Rhodesia LIVES/
HABITE: Ilderton, Ont. TRAINING/FOR-
MATION: Univ Capetown, South Africa
MEDIUM: Batik, oil/Batik, huile.

EX–1: London Public Library & Art Museum,
London, Ont. (1 VI–30 VI 72)

JOSEE DAGNEAULT (Peinture/Painting)
1946 HABITE/LIVES: Sherbrooke, Qué.
FORMATION/TRAINING: Univ Laval;
Ecole des Beaux-Arts, Québec MEDIUM:
Acrylique/Acrylic.

EX–1: "Four Seasons" Galerie d'Art de
l'Univ Sherbrooke (15 XI - 3 XII 72).
GROUPE/GROUP: "Les Moins de 35".

CHRIS DAHL (Printmaking, painting, con-
ceptual/Gravure, peinture, conceptuel)
1948 LIVES/HABITE: Vancouver TRAIN-
ING/FORMATION: Vancouver School of
Art MEDIUM: Serigraphy, photography,
acrylic, film, mail-art/Sérigraphie, photo-
graphie, acrylique, film, art par la poste.

EX–1: Vancouver Art Gallery (Aug/août 72)
GROUP/GROUPE: SCAN.

1

1 DAGNEAULT

2 DAGNEAULT

3 DABINETT *Sea Scene, 1972 (26" x 36")*

4 DAHL *This is an exhibition/installation. You
 are the show. No. 1*

5 DAHL *This is an exhibition/installation. You
 are the show. No. 2*

6 DAHL *This is an exhibition/installation. You
 are the show. No. 3*

2

3

4

5

6

FRANCOIS DALLAIRE (Sculpture, peinture/Sculpture, painting) 1947, Ottawa HABITE/LIVES: Montréal FORMATION/TRAINING: Institut des Arts Appliqués, Montréal; Ecole des Beaux-Arts, Montréal; St. Martins School of Art, London, Eng.; Allgemeine Gewerbeschule, Buseli, Allemagne/Germany MEDIUM: Huile sur bois/Oil on wood.

EX—1: Galerie de la Société des Artistes Professionnels du Québec, Montréal (7 II—7 III 73) GROUPE/GROUP: "Les Moins de 35"

2

3

4

JULIUS DAMASDY (Painting, sculpture/Peinture, sculpture) 1937, Hungary LIVES/HABITE: Toronto TRAINING/FORMATION: Ontario College of Art, Toronto AWARDS & HONOURS/PRIX & HONNEURS: T. Eaton Art Scholarship (Sculpture), 1964; Governor General's Award, 1964/Bourse d'Etudes T. Eaton (Sculpture), 1964; Prix du Gouverneur Général, 1964 MEDIUM: Acrylic/Acrylique.

EX—1: "H2O = Life" Lillian Morrison Gallery, Toronto (28 IV—10 V 73).

1 DALLAIRE *Et c'est un converti, 1969*

2 DALLAIRE *Et maintenant, priez pour moi!, 1969*

3 DALLAIRE *Ma cousine Marguerite, 1967*

4 DAMASDY *Three Way Nonsense, 1973*

KEN DANBY (Painting, drawing, print-making/Peinture, dessin, gravure) 1940, Sault Ste-Marie, Ont. LIVES/HABITE: Guelph, Ont. TRAINING/FORMATION: Ontario College of Art, Toronto AWARDS & HONOURS/PRIX & HONNEURS: Purchase Award, Four Seasons Exhibition, Toronto, 1962; Hadassah Award (Drawing), Toronto, 1965; Jessie Dow Award for Best Painting, Montréal, 1964/Prix d'Achat, Exposition Four Seasons, Toronto, 1962; Prix Hadassah (Dessin), Toronto, 1965; Prix Jessie Dow pour la meilleure Peinture, Montréal, 1964 MEDIUM: Tempera, lithography, watercolour, pencil/Détrempe, lithographie, aquarelle, crayon.

EX—1: William Zierler Gallery, New York (1972); Images Gallery, Toledo, Ohio (1972); Gallery Moos, Toronto (9 XII–30 XII 72); Nancy Poole's Studio, London, Ont. (9 XII–15 XII 72); Gallery Allen, Vancouver (Apr/avril 73).

GROUP/GROUPE: "Third British International Print Biennale" Bradford, Eng.; "Hyper-Réalistes Américains" Paris, France; "Annual Exhibition of Contemporary Canadian Art".

JOSE DANIO Voir/see **JOSEE DAGNEAULT**

GERARD DANSEREAU (Peinture/Painting) 1949 HABITE/LIVES: Montréal FORMATION/TRAINING: CEGEP du Vieux-Montréal; Univ Québec, Montréal MEDIUM: Huile sur bois/Oil on wood. GROUPE/GROUP: "Salon des Métiers d'Art du Québec" (déc/Dec 72).

ANN CLARKE DARRAH (Painting, drawing/Peinture, dessin) 1944, Norfolk, Eng. LIVES/HABITE: Edmonton TRAINING/FORMATION: Slade School of Fine Art, London, Eng. AWARDS & HONOURS/PRIX & HONNEURS: Goldsmith's Travel Grant (Italy), 1965; Canada Council Grant, 1973/Bourse de voyage Goldsmith's (Italie), 1965; Bourse du Conseil des Arts du Canada, 1973. MEDIUM: Charcoal, acrylic, mixed media/Fusain, acrylique, multi-média.

EX—3: with/avec **E. DIENER, H. BRES,** Edmonton Art Gallery, Edmonton (13 V - 4 VI 73).

GROUP/GROUPE: "24th Spokane Annual" Spokane, Wash.; "Flair Square" Calgary; "Alberta Contemporary Drawing" Edmonton Art Gallery; "Stephen Greene's Workshop" Edmonton Art Gallery.

1 DANBY *The Goalie, 1972 (18" x 23")*
Photo: T.E. Moore for Gallery Moos, Toronto

2 DANSEREAU *Ectoplasme I, 1969*

59

JOCELYNE BENOIT-DARVEAU (Peinture/
Painting) 1943, Montréal HABITE/LIVES:
Lauzon, Qué. FORMATION/TRAINING:
Ecole des Beaux-Arts, Montréal MEDIUM:
Acrylique/Acrylic.

EX–1: Galerie Artémise, Lévis, Qué. (12 I–
2 II 73)

MARY DAVIES (Printmaking/Gravure)
1925, Truro, N.S. LIVES/HABITE: To-
ronto TRAINING/FORMATION: Ontario
College of Art, Toronto; Centennial College,
Toronto MEDIUM: Etching, collography,
bas-relief/Eau-forte, photocollotypie, bas-
relief.

EX–5: "Five Printmakers" with/avec **ED
BARTRAM, KATHERINE HUNT, HENRY
DUNSMORE, SYLVIA SINGER,** Aggrega-
tion Gallery, Toronto (16 V–10 VI 72).

GROUP/GROUPE: "Spring National Juried
Show" Agnes Etherington Gallery, Queen's
Univ, Kingston, Ont.; "Inaugural Exhibition"
Aggregation Gallery, Toronto (3 X - 21 X 72);
"Graphex 1"; Art Gallery of Ontario Circu-
lating Exhibition (O.S.A. Members).

1 DARRAH *Whitey's Blues No. 2 (96" x
 72" x 18")*

2 DARVEAU *Jos Gagnon, 1969*

3 DAVIES *Marks IV, 1972 (29 1/4" x 21 3/4")*
 Photo: J. Ayriss for Aggregation Gallery, Toronto

4 DAVIES *Marks II, 1972 (30" x 22")*

1

2

3

MICHAEL DAVIS (Conceptual/Conceptuel)
1942, Toronto LIVES/HABITE: Mt. Albert,
Ont. TRAINING/FORMATION: Ontario
College of Art, Toronto MEDIUM: Clay/Ar-
gile GROUP/GROUPE: "Ceramic Objects"

LOUISE DAZE (Peinture/Painting) 1943,
Montréal HABITE/LIVES: Montréal FOR-
MATION/TRAINING: Ecole des Beaux-Arts,
Montréal; Univ Québec, Montréal MEDIUM:
Huile, acrylique, aquarelle, encre, mine de
plomb, pastel/Oil, acrylic, watercolour, ink,
graphite, pastel.

EX—4: "Exposition-recherche" avec/with: **F.
BOUCHARD, M. JOLICOEUR, P. LAMBERT**
ITINERANTE/CIRCULATING: Galerie
Colline, Collège St-Louis-Maillet, Edmundston,
N.B. (2 XII—15 XII 72); Collège d'Alma, Lac-
St-Jean, Qué. (11 IV—15 IV 73) GROUPE/
GROUP: "Jeunes Peintres Québécois".

MICHAEL DEAN (Drawing/Dessin) 1948,
Manchester, Eng. LIVES/HABITE: Vancouver
TRAINING/FORMATION: Self-taught/Auto-
didacte MEDIUM: Ink/Encre.

EX—1: "Real Surreal" Mary Frazee Gallery,
Vancouver (June/juin—Jul/juil 72).

TOM DEAN (Sculpture, printmaking, con-
ceptual/Sculpture, gravure, conceptuel)
1947 LIVES/HABITE: Québec, Qué. ME-
DIUM: Mixed media/Multi-média.

EX—2: with/avec **R. COLLYER**, Carmen
Lamanna Gallery, Toronto (7 X - 26 X 72).

EX—4: with/avec **R. REITZENSTEIN, J.
DELAVALLE, Y. COZIC**, Carmen Lamanna
Gallery, Toronto (14 IV - 3 V 73).

GROUP/GROUPE: "Les Moins de 35";
"Art 3" Basel, Switzerland.

4

1 DAVIS *Hump Truck, 1973 (10" x 12" x 12")*

2 DAVIS *Hump Truck on Pedestal, 1973 (24" x 12" x 12")*

3 DAVIS *Accessory Humps with Marketing Device, 1973 (20" x 24" x 20")*

4 T. DEAN *Chair, 1970-71 (35" x 15" x 16" x 17")* Photo: Carmen Lamanna Gallery, Toronto

5 T. DEAN *Eleven Consecutive Moments (5'8 1/2")* Photo: Carmen Lamanna Gallery, Toronto

6 DAZE

7 M. DEAN

5

6

7

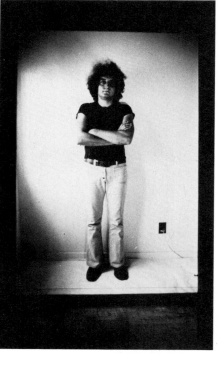

1

2

3

4

5

1 DEJONG

2 DEJONG

3 DESAULNIERS *(22" x 28")*

4 DEROUIN *Bi—Bloc (26" x 40")*

5 DELAVALLE *Bleu, Jaune, Rouge, Vert, 1972*

BEVERLY DE JONG (Metalwork/Métal) 1945, Calgary LIVES/HABITE: Calgary TRAINING/FORMATION: Alberta College of Art; Haystack Mountain School of Crafts, U.S.A. AWARDS & HONOURS/PRIX & HONNEURS: Special Award, Craft Dimensions Show, Royal Ontario Museum, Toronto, 1969/Prix spécial, Exposition Dimensions Artisanales, Royal Ontario Museum, Toronto, 1969 TEACHES/ ENSEIGNE: Alberta College of Art MEDIUM: Silver/Argent.

EX—2: with/avec **KEN SAMUELSON**, Graphic 8 Galleries, Calgary (14 III - 28 III 73).

GROUP/GROUPE: "Flair Square", Calgary; Ontario Institute for Studies in Education, Toronto; "Staff Show" Alberta College of Art, Calgary.

JEAN-MARIE DELAVALLE (Sculpture, conceptuel/Sculpture, conceptual) 1944, Clermont-Ferrand, France HABITE/LIVES: Boucherville, Qué. FORMATION/TRAINING: Ecole des Beaux-Arts de Montréal PRIX & HONNEURS/ AWARDS & HONOURS: Bourses du Conseil des Arts du Canada, 1969, 1970, 1972/ Canada Council Grants, 1969, 1970, 1972.

EX—1: "Screens, etc...Ecrans, etc." Galerie Média, Montréal (7 II - 21 II 73)

EX—2: "Cozic and Delavalle" avec/with **YVON COZIC** organisée par La Galerie Nationale/organized by The National Gallery ITINERANTE/ CIRCULATING: Fine Art Gallery, Univ British Columbia (5 VII - 16 VIII 72); La Galerie Nationale/The National Gallery (15 XI - 15 XII 72); Art Gallery, York Univ, Toronto (28 II - 16 III 73)

EX—4: avec/with **REINHARD REITZENSTEIN**, **TOM DEAN, YVON COZIC**, Carmen Lamanna Gallery, Toronto (14 IV - 3 V 73).

GROUPE/GROUP: "Les Moins de 35".

RENE DEROUIN (Gravure/Printmaking) HABITE/LIVES: Montréal FORMATION/ TRAINING: Ecole des Beaux-Arts de Montréal; Ecole des Beaux-Arts de Mexico PRIX & HONNEURS/AWARDS & HONOURS: Prix du ministère des Affaires culturelles du Québec, 1968, 1971; Bourses du Conseil des Arts du Canada, 1962, 1969/Prizes from the Quebec Ministry for Cultural Affairs, 1968, 1971; Canada Council Grants, 1962, 1969 MEDIUM: Sérigraphie/Serigraphy.

GROUPE/GROUP: "Eight Canadian Printmakers" Centre de la Confédération, Charlottetown; "Grafik"; "Art 3" Bâle, Suisse; "International Graphics"; "Association des Graveurs du Québec à L'Etable" Musée des Beaux-Arts, Montréal.

LOUIS DESAULNIERS (Peinture, gravure, tapisseries/Painting, printmaking, hangings) 1935, Québec HABITE/LIVES: Cap-de-la-Madeleine, Qué. FORMATION/TRAINING: Univ Québec, Trois-Rivières ENSEIGNE/ TEACHES: Univ Québec, Trois-Rivières MEDIUM: Sérigraphie/Serigraphy.

EX—1: Galerie du Parc, Trois-Rivières, Qué. (15 II—26 II 73) GROUPE/GROUP: "Images de la Mauricie".

ISABELLE DESJARDINS (Gravure, peinture/Printmaking, painting) 1948, Chicoutimi, Qué. FORMATION/TRAINING: Ecole des Beaux-Arts de Montréal GROUPE/GROUP: "De Rêves et d'Encre Douce".

ANDREE DESMARCHAIS (Tapisseries, gravure/Hangings, printmaking) 1945, Ste-Anne-de-Bellevue, Qué. HABITE/LIVES: Montréal FORMATION/TRAINING: Ecole des Beaux-Arts de Montréal; Univ Québec, Montréal MEDIUM: Sérigraphie, batik, taille douce/Serigraphy, batik, copper-plate engraving.

EX–1: La Caisse Populaire de Ste-Thérèse, Qué. (avril/Apr 73) GROUPE/GROUP: "L'Association des Graveurs du Québec à L'Etable" Musée des Beaux-Arts de Montréal (nov/Nov 72); "Salon des Métiers d'Art" Musée des Beaux-Arts de Montréal (déc/Dec 72); Galerie de la S.A.P.Q., Montréal (janv/Jan 73); "Les Moins de 35".

YVON DESROSIERS (Sculpture) 1941, Québec, Qué. FORMATION/TRAINING: Ecole des Beaux-Arts de Québec PRIX & HONNEURS/AWARDS & HONOURS: Premier Prix, Sculpture/First Prize, Sculpture, Ecole des Beaux-Arts de Québec, 1963 MEDIUM: Bois, métal, plastique/Wood, metal, plastic GROUPE/GROUP: Galerie Benedek-Grenier, Québec (mai/May 73).

JOYCE DEUTSCHER (Mixed media/Multimédia) 1925 LIVES/HABITE: Regina TRAINING/FORMATION: Museum of Fine Arts, Montréal; Univ Saskatchewan, Regina TEACHES/ENSEIGNE: Martin Collegiate, Regina MEDIUM: Oil, enamel, watercolour, metal, clay, collage/ Huile, émail, aquarelle, métal, argile, collage.

GROUP/GROUPE: "Simpsons Centennial Exhibition" Regina (Oct/oct 72); "Carsask"; Gallery on the Roof, Regina (Feb/févr 73); Grassroots Gallery, Regina.

KATHRYN DEVOS-MILLER (Peinture, gravure, multi-média/Painting, printmaking, mixed media) Chicago, Ill., U.S.A. HABITE/LIVES: Toronto FORMATION/TRAINING: Univ Indiana; Univ Strasbourg, France; Univ Toronto MEDIUM: Imprimerie sur étoffe, collage/Printing on cloth, collage.

EX–1: La Chasse-Galerie, Toronto (nov/Nov 72); Le Théâtre du P'tit Bonheur, Toronto (mai/May 73).

GROUPE/GROUP: La Chasse-Galerie, Toronto (août/Aug 72); Van Stracten Gallery, Chicago, Ill.

1 DESJARDINS *Burin–2 plaques*

2 DEUTSCHER *Winter Sky (5' diam.)*

3 DESJARDINS

4 DESROSIERS *(Max. ht. 20")*

5 DESMARCHAIS

6 DEVOS-MILLER

1

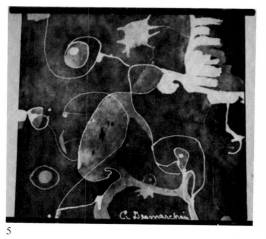

2

3

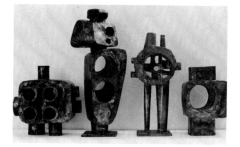

5

4

6

1

JENNIFER DICKSON (Sculpture, print-making/Sculpture, gravure) 1936, Cape Town, South Africa LIVES/HABITE: Montréal TRAINING/FORMATION: Goldsmith's College School of Art, London, Eng. AWARDS & HONOURS/PRIX & HONNEURS: Prix des Jeunes Peintres, Gravure, Biennale de Paris/Young Artists Prize, Printmaking, Paris Biennale MEDIUM: Serigraphy, lithography, low relief metal and plexiglas sculptures, plexiglas shadow boxes, acrylic, photographic silk-screen/Sérigraphie, lithographie, sculptures en métal et en plexiglas (bas relief), "shadow boxes" en plexiglas, acrylique, sérigraphie photographique.

EX—1: "Sweet Death and Other Pleasures" Galerie Martal and Galerie 1640, Montréal (25 XI 72—16 XII 72); Oxford Gallery, Oxford, Eng. (Mar/mars—Apr/avril 73); Galerie Dresdnere, Toronto (31 III—21 IV 73).

GROUP/GROUPE: "3rd British International Print Biennale" Bradford, Eng.; "2nd International Biennial Exhibition of Prints" Seoul, Korea; "IVe Biennale Internationale de la Gravure" Krakow, Poland; "11th Annual Exhibition" Royal Glasgow Institute of Fine Arts, Glasgow, Scotland; "Canadian Printmakers Showcase"; "Contemporary Canadian Prints" Pratt Graphics Center, New York; "10th International Exhibition of Graphic Art" Ljubljana, Yugoslavia; "Summer Exhibition of the Royal Academy of Arts" London, Eng.; "Society of Canadian Painter-Etchers and Engravers" London, Ont.; "Biennale Internationale de l'Estampe" Paris. "Process".

2

3

1 DICKSON *Time Remembered, 1972 (37" x 32 1/2")* Photo: Galerie Martal, Montreal

2 DICKSON *Sutra, 1972 (27" x 48")*

3 DICKSON *Journey to the Second Incarnation with the Aid of the Bell of Giradius, 1972 (30" x 37")*

EVA DIENER (Painting/Peinture) Switzerland LIVES/HABITE: Edmonton EX—3: with/avec **HENDRIK BRES, ANN CLARKE DARRAH,** Edmonton Art Gallery (13 V—4 VI 73) GROUP/GROUPE: "Director's Choice" Edmonton Art Gallery (Nov/nov 72); "Alberta Contemporary Drawings".

LOUISE GOUEFFIC DIERKER (Peinture/Painting) 1933, Marcelin, Sask. HABITE/LIVES: Saskatoon MEDIUM: Huile/Oil. EX—1: St. Thomas More College, Univ Saskatchewan, Saskatoon (15 XI—15 XII 72).

CHRISTOS DIKEAKOS (Conceptual/Conceptuel) 1946 LIVES/HABITE: Vancouver TRAINING/FORMATION: Self-taught/Autodidacte MEDIUM: Photographic collage/Collage photographique EX—1: Nova Scotia College of Art and Design, Halifax (12 III—18 III 73) GROUP/GROUPE: "SCAN".

1 DIENER *Merry Go Round in the Sea No. 1*

2 DIERKER *L'Hiver, 1926, à Blaine Lake, 1973 (2' x 3')*

3 DIKEAKOS *Poster Collage*

4 DMYTRUK *Landscape No. 3, 1972*

IHOR DMYTRUK (Painting, drawing, printmaking/Peinture, dessin, gravure) 1938 LIVES/HABITE: Edmonton TRAINING/FORMATION: Univ Alberta; Vancouver School of Art MEDIUM: Acrylic/Acrylique.

EX—5: "Five Canadian Artists" with/avec **PETER KOLISNYK, RON KOSTYNIUK** et al. CIRCULATING/ITINERANTE: Ukrainian Institute of Modern Art, Chicago, Ill. (29 IX—8 X 72); Evanston Art Centre, Evanston, Ill. (9 X—17 X 72).

GROUP/GROUPE: "Director's Choice" Edmonton Art Gallery, Edmonton (Nov/nov 72); "Alberta Contemporary Drawings".

1

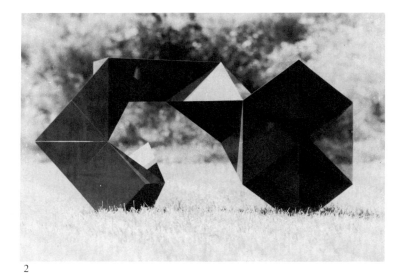

2

3

4

JOHN DOBEREINER (Painting, printmaking/ Peinture, gravure) LIVES/HABITE: Victoria TRAINING/FORMATION: Vancouver School of Art; Univ Washington, Seattle, Wash. TEACHES/ENSEIGNE: Univ Victoria, B.C. MEDIUM: Oil, silkscreen, relief/Huile, séri- graphie, relief GROUP/GROUPE: Zan Art Gallery, Victoria (17 V–18 VI 73).

PETER DOBUSH (Drawing/Dessin) 1908, Winnipeg LIVES/HABITE: Montréal TRAINING/FORMATION: Univ Manitoba, Winnipeg MEDIUM: Ink/Encre.

EX–1: "Gift of the City of Corner Brook" Corner Brook Arts and Culture Centre, Nfld. (Sept/sept 72); "Sketches of Newfoundland" CIRCULATING/ITINERANTE: St. John's Gallery, Nfld. (24 II–8 III 73); Gander Inter- national Airport, Nfld. (18 V–10 VI 73).

GROUP/GROUPE: "Art for All".

ADRIAN DOW (Painting/Peinture) 1946 LIVES/HABITE: Kingston, Ont. TRAIN- ING/FORMATION: Univ Saskatchewan, Regina MEDIUM: Gouache, oil/Gouache, huile GROUP/GROUPE: Rodman Hall, St. Catharines, Ont. (2 III–25 III 73).

ROBERT DOWNING (Hangings, sculpture, drawing, printmaking, painting/Tapisseries, sculpture, dessin, gravure, peinture) 1935, Hamilton LIVES/HABITE: Toronto AWARDS & HONOURS/PRIX & HONNEURS: Canada Council Arts Bursary, 1969, 1971; Canada Council Materials Grant, 1970/ Bourse du Conseil des Arts du Canada, 1969, 1971; Bourse d'achat de matériel, Con- seil des Arts du Canada, 1970 TEACHES/ ENSEIGNE: Ontario College of Art, Toronto MEDIUM: Silkscreen, photography, mosaic, acrylic, batik/Sérigraphie, photographie, mosaïque, acrylique, batik.

EX–1: "Five Years of Robert Downing: 1966- 71" Univ Guelph, Guelph, Ont. CIRCULA- TING/ITINERANTE: Robert McLaughlin Gallery, Oshawa (10 VI–2 VII 72).

GROUP/GROUPE: Winnipeg Rental Library, Winnipeg (Aug/août 72–Apr/avril 73); "100 Years of the Ontario Society of Artists" Tor- onto; Marlborough-Godard Gallery, Toronto (Sept/sept–Oct/oct 72).

1 DOW *Adolescent Dream of Love*

2 DOWNING *Primary Units Through Space No. 1, 1967 (45" x 20" x 50")*

3 DOBEREINER *Announcement of Spring, 1973* Photo: Zan Art Gallery, Victoria

4 DOBUSH *Barn, 5lième Avenue, Ile Perrot, P.Q.*

3

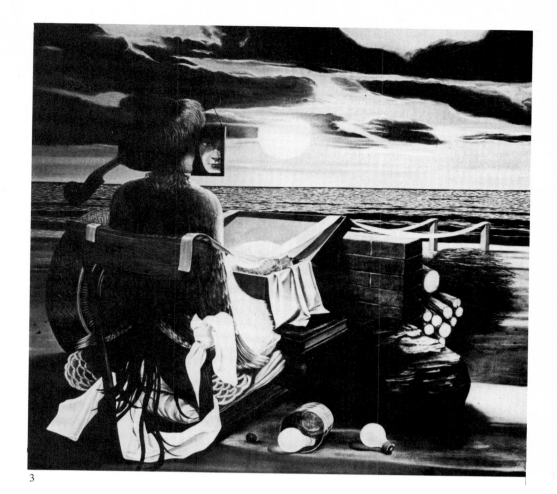

1

4

2

JOSEF DRAPELL (Painting/Peinture) 1940 LIVES/HABITE: Toronto TRAINING/FORMATION: Cranbrook Academy of Art, Cranbrook, Mich. MEDIUM: Acrylic/Acrylique.

EX–1: Robert Elkon Gallery, New York (June/juin 72); Dunkelman Gallery, Toronto (Nov/nov 72).

ANDRE DU BOIS (Céramique, peinture, métal/Ceramics, painting, metalwork) 1947, Québec, Qué. HABITE/LIVES: Rivière-du-Loup, Qué. MEDIUM: Acrylique, encre, argile/Acrylic, ink, clay.

EX–1: Galerie d'Europe, Québec, Qué. (juil/Jul–août/Aug 72) GROUPE/GROUP: "Les Moins de 35".

MARIUS DUBOIS (Peinture, dessin/Painting, drawing) 1949 HABITE/LIVES: Montréal FORMATION/TRAINING: Self-taught/Autodidacte MEDIUM: Huile, crayon, aquarelle/Oil, pencil, watercolour GROUPE/GROUP: "Art 3" Bâle, Suisse.

1 DRAPELL *Lougas (104" x 53")*

2 A. DUBOIS *Série Gribleu, No.6*

3 M. DUBOIS *Le Miroir aux Alouettes (45" x 45")*

4 DRAPELL *Fallcris, 1971*
Photo: Peter MacCallum

CLAUDE DUFOUR (Sculpture, peinture, Sculpture, painting) 1925, Chicoutimi, Qué. HABITE/LIVES: Chicoutimi, Qué. FORMATION/TRAINING: Autodidacte/Self-taught MEDIUM: Aluminium en relief, bronze, métal/Aluminum relief, bronze, metal.

EX—1: Bibliothèque de Ste-Foy, Qué. (9 III—23 III 73). GROUPE/GROUP: "Les Peintres du Saguenay" Hôtel de Ville, Chicoutimi, Qué. (juil/July 72).

CAROLINE DUKES (Sculpture, painting, drawing/Sculpture, peinture, dessin) LIVES/HABITE: Winnipeg TRAINING/FORMATION: College of Art, Budapest; Univ Manitoba MEDIUM: Oil, acrylic/Huile, acrylique.

GROUP/GROUPE: "Manisphere Exhibition"; "Manitoba Society of Artists 47th Annual": Gallery 111, Winnipeg (June/juin 72).

REAL DUMAIS (Gravure, dessin/Printmaking, drawing) 1947 HABITE/LIVES: Montréal FORMATION/TRAINING: Ecole des Beaux-Arts de Montréal; Univ Québec, Montréal MEDIUM: Sérigraphie, encre/Serigraphy, ink. GROUPE/GROUP: "De Rêves et d'Encre Douce".

3

1

2

4

HENRY DUNSMORE (Printmaking/Gravure) 1947, Grangemouth, Scotland LIVES/HABITE: Toronto TRAINING/FORMATION: Sheridan College of Applied Arts and Technology, Oakville, Ont. AWARDS & HONOURS/PRIX & HONNEURS: "Ontario Society of Artists 101st Annual Exhibition", Second prize/Deuxième prix MEDIUM: Serigraphy/Sérigraphie.

EX—5: "Five Printmakers" with/avec **ED BARTRAM, MARY DAVIES, KATHARINE HUNT, SYLVIA SINGER,** Aggregation Gallery, Toronto (16 V—10 VI 72).

GROUP/GROUPE: "Kingston Spring Exhibition"; "SCAN"; "Process"; "National Juried O.S.A. Show"; "Ontario Society of Artists 100th Annual Open Exhibition"; "Juried Group Show" Rothman's Art Gallery, Stratford; "Gallery Artists Summer Show" Aggregation Gallery, Toronto; "New Talent in Printmaking" Marlborough-Godard Gallery, Toronto (Aug/aôut 72); "Inaugural Exhibition" Aggregation Gallery, Toronto (3 X—21 X 72); Gallery 111, Univ Manitoba,Winnipeg.

1 DUMAIS *Bois gravé*

2 DUKES *Interior with Nude* (42" x 49")

3 DUNSMORE *Window Series No. 2, 1972* (22" x 28 7/8") Photo: J. Ayriss for Aggregation Gallery, Toronto

4 DUFOUR

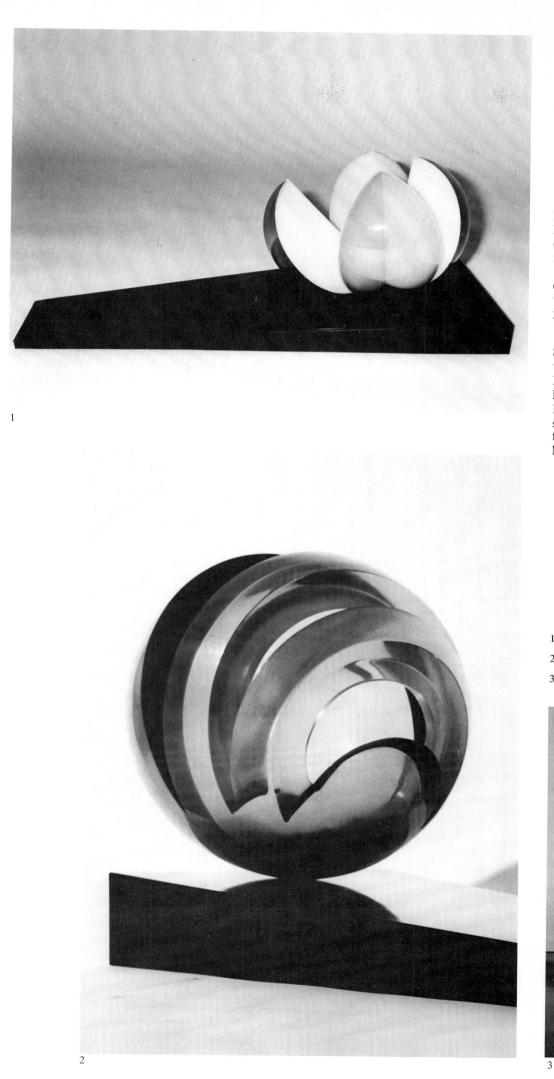

1

2

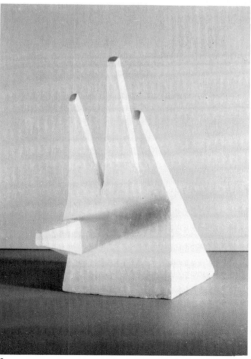

LUCE DUPUIS (Sculpture) 1940, Ste-Marthe, Qué. HABITE/LIVES: St-Léonard, Qué. FORMATION/TRAINING: Univ Québec PRIX & HONNEURS/AWARDS & HONOURS: Bourse du Beth Zion Sisterhood, 1972; Bourse du Premier Ministre du Québec, 1972/Beth Zion Sisterhood Award, 1972; Prize from the Prime Minister of Quebec, 1972 MEDIUM: Sculptures animées en plexiglas et polyester/Mobile polyester and plexiglas sculptures.

EX–1: ITINERANTE/CIRCULATING: La Maison des Arts La Sauvegarde, Montréal (9 IX–9 X 72); Nancy Poole's Studio, Toronto (31 III–18 IV 73).

GROUPE/GROUP: "Art 3" Bâle, Suisse; "Operation Multiple" Galerie Espace (31 V–30 IX 72); Gallery III, Montréal (nov/Nov 72).

SUZANNE DURANCEAU (Sculpture, peinture/Sculpture, painting) 1952 HABITE/LIVES: Montréal FORMATION/TRAINING: Musée des Beaux-Arts, Montréal; Ecole des Beaux-Arts de Montréal MEDIUM: Plâtre, styrofoam, acrylique, huile/ Plaster, styrofoam, acrylic, oil GROUPE/GROUP: "Les Moins de 35".

1 DUPUIS *Eclosion 71*

2 DUPUIS *Détachement 71*

3 DURANCEAU

MICHAEL DURHAM (Painting, drawing/ Peinture, dessin) 1944, England LIVES/ HABITE: London, Ont. TRAINING/FORMATION: Leeds College of Art, Eng.; Tesside College of Art, Eng. AWARDS & HONOURS/PRIX & HONNEURS: First Prize, Painting, Tyne Tees Eisteddfod; First Prize, "Northern Artists Exhibition", Eston, Eng.; Canada Council Project Grant, 1972/Premier Prix de Peinture, Tyne Tees Eisteddfod; Premier Prix, "Exposition Northern Artists" Eston, Angleterre; Bourse du Conseil des Arts du Canada, 1972 MEDIUM: Acrylic, lacquer sprayed on wood/Acrylique, laque pulvérisé sur bois.

EX–1: Trajectory Gallery, London, Ont. (Oct/oct–Nov/nov 72) EX–1: Michael Wyman Gallery, Chicago (2 XII 72–6 I 73) EX–1: London Public Library & Art Museum, London, Ont. (2 III–31 III 73).

*** See colour section/ Voir section couleur**

MADELEINE DUSSAULT (Peinture, dessin/Painting, drawing) 1920, Montréal FORMATION/TRAINING: Autodidacte/ Self-taught MEDIUM: Huile, encre, acrylique sur plexiglas et sur aluminium/Oil, ink, acrylic on plexiglas and on aluminum.

EX–1: La Grange à Séraphin, Montréal (1 II–1 III 73) EX–1: Café La Rescousse, Rivière-du-Loup, Qué. (24 V–31 V 73).

GROUPE/GROUP: Centre d'Art du Mont Royal, Montréal (15 VI–15 IX 72); Carré Dominion, Montréal (15 VI–15 IX 72).

1 DUSSAULT *Explosion solaire*

2 DUSSAULT *Ivresse d'amour (36" x 24")*

3 DUSSAULT *Limbes*

1

2

3

1

2

MONIQUE DUSSAULT (Gravure, dessin, peinture/Printmaking, drawing, painting) 1943, Montréal HABITE/LIVES: Outremont, Qué. FORMATION/TRAINING: Ecole des Beaux-Arts de Montréal MEDIUM: Cuivre, bois, aquarelle/Copper, wood, watercolour.

EX–1: Gare Centrale de Montréal (9 III–11 IV 73) GROUPE/GROUP: "Les Moins de 35"; Centre d'Art du Mont Royal, Montréal (18 I–18 II 73).

GRAYDON DYCK (Drawing/Dessin) 1946, Leamington, Ont. TRAINING/FORMATION: Univ Manitoba School of Art, Winnipeg MEDIUM: Pencil/Crayon.

EX–1: "New Drawings" Aggregation Gallery, Toronto (31 III–19 IV 73).

GROUP/GROUPE: "Annual Christmas Show" Aggregation Gallery, Toronto (5 XII–23 XII 72); "Inaugural Exhibition" Aggregation Gallery, Toronto (3 X–21 X 72); "Gallery Artists" Aggregation Gallery, Toronto (24 X–11 XI 72).

3

DZIDRA (Painting/Peinture) 1926 LIVES/HABITE: Toronto TRAINING/FORMATION: Kunstgewerbeschule, Liepaja; Universität Heidelberg; Universität Gothenburg, Germany/Allemagne MEDIUM: Acrylic/Acrylique.

EX–1: Rosenburg Gallery, Guelph, Ont. (Dec/déc 72).

EX–5: "Stimulus Group Show" with/avec **MAURILIO, WEDOR SALDABRON, PIETRO ZAZETTA, PETER KUNZ**, Rosenburg Gallery, Guelph, Ont. (Mar/mars 73).

1 DUSSAULT *Les Carrigans, 1971*

2 DZIDRA *Stimulus Series, 1972*

3 DYCK *Curfew (30" x 40")* Photo: Aggregation Gallery

4 DYCK *Wanna Ride* Photo: Aggregation Gallery

4

1

2

3

4

MAVIS EHLERT (Sculpture) 1922 LIVES/ HABITE: Hamilton, Ont. TRAINING/FOR-MATION: St. Martins School of Art, London, Eng. MEDIUM: Clay, bronze, cement, plaster, fiberglas, terra cotta/Argile, bronze, ciment, plâtre, fibre de verre, terre cuite.

EX−1: Hamilton Art Gallery, Hamilton, Ont. (18 I−4 II 73).

GROUP/GROUPE: "Canadian Arts" Strat-ford, Ont. (3 VI−4 VI 72); "Annual Exhibi-tion of Contemporary Canadian Art".

DEAN ELLIS (Conceptual/Conceptuel) LIVES/HABITE: Vancouver MEDIUM: Plywood, styrofoam, tape loops, videotape, headphones/Contre-plaqué, styrofoam, boucles de ruban sonore, videotape, écou-teurs.

EX−2: "Directions '72" with/avec **RICHARD PRINCE**, Vancouver Art Gallery, Vancouver (14 XI - 15 XII 72).

JOHN K. ESLER (Printmaking/Gravure) 1933, Pilot Mound, Manitoba LIVES/ HABITE: Calgary TRAINING/FORMATION: Univ Manitoba, Winnipeg AWARDS & HONOURS/PRIX & HONNEURS: First Prize, Art Alliance of Central Pennsylvania; Liberal Unitarian Art Purchase Award; Three C.W. Jeffries Awards/Premier Prix, Art Alliance of Central Pennsylvania; Prix d'achat Liberal Unitarian; Trois prix C.W. Jeffries MEDIUM: Etching, lithography, collography, serigraphy/Eau-forte, litho-graphie, photocollotypie, sérigraphie.

EX−1: Simon Fraser Univ, Burnaby, B.C. (5 IX - 22 IX 72); Graphic 8 Galleries, Calgary (27 IX - 18 X 72); Memorial Univ, St. John's, Nfld. (24 X - 20 XI 72); Grand Falls Gallery, Grand Falls, Nfld. 15 XI - 12 XII 72); Mendel Art Gallery, Saskatoon (13 II - 28 II 73); Mido Gallery, Vancouver (8 V - 26 V 73).

GROUP/GROUPE: "Canadian Printmakers Showcase"; "Printmakers' Exhibition" Mido Gallery, Vancouver (1 IX - 6 X 72); Corner-brook Gallery, Cornerbrook, Nfld. (15 XII 72 - 20 I 73); "Western Canada" Gallery 1640, Montréal; "Graphex 1"; "13th Annual Graphics Exhibition" Calgary; "Process".

LINDSAY EVANS (Painting/Peinture) 1891, Chelsea, Mass., U.S.A. LIVES/ HABITE: Lloydminster, Sask. TRAINING/ FORMATION: Eric Pape School of Art, Boston; St. Martins School of Art, London, Eng. MEDIUM: Oil/Huile.

EX−1: Legion Hall, Lloydminster, Sask. (Feb/févr 73).

1 ESLER

2 ELLIS *Directions '72* Photo: Vancouver Art Gallery

3 EVANS

4 EHLERT *Bird Forms No. 3 (55" x 45" x 45")*

SANDY FAIRBAIRN (Painting, mixed media, sculpture/Peinture, multi-média, sculpture) 1947 LIVES/HABITE: Toronto TRAINING/FORMATION: Ontario College of Art, Toronto AWARDS & HONOURS/ PRIX & HONNEURS: E. Hann Award/Prix E. Hann MEDIUM: Wood, cardboard, formica, xerox, photography/Bois, carton, formica, xerox, photographie.

EX–1: "Mitre Line" Gallery 76, Toronto (4 I–14 I 73).

GROUP/GROUPE: Student Exhibition, Gallery 76, Toronto.

GATHIE FALK (Ceramics, mixed media, painting/Céramique, multi-média, peinture) 1919, Alexander, Man. LIVES/HABITE: Vancouver TRAINING/FORMATION: Univ B.C., Vancouver AWARDS & HONOURS/ PRIX & HONNEURS: Canada Council Grants, 1967, 1968, 1969; Vancouver Sun Award, 1968/Bourses du Conseil des Arts du Canada, 1967, 1968, 1969; Prix Vancouver Sun, 1968 MEDIUM: Acrylic, oil, wood, enamel, varnish/Acrylique, huile, bois, émail, vernis.

GROUP/GROUPE: "SCAN"; "Realism: Emulsion and Omission"; "Ceramic Objects"; "Theatre Art Works".

EDWARD FALKENBERG (Sculpture, painting/Sculpture, peinture) 1936, Edmonton LIVES/HABITE: Claremont, Ont. TRAINING/FORMATION: Univ Alberta, Edmonton; Alberta Institute of Technology and Art, Calgary; Ontario College of Art, Toronto MEDIUM: Steel plate, metal rods, plywood, stoneware/Acier en feuilles, tiges de métal, contreplaqué, poterie.

EX–1: "Edward Falkenberg Retrospective" Ontario Association of Architects, Toronto (1 VI–30 VI 72).
GROUP/GROUPE: Eaton's Fine Art Gallery, Toronto (5 X–18 X 72); "Society of Canadian Artists" Toronto; Pollock Gallery, Toronto (21 IX–29 IX 72).

W. FALKENBERG (Sculpture) 1929 LIVES/HABITE: Toronto TRAINING/ FORMATION: Academy of Art, Munich MEDIUM: Wood/Bois EX–1: R.M. Gallery, Toronto (Mar/mars 73) GROUP/ GROUPE: "Sculptors' Society of Canada" Toronto-Dominion Centre, Toronto; "Sculptors' Society of Canada" Scarborough College, Scarborough, Ont.

1 FALK *Red Angel, 1972*

2 FAIRBAIRN *Mitre Line, 1972*

3 E. FALKENBERG *Claremont Hills, 1972 (11" x 6" x 12")*

4 W. FALKENBERG *Escape, 1971*

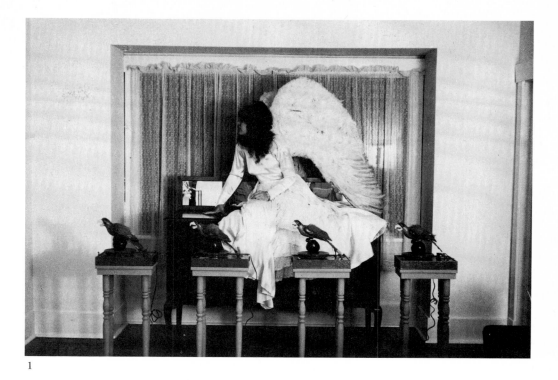

1

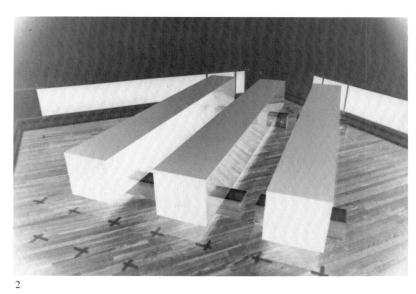

2

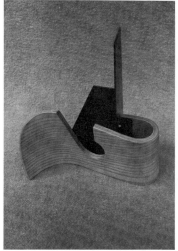

3

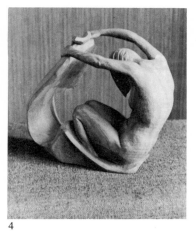

4

1

2

3

4

PIERRE FAUCHER (Peinture, gravure/
Painting, printmaking) 1931, Montréal
HABITE/LIVES: Montréal FORMATION/
TRAINING: Ecole des Beaux-Arts de Mont-
réal; Ecole des Arts Graphiques, Montréal
PRIX & HONNEURS/AWARDS & HONOURS:
Bourse du Gouvernement du Québec/Award
from the Government of Quebec MEDIUM:
Huile, acrylique, encre/Oil, acrylic, ink EX—1:
Galerie Les Deux B, St-Antoine-sur-Richelieu,
Qué. (31 III—30 IV 73).

PHILIPPA FAULKNER (Painting/Peinture)
1917, Belleville, Ont. LIVES/HABITE:
Toronto TRAINING/FORMATION: Doon
School of Art, Ont.; Instituto Allende, San
Miguel de Allende, Mexico; Parsons School
of Design, New York AWARDS & HONOURS/
PRIX & HONNEURS: First Prize, "Annual
Show" Instituto Allende, Mexico, 1960;
First Prize, "Eastern Ontario Exhibition"
1965/Premier Prix "Annual Show" Instituto
Allende, Mexico, 1960; Premier Prix,
"Eastern Ontario Exhibition" 1965 TEACHES/
ENSEIGNE: St. Michael's Academy, Belleville,
Ont. MEDIUM: Watercolour, oil, acrylic/
Aquarelle, huile, acrylique.

EX—3: Morris Gay, Toronto (Oct/oct—Nov/
nov 72).

GROUP/GROUPE: "Painters in Watercolour";
"Canadian Arts" Stratford, Ont.; O'Keefe
Centre, Toronto, 1973; Ontario Institute
for Studies in Education, Toronto.

1 FAVRO *'61 Corvair, Country Road, Stump
with Maple Leaves, 1972* Photo: Carmen
Lamanna Gallery, Toronto

2 FAUCHER *Bons Baisers du Pays des Bulles,
1973*

3 FAULKNER *Joggins Point, 1972*

4 FAVREAU

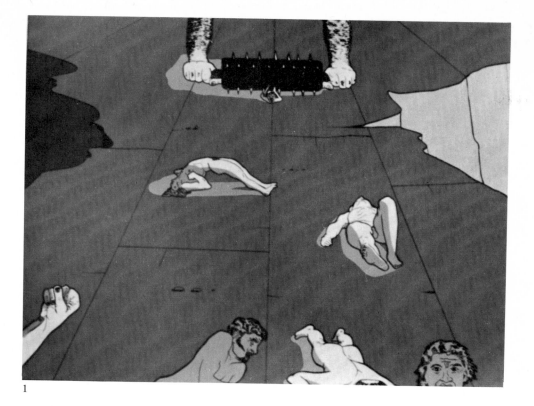

2

1

MARCEL FAVREAU (Peinture/Painting) 1922 HABITE/LIVES: Montreal FORMA-TION/TRAINING: Ecole des Beaux-Arts de Montréal MEDIUM: Huile/Oil EX—1: Centre Culturel de Verdun, Verdun, Qué. (17 I—5 II 73).

MURRAY FAVRO (Sculpture, conceptual, drawing/Sculpture, conceptuel, dessin) 1940, Huntsville, Ont. LIVES/HABITE: London, Ont. MEDIUM: Ink/Encre.

EX—1: Carmen Lamanna Gallery, Toronto (15 IV—4 V 72).

GROUP/GROUPE: "Realism: Emulsion and Omission"; Carmen Lamanna Gallery, Toronto (14 XII—28 XII 72).

WILLIAM FEATHERSTON (Sculpture, print-making, painting/Sculpture, gravure, peinture) Toronto LIVES/HABITE: Victoria TEACH-ES/ENSEIGNE: Univ Victoria MEDIUM: Silkscreen/Sérigraphie.

EX—1: Art Gallery of Greater Victoria, Victoria (23 I—11 II 73).

GROUP/GROUPE: "Third British International Print Biennale", Bradford, Eng.; Gallery Pascal, Toronto (21 IV—26 IV 73); Bau XI Gallery, Vancouver (Mar/mars 73).

JAMES WARREN FELTER (Painting, printmaking/Peinture, gravure) 1943, Bainbridge, New York LIVES/HABITE: Vancouver TRAINING/FORMATION: Univ South Florida, Tampa, Fla.; Univ Washington, Seattle, Wash. MEDIUM: Oil, acrylic, ink/Huile, acrylique, encre.

EX—1: "Maze Series" Galeria Siglo XX, Quito, Ecuador (5 V—5 VI 72).

GROUP/GROUPE: "Vancouver Art Gallery Instructors Invitational Exhibition"; Annex Gallery, West Vancouver, B.C. (9 IV—18 IV 73); "1973 National Print & Drawing Show" West Illinois Univ (8 V—22 V 73).

KERRY FERRIS (Painting/Peinture) 1949, London, Ont. LIVES/HABITE: London, Ont. MEDIUM: Acrylic/Acrylique EX—5: McIntosh Gallery, London, Ont. (May/mai 73) GROUP/GROUPE: "33rd Annual Western Ontario Exhibition".

MARCELLE FERRON (Peinture/Painting) 1924, Louiseville, Qué. PRIX & HONNEURS/ AWARDS & HONOURS: Bourse du Conseil des Arts du Canada; Médaille d'Argent, Biennale de Sao Paulo, Brésil, 1962/Canada Council Grant; Silver Medal, Sao Paulo Biennale, Brazil, 1962 MEDIUM: Huile, verre/Oil, glass.

EX—1: Centre Culturel Canadien, Paris (10 X—26 XI 72); Musée de Québec (5 IV—30 IV 73); "Rétrospective" Musée des Beaux-Arts de Montréal (5 IV—30 IV 73); "Marcelle Ferron-Rétrospective" La Galerie d'Art de l'Univ Sherbrooke (27 V—10 VI 73).

3

4

1 FEATHERSTON *1972*

2 FERRON *Sans titre, 1961 (34 1/2" x 44")*
Photo: Conseil des Arts du Canada

3 FERRIS *Fungus Hunters, 1972*

4 FELTER *Ch'ien, 1972 (19" x 19")*

1

2

3

4

ROBIN W. FIELD (Painting, drawing, print-making/Peinture, dessin, gravure) 1945 LIVES/HABITE: Calgary, Alta. TRAINING/ FORMATION: Sir George Williams Univ, Montréal; Shepy National Arts of Canada, Edmonton; Heatherty School of Art, London, Eng. MEDIUM: Acrylic, silkscreen, pencil, watercolour, etching, oil/Acrylique, sérigraphie, crayon, aquarelle, eau-forte, huile.

EX—1: "Robin Field" Sir George Williams Univ Art Gallery, Montréal (19 V—9 VI 72).

EDWARD FIELDING (Painting, sculpture/ Peinture, sculpture) 1943, San Diego, Calif. LIVES/HABITE: Toronto TRAINING/ FORMATION: Philadelphia College of Art, Philadelphia, Penn. MEDIUM: Aluminum, acrylic sheet, fluorescent lighting/Aluminium, acrylique en feuilles, lumière fluorescente.

GROUP/GROUPE: Owens Art Gallery, Mount Allison Univ, Sackville, N.B. (Jan/janv—Feb/ févr 73); New Brunswick Museum, St. John, N.B.; "Hodgepodge" Patmos Gallery, Toronto (June/juin—Sept/sept 72); "Butterflies" Patmos Gallery, Toronto (Nov/nov 72); York Univ, Toronto (30 X—16 XI 72).

AUGUSTIN FILIPOVIC (Sculpture) 1931, Davor, Croatia (Yugoslavia) LIVES/HABITE: Toronto TRAINING/FORMATION: Academy of Fine Arts, Zagreb; Academy of Fine Arts, Rome AWARDS & HONOURS/PRIX & HONNEURS: Second Prize, La Mostra d'Arte di Lazio, Rome, 1952; Prize of the Mayor of Rome, 1958/Deuxième Prix, La Mostra d'Arte di Lazio, Rome, 1952; Prix du Maire de Rome, 1958 TEACHES/ENSEIGNE: Central Technical School, Toronto MEDIUM: Bronze.

EX—1: Gallery Moos, Toronto (14 IV—4 V 73); The New Bertha Schaefer Gallery, New York.

GROUP/GROUPE: Rodman Hall Arts Centre, St. Catharines, Ont. (1973); "Sculptors Society of Canada" Scarborough College, Toronto (5 XI—27 XI 72); "Sculptors Society of Canada" Toronto-Dominion Centre, Toronto (15 X—3 XI 72).

ANNE FINES (MRS. C. WELCH) (Painting, drawing, printmaking/Peinture, dessin, gravure) 1946, Toronto LIVES/HABITE: Scarborough, Ont. TRAINING/FORMATION: Art School of the Society of Arts and Crafts, Detroit AWARDS & HONOURS/PRIX & HONNEURS: Canada Council Grant, 1968, 1969; J.C. Teron Award, painting, 1970/Bourse du Conseil des Arts du Canada, 1968, 1969; Prix J.G. Teron, peinture, 1970 MEDIUM: Oil, lithography, gouache, pastel, charcoal, pencil/Huile, lithographie, gouache, pastel, fusain, crayon

EX—1: J. Walter Thompson Company Ltd., Toronto (13 VII—11 IX 72)

EX—4: with/avec **IAN GARRIOCH, JOHN MACKILLOP, E.C. BECK,** Merton Gallery, Toronto (30 X—10 XI 72)

*** See colour section/ Voir section couleur**

1 FIELDING *Altar, 1970*

2 FILIPOVIC *Nocturne, 1972 (70" x 24")*

3 FINES *The Conversation, 1972 (5 1/6" x 6 1/2")*

4 FIELD *Blue Cube and Spirit White, 1972 (20" x 26")*

KEN FINLAYSON (Sculpture, printmaking/ Sculpture, gravure) LIVES/HABITE: Toronto TRAINING/FORMATION: Ontario College of Art, Toronto MEDIUM: Mixed media, collage/Multi-média, collage.

EX–1: "You Give Yourself Away with Everything You Say" Gallery 76, Ontario College of Art, Toronto (1 II–11 II 73) GROUP/ GROUPE: "Information and Perception" Gallery 76, Ontario College of Art, Toronto (24 III–23 IV 73).

GIUSEPPE FIORE (Peinture, sculpture, gravure/Painting, sculpture, printmaking) 1931, Mola di Bari, Italie HABITE/LIVES: Mille Iles, Comté d'Argenteuil, Qué. FORMATION/ TRAINING: Liceo Artistico et Accademia di Belle Arti, Napoli; Univ Napoli, Italie; Ecole des Beaux-Arts, Montréal; Institut de l'Environnement, Paris PRIX & HONNEURS/ AWARDS & HONOURS: Bourses du Conseil des Arts du Canada, 1968, 1972; Prix de la S.P.E.Q., 1968; Prix de l'U.Q.A.M., 1971; Prix du Gouvernement du Québec/Canada Council Awards, 1968, 1972; Prize from the S.P.E.Q., 1968; Prize from the U.Q.A.M., 1971; Quebec Government Prize MEDIUM: Acrylique, bois laqué, plexiglas, lithographie/ Acrylic, lacquered wood, plexiglas, lithography.

EX–4: Galerie de l'Université de Québec, Montréal (nov/Nov 72).

GROUPE/GROUP: "Graphisme" Bibliothèque Centrale de Prêt, Alma, Qué.; "Neuvième Biennale de Menton", France (juil/ Jul 72); Centre Artistique de Rencontres Internationales, Nice, France (juin/June 72).

BRIAN FISHER (Painting, printmaking, drawing/Peinture, gravure, dessin) 1939 LIVES/HABITE: Vancouver TRAINING/ FORMATION: Regina School of Art; Vancouver School of Art; L'Accademia di Belle Arti, Rome AWARDS & HONOURS/PRIX & HONNEURS: Italian Government Scholarship; Canada Council Junior Fellowship, 1962; Purchase Award, "Young B.C. Painters" Victoria, 1966; Major Award, "Perspective '67"/Bourse du Gouvernement Italien; Bourse de travail du Conseil des Arts du Canada, 1962; Prix d'Achat, "Young B.C. Painters" Victoria, 1966; Prix majeur, "Perspective '67" MEDIUM: Acrylic, serigraphy, ink/Acrylique, sérigraphie, encre.

EX–1: Bau-XI Gallery, Vancouver (5 XII– 23 XII 72).

GROUP/GROUPE: "Prints by Painters of B.C."; "Works on Paper" Marlborough-Godard Gallery, Toronto (13 IX–30 IX 72).
*** See colour section/ Voir section couleur**

ROBERT FONES (Printmaking, sculpture/ Gravure, sculpture) 1949 LIVES/HABITE: London, Ont. MEDIUM: Wood, steel, painted plywood, wire mesh, wooden cones/ Acier, contre-plaqué, bois, treillis de fils de fer, cônes de bois.

EX–3: with/avec **IAN CARR-HARRIS, COLETTE WHITEN,** Carmen Lamanna Gallery, Toronto (16 IX–5 X 72).
GROUPE/GROUP: Carmen Lamanna Gallery, Toronto (11 VIII–14 IX 72).

1

2

3

1 FONES *Cone Trap, 1972 (7 1/2" diam. x 16 1/2")* Photo: Rick Porter for Carmen Lamanna Gallery, Toronto

2 FINLAYSON Photo: Gallery 76, Ontario College of Art, Toronto

3 FIORE *Sculptures-Jeu, 1972*

1

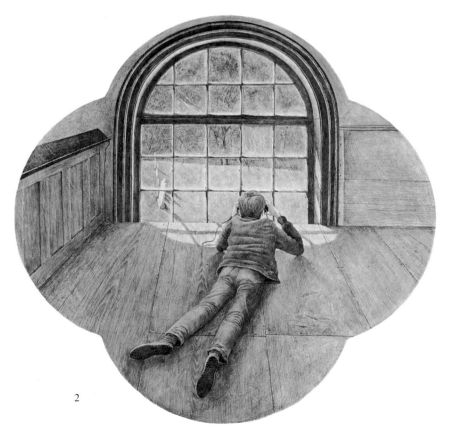

2

MICHEL ALAIN FORGUES (Peinture/Painting) 1945, Lauzon, Qué. HABITE/LIVES: Ste-Ursule, Qué. FORMATION/TRAINING: Institut des Arts Appliqués, Montréal; Sheridan School of Design, Port Credit, Ont. MEDIUM: Collage, acrylique/Collage, acrylic.

EX–1: La Caisse Populaire Laurier, Ste-Foy, Qué. (25 I–13 II 73). GROUPE/GROUP: La Société des Artisans, Montréal (3 VI– 10 VI 72); Musée du Québec (24 I–4 II 73).

THOMAS DE VANY FORRESTALL (Painting, sculpture, drawing/Peinture, sculpture, dessin) 1936, Middleton, Nova Scotia LIVES/ HABITE: Dartmouth, Nova Scotia TRAINING/ FORMATION: Mount Allison Univ, Sackville, N.B.; Univ New Brunswick, Fredericton, N.B. AWARDS & HONOURS/PRIX & HONNEURS: Canada Council Travel Grant, 1958/Bourse de voyage du Conseil des Arts du Canada, 1958 MEDIUM: Watercolour, welded steel, acrylic, egg tempera/Aquarelle, acier soudé, acrylique, détrempe à l'oeuf.

EX–1: Organized by/organisée par Beaverbrook Art Gallery, Fredericton, N.B. CIRCULATING/ITINERANTE: Art Gallery of Windsor, Windsor, Ont. (20 V–5 VI 72); Musée des Beaux-Arts de Montréal (1 VII– 31 VII 72); Winnipeg Art Gallery (15 VIII– 15 IX 72).

EX–1: Canadian Cultural Centre, Paris (Nov/nov 72); New Brunswick Museum (Nov/nov 72–Mar/mars 73); Galleries 3, Dartmouth, N.S. (Spring/printemps 73).

GROUP/GROUPE: "Artists of the Province" Cassel Galleries, Fredericton, N.B. (Oct/oct– Nov/nov 72); "New Brunswick Artists" Cassel Galleries, Fredericton, N.B. (13 II–17 III 73); "Diversity"; "Art for All"; "Annual Exhibition of Contemporary Canadian Art"; "December Choice" Morrison Gallery, Toronto (Dec/déc 72); "Artists Choice" Roberts Gallery, Toronto (24 I–3 II 73).

JACQUELINE MARCOUX-FORTIN (Peinture/Painting) 1911, Thetford Mines, Qué. HABITE/LIVES: Beloeil, Qué. MEDIUM: Huile, aquarelle/Oil, watercolour EX–1: "Impressions fééeriques de la mer" Centre Culturel de Beloeil, Qué. (14 IX–17 IX 72)

1 FORRESTALL *Day Off*, 1973

2 FORRESTALL *The Watcher, 1970 (30 3/4" x 30 3/4")*

3 FORTIN *Impressions fééeriques de la mer, 1972* Photo: S.A.P.Q.

3

VELMA FOSTER (Printmaking/Gravure) LIVES/HABITE: Calgary TRAINING/FORMATION: Alberta College of Art, Calgary; Emma Lake, Saskatchewan; Univ Calgary AWARDS & HONOURS/PRIX & HONNEURS: Canada Council Grants/Bourses du Conseil des Arts du Canada TEACHES/ENSEIGNE: Alberta College of Art, Calgary MEDIUM: Silkscreen, etching/Sérigraphie, eau-forte.

EX–2: with/avec **JIM DOW**, Univ Alberta Art Gallery and Museum, Edmonton (9 IV–4 V 73)

GROUP/GROUPE: "Grafik"; "International Graphics"; "West '71"; "8 Canadian Printmakers"; "Alberta Contemporary Drawings".

MARIE-NOELLE DE LA FOUCHARDIERE (Peinture, tapisseries/Painting, hangings) 1946 HABITE/LIVES: Montréal FORMATION/TRAINING: Ecole des Arts Appliqués, Paris EX–1: Centre Communautaire de L'Ile des Soeurs, Montréal (4 XI–5 XI 72) GROUPE/GROUP: "Les Moins de 35"; L'Ecole Vincent d'Indy, Montréal (16 II–16 III 73).

1 FOSTER *Mirror, Mirror, 1967*
Photo: Edmonton Journal

2 FOULGER *Blackloam, 1972*

3 DE LA FOUCHARDIERE *Le Bélier, 1971*

RICHARD FOULGER (Printmaking/Gravure) 1949, Kamloops, B.C. LIVES/HABITE: Kamloops TRAINING/FORMATION: Alberta College of Art, Calgary; Vancouver School of Art MEDIUM: Serigraphy/Sérigraphie.

GROUP/GROUPE: Burnaby Art Gallery (4 IV–29 IV 73); Danish Art Gallery, Vancouver (1972); "Canadian Printmakers Showcase '72"; "International Graphics"; "Canadian Society of Painter-Etchers and Engravers Exhibition".

4 FORGUES *Sans titre, 1972 (12" x 12")*

5 FORGUES *Sans titre, 1972 (12" x 12")*

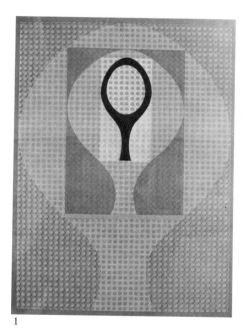

1

2

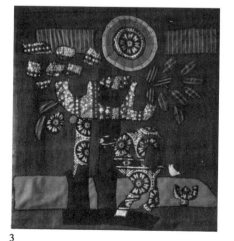

3

4

5

1 FOURNELLE *Pièce machinée, 1966*

2 FRANCIS *Mexico, 1973*

3 FRANKLIN *2 White Forms, 1973*

4 FRANKLIN *3 Red Forms, 1973*

5 FRANKLIN *3 White Forms, 1973*

6 FOURNELLE *L'Oeuf, 1967 (40" x 70")*

ANDRE FOURNELLE 1939, Montréal HABITE/LIVES: Pierrefonds, Qué. FORMATION/TRAINING: Ecole des Beaux-Arts de Montréal; Ecole Technique de Montréal; Institut des Arts Appliqués, Montréal MEDIUM: Plexiglas, acier peint et chromé, bronze rouge, cuivre/Plexiglass, painted and chromed steel, red bronze, copper GROUPE/GROUP: "Les Moins de 35".

BRITTON M. FRANCIS (Painting/Peinture) 1947 LIVES/HABITE: Kamloops, B.C. TRAINING/FORMATION: Alberta College of Art; Instituto Allende, San Miguel de Allende, Mexico MEDIUM: Acrylic, polymer, watercolour, graphite/Acrylique, polymère, aquarelle, mine de plomb EX–1: Canadian Art Galleries, Calgary (14 II–28 II 73).

HANNAH FRANKLIN (Sculpture) 1937, Poland LIVES/HABITE: Westmount, Que. TRAINING/FORMATION: Montreal Museum of Fine Arts AWARDS & HONOURS/PRIX & HONNEURS: Canada Council Materials Grant, 1969; First Prize, Sculpture, Hadassah Exhibition, 1970, 1972/Prix d'achat de matériel, Conseil des Arts du Canada, 1969; Premier Prix, Sculpture, Exposition Hadassah, 1970, 1972 MEDIUM: Plexiglas, vinyl, plastic/Plexiglas, vinyle, plastique.

EX–3: "Canada Banners" with/avec **SHIRLEY RAPHAEL, ROBERT VENOR,** Saidye Bronfman Centre, Montréal (12 III–2 IV 73).

GROUP/GROUPE: "Operation Multiple" Galerie Espace, Montréal (31 V–30 IX 72); Studio 23 Galerie, St-Sauveur-des-Monts, Qué. (17 VI–8 VII 72); "Estival '72" Galerie Espace (31 V–30 IX 72).

ERIC FREIFELD (Painting, drawing/Peinture, dessin) 1919, Saratov, Russia LIVES/HABITE: Toronto TRAINING/FORMATION: Banff School of Fine Arts, Banff, Alta.; St. Martins School of Art, London, Eng.; Art Students' League, New York AWARDS & HONOURS/PRIX & HONNEURS: Carnegie Trust Fund Scholarship, 1937; Alberta Society of Artists Award, 1937; Queen's Univ Travelling Fellowship, 1941; C.W. Jeffries Award, 1957; Canada Council Senior Arts Grants, 1961, 1971; Canada Council Travel Grant, 1968/Bourse du Carnegie Trust Fund, 1937; Prix de l'Alberta Society of Artists, 1937; Bourse de voyage Queen's Univ, 1941; Prix C.W. Jeffries, 1957; Bourses de travail libre du Conseil des Arts du Canada, 1961, 1971; Bourse de Voyage du Conseil des Arts du Canada, 1968 TEACHES/ENSEIGNE: Ontario College of Art, Toronto; Vancouver School of Art MEDIUM: Watercolour, carbon pencil, chalk/Aquarelle, mine de carbone, craie.

EX—1: "Eric Freifeld" CIRCULATING/ITINE-RANTE: New Brunswick Museum, St. John, N.B. (June/juin 72); Gander International Airport, Gander, Nfld. (Aug/août 72); Memorial Univ, St. John's, Nfld. (Sept/sept 72); Confederation Centre, Charlottetown (Oct/oct 72); Owens Art Gallery, Mount Allison Univ, Sackville, N.B. (Nov/nov 72).

EX—1: Morris Gallery, Toronto (11 XI—25 XI 72).

1

GROUP/GROUPE: "Annual Exhibition of Contemporary Canadian Art".

JOAN FRICK (Painting, drawing/Peinture, dessin) 1942, Toronto LIVES/HABITE: Toronto TRAINING/FORMATION: Ecole des Beaux-Arts de Montréal AWARDS & HONOURS/PRIX & HONNEURS: Canada Council Project Costs Grant/Bourse de frais du Conseil des Arts du Canada MEDIUM: Oil, graphite, prismacolour/Huile, mine de plomb, couleur prismatique.

EX—1: Aggregation Gallery, Toronto (21 IV—10 V 73).

GROUP/GROUPE: "SCAN"; "Christmas Show" Aggregation Gallery, Toronto; "Inaugural Exhibition" Aggregation Gallery, Toronto; "Kingston Spring Exhibition"; "National Home Show"; Art Gallery of Ontario, Toronto.

GILL FUROY (Painting, printmaking/Peinture, gravure) 1951 LIVES/HABITE: Toronto TRAINING/FORMATION: Ontario College of Art, Toronto MEDIUM: Oil, acrylic, watercolour, etching, steel, 3-D canvas/Huile, acrylique, aquarelle, eau-forte, acier, toile tridimensionnelle.

EX—2: "The Greatest Show on Earth" with/avec **RON VAN LEEUWEN**, Sarnia Public Library and Art Gallery, Sarnia, Ont. (26 V—26 VI 72).

GROUP/GROUPE: "Ontario Society of Artists 101st Annual Exhibition".

1 FUROY *Shin kickin'*, 1971

2 FREIFELD *Pauline, 1966*

3 FRICK *Blood Manoeuvre II, 1973* *(66" x 84")*

4 FREIFELD *San Drawing, 1949*

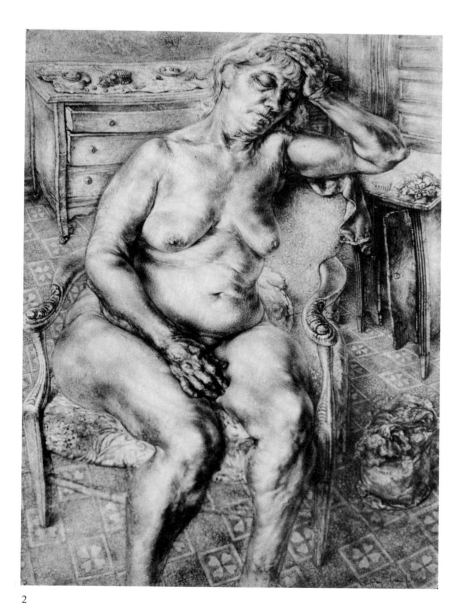

2

3

4

1

YVON GAGNER (Peinture/Painting) 1946, Montréal HABITE/LIVES: Montréal FORMATION/TRAINING: Institut des Arts Appliqués, Montréal; CEGEP du Vieux-Montréal; Univ Québec, Montréal MEDIUM: Huile/Oil.

EX—1: Centre Culturel Pierre Vanier, Chateauguay, Qué. (4 II—16 II 73).

GROUPE/GROUP: "Exposition des Etudiants de l'U.Q.A.M." Plaza Alexis Nihon, Montréal; "Les Moins de 35"; "Grand Prix de Paris" Académie Raymond Duncan, Paris; Ligoa Duncan Gallery, New York (juin/June 72).

JEAN GALT (Painting/Peinture) 1928 LIVES/HABITE: Toronto TRAINING/FORMATION: Central Technical School, Toronto; Univ Toronto MEDIUM: Oil/Huile.

EX—1: Johnston Hall, Univ Guelph, Ont. (30 III—27 IV 73) GROUP/GROUPE: "Society of Canadian Artists Show" Shaw Rimmington Gallery, Toronto (Feb/fév 73).

IAN GARRIOCH 1936 LIVES/HABITE: Nanaimo, B.C. TRAINING/FORMATION: Univ Washington, Seattle, Wash. MEDIUM: Acrylic, lithography/Acrylique, lithographie.

EX—1: "Plexiglas Boxes and Acrylics" Gordon Galleries, Prince George, B.C. (Feb/févr 73); Zan Art Gallery, Victoria (17 V—18 VI 73).

EX—4: with/avec **EUGENE BECK, ANNE FINES, JOHN MACKILLOP**, Merton Gallery, Toronto (30 X—10 XI 72).

GROUP/GROUPE: "SCAN"; Nanaimo Museum, Nanaimo, B.C. (Nov/nov 72).

CARMEL GASCON (Peinture, tapisseries/ Painting, hangings) 1924, Shawinigan, Qué. HABITE/LIVES: Trois-Rivières, Qué. MEDIUM: Acrylique, laine/Acrylic, wool.

EX—1: Centre Culturel de Valcourt, Valcourt, Qué. (8 V—31 V 73).

EX—4: avec/with: **R. NORMANDIN, N. BRODBECK, J. LACROIX**, Galerie du Parc, Trois-Rivières, Qué. (9 II—20 II 72).

GROUPE/GROUP: "Images de la Mauricie".

2

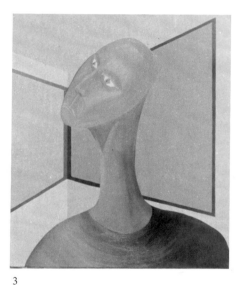

3

1 GARRIOCH *Atlas Seal (20" x 20")*

2 GASCON *Je m'invente et me crée (65" x 43")*

3 GAGNER *Le Professeur*

4 GALT *Winter Berries (16" x 20")*

4

SUZANNE GAUTHIER (Gravure/Print-making) 1950, Matane, Qué. HABITE/LIVES: Montréal FORMATION/TRAINING: CEGEP du Vieux-Montréal; Univ Québec, Montréal MEDIUM: Eau-forte/Etching GROUPE/GROUP: "Salon des Métiers d'Art"; "Les Moins de 35".

2

1

DENNIS GEDEN (Painting, printmaking/Peinture, gravure) 1944, North Bay, Ont. LIVES/HABITE: North Bay, Ont. TRAINING/FORMATION: Sir George Williams Univ, Montréal AWARDS & HONOURS/PRIX & HONNEURS: Canada Council Grant/Bourse du Conseil des Arts du Canada MEDIUM: Oil, watercolour, lithography/Huile, aquarelle, lithographie GROUP/GROUPE: La Cimaise Gallery, Toronto (14 IV—10 V 73).

GENERAL IDEA (Conceptual/Conceptuel) LIVES/HABITE: Toronto MEDIUM: Mixed media/Multi-média.

EX—3: with/avec **J. HEWARD, B. GOODWIN**, Galerie B, Montréal (Apr/avril 73).

GROUP/GROUPE: "Realism: Emulsion & Omission"; Carmen Lamanna Gallery, Toronto (11 VIII—14 IX 72).

LUBA GENUSH (Peinture, dessin, gravure/Painting, drawing, printmaking) 1924 HABITE/LIVES: Montréal FORMATION/TRAINING: School of Fine Arts, Kiev, U.S.S.R.; Academy of Fine Arts, Vienna, Austria; Ecole du Meuble, Montréal; Musée des Beaux-Arts, Montréal MEDIUM: Sérigraphie, aluminium relief, eau-forte/Silk-screen, aluminum relief, etching.

GROUPE/GROUP: "International Graphics"; "Quatrième Biennale Internationale de la Gravure" Cracovie, Pologne; "Canadian Contemporary Exhibition of Painting and Sculpture" T. Eaton Co. Ltée., Montréal; "Association des Graveurs du Québec à l'Etable" Musée des Beaux-Arts, Montréal; "56th Annual Exhibition" Canadian Society of Painter-Etchers and Engravers; "3rd British International Print Biennale" Bradford, Eng.; Bureau du Premier Ministre, Québec; "Salon des Métiers d'Art"; "Troisième Biennale Internationale de l'Estampe" Paris; "Exhibition of Ukrainian Graphic Artists" Univ Montréal.

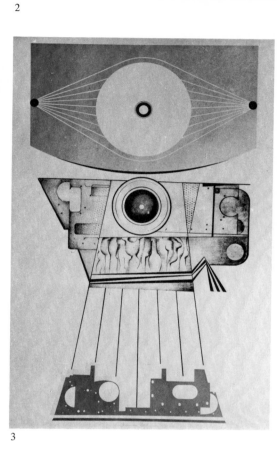

3

4

5

1 GAUTHIER *Le Nord-Est, 1972*

2 GENERAL IDEA *Financial Wipeout*

3 GENUSH *Le Troisième Oeil, 1972*

4 GENUSH *Machine, 1970*

5 GEDEN *Forest Ranger*

1 GERSOVITZ *Chocolate Box for a Cannibal*

2 GERSOVITZ *Silk and Wood II*

SARAH GERSOVITZ (Printmaking, painting/ Gravure, peinture) LIVES/HABITE: Montreal TRAINING/FORMATION: Museum of Fine Arts, Montreal AWARDS & HONOURS/PRIX & HONNEURS: Award, Seagram's Fine Art Exhibition, Montreal; Anaconda Award, Canadian Society of Painter-Etchers and Engravers; Graphic Art Award, First Winnipeg Biennial Show/Prix, Exposition des Beaux-Arts Seagram, Montréal; Prix Anaconda, Canadian Society of Painter-Etchers and Engravers; Prix d'Art Graphique, Première Exposition Biennale de Winnipeg MEDIUM: Silkscreen, metal prints/ Sérigraphie, estampe.

EX–1: Alice Peck Gallery, Burlington, Ont. (Sept/sept 72).

GROUP/GROUPE: "Graphex 1"; "Canadian Printmakers Showcase"; "Kingston Spring Show"; "International Graphics"; "Hadassah Show" Montréal; "Canadian Society of Graphic Art" McIntosh Gallery, Univ Western Ontario, London; "Ontario Society of Artists" National Gallery, Ottawa (June/juin 72); "IBIZAGRAPHIC" Spain/Espagne (June/ juin–Nov/nov 72); "Instructors' Exhibition" Saidye Bronfman Centre, Montréal (Sept/ sept 72); "Association des Graveurs du Québec à l'Etable" Museum of Fine Arts, Montréal (Oct/oct 72); Thomas More Institute, Montréal (Nov/nov 72); National Council of Jewish Women, Ottawa (Apr/avril 73); "International Play Group Exhibition" New York (May/mai 73).

ROBERT GERVAIS (Peinture/Painting) 1943, Jonquière, Qué. HABITE/LIVES: Laval, Qué. MEDIUM: Acrylique/Acrylic EX–1: Les Editions du Jour, Montréal (11 I–30 I 73) GROUPE/GROUP: "Les Moins de 35".

DAVID GILHOOLY (Ceramics/Céramique) 1943, Auburn, California LIVES/HABITE: Aurora, Ont. TRAINING/FORMATION: Univ California TEACHES/ENSEIGNE: York Univ, Toronto MEDIUM: Earthenware/ Faïence.

EX–1: "Gifts from the Frog World" CIRCULATING/ITINERANTE: York Univ, Toronto (20 XI–8 XII 72); Robert McLaughlin Gallery, Oshawa, Ont. (12 XII 72–14 I 73); Univ Waterloo, Waterloo, Ont. (17 I–31 I 73).

EX–1: "Souvenirs from the Frog World" CIRCULATING/ITINERANTE: Manolides Gallery, Seattle, Washington (Feb/févr 73); Beckett Gallery, Hamilton, Ont. (Mar/mars 73).

GROUP/GROUPE: "Realism: Emulsion & Omission"; "Image Bank Postcard Show 1971-1974"; "Ceramic Objects"; "International Academy of Ceramics" Victoria & Albert Museum, London, Eng.; Norman MacKenzie Gallery, Regina, Sask.; "Supra Crafts Show 1973-1974" Oakland Museum, Oakland, Calif.; "Joseph Monsen Collection" San Francisco Museum of Art (Oct/oct–Dec/déc 72); "20th Century Bestiary" San Jose State Univ, San Jose, Calif. (Nov/nov 72); "Nut Art" California State College, Hayward, Calif. (Dec/déc 72); "Cup Show" David Stuart Galleries, Los Angeles, Calif. (Dec/déc 72).

1

2

3

4

5

CLAUDE GIRARD (Peinture, conceptuel/
Painting, conceptual) 1938, Chicoutimi, Qué.
HABITE/LIVES: Montréal FORMATION/
TRAINING: Ecole des Beaux-Arts, Québec;
Académie des Beaux-Arts, Venise, Italie ME-
DIUM: Huile, acrylique, acier inoxydable,
éclairage/Oil, acrylic, stainless steel, lighting.

EX–1: Galerie L'Apogée, St-Sauveur-des-Monts,
Qué. (26 V–21 VI 72).

GROUPE/GROUP: "Art 3" Bâle, Suisse.

SUZANNE R. GIRARD (Gravure/Print-
making) 1936, Montréal HABITE/LIVES:
Montréal FORMATION/TRAINING: Ecole
des Beaux-Arts de Montréal; Univ Québec,
Montréal MEDIUM: Relief, eau-forte, séri-
graphie, lithographie/Relief, etching, seri-
graphy, lithography.

GROUPE/GROUP: "De Rêves et d'Encre
Douce"; La Librairie du Centre, Centre
National des Arts, Ottawa (1972).

1 GILHOOLY *The Honey Sisters Doing a
 Garden Blessing, 1972 (26" x 33" x 12")*

2 GILHOOLY *The Miracle of Compost
 Vegebarrow, 1973 (36" x 19" x 33")*

3 GERVAIS *Optique (24" x 30")*

4 S. GIRARD

5 C. GIRARD *Fields, 1970 (40" x 48")*

1

ELEANOR R. GOLFMAN (Painting, print-making, drawing/Peinture, gravure, dessin) LIVES/HABITE: Winnipeg TRAINING/FOR-MATION: Univ Minnesota; Univ Manitoba MEDIUM: Acrylic, lithography, ink/Acrylique, lithographie, encre GROUP/GROUPE: "Second Sun Centre Art Show" Centennial Concert Hall, Winnipeg (Summer/été 72).

BETTY GOODWIN (Printmaking/Gravure) 1923 LIVES/HABITE: Ste-Adèle, Que. TRAINING/FORMATION: Sir George Williams Univ, Montreal MEDIUM: Etching, collage/Eau-forte, collage.

EX–1: Galerie B, Montreal (15 X–15 XI 72).

EX–3: with/avec K. ELOUL, R. LETENDRE, Bau-XI Gallery, Vancouver (28 VIII–9 IX 72).

GROUP/GROUPE: "International Graphics"; "Third British International Print Biennale" Bradford, Eng. (7 VII–30 IX 72).

JAMES GORDANEER (Drawing, painting/ Dessin, peinture) LIVES/HABITE: Orange-ville, Ont.

EX–1: Gadatsy Gallery, Toronto (27 I–15 II 73); Merton Gallery, Toronto (30 IV–18 V 73).

EX–4: with/avec ROBERT ANDERSON, TOM HODGSON, JOHN HENRY MARTIN, Merton Gallery, Toronto (6 XII–30 XII 72).

GROUP/GROUPE: "Kingston Spring Exhibition"

TOM GRAFF (Conceptual/Conceptuel) LIVES/HABITE: Vancouver MEDIUM: Mixed media/Multi-média GROUP/ GROUPE: "SCAN"; "Theatre Arts Works".

3

4

2

1 GOODWIN *Shirt Three*
Photo: Galerie B, Montréal

2 GOLFMAN *Involvement-Evolvement No. 9, 1970 (30" x 54")*

3 GORDANEER *Untitled, 1973*
Photo: Merton Gallery, Toronto

4 GRAFF *Ode to Jack Chambers, Detail, 1971*

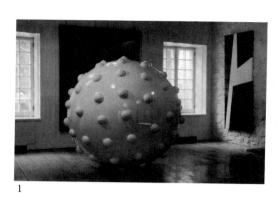
1

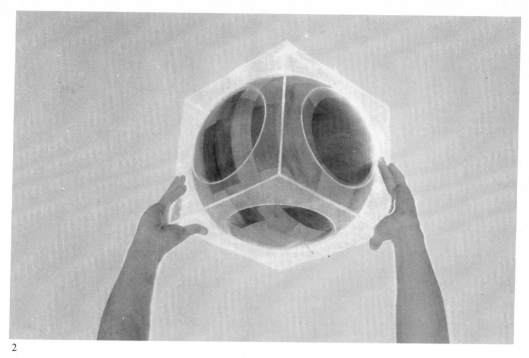
2

PIERRE GRANCHE (Sculpture) 1948, Montréal HABITE/LIVES: Montréal FORMATION/TRAINING: Ecole des Beaux-Arts de Montréal PRIX & HONNEURS/AWARDS & HONOURS: Bourse du Conseil des Arts du Canada, 1972/Canada Council Grant, 1972 MEDIUM: Polyester, bois, acrylique, aluminium/Polyester, wood, acrylic, aluminum.

EX—3: "Interrelation Sphère et Cube" avec/with **B. SCHIELE**, **M. TREMBLAY-GILLON**, La Maison des Arts La Sauvegarde, Montréal (26 V—26 VI 72).

GROUPE/GROUP: "Les Moins de 35"; "Formoptic".

FRANCINE GRAVEL (Gravure, peinture/Printmaking, painting) 1944 HABITE/LIVES: Calgary FORMATION/TRAINING: Ecole des Beaux-Arts de Montréal; Haut Institut des Beaux-Arts d'Avers, Belgique; Univ Calgary MEDIUM: Eau-forte, gravure/Etching, engraving.

GROUPE/GROUP: Galerie Paris, Montréal (21 V—8 VI 72); "Square des Arts" Montréal (été/Summer 72); Planetarium of Calgary, Calgary (14 X—16 X 72); Art College of Alberta, Edmonton (oct/Oct 72); Society of Canadian Painter-Etchers and Engravers (1 XI—29 XI 72); Graphic 8 Galleries, Calgary (5 XII—30 XII 72); Continuing Art Association, Calgary (janv/Jan 73); Maison des Arts La Sauvegarde, Montréal (6 I—5 II 73).

BARBARA GREEN (Painting/Peinture) 1927, Hamilton, Ont. LIVES/HABITE: Toronto TRAINING/FORMATION: Central Technical School, Toronto; Ontario College of Art, Toronto MEDIUM: Watercolour/Aquarelle GROUP/GROUPE: "Painters in Watercolour".

GARY GREENWOOD (Painting, printmaking, conceptual/Peinture, gravure, conceptuel) 1946, Toronto LIVES/HABITE: Toronto TRAINING/FORMATION: Ryerson Polytechnical Institute, Toronto AWARDS & HONOURS/PRIX & HONNEURS: Canada Council Grant, 1973/Bourse du Conseil des Arts du Canada, 1973 MEDIUM: Plexiglas, lights, photo-silkscreen, acrylic/Plexiglas, lampes, sérigraphie photographique, acrylique.

EX—1: A Space Gallery, Toronto (3 IV—5 IV 73).

3

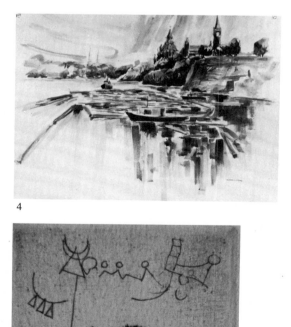
4

5

1 GRANCHE *Sphère 80, 1972*

2 GRANCHE *Sphère Cube, 1972*

3 GREENWOOD *Beacons Looking West, 1972*
(4 pcs.: 20" x 30")

4 GREEN *Parliament Buildings from the River, 1970*

5 GRAVEL *Méditation, 1972*

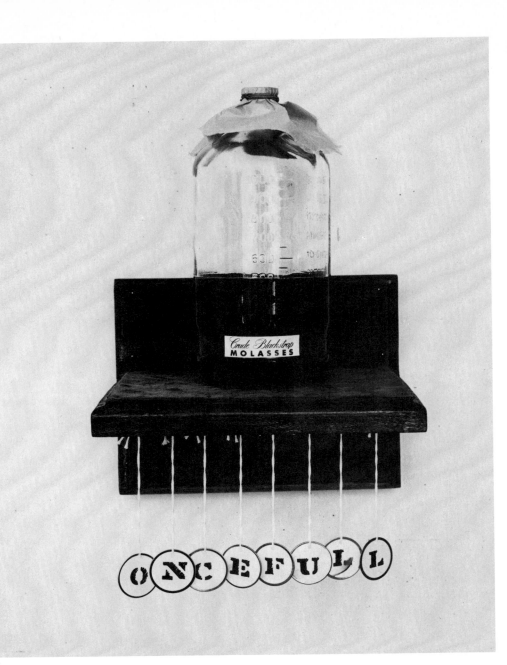

1

JOHN GREER (Conceptual/Conceptuel)
1944, Amherst, N.S. LIVES/HABITE:
Joggins, N.S. TRAINING/FORMATION:
Nova Scotia College of Art and Design,
Halifax; Montreal Museum of Fine Arts;
Vancouver School of Art AWARDS &
HONOURS/PRIX & HONNEURS: Canada
Council Grants, 1968, 1969, 1972/Bourses
du Conseil des Arts du Canada, 1968, 1969,
1972 MEDIUM: Constructions, photo-
graphs/Constructions, photographies.

EX−1: "Somethings" Anna Leonowens
Gallery, Halifax (25 V−8 VI 72); Isaacs
Gallery, Toronto (14 II−28 II 73).

GROUP/GROUPE: "Morbus" Dalhousie
Univ Art Gallery, Dalhousie, N.S. (3 IV−
22 IV 73).

HELEN FRANCES GREGOR (Hangings/
Tapisseries) 1921, Prague, Czechoslovakia
LIVES/HABITE: Toronto TRAINING/FOR-
MATION: Royal College of Art, London, Eng.;
School of American Craftsmen, Rochester,
N.Y. AWARDS & HONOURS/PRIX & HON-
NEURS: Canada Council Grants/Bourses du
Conseil des Arts du Canada MEDIUM:
Textile, tapestry/Textile, tapisserie.

EX−1: "Tapestry" Art Gallery of the
Kitchener Public Library, Kitchener, Ont.
(2 II−23 II 73).

GROUP/GROUPE: Ontario Scoiety of
Artists "100 Years Retrospective" (Sept/sept
72); Ontario Society of Artists "101st Open
Exhibition" Hamilton Art Gallery, Hamilton,
Ont. (Feb/févr 73).

1 GREER *Once Full*, 1973 (12" x 9" x 7 1/2")
 Photo: Isaacs Gallery, Toronto

2 GREER *Forty Lashes for Canadian Art*,
 1972 (4 1/2" x 8" x 8") Photo: Isaacs
 Gallery, Toronto

3 GREGOR *Op Horizon No. 5, 1973*

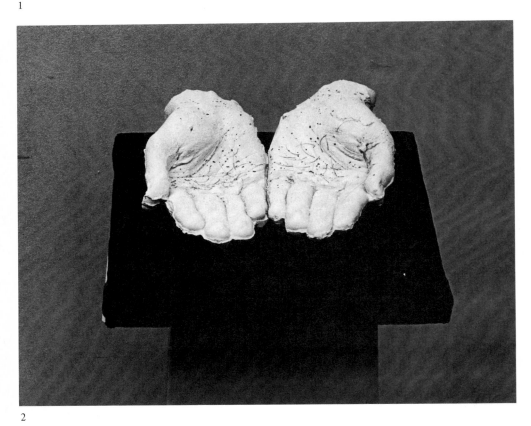

2

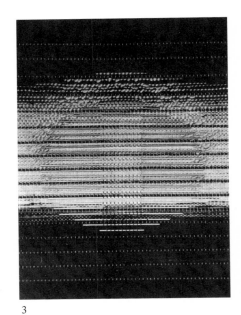

3

HAZEL GRENKIE (Painting, printmaking/ Peinture, gravure) 1916, Zealandia, Sask. LIVES/HABITE: Rosetown, Sask. TRAINING/FORMATION: Univ Saskatchewan, Saskatoon AWARDS & HONOURS/PRIX & HONNEURS: Prize/Prix, Watrous Art Salon, 1972 MEDIUM: Acrylic, relief/Acrylique, relief GROUP/GROUPE: "North Saskatchewan Juried Show"; "A Summer Show".

ANDREE de GROOT (Peinture, dessin, sculpture/Painting, drawing, sculpture) 1908, Bourgogne, France HABITE/LIVES: Outremont, Qué. FORMATION/TRAINING: Univ Wilno, Pologne; Académie Royale, Lille, France; Académie des Beaux-Arts, Montpellier, France; Académie de la Grande Chaumière, Paris MEDIUM: Aquarelle, huile/Watercolour, oil.

EX–1: Centre Communautaire de l'Univ Montréal (24 IX–10 X 72); Caisse Populaire Desjardins, Ste-Thérèse, Qué. (10 XI–10 XII 72).

EX–2: Institut Goethe, Montréal (4 XII– 22 XII 72).

GROUPE/GROUP: The Arts Corner, Montréal; Atwater Library, Montréal; Société des Artistes Professionnels du Québec "Inauguration" (déc/ Dec 72–janv/Jan 73); Galerie Georges Dor, Longueuil, Qué.; "Festival Accord" German House, Québec; Galerie de la S.A.P.Q. (oct/ Oct–nov/Nov 72).

LADISLAV GUDERNA (Painting, printmaking, drawing/Peinture, gravure, dessin) 1921, Nitra, Czechoslovakia LIVES/HABITE: Toronto TRAINING/FORMATION: Academy of Creative Arts, Belgrade, Yugoslavia; Technical Academy, Bratislava, Czechoslovakia MEDIUM: Oil, collage, tempera, charcoal, sepia, ink, pastel/Huile, collage, détrempe, fusain, sépia, encre, pastel.

EX–4: with/avec **W. ANDERSON, J. HOVADIK, SENGGIH**, D & H Gallery, Toronto (27 II–23 III 73).

GROUP/GROUPE: "Society of Canadian Artists 5th Juried Exhibition" Eatons Art Gallery, Toronto (5 X–18 X 72); "New Canadian Art Exhibition" St. Lawrence Centre, Toronto (5 XI–19 XI 72); Saracen Gallery, Brampton, Ont. (31 III–15 IV 73).

GLENN GUILLET (Drawing, sculpture/Dessin, sculpture) 1949, Prince Rupert, B.C. LIVES/HABITE: Edmonton TRAINING/ FORMATION: Univ Alberta MEDIUM: Bronze, polyester, graphite pencil/Bronze, polyester, mine de plomb.

EX–1: "Glenn Guillet" Edmonton Art Gallery, Edmonton (7 I–30 I 73).

1 DE GROOT *R. Deprès*

2 GUILLET *Study of Rock No. 6, 1973*
 Photo: Edmonton Journal

3 GUDERNA *Imaginary Landscape, 1973*

4 GRENKIE *Infinity III, 1972*

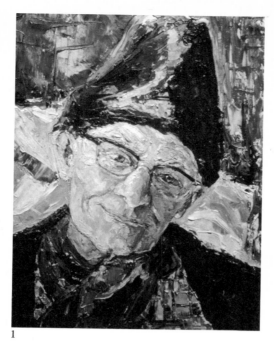

1 B. HALL *Clouds on Toast*

2 B. HALL *Avocado*

3 J. HALL *Pepsi, 1970 (8' x 6')*

4 J. HALL *Runner, 1969 (98" x 68")*

BARBARA B. HALL (Printmaking, conceptual, drawing/Gravure, conceptuel, dessin) 1942, New York LIVES/HABITE: Toronto TRAINING/FORMATION: Art Institute of Chicago; San Francisco Academy of Art TEACHES/ENSEIGNE: Art Gallery of Ontario, Toronto MEDIUM: Etching, silkscreen, assembled objects/Eau-forte, sérigraphie, arrangements d'objets.

GROUP/GROUPE: "SCAN"; "Canadian Printmakers Showcase"; "Graphex I"; "Graphik Biennale" Europahaus, Vienna (1972); Rodman Hall, St. Catharines, Ont. (1973); "XIII Premi Internacional" Dibiux Joan Miró, Barcelona (1973); "Open Studio" Morris Gallery, Toronto (May/mai 73); "New Talent in Printmaking"; Marlborough-Godard Gallery, Montreal (8 VIII–31 VIII 72); "Kingston Spring Exhibition".

JOHN HALL (Painting/Peinture) 1943, Edmonton LIVES/HABITE: Calgary TRAINING/FORMATION: Alberta College of Art; Instituto Allende, San Miguel de Allende, Mexico TEACHES/ENSEIGNE: Univ Calgary MEDIUM: Acrylic, canvas, aluminum, metal/ Acrylique, toile, aluminium, métal.

GROUP/GROUPE: "SCAN"; "Realism: Emulsion & Omission"; "Art of the Provinces" Canadian National Exhibition, Toronto (Aug/ août 72); "Survey Show of Contemporary Alberta Art" Banff School of Fine Arts, Banff, Alta. (Feb/févr 73); "West '71"; "Kingston Spring Show"; "24th Annual Spokane Art Exhibition".

*** See colour section/ Voir section couleur**

1

2

3

4

5

6

JOAN HAMILTON-SMITH (Painting/Peinture) 1925 LIVES/HABITE: Toronto TRAINING/FORMATION: Ontario College of Art, Toronto MEDIUM: Oil, watercolour, acrylic, collage/Huile, aquarelle, acrylique, collage.

GROUP/GROUPE: Kar Gallery, Toronto (5 IX–10 IX 72); Kar Gallery, Toronto (4 XI–15 XII 72).

KATHY TAVES HARDY (Printmaking, ceramics/Gravure, céramique) 1951, Sask. LIVES/HABITE: Meadow Lake, Sask. TRAINING/FORMATION: Univ Saskatchewan, Saskatoon MEDIUM: Etching, clay/Eau-forte, argile.

EX–1: Marquis Gallery, Saskatoon (2 IV–6 IV 73).

GROUP/GROUPE: Norman MacKenzie Art Gallery, Regina (Feb/févr 73); "North Saskatchewan Juried Show" Saskatoon.

MICHAEL HARRIS (Painting/Peinture) 1945, Winnipeg LIVES/HABITE: Winnipeg TRAINING/FORMATION: Univ Manitoba AWARDS & HONOURS/PRIX & HONNEURS: Canada Council Awards, 1972, 1973/Bourses du Conseil des Arts du Canada, 1972, 1973 MEDIUM: Oil, acrylic/Huile, acrylique.

GROUP/GROUPE: "Manitoba Mainstream"; "Winnipeg Under 30"; "Two Nations—Six Artists".

FRED HARRISON (Painting/Peinture) 1947, Toronto LIVES/HABITE: Brome, Que. TRAINING/FORMATION: Ontario College of Art, Toronto MEDIUM: Oil, acrylic/Huile, acrylique GROUP/GROUPE: "Les Moins de 35".

DONALD HARVEY (Painting, printmaking/Peinture, gravure) 1930 LIVES/HABITE: Victoria TRAINING/FORMATION: Worthing College of Art, London, Eng.; Brighton College of Art, Brighton, Eng. MEDIUM: Silkscreen, oil, acrylic/Sérigraphie, huile, acrylique GROUP/GROUPE: Zan Art Gallery, Victoria (18 V–18 VI 73); "Western Canada" Gallery 1640, Montreal (3 III–31 III 73).

1 HAMILTON-SMITH *Past Memory, 1972*

2 HARDY *A Series of Boxes, 1973*

3 HARRIS *Mayday—Man Carrying a Boy, 1971*

4 HARRISON *La Grange d'Alfred Burton*

5 HARDY *Arrow Box No. 1, 1973*

6 HARVEY *Poppy Black, 1973*

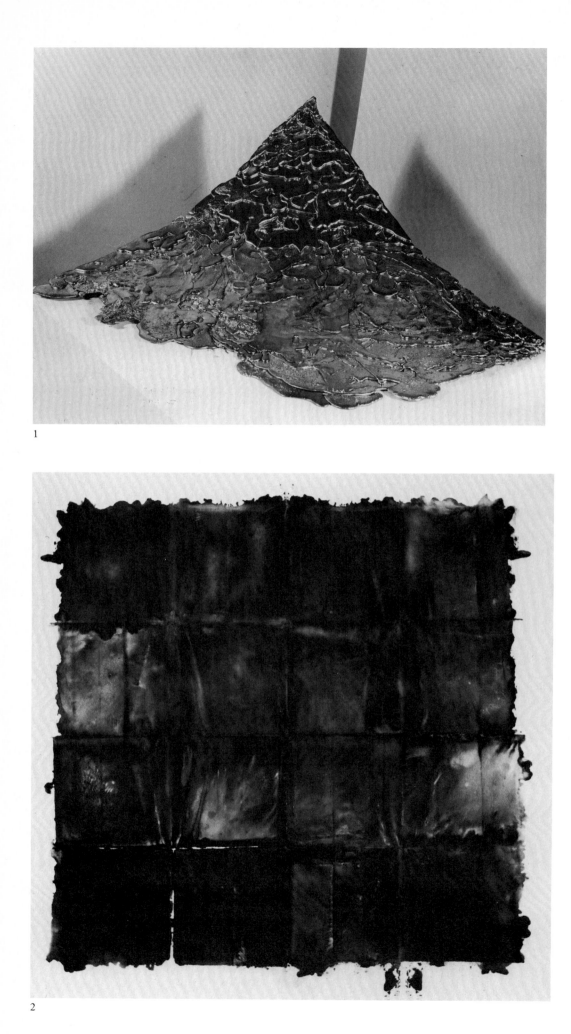

MICHAEL HAYDEN (Conceptual, sculpture/ Conceptuel, sculpture) 1943 LIVES/HA-BITE: Mt. Bridges, Ont. TRAINING/FORMA-TION: Ontario College of Art, Toronto AWARDS & HONOURS/PRIX & HONNEURS: Canada Council Grants, 1966, 1967, 1968, 1970/Bourses du Conseil des Arts du Canada, 1966, 1967, 1968, 1970 MEDIUM: Acrylic, sound system, aluminum, strobe lights, video, plexiglas, etc./Acrylique, équipement sonore, aluminium, lampes stroboscopiques, vidéo, plexiglas, etc.

EX—1: "Kitchener-Waterloo Meets Michael Hayden" CIRCULATING/ITINERANTE: Conestoga College, Kitchener, Ont. (30 XI 72); Kitchener-Waterloo Art Gallery (1 XII—31 XII 72); Kitchener Farmers Market (2 XII 72); St. Jerome High School, Kitchener, Ont. (7 XII 72); Univ Waterloo (7 XII 72); Waterloo Collegiate Institute (8 XII 72).

EX—1: "Corners" Gallery Moos, Toronto (7 X—25 X 72).

GROUP/GROUPE: "SCAN"; "Plastic Fantastic"; "Six Canadian Sculptors" Rodman Hall, St. Catharines, Ont.

CHRIS HAYWARD (Painting/Peinture) 1938, London, Eng. LIVES/HABITE: Dalhousie Station, Qué. TRAINING/FORMATION: Sir George Williams Univ, Montreal AWARDS & HONOURS/PRIX & HONNEURS: Tokyo Universidade Prize, 1967; Canada Council Grants, 1968, 1969, 1971; Alcan Award, 1970/Prix Tokyo Universidade, 1967; Bourses du Conseil des Arts du Canada, 1968, 1969, 1971; Prix Alcan, 1970 TEACHES/ENSEIGNE: Montreal School of Art and Design MEDIUM: Acrylic/Acrylique.

EX—1: "Recent Folded Paintings" Aggregation Gallery, Toronto (23 X—11 XI 72).

GROUP/GROUPE: "SCAN"; "Gallery Artists" Aggregation Gallery, Toronto (24 X—11 XI 72); "Faculty Show" Sir George Williams Univ, Montreal (24 I—18 II 73); Montreal Museum of Fine Arts (Apr/avril 73).

*** See colour section/ Voir section couleur**

1 HAYDEN *Cornered Man, 1972*
 Photo: T.E. Moore for Gallery Moos, Toronto

2 HAYWARD *McVoughty, 1972 (5' x 5')*
 Photo: Aggregation Gallery, Toronto

MARY HECHT (Sculpture) New York, N.Y. LIVES/HABITE: Toronto TRAINING/FORMATION: Univ Cincinnati; Univ Iowa; Art Students League, New York; Columbia Univ; Art Academy of Cincinnati; Camberwell School of Art, London, Eng. MEDIUM: Bronze, wood, stone, aluminum/Bronze, bois, pierre, aluminium.

EX—1: St. Lawrence Centre, Toronto (28 VI 72); Fairfield Univ, Fairfield, Conn. (29 IV– 6 V 73).

EX—2: "Jewish Tradition in Contemporary Art" with/avec **SEYMOUR ROSENTHAL**, The Indianapolis Museum of Art, Indianapolis, Indiana (9 XI–4 XII 72).

GROUP/GROUPE: "The Art of the Dance" O'Keefe Centre, Toronto (14 V–19 V 73).

FRANKLYN HEISLER (Ceramics/Céramique) 1949, Bridgewater, N.S. LIVES/ HABITE: Halifax TRAINING/FORMATION: Nova Scotia College of Art and Design; Univ Saskatchewan AWARDS & HONOURS/ PRIX & HONNEURS: Canada Council Bursary, 1971/Bourse du Conseil des Arts du Canada, 1971.

EX—1: "Clay Works" Anna Leonowens Gallery, Nova Scotia College of Art and Design, Halifax (7 VII–30 VII 72).

MONIQUE HENAUT (Peinture, gravure/ Painting, printmaking) 1933, France HABITE/LIVES: Montréal FORMATION/ TRAINING: Ecole des Beaux-Arts de Montréal; Univ Québec, Montréal ENSEIGNE/ TEACHES: CEGEP du Vieux-Montréal MEDIUM: Acrylique, collage/Acrylic, collage.

EX—1: Studio 23, St-Sauveur-des-Monts, Qué. (20 I–14 II 73).

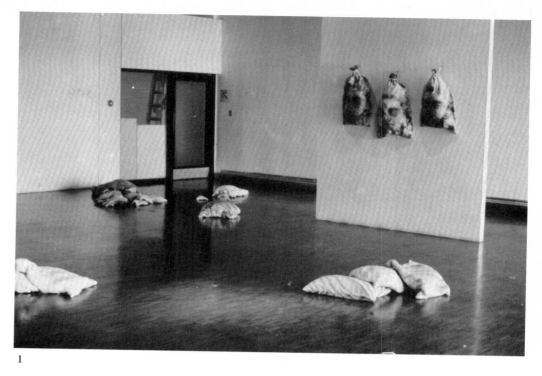

1

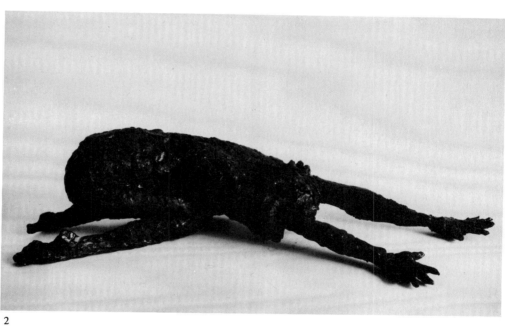

2

3

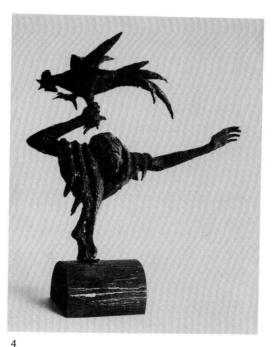

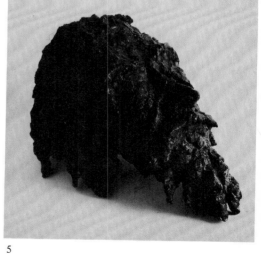

5

1 HEISLER *Installation Shot/Photo de l'exposition, 1972* Photo: Nova Scotia College of Art & Design, Halifax

2 HECHT *Job, 1973 (220")* Photo: John Reeves

3 HENAUT *Venise, 1972*

4 HECHT *The Sacrifice (Homage to Lipschitz), 1973 (24" x 19")* Photo: John Reeves

5 HECHT *Head of John the Baptist, 1973 (7" x 13")* Photo: John Reeves

4

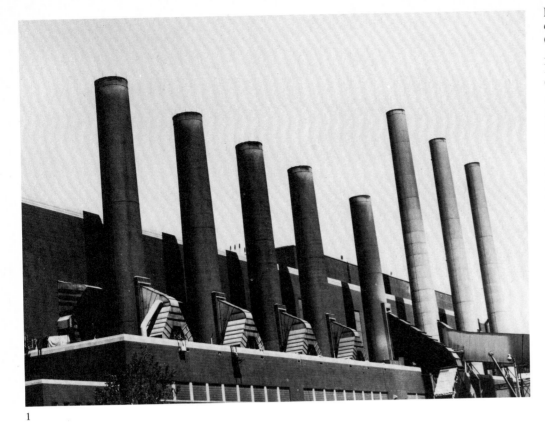

1

2

3

4

1 HENRICKSON *Awakening 4*

2 F. HENRY *1973*

3 F. HENRY *1973*

4 P. HENRY *Famille d'oiseaux, 1971*
 (16" x 20")

MARTHA HENRICKSON (Conceptual/Conceptuel) 1942, New York LIVES/HABITE: Oshawa, Ont. TRAINING/FORMATION: Art Students League, New York AWARDS & HONOURS/PRIX & HONNEURS: Canada Council Grant, 1971/Bourse du Conseil des Arts du Canada, 1971 MEDIUM: Photographs, slides, tape, transcribed conversations, etc./Photographies, diapositives, ruban sonore, transcription de conversations, etc.

EX—2: "Awakenings" with/avec **THOMAS HENRICKSON** CIRCULATING/ITINE-RANTE: Memorial Univ Art Gallery, St. John's, Nfld. (12 XII—29 XII 72); Owens Art Gallery, Mount Allison Univ, Sackville, N.B. (6 I—10 II 73).

THOMAS HENRICKSON (Conceptual/Conceptuel) 1944, New York LIVES/HABITE: Oshawa, Ont. TRAINING/FORMATION: Pratt Institute, New York; Brooklyn College, New York TEACHES/ENSEIGNE: Ryerson Polytechnical Institute, Toronto MEDIUM: Photographs, slides, tape, transcribed conversations, etc./Photographies, diapositives, ruban sonore, transcription de conversations, etc.

EX—2: "Awakenings" with/avec **MARTHA HENRICKSON** CIRCULATING/ITINE-RANTE: Memorial Univ Art Gallery, St. John's, Nfld. (12 XII—29 XII 72); Owens Art Gallery, Mount Allison Univ, Sackville, N.B. (6 I—10 II 73).

FRANK HENRY (Sculpture, drawing/Sculpture, dessin) LIVES/HABITE: Toronto TRAINING/FORMATION: Ontario College of Art, Toronto MEDIUM: Plastic/Plastique.

EX—1: "Frank's Pranks and Henry's Follies" Gallery 76, Toronto (16 IV—29 IV 73).

EX—1: Eatons Art Gallery, Toronto (Sept/sept 72); Scarborough Public Library, Scarborough, Ont. (16 I—23 II 73).

PIERRE HENRY (Peinture, dessin/Painting, drawing) 1932, Bonaventure, Qué. HABITE/LIVES: Oakville, Ont. FORMATION/TRAINING: Ecole des Beaux-Arts de Montréal MEDIUM: Huile, fusain, conté/Oil, charcoal, conté.

EX—1: La Chasse-Galerie, Toronto (juin/June—sept/Sept 72).

EX—2: "Dessins et Peintures" avec/with **EDMOND GAUTHIER**, Centre Saint-Louis-de-France, Don Mills, Ont. (nov/Nov 72).

ROSS HEWARD (Painting/Peinture) 1937, Montreal LIVES/HABITE: Paris, France TRAINING/FORMATION: Bishop's Univ, Eng.; Oxford Univ, Eng. MEDIUM: Oil/Huile GROUP/GROUPE: La Cimaise Gallery, Toronto (14 IV—10 V 73).

*** See colour section/Voir section couleur**

GORDON HILL (Sculpture) 1913 LIVES/
HABITE: Chatham, Ont. MEDIUM: Stainless
steel, anodized aluminum/Acier inoxydable,
aluminium anodisé.

EX–1: Thames Theatre Gallery, Chatham, Ont.
(17 IX–7 X 72).

GROUP/GROUPE: Shaw-Rimmington Gallery,
Toronto (June/juin-Sept/sept 72) "Sculptors'
Society of Canada" Toronto-Dominion Centre,
Toronto (15 X–3 XI 72); "Sculptors' Society
of Canada" Scarborough College, Toronto
(5 XI–27 XI 72); "26th Annual Chatham-Kent
Art Association Exhibition".

1

MARTIN HIRSCHBERG (Sculpture, paint-
ing, drawing/Sculpture, peinture, dessin) 1937
LIVES/HABITE: Thornhill, Ont. TRAINING/
FORMATION: Central Technical School, To-
ronto; Ontario College of Art, Toronto; Insti-
tuto Allende, San Miguel de Allende, Mexico
MEDIUM: Acrylic, fluorescent lights/Acry-
lique, lampes fluorescentes.

EX–1: The Electric Gallery, Toronto (27 I–
15 II 73).

EX–1: "Out of the Blue" Hart House Gallery,
Toronto (23 V–10 VI 72).

EX–5: The Electric Gallery, Toronto (Jul/juil
72).

GROUP/GROUPE: "SCAN"; "Kingston Spring
Exhibition".

TOM HODGSON (Painting, printmaking/Pein-
ture, gravure) LIVES/HABITE: Toronto
MEDIUM: Oil/Huile EX–1: Merton Gallery,
Toronto (8 XII 72–20 I 73) EX–4: Merton
Gallery, Toronto (6 XII–30 XII 72)
GROUP/GROUPE: "Toronto Painting".

TREVOR HODGSON (Painting, drawing/
Peinture, dessin) 1931, Yorkshire, Eng.
LIVES/HABITE: Kingston, Ont. TRAIN-
ING/FORMATION: Lancaster College of
Art, Eng.; Univ London, Eng. TEACHES/
ENSEIGNE: Queen's Univ, Kingston, Ont.
MEDIUM: Oil, acrylic/Huile, acrylique.

EX–1: Agnes Etherington Art Centre,
Queen's Univ, Kingston, Ont. (18 III–
1 IV 73). GROUP/GROUPE: "Kings-
ton Spring Exhibition".

2

3

4

5

6

1 HIRSCHBERG *Translumination, 1970*

2 HILL *Ramses, 1972*

3 TREVOR HODGSON *Monolith I, 1972*

4 TREVOR HODGSON *Fold, 1973*

5 TREVOR HODGSON *Untitled, 1973*

6 TOM HODGSON *Mellow Earth (64" x 84")*
Photo: Merton Gallery, Toronto

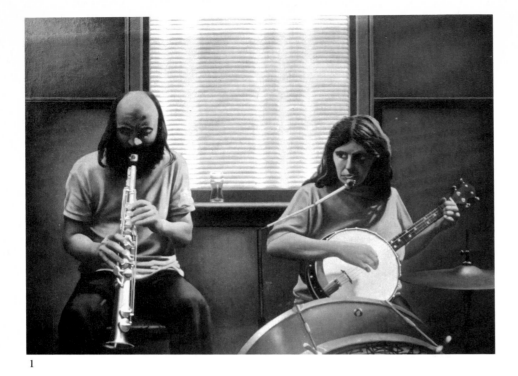

1

2

3

5

4

1 HOLDSWORTH *Jim & Melissa, 1973 (28" x 38")*

2 HOLYOAK *Paranoia (32 1/4" x 44 1/2")*

3 HOENIGAN

4 B. HONE *Plastic Plate (with ants)*
 Photo: Dunlop Art Gallery, Regina

5 B. HONE, M. HONE *Installation Shot/ Photo de l'exposition* Photo: Dunlop Art Gallery, Regina

HENRY HOENIGAN (Painting, drawing/ Peinture, dessin) 1917, Poland LIVES/HA-BITE: Toronto TRAINING/FORMATION: Cracow Academy, Poland MEDIUM: Oil, acrylic, pastel, chalk, gouache/Huile, acrylique, pastel, craie, gouache.

GROUP/GROUPE: Lambton Gallery, Toronto (Feb/févr 73); Estée Gallery, Toronto (Jan/ janv 73).

GEOFFREY LEIGH HOLDSWORTH (Painting, printmaking, drawing/Peinture, gravure, dessin) 1952, London, Ont. LIVES/HABITE: London, Ont. MEDIUM: Pencil, pencil on wood, egg tempera, oil, lithography/Crayon, crayon sur bois, détrempe à l'oeuf, huile, lithographie.

EX–4: "The Young Realists" with/avec **BRIAN JONES, KLAAS VERBOOM, HARRI AALTO**, Nancy Poole's Studio, London, Ont. (3 II–20 II 72)

*** See colour section/ Voir section couleur**

DON HOLYOAK (Painting/Peinture) 1952, Toronto LIVES/HABITE: Vancouver MEDIUM: Oil, enamel, acrylic/Huile, émail, acrylique.

EX–1: Open Space Gallery, Vancouver (May/ mai 73).

GROUP/GROUPE: "Vancouver International Exchange Exhibition"; "San Francisco Arts Festival" (Sept/sept 72); "SCAN"; Galerie Allen, Vancouver (30 XI–22 XII 72).

BETH HONE (Ceramics/Céramique) 1918 LIVES/HABITE: Regina TRAINING/FOR-MATION: School of Art, Farnham, Surrey, Eng.; Univ Saskatchewan MEDIUM: Porcelain, stoneware/Porcelaine, grès.

EX–2: with/avec **McGREGOR HONE**, Dunlop Art Gallery, Regina (12 XI–3 XII 72).

GROUP/GROUPE: "A June Show"; "Carsask"; "Regina Ceramics Now"; "Simpsons Centennial Exhibition" Regina.

McGREGOR HONE (Painting, printmaking, sculpture/Peinture, gravure, sculpture) 1920 LIVES/HABITE: Regina TRAINING/FOR-MATION: Central School of Arts and Crafts, London, Eng. AWARDS & HONOURS/PRIX & HONNEURS: Canada Council Art Teachers Grant, 1959/Bourse des professeurs d'art du Conseil des Arts du Canada, 1959 MEDIUM: Watercolour, acrylic, ink, wood, cord, serigraphy/Aquarelle, acrylique, encre, bois, corde, sérigraphie.

EX–2: with/avec **BETH HONE**, Dunlop Art Gallery, Regina (12 XI–3 XII 72).

GROUP/GROUPE: "Simpsons Centennial Exhibition" Regina; "A June Show".

GEORGE A. HORVATH (Painting/Peinture) 1933, Hungary LIVES/HABITE: Calgary TRAINING/FORMATION: Art Instruction Schools Incorporated, U.S.A. AWARDS & HONOURS/PRIX & HONNEURS: Art Instruction Schools International Competitions: Best Portrait Painting, 1962; Best Portrait in Oils, 1964; Best Figure Painting, 1969/Concours International Art Instruction Schools: Meilleur Portrait, 1962; Meilleur Portrait à l'huile, 1964; Meilleure Peinture de personnages, 1969 MEDIUM: Oil, pastel/Huile, pastel.

EX–1: Gainsborough Galleries, Calgary (11 XII–17 XII 72).

RUBY HOSKINS (Painting/Peinture) 1909, Cardiff, Wales LIVES/HABITE: Smithers, B.C. TRAINING/FORMATION: Laguna Beach School of Art and Design, Laguna Beach, Calif. MEDIUM: Oil/Huile.

EX–1: St. Thomas More Gallery, Univ Saskatchewan, Saskatoon (15 X–15 XI 72).

CATHRIN HOSKINSON (Printmaking/Gravure) 1949, Vancouver LIVES/HABITE: Montreal TRAINING/FORMATION: Univ British Columbia; Sir George Williams Univ, Montreal AWARDS & HONOURS/PRIX & HONNEURS: Purchase Award, 6th Burnaby Print Show, 1971; Canada Council Grant, 1972/ Prix d'acquisition, Sixième Exposition de Gravures de Burnaby, 1971; Bourse du Conseil des Arts du Canada, 1972 MEDIUM: Serigraphy/ Sérigraphie.

GROUP/GROUPE: "3rd British International Print Biennale" Bradford, Eng. (7 VII–30 IX 72); "Canadian Printmakers Showcase"; "56th Annual Exhibition" Society of Canadian Painter-Etchers and Engravers; "Graphex I"; "40th Annual Exhibition of the Canadian Society of Graphic Art"; "International Graphics"; "Process"; "13th Annual Calgary Graphics Show"; "New Talent in Printmaking" Marlborough-Godard Gallery, Montreal (8 VIII–31 VIII 72).

EVELYN HULL (Painting, drawing/Peinture, dessin) LIVES/HABITE: Saskatoon TRAINING/FORMATION: Univ Saskatchewan, Saskatoon MEDIUM: Oil, acrylic, charcoal/Huile, acrylique, fusain GROUP/GROUPE: "Northern Saskatchewan Juried Exhibition".

1 HOSKINSON *Reflection with Surrounding Mountains, 1972 (20" x 26")*

2 HORVATH *Golden Harvest, 1972*

3 HOSKINS *Moricetown Village, 1972*

4 HULL *Montreal River No. 2, 1973*

1

2

3

4

KATHARINE HUNT (Printmaking/Gravure) 1945, Toronto LIVES/HABITE: Toronto TRAINING/FORMATION: Univ Manitoba; Centennial College, Toronto AWARDS & HONOURS/PRIX & HONNEURS: Purchase Award/Prix d'acquisition, Boston Printmakers Annual Exhibition, 1970 MEDIUM: Serigraphy, embossed serigraphy, aquatint/Sérigraphie, sérigraphie en bosse, aquatinte.

EX—1: Fleet Gallery, Winnipeg (Spring/ printemps 73).

GROUP/GROUPE: "Canadian Printmakers Showcase"; "Christmas Show" Aggregation Gallery, Toronto (5 XII—23 XII 72); "Canadian Heritage" Art Gallery of Ontario, Toronto; "1972 Printmakers Annual Exhibition" Boston, Mass.; "Kingston Spring Exhibition".

JACQUES HURTUBISE (Peinture/Painting) 1939, Montréal HABITE/LIVES: Terrebonne, Qué. FORMATION/TRAINING: Ecole des Beaux-Arts de Montréal PRIX & HONNEURS/ AWARDS & HONOURS: Grand Prix de Peinture, Concours artistiques de la Province de Québec, 1965; Premier Prix de Peinture, Exposition Hadassah, 1968; Bourse de travail libre du Conseil des Arts du Canada, 1970; Bourse Max Beckman Foundation; Bourse du Ministère des Affaires Culturelles du Québec/First Prize, Painting, Province of Quebec Art Competition, 1965; First Prize, Painting, Hadassah Exhibition, 1968; Senior Arts Grant, Canada Council, 1970; Max Beckman Foundation Award; Quebec Ministry of Cultural Affairs Award MEDIUM: Acrylique, huile, néon, sérigraphie/Acrylic, oil, neon, serigraphy.

EX—1: "Jalons de Jacques Hurtubise" Stewart Hall, Pointe-Claire Cultural Centre (9 IX—23 IX 72).

EX—1: Galerie Godard-Lefort, Montréal (1972); Musée d'Art Contemporain, Montréal (4 II—25 II 73); Séminaire de St-Hyacinthe, Qué. (18 II—21 II 73); Musée Régional de Rimouski, Rimouski, Qué. (mars/Mar 73); Marlborough-Godard Gallery, Toronto (29 V—13 VI 73); Galerie Jolliet, Québec (21 XI—21 XII 72); Musée du Québec, Québec (23 XI—21 XII 72).

GROUPE/GROUP: "Graphisme".

*** Voir section couleur/ See colour section**

1 HUNT *Drift, 1972 (15 3/8" x 18 3/8")*
 Photo: Aggregation Gallery, Toronto

2 HURTUBISE *Iris, 1966 (68" x 68")*
 Photo: Musée d'Art Contemporain, Montréal, et l'Office du Film du Québec.

GERSHON ISKOWITZ (Painting/Peinture)
1921, Poland LIVES/HABITE: Toronto
TRAINING/FORMATION: Warsaw Academy
of Fine Art, Warsaw, Poland MEDIUM: Oil,
watercolour, ink/Huile, aquarelle, encre.

EX–1: "Gershon Iskowitz—New Paintings"
Gallery Moos, Toronto (24 III–12 IV 73) and
Hart House Gallery, Univ Toronto, Toronto
(24 III–13 IV 73).

GROUP/GROUPE: "XXVI Venice Biennale"
Venice, Italy (1972); "Annual Exhibition of
Contemporary Canadian Artists"; "Toronto
Painting".

* See colour section/ Voir section couleur

INSURRECTION ART CO. See/Voir
ROBERT WALKER, MICHAEL HASLAM

1 ISKOWITZ *Painting in Violet and Mauve,*
 1972 (90" x 78") Photo: T.E. Moore for
 Gallery Moos, Toronto

2 INSURRECTION ART CO. *Drawings of*
 Universal North American Indian Hand Signs

3 INSURRECTION ART CO. *Drawings of*
 Conventionalized Hopi Feather Designs, and
 Detotalized Bird

4 INSURRECTION ART CO. *Drawings of*
 Universal North American Indian Hand
 Signs—Detail

1

2

3

4

1

2

4

5

6

SARAH JACKSON (Sculpture, drawing/ Sculpture, dessin) 1924, Detroit, Michigan LIVES/HABITE: Halifax TRAINING/FORMATION: Wayne State Univ, Detroit, Michigan MEDIUM: Bronze, ink/Bronze, encre.

EX—1: St. Mary's Univ, Halifax (9 III—31 III 73) GROUP/GROUPE: "Third Annual Exhibition of Contemporary Professional Quebec Artists".

JACQUES JACMAIN (Peinture, gravure/ Painting, printmaking) 1940, Montréal HABITE/LIVES: Repentigny, Qué. EX—1: Hôtel Le Kennedy, Repentigny, Qué. (1 III—15 IV 73) GROUPE/GROUP: "Les Moins de 35".

ALEX JANVIER (Painting, drawing/Peinture, dessin) LIVES/HABITE: Edmonton.

EX—2: with/avec A. EVEY, Framecraft Gallery, Edmonton (Dec/déc 72).

EX—3: "Treaty Numbers, 23, 287, 1171" with/ avec J. BEARDY, D.O. BEAVON, Winnipeg Art Gallery, Winnipeg (12 VIII—10 X 72).

GROUP/GROUPE: "Alberta Contemporary Drawings".

TOM JAREMA (Conceptual/Conceptuel) 1952 LIVES/HABITE: Toronto TRAINING/ FORMATION: Ontario College of Art, Toronto MEDIUM: Film, wood, paint, rope, etc./Film, bois, peinture, corde, etc.

EX—3: with/avec E. McLAUGHLIN, M. NAUNHEIMER, Gallery 76, Ontario College of Art, Toronto (11 I—21 I 73).

PAUL JARSKY (Painting/Peinture) 1950 LIVES/HABITE: St. Catharines, Ont. TRAINING/FORMATION: Self-taught/Autodidacte MEDIUM: Acrylic, collage/Acrylique, collage.

EX—3: with/avec R. BURDSAL, R. RIGLI, Lynn Kottler Galleries, New York (18 II—3 III 73).

CHARLES JEAN (Peinture, tapisseries/ Painting, hangings) 1949 HABITE/LIVES: Québec, Qué. FORMATION/TRAINING: McGill Univ, Montréal MEDIUM: Huile, acrylique, aquarelle, batik/Oil, acrylic, watercolour, batik.

EX—1: Ski Room Lobby, Château Frontenac, Québec (12 VII—16 VII 72); Centre International, Québec (1 X—1 XI 72).

1 JANVIER *Let Live, 1972 (15 7/16" x 23 1/4")* Photo: Winnipeg Art Gallery

2 JACMAIN *4 saisons bloc, 1973 (24" x 30")*

3 JARSKY *Frog Series No. 27*

4 JACKSON

5 JAREMA *The Graft, 1972*

6 JEAN

JANA JENICEK (Peinture, dessin/Painting, drawing) 1941, Prague HABITE/LIVES: Montréal FORMATION/TRAINING: Académie des Beaux-Arts, Prague; Ecole des Arts Décoratifs, Prague; Centre International des Etudes des Mosaïques, Ravenne, Italie MEDIUM: Huile, acrylique, encre/Oil, acrylic, ink.

EX—1: Mission Saint-Wenceslas, Montréal (1972).

EX—2: avec/with **FERNAND SEGUIN**, Galerie L'Art Français, Montréal (17 II—3 III 73).

GROUPE/GROUP: Galerie L'Art Français, Montréal (1 VII—31 VIII 72); "Femmes Peintres" Centre Maisonneuve, Montréal (1972); Boutique The Garden, Montréal (1972); "Exhibit '72" Beth Sion Synagogue, Montréal (1972); "Salon des Métiers d'Art" Montréal (1972); Galerie de la S.A.P.Q., Montréal (7 X—15 XI 72); Cold Hollow Gallery, Cold Hollow, Vermont (7 X—15 XI 72); "The World of Drawing" Montréal (1973); "Les Moins de 35".

KENNETH MARK JENKYNS (Drawing/Dessin) 1950, Winnipeg LIVES/HABITE: Winnipeg TRAINING/FORMATION: Univ Manitoba, Winnipeg MEDIUM: Pencil/Crayon.

EX—1: Upstairs Gallery, Winnipeg (14 IX—28 IX 72)

GROUP/GROUPE: "Manisphere '72"; "Green Inland Gathering" Univ Manitoba, Winnipeg.

ANNA JESENKO (Peinture/Painting) 1925, Austria HABITE/LIVES: St-Jérôme, Qué. FORMATION/TRAINING: Washington School of Fine Arts, Washington, D.C.; Musée des Beaux-Arts, Montréal MEDIUM: Huile, acrylique, encre/Oil, acrylic, ink.

GROUPE/GROUP: Galerie de la S.A.P.Q., Montréal (7 X—15 XI 72).

CLAUDE JIRAR (Peinture/Painting) 1944, Québec HABITE/LIVES: Québec FORMATION/TRAINING: Ecole des Beaux-Arts de Québec PRIX & HONNEURS/AWARDS & HONOURS: Bourse du Conseil des Arts du Canada/Canada Council Grant ENSEIGNE/TEACHES: Ecole des Arts Visuels de l'Univ Laval, Ste-Foy, Qué. MEDIUM: Acrylique/Acrylic.

EX—1: Musée du Québec, Québec (26 IV—4 VI 73) GROUPE/GROUP: Vehicule Art, Montréal (13 X—3 XI 72); "Les Moins de 35"; "Tour des Arts" Univ Laval, Ste-Foy, Qué. (24 X—5 XI 72).

1 JENICEK *L'Amour à donner (18" x 14")*

2 JESENKO *Springtime-Resurrection*

3 JIRAR *Alfa-alfé*

4 JIRAR *Entre deux mers*

5 JENICEK *Cette Beauté, 1972 (38" x 24")*

6 JENKYNS *(23" x 35")*

1

2

3

4

5

6

1

2

3

4

5

MICHEL JOLICOEUR (Peinture/Painting)
1946, Saint-Laurent, Qué. HABITE/LIVES:
Montréal FORMATION/TRAINING:
Univ Québec, Montréal; Ecole des Beaux-Arts
de Montréal MEDIUM: Acrylique, aquarelle,
encre de Chine, crayon de couleur, mine de
plomb, détrempe, collage/Acrylic, watercolour,
India ink, colour pencils, graphite, tempera,
collage.

EX–4: "Exposition-recherche" avec/with
FRANCINE BOUCHARD, **LOUISE DAZE**,
PIERRETTE LAMBERT ITINERANTE/
CIRCULATING: Galerie Colline, Collège St-
Louis-Maillet, Edmundston, N.B. (2 XII–
15 XII 72); Collège d'Alma, Lac-St-Jean,
Qué. (11 IV–15 IV 73).

GROUPE/GROUP: "Jeunes Peintres qué-
bécois".

BILL JONES (Conceptual, printmaking/
Conceptuel, gravure) 1946, Antioch, Calif.
LIVES/HABITE: West Vancouver TRAINING/
FORMATION: Univ Oregon, Eugene, Oregon
MEDIUM: Video tape, offset lithography,
information environments, photography/Ruban
vidéo, lithographie offset, environnements
d'information, photographie.

EX–1: "Bill Jones" Vancouver Art Gallery,
Vancouver (7 VI–9 VII 72) GROUP/
GROUPE: "SCAN".

MARVIN JONES (Printmaking, drawing,
sculpture/Gravure, dessin, sculpture) 1940,
Flora, Ill. LIVES/HABITE: Edmonton
TRAINING/FORMATION: Univ Illinois,
Urbana, Ill.; Roosevelt Univ, Chicago; Anderson
College, Anderson, Ind.; Univ California, Davis,
Calif. TEACHES/ENSEIGNE: Univ Alberta
MEDIUM: Ink, linoleum engraving, etching/
Encre, gravure sur linoléum, eau-forte.

EX–1: Univ Calgary, Calgary (1972); Oxford
Gallery, Oxford Univ, Eng. (Dec/déc 72–Jan/
janv 73); Burnaby Art Gallery, Burnaby, B.C.;
Cornerbrook Gallery, Cornerbrook, Nfld.
(20 I–10 II 73); Grand Falls Gallery, Grand
Falls, Nfld. (17 II–14 IV 73); Memorial Univ,
St. John's (Dec/déc 72–Jan/janv 73).

EX–2: with/avec **DAVID GILHOOLY**,
Manolides Gallery, Seattle, Washington (Jan/
janv–Feb/févr 73).

EX–4: "Commentaries on Urban Man" with/
avec **HARRY SAVAGE**, **RON KOSTYNIUK**,
DEREK BESANT, Confederation Art Gallery,
Charlottetown (7 XI–25 XI 72).

GROUP/GROUPE: "Third British International
Print Biennale" Bradford, Eng. (7 VII–30 IX
72); "24th Spokane Annual" (1972); "West
'71"; "Drawings U.S.A." Minnesota Museum of
Art, Minneapolis (Apr/avril–Aug/août 73);
"Images on Paper" SAA Gallery, Springfield,
Ill. (Feb/févr–Mar/mars 73).

*** See colour section/ Voir section couleur**

1 B. JONES *Landscape No. 1 (60" x 60")*

2 B. JONES *Landscape No. 2 (60" x 60")*

3 B. JONES *Landscape No. 3 (60" x 60")*

4 M. JONES *4 P.M.–8 A.M., 1972*

5 JOLICOEUR *1972*

1

BOB JORDAN (Printmaking, painting, conceptual/Gravure, peinture, conceptuel) 1941, Toronto LIVES/HABITE: Lakefield, Ont. MEDIUM: Acrylic, oil, watercolour, plexiglas, monoprints/Acrylique, huile, aquarelle, plexiglas, monogravures.

EX−1: Aggregation Gallery, Toronto (Dec/déc 72); Durham College, Oshawa, Ont. (1972).

EX−4: "Images: Earth/Water/Sky" with/avec **ED BARTRAM, SYLVIA PALCHINSKI, ROBERT SINCLAIR,** Aggregation Gallery, Toronto (19 V−13 VI 73).

GROUP/GROUPE: "SCAN"; "National Home Show" Canadian National Exhibition, Toronto (1972); "Inaugural Exhibition" Aggregation Gallery, Toronto (3 X−21 X 72).

2

DENIS JUNEAU (Sculpture, peinture/Sculpture, painting) 1925, Montréal HABITE/ LIVES: Montréal FORMATION/TRAINING: Ecole des Beaux-Arts de Montréal; Centro Studi di Arte Industria de Novara, Italie PRIX & HONNEURS/AWARDS & HONOURS: Bourses du Conseil des Arts du Canada, 1961, 1968; Grand Prix de l'Urbanisme de la Province de Québec, 1965/Canada Council Grants, 1961, 1968; Province of Quebec Grand Prize for City Planning, 1965 MEDIUM: Acrylique/ Acrylic.

EX−1: "Pendules" Galerie de Montréal, Montréal (12 IV−30 IV 73).

GROUPE/GROUP: "Art 3" Bâle, Suisse; "Estival 72" Galerie Espace, Montréal (31 V−30 IX 72).

3

4

1 JORDAN *Springland, 1972 (15" x 84")* Photo: Aggregation Gallery, Toronto

2 JORDAN *Untitled, 1970 (28 1/4" x 50 1/2")* Photo: Aggregation Gallery, Toronto

3 JUNEAU *Groupe de 9 Eléments géométriques II, 1973 (71" x 100")* Photo: Carmen Lamanna Gallery, Toronto

4 JUNEAU *Pendules Numéro 6, 1972 (69" x 15")* Photo: Carmen Lamanna Gallery, Toronto

5 M. JONES *Vegetable Nightclub 1973*

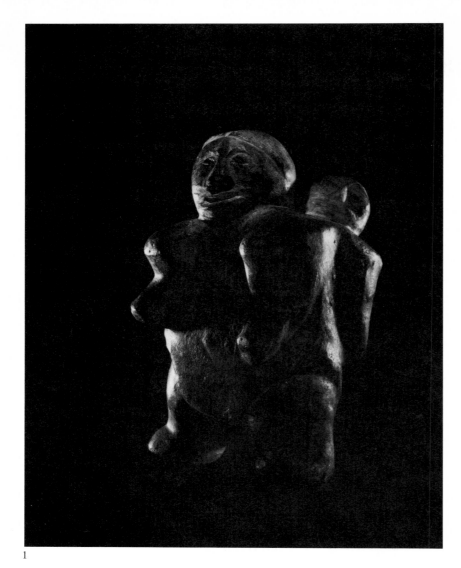

1

2

3

4

EDVIN KARATSON (Painting/Peinture) 1924, Casbrendek, Hungary LIVES/HABITE: Toronto TRAINING/FORMATION: Academy of Fine Art, Vienna; Academy of Fine Art, Budapest MEDIUM: Oil/Huile.

EX—1: "Post Impr." Art of the New Renaissance Gallery, Toronto (Aug/août 72); Art of the New Rennaissance Gallery, Toronto (Oct/oct 72).

RONNI KATZ (Painting/Peinture) 1936, Toronto LIVES/HABITE: Toronto TRAINING/FORMATION: Ryerson Polytechnical Institute, Toronto MEDIUM: Acrylic, ink, watercolour, oil, tempera/Acrylique, encre, aquarelle, huile, détrempe.

EX—1: Don Mills Library, Toronto (2 VI—29 VI 72); Learning Resources Centre, Toronto (1 II—28 II 73).

GROUP/GROUPE: "Adath Israel Annual Art Show" Toronto (Jan/janv 73); "Pioneer Women's 1st Annual Art Exhibit" Toronto (May/mai 73).

JOHN KAVIK (Sculpture) 1897 LIVES/HABITE: Rankin Inlet, N.W.T. MEDIUM: Black stone, dark grey stone, grey stone/Pierre noire, pierre gris foncé, pierre grise.

EX—2: with/avec **ANGAKTAGUAK**, Innuit Art Gallery, Toronto (25 IV—3 V 73) GROUP/GROUPE: "Sculpture/Inuit".

BEVERLEY LAMBERT KELLY (Painting, printmaking, ceramics/Peinture, gravure, céramique) 1943, Biggar, Sask. LIVES/HABITE: Regina TRAINING/FORMATION: Saskatoon Technical Institute; Univ Saskatchewan, Regina AWARDS & HONOURS/PRIX & HONNEURS: Reeves Painting Award; Canada Council Grants/Prix de peinture Reeves; Bourses du Conseil des Arts du Canada MEDIUM: Brick, plastic, wood, plexiglas, stoneware, earthenware, lithography, intaglio/Brique, plastique, bois, plexiglas, grès, faïence, lithographie, intaille.

GROUP/GROUPE: "Simpsons Centennial Exhibition"; "SCAN"; "Another Eleven Saskatchewan Artists"; "Carsask"; "A June Show".

1 KAVIK *(8")* Photo: Innuit Gallery, Toronto

2 KARATSON *Kreutzen, 1970*

3 KATZ *Orange Velvet, 1972*

4 KELLY *Willows, Sask., "Homage to Sarah Binks", 1972*

VALERIE KENT (Printmaking/Gravure)
1947 LIVES/HABITE: Montreal TRAIN-
ING/FORMATION: Sir George Williams Univ,
Montreal; Univ Iowa; Ecole des Beaux-Arts de
Montreal MEDIUM: Etching, intaglio/Eau-
forte, intaille.

GROUP/GROUPE: "24th Annual Iowa
Artists Exhibition" Des Moines Art Gallery,
Des Moines, Iowa.

JOHN PHILIP KITSCO (Drawing, painting/
Dessin, peinture) 1947 LIVES/HABITE:
Stettler, Alta. TRAINING/FORMATION:
Self-taught/Autodidacte MEDIUM: Photo-
collage, ink, oil, watercolour, acrylic, metal,
wood/Photo-collage, encre, huile, aquarelle,
acrylique, métal, bois GROUP/GROUPE:
Heart of Alberta Art Gallery, Stettler, Alta.
(1 II–10 II 73).

LEO KLAUSNER (Sculpture) Russia
LIVES/HABITE: Toronto TRAINING/FOR-
MATION: Art Academy, Krakow, Poland
MEDIUM: Wood/Bois.

EX–1: "The Fourth Dimension" Scarborough
Public Libraries, Cedarbrae Branch, Toronto
(18 I–16 II 73).

EX–1: Estée Gallery, Toronto (7 X–10 XI
72); Estée Gallery, Toronto (7 IV–28 IV 73);
Scarborough College, Toronto (Apr/avril 73).

GROUP/GROUPE: "Aviva Art Show" Toronto
(Apr/avril 73).

BERT KLOEZEMAN (Printmaking/Gravure)
1921, Malaya LIVES/HABITE: London, Ont.
TRAINING/FORMATION: Royal Academy of
Fine Arts, The Hague, Netherlands AWARDS
& HONOURS/PRIX & HONNEURS: Sterling
Trust Award for Best Print, 1963; Gold Medal,
Graphics, Canadian National Exhibition, 1968/
Prix Sterling Trust pour la meilleure Gravure,
1963; Médaille d'Or, Arts graphiques, Exposi-
tion Canadienne Nationale, 1968 TEACHES/
ENSEIGNE: H.B. Beal Secondary School, Lon-
don, Ont. MEDIUM: Etching/Eau-forte.

EX–1: Nancy Poole's Studio, Toronto (Au-
tumn/automne 72).

GROUP/GROUPE: "Canadian Printmakers
Showcase"; "International Graphics".

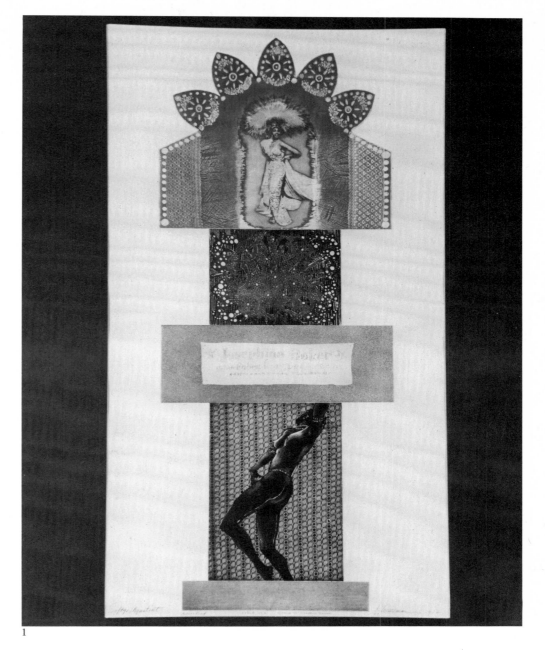

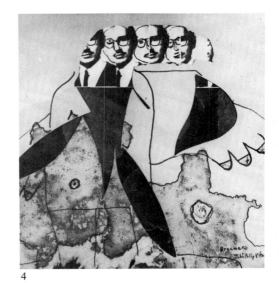

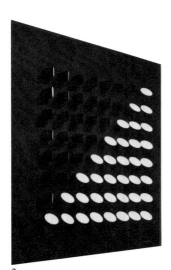

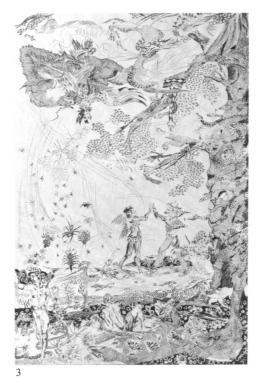

1 KLOEZEMAN *Homage to Josephine Baker,
1972* Photo: David Hallam

2 KLAUSNER *Fugue No. 3* Photo: Dr.
Jerry Brail for Estée Gallery, Toronto

3 KENT *Beating the Joneses to Breakfast*

4 KITSCO *Dreamer, 1973 (8" x 10")*
Photo: Heart of Alberta Gallery, Stettler,
Alta.

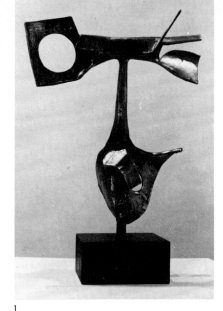

1

2

3

4

1 KNOWLTON *1972* Photo: Edmonton Journal

2 KNOWLES *After the Rain, 1971 (32" x 34")* Photo: Waddington Galleries, Montreal

3 KNIGHT *Series 3D*

4 KNIGHT *Series 3D*

JACK THOMAS KNIGHT 1949, Welland, Ont. LIVES/HABITE: Buffalo, N.Y. TRAINING/FORMATION: Niagara County Community College, Niagara Falls, N.Y.; State Univ, Buffalo, N.Y. MEDIUM: Acrylic and enamel on canvas, enamel on galvanized steel/Acrylique et émail sur toile, émail sur acier galvanisé.

GROUP/GROUPE: Charles Burchfield Centre, State Univ, Buffalo, N.Y. (1972).

DOROTHY KNOWLES (Painting/Peinture) 1927, Unity, Sask. LIVES/HABITE: Saskatoon TRAINING/FORMATION: Univ Saskatchewan, Saskatoon; Emma Lake Summer School, Sask.; Banff School of Fine Arts; Goldsmith's School of Art, London, Eng. AWARDS & HONOURS/PRIX & HONNEURS: Canada Council Grant, 1966/Bourse du Conseil des Arts du Canada, 1966 TEACHES/ENSEIGNE: Univ Saskatchewan MEDIUM: Watercolour, oil, acrylic/Aquarelle, huile, acrylique.

EX—1: Dunlop Art Gallery, Regina (14 X— 5 XI 72).

EX—1: "Dorothy Knowles" The Glenbow-Alberta Institute, Calgary CIRCULATING/ ITINERANTE: Edmonton Art Gallery (10 V— 10 VI 73).

EX—3: with/avec **W. PEREHUDOFF, H. LEROY**, Waddington Galleries, Montreal (26 VIII—15 IX 72).

EX—5: "Watercolour Painters from Saskatchewan" with/avec **ROBERT SYMONS, ROBERT HURLEY, ERNEST LINDNER, RETA COWLEY**, organized by the National Gallery/organisée par La Galerie Nationale CIRCULATING/ITINERANTE: Moose Jaw Art Museum, Moose Jaw, Sask. (15 V—15 VI 72); Burnaby Art Gallery, Burnaby, B.C. (1 VII—31 VII 72); Rothman's Art Gallery, Stratford, Ont. (15 VIII—15 IX 72); Dunlop Art Gallery, Regina (14 X—5 XI 72).

GROUP/GROUPE: "Annual Exhibition of Contemporary Canadian Art"; "Saskatchewan Arts Board Exhibition"; "West '71"; "Art for All"; "North Saskatchewan Juried Show"; "Directors Choice" Edmonton Art Gallery (Nov/nov 72); "A June Show"; "Christmas Show" Beckett Gallery, Hamilton, Ont. (l972).

JONATHAN KNOWLTON (Painting, drawing/Peinture, dessin) 1937 LIVES/HABITE: Edmonton TRAINING/FORMATION: Yale Univ; Univ California, Berkeley, Calif. TEACHES/ENSEIGNE: Univ Alberta MEDIUM: Acrylic, coloured ink/Acrylique, encre de couleur.

EX—1: Edmonton Art Gallery, Edmonton (June/juin 72) GROUP/GROUPE: "Staff Show" Univ Alberta Art Gallery and Museum (9 X—31 X 72); "Alberta Contemporary Drawings".

PETER KOLISNYK (Printmaking, painting, sculpture/Gravure, peinture, sculpture) 1934, Toronto LIVES/HABITE: Cobourg, Ont. AWARDS & HONOURS/PRIX & HONNEURS: Prize, Canadian Society of Painters in Watercolour, 1962; Purchase Award, Art Institute of Ontario Centennial Exhibition, 1967; Sculpture Award, "Canadian Artists '68" Art Gallery of Ontario; Ontario Society of Artists Sculpture Award, 1972/Prix, Canadian Society of Painters in Watercolour, 1962; Prix d'acquisition, Art Institute of Ontario, Exposition du Centenaire, 1967; Prix de Sculpture "Canadian Artists '68" Art Gallery of Ontario; Prix de Sculpture, Ontario Society of Artists, 1972 MEDIUM: Acrylic, oil, wood, formica, plexiglas, cut paper, watercolour, pencil, ink, plastic/Acrylique, huile, bois, formica, plexiglas, papier découpé, aquarelle, crayon, encre, plastique.

EX–1: "Inventory" Robert McLaughlin Gallery, Oshawa (13 II–4 III 73).

EX–1: Art Gallery of Brant, Brantford, Ont. (31 III–22 IV 73).

EX–2: with/avec **H.F. GREGOR**, London Public Library & Art Gallery, London, Ont. (1972).

EX–5: "5 Canadian Artists" with/avec **IHOR DMYTRUK, RON KOSTINIUK et al** CIRCULATING/ITINERANTE: Ukrainian Institute of Modern Art, Chicago (29 IX–8 X 72); Evanston Art Center, Evanston, Ill. (9 X–17 X 72).

GROUP/GROUPE: "Plastic Fantastic"; "Recent Vanguard Acquisitions" Art Gallery of Ontario (1972); Ontario Society of Artists "100 Years" Exhibition.

EDWARD KONIUSZY (Sculpture) 1919, Poland LIVES/HABITE: Toronto TRAINING/FORMATION: Folklor Arts School, Zakopane, Poland; High Arts School, Tarnow, Poland; Academy of Arts, Krakow, Poland MEDIUM: Wood, stone, bronze/Bois, pierre, bronze.

EX–1: A. Campbell District Library, Scarborough, Ont. (12 VII–8 VIII 72).

GROUP/GROUPE: Niagara Falls Art Gallery & Museum, Niagara Falls, Ont.; "Sculptors' Society of Canada" Toronto-Dominion Centre (15 X–3 XI 72); "New Canadian Art Exhibition" Toronto (5 VI–19 VI 72).

EVEE KORDA (Sculpture) Budapest, Hungary LIVES/HABITE: Toronto TRAINING/FORMATION: Central Technical School, Toronto MEDIUM: Bronze.

EX–2: with/avec **SARAH SILVER**, Walter Engel Gallery, Toronto (Aug/août 72).

EX–2: Estée Gallery, Toronto (Feb/févr 73).

1 KORDA *Love (15" x 6")*

2 KOLISNYK *"Refractor III, 1969 (6' x 12")*

3 KONIUSZY *Fence* Photo: Egon H. Sleeuw

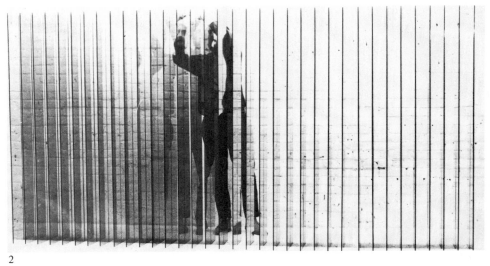

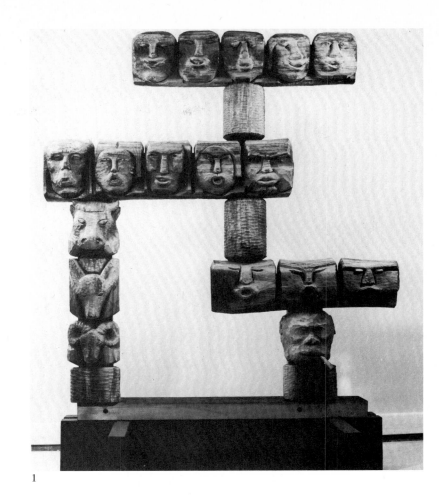

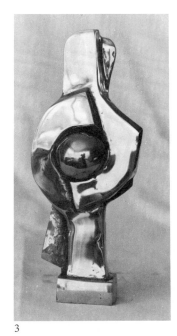

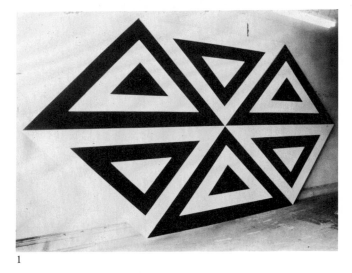

1

2

3

4

WILLIAM THOMAS KORT (Painting, print-making, drawing/Peinture, gravure, dessin) 1943 LIVES/HABITE: Toronto TRAINING/FORMATION: Central Technical School, Toronto MEDIUM: Acrylic, serigraphy/Acrylique, sérigraphie. EX–1: Erindale College, Univ Toronto, Toronto (12 XI–2 XII 72); The Artists' Gallery, Toronto (31 VIII–16 IX 72).

LENA KOSTIUK (Painting/Peinture) 1930, McRae, Alta. LIVES/HABITE: Edmonton TRAINING/FORMATION: Self-taught/Autodidacte MEDIUM: Oil/Huile EX–1: "Oil Paintings of Early Memories" Galerie Lefebvre, Edmonton (18 III–31 III 73).

5

6

1 KORT *Structures: No. 10, Series No. 1* *(9'2" x 18'4")*

2 KOWALLEK *No. 21 of "The Altered Landscape"*

3 KOSTIUK *The Riders, 1973* Photo: Edmonton Journal

4 KROSNICK

5 KOSTYNIUK *1971 (4' x 4')*

6 KOSTYNIUK *(4' x 4')*

RON KOSTYNIUK 1941, Wakaw, Sask. LIVES/HABITE: Calgary TRAINING/FORMATION: Univ Saskatchewan; Univ Alberta; Univ Wisconsin AWARDS & HONOURS/PRIX & HONNEURS: Alberta Government Visual Arts Grant; Prize in "Winnipeg Show, 1968"; Canada Council Arts Bursary, 1969/Prix des Arts Visuels du gouvernement de l'Alberta; Prix au "Winnipeg Show, 1968"; Bourse du Conseil des Arts du Canada, 1969 TEACHES/ENSEIGNE: Univ Calgary MEDIUM: Relief structures/Structures en relief.

EX–4: "Commentaries on Urban Man" with/avec **H. SAVAGE, M. JONES, D. BESANT**, Confederation Art Gallery, Charlottetown, P.E.I. (7 XI–25 XI 72).

EX–1: "Relief Structures" CIRCULATING/ITINERANTE: Glenbow-Alberta Institute, Calgary (Dec/déc 72–Jan/janv 73); York Univ Art Gallery, Toronto (Feb/févr 73); Beaverbrook Art Gallery, Fredericton (Mar/mars 73); Dalhousie Univ, Halifax (Apr/avril 73); Memorial Univ, St. John's, Nfld. (May/mai 73).

EX–1: "Recent Structures" Mendel Art Gallery, Saskatoon (1972).

EX–5: "Five Canadian Artists" with/avec **I. DMYTRUK, P. KOLISNYK et al** CIRCULATING/ITINERANTE: Ukranian Institute of Modern Art, Chicago (29 IX–8 X 72); Evanston Art Centre, Evanston, Ill. (9 X–17 X 72).

GROUP/GROUPE: "West '71".

HELE KOWALLEK (Painting, printmaking/
Peinture, gravure) 1951, Detmold, Germany
LIVES/HABITE: Vancouver TRAINING/
FORMATION: Self-taught/Autodidacte
AWARDS & HONOURS/PRIX & HONNEURS:
John Oliver Fine Arts Award, 1969, 1970;
First Place, United Nations Creative Arts Com-
petition, 1970; Special Award, F.C.A. Open
Garden Exhibition, 1972/Prix des Beaux-Arts
John Oliver, 1969, 1970; Première Place,
Concours des Arts de Création des Nations
Unies, 1970; Prix spécial, F.C.A. Open Garden
Exhibition, 1972 MEDIUM: Etching/Eau-
forte.

EX—1: Gallery 111, Tsawwassen, B.C. (June/
juin 72); New Westminster Central Library,
New Westminster, B.C. (Nov/nov—Dec/déc
72); Fireside Gallery, Vancouver (Dec/déc 72);
Vancouver Central Public Library, Vancouver
(Dec/déc 72—Jan/janv 73).

EX—2: Open Space, Victoria (Sept/sept 72).

GROUP/GROUPE: "Under 25" F.C.A. Art
Exhibition, Burnaby Art Gallery, Burnaby,
B.C.

JULIE KROSNICK (Sculpture, conceptual/
Sculpture, conceptuel) 1947 LIVES/HA-
BITE: Toronto TRAINING/FORMATION:
Brandeis Univ, Waltham, Mass.; Ontario
College of Art, Toronto MEDIUM: Cloth,
feathers, thread, clothesline, cotton balls,
string, glue, ink, pantyhose, gloves, etc./Tissu,
plumes, fil, étendoir, boules de coton, corde,
colle, encre, bas-culotte, gants, etc.

GROUP/GROUPE: "Women's Work" Gallery
76, Ontario College of Art, Toronto (15 II—
25 II 73); Gallery Z, Toronto (14 III—30 IV
73).

NOBUO KUBOTA (Sculpture) 1932, Van-
couver LIVES/HABITE: Toronto TRAIN-
ING/FORMATION: Univ Toronto AWARDS
& HONOURS/PRIX & HONNEURS: Canada
Council Grants, 1967, 1969, 1971/Bourses du
Conseil des Arts du Canada, 1967, 1969, 1971
TEACHES/ENSEIGNE: Ontario College of
Art, Toronto: York Univ, Toronto MEDIUM:
Painted wood, metal/Bois peint, métal.

EX—1: Isaacs Gallery, Toronto (6 XII—30 XII
72).

GROUP/GROUPE: "Art for All".

MICHAEL KUCZER (Painting/Peinture)
1910, Winnipeg LIVES/HABITE: Stouffville,
Ont. TRAINING/FORMATION: Winnipeg
School of Art MEDIUM: Oil, acrylic/Huile,
acrylique.

EX—1: "Retrospective" CIRCULATING/
ITINERANTE: Gibson Gallery, Amherstburg,
Ont. (27 V—11 VI 72); Art Gallery of St.
Thomas & Elgin, St. Thomas, Ont. (18 VII—27
VIII 72).

EX—1: "Recent Paintings" Niagara Falls Art
Gallery & Museum (22 X—27 XI 72); Ontario
Association of Architects, Toronto (8 I—2 II 73).

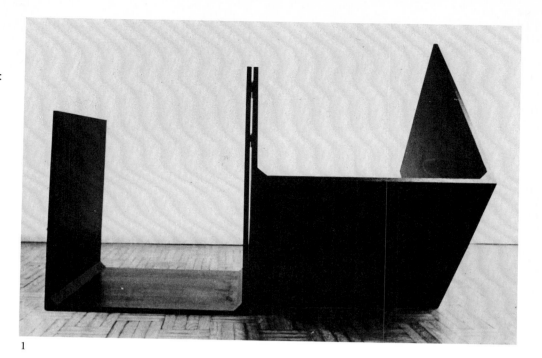

1

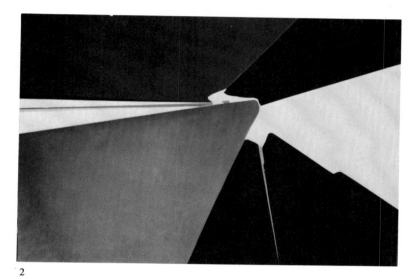

2

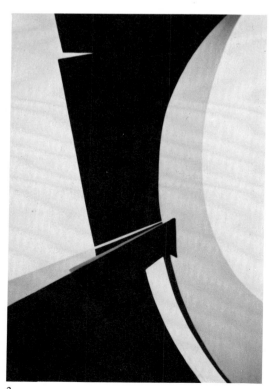

3

1 KUBOTA *Dissection II, 1969 (3'9" x 4'
 x 5')* Photo: Lyle Wachovsky for Isaacs
 Gallery, Toronto

2 KUCZER *Interrupted Cadence, 1972 (7' x 5')*

3 KUCZER *Grandioso, 1972 (5' x 7')*

1

2

3

4

SHARON KULIK (Conceptual/Conceptuel) LIVES/HABITE: Saugus, Calif. TRAINING/ FORMATION: Cleveland Institute of Art; Nova Scotia College of Art and Design; Chicago Art Institute MEDIUM: Video, slides, photographs, etc./Vidéo, diapositives, photographies, etc. EX–1: Mezzanine Gallery, Nova Scotia College of Art and Design, Halifax (20 V–27 V 73).

WILLIAM KURELEK (Painting/Peinture) 1927, Alberta LIVES/HABITE: Toronto TRAINING/FORMATION: Self-taught/Autodidacte AWARDS & HONOURS/PRIX & HONNEURS: Canada Council Senior Fellowship, 1969/Bourse de travail libre du Conseil des Arts du Canada, 1969 MEDIUM: Watercolour, mixed media/Aquarelle, multi-média.

EX–1: Univ Edinburgh, Scotland (1972); Commonwealth Institute, London, Eng. (1972); Isaacs Gallery, Toronto (10 X–30 X 72).

GROUP/GROUPE: "Annual Exhibition of Contemporary Canadian Art"; "Art for All".

1 KULIK *Biochemical Evolution*

2 KULIK *Biochemical Evolution*

3 KULIK *Biochemical Evolution*

4 KURELEK *Balsam Avenue after Heavy Snow* Photo: Lyle Wachovsky for Isaacs Gallery, Toronto

5 KURELEK *Early Spring on Scarborough Bluffs* Photo: Lyle Wachovsky for Isaacs Gallery, Toronto

5

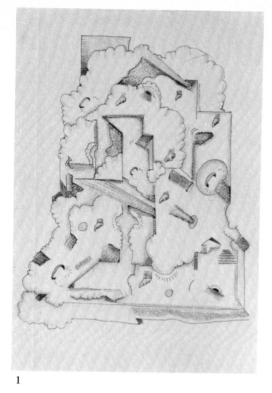

1

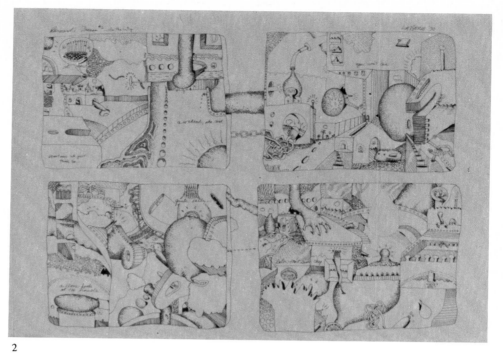

2

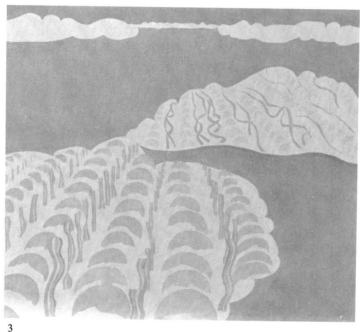

3

PAUL LABERGE (Tapisseries, peinture/
Hangings, painting) 1945, Cap-de-la-Madeleine,
Qué. HABITE/LIVES: St-Lambert, Qué.
FORMATION/TRAINING: Univ Montréal; Sir
George Williams Univ, Montréal MEDIUM:
Tapisserie, acrylique/Tapestry, acrylic.

EX—2: "On Fait pas ben gros d'argent mais on
a du fun en maudit" avec/with **C. MAGNAN**,
Sir George Williams Univ Art Gallery, Mont-
réal (30 XI–12 XII 72).

PHILIP E. LA BORIE (Painting, drawing/
Peinture, dessin) 1939, Rochester, N.Y.
LIVES/HABITE: Vancouver TRAINING/
FORMATION: San Francisco Art Institute
MEDIUM: Oil, pen, ink, pastel/Huile, plume,
encre, pastel GROUP/GROUPE: "SCAN".

1 LA BORIE *1972*

2 LA BORIE *Drawing, 1970 (18" x 24")*

3 LABERGE *Une P'tite Rangée d'arc-en-ciel,
 une P'tite Rangée d'soleils...' (57" x 57")*

4 LABERGE *Lever d'soleil (57" x 57")*

4

1

2

3

4

LACELIN (PHILIPPE BELLEFLEUR) (Peinture, gravure/Painting, printmaking) 1938 HABITE/LIVES: Montréal FORMATION/TRAINING: Univ Montréal; Ecole des Beaux-Arts d'Aix-en-Provence, France PRIX & HONNEURS/AWARDS & HONOURS: Bourse du gouvernement du Québec, 1969/Quebec Government Scholarship, 1969 MEDIUM: Huile, acrylique, collage/Oil, acrylic, collage.

EX—1: Galerie Artlenders, Westmount, Qué. (15 X—28 X 72).

EX—2: "Livernois" avec/with **PAUL LIVERNOIS**, Galerie Les Deux B, St-Antoine-sur-Richelieu, Qué. (2 XII—23 XII 72).

GROUPE/GROUP: "Annual Exhibition of Contemporary Canadian Art"; Roberts Gallery, Toronto (24 I—3 II 73).

EDOUARD LACHAPELLE (Gravure, peinture, dessin/Printmaking, painting, drawing) 1943, Montréal HABITE/LIVES: Outremont, Qué. FORMATION/TRAINING: Univ Montréal MEDIUM: Linogravure, acrylique, huile, aquarelle, encre de Chine, pastel, crayon, sépia, lavis, collage/Linocut, acrylic, oil, watercolour, India ink, pastel, pencil, sepia, wash-tint, collage.

EX—1: La Chasse-Galerie, Toronto (21 IX—7 X 72).

EX—1: "Marie Calumet" ITINERANTE/CIRCULATING: Les Magasins Dupuis, Montréal (12 XII—23 XII 72); La Librairie du Centre, Centre National des Arts, Ottawa (27 XII 72—10 I 73).

EX—2: "Ecritures occidentale et orientale" avec/with **JOHNNY GOH**, Centre d'Art du Mont-Royal, Montréal (16 IX—17 X 72).

EX—2: "Jolies-fle-fleurs et beaux petits paysages kucul (turels)" avec/with **MARC SYLVAIN**, Ecole de Musique Vincent d'Indy, Outremont, Qué. (déc/Dec 72—janv/Jan 73).

GROUPE/GROUP: "Graveurs de Québec" Pavillon de la Gravure, Terre des Hommes, Montréal (juil/Jul 72).

STEPHEN LACK (Conceptual/Conceptuel) HABITE/LIVES: Montréal FORMATION/TRAINING: Ecole des Beaux-Arts de Montréal; Instituto Allende, San Miguel de Allende, Mexico EX—1: Stephen's White House Tour of the Studio" Vehicule Art, Montréal (avril/Apr 73) GROUPE/GROUP: "Quebec Underground".

1 LACHAPELLE *Julie des quatres saisons, l'automne, 1972*

2 LACELIN Photo: Artlenders, Montreal

3 LACELIN Photo: Artlenders, Montreal

4 LACK *Detail of Inanimate Pose (3' x 1'6")*

RICHARD LACROIX (Gravure, peinture, sculpture/Printmaking, painting, sculpture) 1939, Montréal HABITE/LIVES: Montréal FORMATION/TRAINING: Institut des Arts Graphiques, Montréal; Ecole des Beaux-Arts de Montréal; Univ Montréal; Institut des Arts Appliqués, Montréal PRIX & HONNEURS/ AWARDS & HONOURS: Bourses du Conseil des Arts du Canada, 1961, 1963; Bourses du ministère des Affaires culturelles du Québec, 1968, 1971; Premier Prix, Concours "Fête des Fleurs" Musée des Beaux-Arts de Montréal, 1960; Prix d'acquisition "Salon du Printemps" Musée des Beaux-Arts de Montréal, 1962; Prix de la Deuxième Exposition de Gravure Burnaby, 1963; Prix de la Canadian Graphic Association, Toronto, 1964; Prix de la Biennale Internationale de Gravure, Lugano, 1964; Premier Prix de Peinture, Exposition Hadassah, Montréal, 1965; Deuxième Prix de Peinture, Exposition Hadassah, Montréal, 1966; Prix d'acquisition, Dixième Exposition Annuelle Calgary Graphics, 1970/Canada Council Grants, 1961, 1963; Grants from the Quebec Ministry for Cultural Affairs, 1968, 1971; First Prize, "Fête des Fleurs" Competition, Montreal Museum of Fine Arts, 1960; Purchase Award "Salon du Printemps" Montreal Museum of Fine Arts, 1962; Prize, Second Burnaby Print Exhibition, 1963; Prize, Canadian Graphic Association, Toronto, 1964; Prize, International Print Biennale, Lugano, 1964; First Prize for Painting, Hadassah Exhibition, Montreal, 1965; Second Prize for Painting, Hadassah Exhibition, Montreal, 1966; Purchase Award, Tenth Annual Calgary Graphics Exhibition, 1970 MEDIUM: Sérigraphie, plastiques moulés sur polystyrène/Serigraphy, moulded plastics on polystyrene.

GROUPE/GROUP: "Process"; "Graphisme"; "International Graphics"; "Boston Printmakers Annual Exhibition"; "Exposition Annuelle de Gravures Canadiennes et Européennes" Galerie l'Art français, Montréal (1 IX–30 IX 72); "Neuvième Biennale Internationale d'Art de Menton" France; "Troisième Biennale Internationale de l'Estampe" Paris; "Art 3" Bâle, Suisse; "Contemporary Canadian Prints" Pratt Graphic Centre, New York; Expositions de la collection de la Banque Provinciale du Canada (1972–73); "Huitième Biennale Internationale de la Gravure" Tokyo; "56th Annual Exhibition" Society of Canadian Painter-Etchers and Engravers, Toronto.

1 LACROIX *Crystal III, 1971 (20" x 26")*
 Photo: La Guilde Graphique, Montreal

2 LACROIX *Crystal V, 1971 (20" x 26")*
 Photo: La Guilde Graphique, Montreal

1

2

MADELEINE LALIBERTE (Peinture/Painting)
HABITE/LIVES: Québec MEDIUM: Aquarelle,
huile/Watercolour, oil GROUPE/GROUP:
"Art for All"; "Exposition de Natures Mortes"
Musée de Québec; Centre d'Art du St-Laurent,
Ile d'Orleans, Québec.

PIERRETTE LAMBERT (Peinture, sculpture/
Painting, sculpture) 1948, Montréal HA-
BITE/LIVES: Montréal FORMATION/
TRAINING: Ecole des Beaux-Arts de Mont-
réal; Univ Québec, Montréal MEDIUM:
Acrylique, huile, aquarelle, encre, collage/
Acrylic, oil, watercolour, ink, collage.

EVA LANDORI (Gravure/Printmaking)
Budapest, Hungary HABITE/LIVES: Mont-
réal FORMATION/TRAINING: Académie
Jaschik, Budapest; Académie de la Grande
Chaumière, Paris PRIX & HONNEURS/
AWARDS & HONOURS: Prix de la Société
des Arts Plastiques de Québec, 1956; Prix,
Concours des Murales, Musée des Beaux-Arts
de Montréal, 1957; Prix de l'Exposition "Print-
makers of Canada" Toronto, 1964/Award
from la Société des Arts Plastiques de Québec,
1956; Award, Mural Competition, Montreal
Museum of Fine Arts, 1957; Award, "Print-
makers of Canada" Exhibition, Toronto, 1964
MEDIUM: Eau-forte/Etching.

EX—4: "Exposition-recherche" avec/with
F. BOUCHARD, L. DAZE, M. JOLICOEUR,
ITINERANTE/CIRCULATING: Galerie
Colline, Collège St-Louis-Maillet, Edmundston,
N.B. (2 XII—15 XII 72); Collège d'Alma, Qué.
(11 IV—15 IV 73).

GROUPE/GROUP: "Jeunes Peintres Québé-
cois".

EX—1: Galerie L'Apogée, St-Sauveur-des-Monts,
Qué. (25 VII—25 VIII 72).

GROUPE/GROUP: "International Graphics";
"Quatrième Biennale de la Gravure" Cracovie,
Pologne; "Grafik Biennale" Vienne; "Nor-
wegian International Print Biennale" Fredrik-
stad, Norvège; "Association des Graveurs du
Québec à l'Etable" Musée des Beaux-Arts de
Montréal; "Deuxième Biennale Internationale
de la Gravure" Frechen, Allemagne; "Expo-
sition Internationale de la Gravure" Sao
Paulo, Brésil; "10th Show of Canadian Artists"
Thomas More Institute, Montréal; "Society of
Canadian Painter-Etchers and Engravers" Lon-
don, Ont.

1 LANDORI *The Crowd Is People I, 1968*

2 LANDSLEY *Valley Entrance No. 1, 1972*
 (57" x 69")

3 LAMBERT *(5" x 7")*

4 LALIBERTE *Port au Persil, Comté Charle-
 voix* Photo: W.B. Edwards

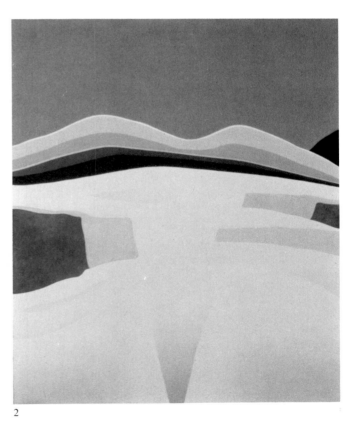

1

2

3

4

PATRICK LANDSLEY (Painting/Peinture) 1926, Winnipeg LIVES/HABITE: Ste-Agathe-des-Monts, Qué. TRAINING/FORMATION: Winnipeg School of Art; Montreal Museum of Fine Arts; Académie Montmartre, Paris; Académie Ranson, Paris AWARDS & HONOURS/PRIX & HONNEURS: Canada Council Grants, 1966, 1967, 1970; Prize, Annual Winnipeg Show, 1955/Bourses du Conseil des Arts du Canada, 1966, 1967, 1970; Prix, Annual Winnipeg Show, 1955 TEACHES/ENSEIGNE: Sir George Williams Univ MEDIUM: Acrylic, oil/Acrylique, huile.

EX—1: "Patrick Landsley" Weissman Gallery, Sir George Williams Univ, Montreal (22 II—13 III 73).

GROUP/GROUPE: Studio 23, St-Sauveur-des-Monts, Qué. (17 VI—8 VII 72); Weissman Gallery, Sir George Williams Univ, Montreal (19 X—7 XI 72); "3rd Annual Exhibition of Contemporary Professional Quebec Artists" Dawson College, Montreal (5 IV—17 VI 73).

ROBERT LANGSTADT (Gravure/Print-making) 1912 HABITE/LIVES: Montréal MEDIUM: Estampe/Woodcut.

GROUPE/GROUP: "Canadian Printmakers Showcase"; Weissman Gallery, Sir George Williams Univ, Montréal (19 X—7 XI 72); Gallery 1640, Montréal; "Association des Graveurs du Québec à l'Etable" Musée des Beaux-Arts, Montréal.

GAETAN LAPOINTE (Peinture/Painting) 1950 HABITE/LIVES: Montréal FORMATION/TRAINING: CEGEP du Vieux-Montréal MEDIUM: Huile/Oil.

EX—4: Atelier du Théâtre sans façon, Montréal (13 X—15 X 72) GROUPE/GROUP: "Les Moins de 35".

LEOPOLD LAPRE (Gravure/Printmaking) 1933, Montréal HABITE/LIVES: Montréal FORMATION/TRAINING: Ecole des Beaux-Arts de Montréal MEDIUM: Sérigraphie, photogrammes/Serigraphy, photograms.

EX—2: "Photogrammes" avec/with **PHILIPPE LIM**, La Maison des Arts La Sauvegarde, Montréal (16 III—16 IV 73).

FRANCINE LARIVEE (Sculpture, conceptuel/Sculpture, conceptual) HABITE/LIVES: Montréal FORMATION/TRAINING: Ecole des Beaux-Arts, Montpellier, France; Ecole des Beaux-Arts de Montréal; Univ Québec, Montréal MEDIUM: Assemblages d'objets trouvés, plâtre, verre, film, etc./Assemblages of found objects, plaster, glass, film, etc. GROUPE/GROUP: "Les Moins de 35"; "Montréal plus ou moins" Musée des Beaux-Arts de Montréal (15 VI—15 VIII 72).

1 LANGSTADT *Broadsheet: No. 10*

2 LARIVEE *Environnement, 1972*

3 LAPRE

4 LAPOINTE *Pour que renaisse l'idée de l'absolu, 1971*

1

2

3

4

1 LAUZON *Petit Berceaux pour bercer les gros poupons, 1973*

2 LEDUC *Mai 68 (39" x 57")* Photo: Galerie Jolliet, Québec

3 LAU *Souvenir I, 1972*

4 LEMIEUX *Cosmos 201*

TIN-YUM LAU (Peinture, gravure/Painting, printmaking) 1941, Hong Kong HABITE/LIVES: Montréal FORMATION/TRAINING: Ecole des Beaux-Arts Linghai, Hong Kong; Institut technique des Beaux-Arts, Hong Kong; Ecole Nationale de Beaux-Arts, Paris; Ecole Supérieure des Arts Modernes, Paris MEDIUM: Sérigraphie, aquatinte, eau-forte, linogravure/Serigraphy, aquatint, etching, linocut.

EX—1: Les Editions du Jour, Montréal (oct/Oct 72); Galerie L'Ezotérik, Montréal (1 II—28 II 73).

EX—2: avec/with **P. TETREAULT**, Les Ateliers du Vieux Longueuil, Longueuil, Qué. (5 X—15 X 72).

GROUPE/GROUP: "Les Moins de 35"; "Canadian Printmakers Showcase"; "Graphic Drawings by Contemporary Chinese Artists" The Way Gallery, New York (10 VI—2 VII 72);

La Guilde Graphique, Montréal (nov/Nov 72); Galerie d'Art Benedek-Grenier, Québec (mars/Mar 73); "Exhibition of Contemporary Prints" City Museum Art Gallery, Hong Kong (30 III—29 IV 73); Gallery Pascal, Toronto (avril/Apr 73).

REAL LAUZON (Sculpture) 1945, Montréal HABITE/LIVES: St-Basile-le-Grand, Qué. FORMATION/TRAINING: Ecole des Beaux-Arts de Québec; Ecole des Beaux-Arts de Montréal; Univ Québec, Montréal MEDIUM: Bois peint, collage, photographies/Painted wood, collage, photographs GROUPE/GROUP: "Les Moins de 35"; "Exposition des Appariteurs" Univ Québec, Montréal; "Montréal plus ou moins" Musée des Beaux-Arts de Montréal (15 VI—15 VIII 72).

* **Voir section couleur/ See colour section**

FERNAND LEDUC (Peinture/Painting) 1916, Montréal HABITE/LIVES: Paris FORMATION/TRAINING: Ecole des Beaux-Arts de Montréal PRIX & HONNEURS/AWARDS & HONOURS: Prix aux Concours artistiques de la Province de Québec, 1957; Bourses du Conseil des Arts du Canada, 1959, 1967/Prize in the Province of Quebec Art Competition, 1957; Canada Council Grants, 1959, 1967 MEDIUM: Huile/Oil. EX—1: Galerie Jolliet, Québec (juin/June 72); Galerie III, Montréal (oct/Oct 72); Centre Culturel canadien, Paris (mai/May 73).

MAURICE LEMIEUX (Sculpture) Valleyfield, Qué. HABITE/LIVES: Montréal FORMATION/TRAINING: Ecole des Arts et Métiers de Valleyfield MEDIUM: Aluminium mousse/Foam aluminum EX—2: avec/with **R. NADON**, La Maison des Arts La Sauvegarde, Montréal (17 XI 72—1 I 73).

ISTVAN LENDVAY (Painting/Peinture) 1929, Csorna, Hungary LIVES/HABITE: Toronto TRAINING/FORMATION: Budapest Univ, Hungary AWARDS & HONOURS/ PRIX & HONNEURS: Ontario Government Purchase Award, 1971/Prix d'acquisition du gouvernement ontarien, 1971 MEDIUM: Oil, copper, powdered stone/Huile, cuivre, pierre pulvérisée.

EX–1: Yespersen–Kay Systems, Toronto and New York (June/juin–Dec/déc 72); Ontario Association of Architects, Toronto (Jul/juil–Aug/août 72); Ontario Association of Architects, Toronto (Feb/févr 73).

GROUP/GROUPE: "Hadassah Art Show" Toronto (Apr/avril 73).

HUGH LEROY (Sculpture) 1939, Montreal LIVES/HABITE: Montreal TRAINING/FORMATION: Montreal Museum of Fine Arts; Sir George Williams Univ, Montreal AWARDS & HONOURS/PRIX & HONNEURS: Canada Council Grants, 1966, 1967, 1968; Canada Council Senior Arts Grant, 1969; First Prize, Sculpture, "Perspective '67" Toronto, 1967; UNESCO Fellowship, 1968/Bourses du Conseil des Arts du Canada, 1966, 1967, 1968; Bourse de travail libre du Conseil des Arts du Canada, 1969; Premier Prix, Sculpture, "Perspective '67" Toronto, 1967; Bourse de l'UNESCO, 1968 MEDIUM: Fiberglas, steel/Fibre de verre, acier.

EX–1: Waddington Galleries, Montreal (14 VI–1 VII 72) GROUP/GROUPE: "Plastic Fantastic".

RITA LETENDRE (Gravure, peinture/Printmaking, painting) 1928, Drummondville, Qué. HABITE/LIVES: Toronto FORMATION/ TRAINING: Ecole des Beaux-Arts de Montréal PRIX & HONNEURS/AWARDS & HONOURS: "Prix de la Jeune Peinture" Montréal, 1959; Prix Rodolphe de Repentigny, Montréal, 1960; Bourses de voyage du Conseil des Arts du Canada (France, Italie) 1962, 1963; Premier Prix de Peinture, Exposition Canadienne Nationale, 1968; Premier Prix de Peinture, Ontario Society of Artists, 1970; Bourse de travail libre du Conseil des Arts du Canada, 1971/ "Prix de la Jeune Peinture" Montréal, 1959; Rodolphe de Repentigny Prize, Montréal, 1960; Canada Council Travel Grants (France, Italy) 1962, 1963; First Prize, Painting, Canadian National Exhibition, 1968; First Prize, Painting, Ontario Society of Artists, 1970; Canada Council Senior Fellowship, 1971 MEDIUM: Sérigraphie, acrylique/Silkscreen, acrylic.

EX–1: Malvina Miller Gallery, San Francisco, Calif. (1972); Gallery Moos, Toronto (16 IX–3 X 72); DeVorzon Gallery, Los Angeles, Calif. (1972); Arwin Galleries, Detroit, Mich.; Musée d'Art Contemporain, Montréal (5 XI–10 XII 72).

EX–2: avec/with **K. ELOUL**, Faculty of Architecture, Univ Toronto (4 I–15 I 73).

EX–3: avec/with **K. ELOUL, B. GOODWIN**, Bau-Xi Gallery, Vancouver (28 VIII–9 IX 72).

GROUPE/GROUP: "Artario '72"; "Canadian Printmakers Showcase"; "Sources III" Cranbrook Academy Art Gallery, Cranbrook, Mich. (1972); "18th National Print Show" Brooklyn Museum, New York (1972); "Process".

1 LETENDRE *Zoor, 1972 (48" x 72")* Photo: T.E. Moore for Gallery Moos, Toronto

2 LEROY *Bird, 1972 (30' x 3'6")* Photo: Waddington Galleries, Montreal

3 LENDVAY *Northern Mirage, 1972*

1

2

3

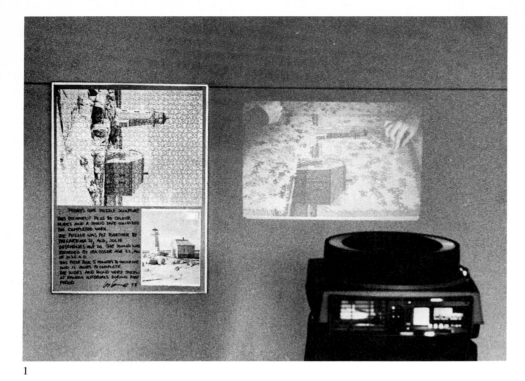

1

2

3

LES LEVINE (Conceptual/Conceptuel) 1935, Dublin, Ireland LIVES/HABITE: Halifax and New York TRAINING/FORMATION: Central School of Arts and Crafts, London, Eng. MEDIUM: Silkscreen, photo-offset lithography, video etc./Sérigraphie, lithographie offset, vidéo etc.

EX–1: "Conceptual Decorative/Conceptuel décoratif" organized by The National Gallery/ organisée par La Galerie nationale CIRCULATING/ITINERANTE: Winnipeg Art Gallery, Winnipeg (15 VI–15 VII 72); Memorial Univ Art Gallery, St. John's, Nfld. (1 VIII–31 VIII 72).

EX–1: "Position: Neo-Dramatic Art Works" Fischbach Gallery, New York (Nov/nov 72); "The Troubles: An Artist's Document of Ulster" Finch College Museum of Art, New York (12 XII 72–25 II 73); "Close-Up" Galerie de Gestlo, Hamburg, West Germany (12 I–8 II 73); "Hearing and Other Things" Vehicle Art, Montreal (4 IV–8 IV 73); "Peggy's Cove" Isaacs Gallery, Toronto (14 IV–4 V 73).

GROUP/GROUPE: "Toronto Painting"; "Plastic Fantastic".

MARILYN LEVINE (Sculpture, ceramics/ Sculpture, céramique) 1935, Regina LIVES/ HABITE: Salt Lake City, Utah TRAINING/ FORMATION: Univ Alberta; Univ Saskatchewan, Regina; Univ California, Berkeley AWARDS & HONOURS/PRIX & HONNEURS: Canada Council Grants, 1968, 1970/Bourses du Conseil des Arts du Canada, 1968, 1970 MEDIUM: Leather, clay/Cuir, argile.

EX–1: Bernard Danenberg Galleries, New York (9 I–27 I 73).

GROUP/GROUPE: "SCAN"; Indianapolis Museum of Art (June/juin 72); "Looking West" A.C.A. Galleries, New York (Sept/sept–Oct/oct 72); "Cup Show" David Stuart Galleries, Los Angeles (Oct/oct 72); "A Decade of Ceramic Art, 1962–72" San Fransisco Museum of Art (Oct/oct–Nov/nov 72); "Regina Ceramics Now"; "Realism Now" New York Cultural Center (Dec/déc 72); Dunlop Art Gallery, Regina (9 XII 72–7 I 73); "Regina-Saskatoon Ceramics" Marquis Gallery, Univ Saskatchewan, Saskatoon (Jan/janv 73); "Fifth Annual Whitewater Ceramics Invitational" Crossman Gallery, Univ Wisconsin (Feb/févr 73); "Ceramic Objects"; "First Annual Kentucky Ceramic Invitational" Student Center Gallery, Lexington, Ky. (Mar/ mars 73); "N.C.E.C.A. Invitational" Art Gallery, Northern Arizona Univ, Flagstaff, Ariz. (Apr/avril 73).

1 L. LEVINE *Paint, 1969 (30' x 14')*
 Photo: Isaacs Gallery, Toronto

2 M. LEVINE *Jacket No. 8, 1972 (35" x 21" x 5 3/4")*

3 M. LEVINE *Black Boots, 1972 (lifesize)*

STANLEY LEWIS (Sculpture, printmaking/ Sculpture, gravure) 1930, Montreal LIVES/ HABITE: Montreal TRAINING/FORMA- TION: Montreal Museum of Fine Arts; Insti- tuto Allende, San Miguel de Allende, Mexico AWARDS & HONOURS/PRIX & HONNEURS: Elizabeth T. Greenshields Memorial Founda- tion Grants, 1956, 1957, 1958; National Art and Photography Exhibitions: Prize for Sculp- ture, 1960, Prize for stone-cut prints, 1962/ Bourses de la Fondation Commémorative Eli- zabeth T. Greenshields, 1956, 1957, 1958; Expositions Nationales d'Art et de Photogra- phie: Prix de sculpture, 1960, Prix de gravure sur pierre, 1962 MEDIUM: Stone-cut print- ing/Gravure sur pierre.

GROUP/GROUPE: "Graphisme"; "Estival 72" Galerie Espace, Montreal (Summer/été 72); "Staff Show" Saidye Bronfman Centre, Montreal (24 IX 72).

LIN CHIEN-SHIH (Painting, printmaking, calligraphy/Peinture, gravure, calligraphie) 1918, Canton, China LIVES/HABITE: Van- couver TRAINING/FORMATION: Sun Yat Sen Univ MEDIUM: Rice paper, Chinese mineral paints and inks/Papier de riz, pein- tures et encres minérales chinoises.

EX—1: Bau-Xi Gallery, Vancouver (16 X—2 XI 72) GROUP/GROUPE: Bau-Xi Gallery, Van- couver (Apr/avril 73).

ERNEST LINDNER (Painting, sculpture, draw- ing/Peinture, sculpture, dessin) 1897, Vienna, Austria LIVES/HABITE: Saskatoon TRAIN- ING/FORMATION: Self-taught/Autodidacte AWARDS & HONOURS/PRIX & HONNEURS: Canada Council Grants, 1959, 1966; "Print of the Year" Toronto, 1944/Bourses du Conseil des Arts du Canada, 1959, 1966; "Meilleure gravure de l'année" Toronto, 1944 MEDIUM: Watercolour, wood, pencil/Aquarelle, bois, crayon.

EX—1: "Drawings 1969-72" organized by/or- ganisée par Saskatoon Art Gallery CIRCULA- TING/ITINERANTE: Mendel Art Gallery, Sas- katoon; Norman Mackenzie Art Gallery, Regi- na; Winnipeg Art Gallery, Winnipeg; Agnes Eth- erington Art Centre, Kingston, Ont.; Burnaby Art Gallery, Burnaby, B.C.; Glenbow-Alberta Institute, Calgary; Beaverbrook Art Gallery, Fredericton; Confederation Art Gallery, Char- lottetown.

EX—2: With/avec **ROBERT BLACK**, Beaver- brook Art Gallery, Fredericton (Oct/oct 72).

EX—5: "Watercolour Painters from Saskatche- wan" with/avec **ROBERT HURLEY, RETA COWLEY, DOROTHY KNOWLES, ROBERT SYMONS,** organized by the National Gallery/ organisée par la Galerie Nationale CIRCULAT- ING/ITINERANTE: Moose Jaw Art Museum (15 V—15 VI 72); Burnaby Art Gallery (1 VII— 31 VII 72); Rothman's Art Gallery, Stratford, Ont. (15 VIII—15 IX 72); Dunlop Art Gallery, Regina (14 X—5 XI 72).

GROUP/GROUPE: "Saskatchewan Arts Board Exhibition"; "A June Show".

1 LIN *1973 No. 1*

2 LEWIS *Creation of Adam, 1970* *(27" x 15" x 7")*

3 LINDNER *Crouching Woman, 1971* *(21 1/2" x 29 1/2")* Photo: Glenbow- Alberta Institute, Calgary

4 LINDNER *Repose, 1971 (29 1/4" x 22 1/2")* Photo: Glenbow-Alberta Institute, Calgary

1

2

3

4

IAN LINTON (Drawing, painting/Dessin, peinture) 1948, Hamilton, Ont. LIVES/ HABITE: Hamilton, Ont. TRAINING/FOR-MATION: Self-taught/Autodidacte MEDIUM: Oil, charcoal, pastel/Huile, fusain, pastel.

EX—4: Three shows with/Trois expositions avec **R. NUDDS, W. NUDDS, J. CAVAEL,** Reos Art Gallery, Hamilton, Ont. (15 VIII— 15 IX 72); Reos Gallery (15 XII 72—15 I 73); Reos Gallery (15 III—31 V 73).

MARGARET LITTLE (Painting, printmaking/ Peinture, gravure) 1929 LIVES/HABITE: London, Ont. TRAINING/FORMATION: Vancouver School of Art; Victoria Art Gallery; Fanshawe College, London, Ont.; H.B. Beal Technical School, London, Ont. MEDIUM: Oil, acrylic, watercolour, etching, monoprint/ Huile, acrylique, aquarelle, eau-forte, mono-gravure.

EX—1: Glen Gallery, London, Ont. (25 IV— 17 V 73).

PAUL LIVERNOIS (Sculpture, peinture/ Sculpture, painting) 1948 HABITE/LIVES: Boucherville, Qué. FORMATION/TRAIN-ING: Univ Québec, Montréal MEDIUM: En-cre, acrylique, huile, plâtre/Ink, acrylic, oil, plaster.

EX—1: Galerie l'Apogée, St-Sauveur-des-Monts, Qué. (3 III—27 III 73).

EX—2: "Livernois" avec/with **LACELIN,** Ga-lerie d'Art Les Deux B, St-Antoine-sur-Riche-lieu, Qué. (2 XII—23 XII 72).

SIGRID LOCHNER (Painting, printmaking, hangings/Peinture, gravure, tapisseries) 1925, Dresden, Germany LIVES/HABITE: London, Ont. TRAINING/FORMATION: Painting Academy, Dresden, Germany MEDIUM: Oil, linocut, batik/Huile, gravure sur linoléum, ba-tik.

GROUP/GROUPE: "Stratford Artists Associa-tion Exhibition" Stratford, Ont. (4 VII—16 VII 72); "Western Fair Art Show" London, Ont. (8 IX—15 IX 72).

FRANCOIS LORTIE voir/see **NISKA**

1 LIVERNOIS

2 LOCHNER *Midnight Talk, 1971 (8" x 10")*

3 LINTON *Torso, 1972*

4 LITTLE *Poppies, 1973*

PIERRE LUSSIER (Peinture/Painting) 1945
HABITE/LIVES: Outremont, Qué. MEDIUM:
Huile/Oil.

EX–1: "Le Logge" Palazzo dei Priori, Assissi,
Italie (21 IX–31 IX 72).

HAROLD L. LYON (Painting/Peinture)
1930, Windsor, Ont. LIVES/HABITE: West-
bank, B.C. TRAINING/FORMATION: Mein-
zinger School of Art, Detroit, Mich.; Ontario
College of Art, Toronto MEDIUM: Oil/Huile.

EX–1: Leafhill Galleries, Victoria (16 VI–24
VI 72); T.H. Morgan Co. Ltd., Edmonton (17
IX–26 IX 72); Jack Hambleton Galleries Ltd.,
Kelowna, B.C. (12 X–21 X 72); Leafhill Gal-
leries, Victoria (11 XII–18 XII 72); Artists
Sales Gallery, Seattle, Wash. (8 XII–10 XII 72);
Gainsborough Galleries, Calgary (16 IV–23 IV
73).

ADRIANA LYSAK (Gravure/Printmaking)
1930, Ukraine HABITE/LIVES: Montréal
FORMATION/TRAINING: Sir George Williams
Univ, Montréal; Ecole des Beaux-Arts de Mon-
tréal MEDIUM: Plexiglas.

EX–1: "Assemblages et Gravures sur Plexi-
glas" Galerie de la Société des Artistes Pro-
fessionnels du Québec, Montréal (26 IV–12
V 73).

GROUPE/GROUP: "Square des Arts" Mont-
réal (3 VI 72); Salon de l'Agriculture, Place
Bonaventure, Montréal (15 IX–30 IX 72);
Salon des Métiers d'Art, Place Bonaventure,
Montréal (3 XII–23 XII 72); Salon Inter-
national de l'Art Libre, Paris (19 XI–5 XII 72);
"Graphics by Ukranian-Canadian Artists".

1 LUSSIER

2 LYON *Storm Thunder (24" x 48")*

3 LYSAK *Small Group (18" x 24")*

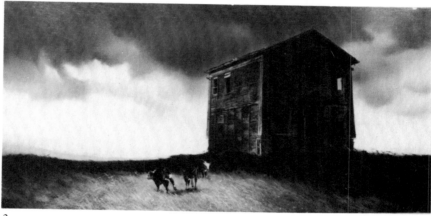

1

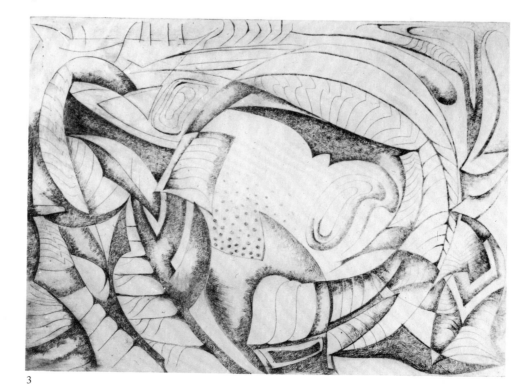

2

3

1

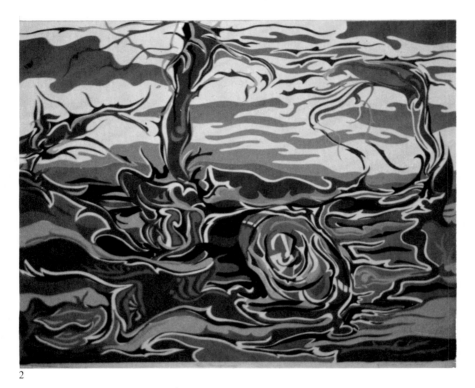

2

GERTRUDE J. MAARTENSE (Printmaking, sculpture/Gravure, sculpture) Netherlands LIVES/HABITE: Winnipeg TRAINING/FORMATION: Univ Alberta; Forum Art Institute, Winnipeg AWARDS & HONOURS/PRIX & HONNEURS: First Prize, Manitoba Society of Artists Exhibition, 1966; Second Prize, Graphics, Manitoba Society of Artists Exhibition, 1972/Premier Prix, Exposition Manitoba Society of Artists, 1966; Deuxième Prix, Art graphique, Exposition Manitoba Society of Artists, 1972 MEDIUM: Silkscreen/Sérigraphie.

EX–3: "Manisphere Members' Exhibition" with/avec **G. LEWKOWICH, E. CRINGAN,** Assiniboine Park Conservatory, Winnipeg (17 XII 72–17 I 73).

DON MABIE (Printmaking/Gravure) 1947, Calgary LIVES/HABITE: Toronto TRAINING/FORMATION: Alberta College of Art, Calgary; Instituto Allende, San Miguel de Allende, Mexico AWARDS & HONOURS/PRIX & HONNEURS: Canada Council Travel Grants, 1969, 1971; Canada Council Arts Bursaries, 1969, 1970; Purchase Award, 9th Annual Calgary Graphics Exhibition, 1969; Purchase Award, "Manisphere '69"; Saskatchewan Fine Art Exhibition Award, 1969; Purchase Award, 5th Burnaby Print Show, 1969/Bourses de voyage du Conseil des Arts du Canada, 1969, 1971; Bourses du Conseil des Arts du Canada, 1969, 1970; Prix d'acquisition, Neuvième Exposition Annuelle Calgary Graphics, 1969; Prix d'acquisition, "Manisphere '69"; Prix de l'Exposition des Beaux-Arts de Saskatchewan, 1969; Prix d'acquisition, Cinquième Exposition de Gravure de Burnaby, 1969 MEDIUM: Silkscreen, collage/Sérigraphie, collage.

EX–1: "Live Life" Artists' Gallery, Toronto (10 VIII–26 VIII 72).

GROUP/GROUPE: "SCAN"; "Kingston Spring Exhibition"; "Re-Cycle" Tokiwa Gallery, Tokyo (Sept/sept 72); "Manisphere '72" International Exchange Exhibition, Winnipeg (May/mai–June/juin 72).

MARJORY S. MACINTYRE (Painting/Peinture) 1898, St. John, N.B. LIVES/HABITE: St. John, N.B. TRAINING/FORMATION: Mount Allison Ladies' College; Art Students League, New York; Montreal Museum of Fine Arts MEDIUM: Acrylic, oil, collage, watercolour/Acrylique, huile, collage, aquarelle.

EX–1: "Collages" The Little Gallery, Univ New Brunswick, Fredericton (25 III–7 IV 73).

1 MABIE *Live Life Nos. 30 and 32 in combination–220 sections, 1972*

2 MAARTENSE *The Conspiracy, 1972 (13 3/4" x 17")*

3 MAARTENSE *Communication, 1972 (15 1/2" x 22")*

4 MacINTYRE *Still Life with Bread, 1967*

3

4

AILSA MARGUERITE MacKAY (Painting/Peinture) 1918, Manitoba LIVES/HABITE: Edmonton TRAINING/FORMATION: Univ Alberta; Univ Manitoba MEDIUM: Acrylic, oil, pastel/Acrylique, huile, pastel.

EX—1: Univ Alberta Art Gallery and Museum, Edmonton (26 VII—16 VIII 72).

KARL MacKEEMAN (Printmaking/Gravure) 1948, Halifax LIVES/HABITE: Devil's Island, N.S. TRAINING/FORMATION: Nova Scotia College of Art and Design MEDIUM: Lithography, etching, intaglio/Lithographie, eau-forte, intaille EX—1: "Graphics" Dalhousie Univ Student Union, Halifax (25 II—3 III 73).

ROBIN MacKENZIE (Conceptual/Conceptuel) 1938, Pickering, Ont. LIVES/HABITE: Pickering, Ont. AWARDS & HONOURS/PRIX & HONNEURS: Centennial Purchase Award, 1967; Canada Council Materials Grant, 1967; Canada Council Short Term Grants, 1968, 1969, 1971, 1972; Prizes, "Spring Show" Agnes Etherington Art Centre, Kingston, 1970, 1972/Prix d'aquisition du Centenaire, 1967; Bourse de frais du Conseil des Arts du Canada, 1967; Bourses de courte durée du Conseil des Arts du Canada, 1968, 1969, 1971, 1972; Prix, "Spring Show" Agnes Etherington Arts Centre, Kingston, 1970, 1972 MEDIUM: Natural and electronic systems, electrified wire pulse, steel wires/Systèmes naturels et électroniques; pouls de fil de fer électrifié; fils d'acier.

EX—1: Carmen Lamanna Gallery, Toronto (18 XI—7 XII 72); "Robin MacKenzie Exhibition" Anna Leonowens Gallery, Nova Scotia College of Art and Design, Halifax (23 III—7 IV 73).

GROUP/GROUPE: "Kingston Spring Exhibition"; Canadian National Exhibition, Toronto (Aug/août—Sept/sept 72); Carmen Lamanna Gallery, Toronto (14 XII—28 XII 72).

1

2

4

1 MacKAY *1972 (5' 9" diam.)* Photo: Univ Alberta Art Gallery, Edmonton

2 MacKAY *1972 (5' 10 1/2")* Photo: Univ Alberta Art Gallery, Edmonton

3 MacKEEMAN *4 Views (21" x 15 1/2")*

4 MacKENZIE *Untitled No. 1, 1972 (77" diam.)* Photo: Carmen Lamanna Gallery, Toronto

1

DONNA MacLEAN (Hangings, painting/ Tapisseries, peinture) 1914 LIVES/HABITE: Medicine Hat TRAINING/FORMATION: Ontario College of Art, Toronto MEDIUM: Oil, watercolour, charcoal, conté, pastel, ink, acrylic, batik/Huile, aquarelle, fusain, conté, pastel, encre, acrylique, batik.

EX−3: "The Great Plains−A Celebration of Light" with/avec **MARGARET MANN-BUTUK, JOAN VAN BELKUM**, organized by/organisée par Medicine Hat Gallery Association, Medicine Hat, Alta. CIRCULATING/ITINERANTE: Burnaby Art Gallery, Burnaby, B.C. (Feb/févr 72); Kamloops Community Centre, Kamloops, B.C. (Apr/avril 72); Penticton, B.C. (May/mai 72); Heritage Museum, Dartmouth, N.S. (Jan/janv−Feb/févr 73).

TOBY MacLENNAN (Conceptual, sculpture/ Conceptuel, sculpture) 1939, Detroit, Mich. LIVES/HABITE: Vancouver TRAINING/ FORMATION: Univ Michigan; Univ Mexico; Wayne State Univ; School of the Art Institute of Chicago; Nova Scotia College of Art and Design AWARDS & HONOURS/PRIX & HONNEURS: Canada Council Grants, 1971, 1972/Bourses du Conseil des Arts du Canada, 1971, 1972 MEDIUM: Performance. Metal, rock, cloth, wood, man, chickens, pigs' ears, fur, paint, rope, rubber, glass, photographs, plastic, geraniums etc./Représentation. Métal, pierre, tissu, bois, l'homme, poulets, oreilles de cochons, fourrure, peinture, corde, caoutchouc, verre, photographies, plastique, géraniums etc. GROUP/GROUPE: "SCAN".

MIRO MALISH (Painting, drawing/Peinture, dessin) 1944, Bratislava, Czechoslovakia LIVES/HABITE: Toronto TRAINING/FORMATION: Bratislava School of Ceramics, Czechoslovakia MEDIUM: Oil, ink/Huile, encre.

EX−1: La Cimaise Gallery, Toronto (27 V− 9 VI 72); La Cimaise Gallery (8 XII−23 XII 72) GROUP/GROUPE: La Cimaise Gallery (14 IV−10 V 73).

ELIZABETH MANLEY (Painting/Peinture) 1938, Winnipeg LIVES/HABITE: Dundas, Ont. TRAINING/FORMATION: Univ Manitoba; Banff School of Fine Arts, Banff, Alta.; Montreal School of Fine Arts; Chicago Art Institute MEDIUM: Oil, intaglio/Huile, intaille.

EX−1: Lillian Morrison Art Gallery, Toronto (22 IX−6 X 72); Galerie André Weil, Paris, France (4 IV−17 IV 73).

3

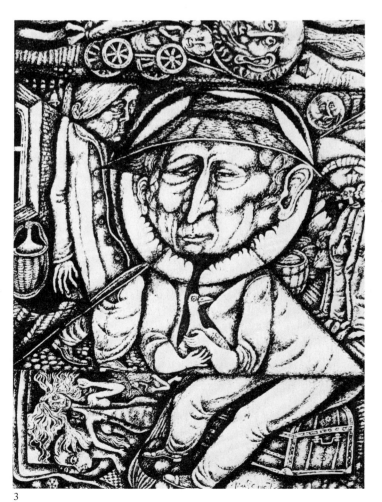

4

1 MacLENNAN

2 MANLEY *Anemones, 1972*

3 MALISH *The Miser who Stole the Bird (Detail)* Photo: La Cimaise Gallery, Toronto

4 MacLEAN

MARGARET MANN-BUTUK (Drawing, painting/Dessin, peinture) 1913 LIVES/HABITE: Medicine Hat, Alta. TRAINING/FORMATION: Banff School of Fine Art, Banff, Alta. MEDIUM: Ink, oil, watercolour, acrylic/Encre, huile, aquarelle, acrylique.

EX—3: "The Great Plains—A Celebration of Light" with/avec **JOAN VAN BELKUM**, **DONNA MacLEAN**, organized by/organisée par Medicine Hat Gallery Association, Medicine Hat, Alta. CIRCULATING/ITINERANTE: Burnaby Art Gallery, Burnaby, B.C. (Feb/févr 72); Kamloops Community Centre, Kamloops, B.C. (Apr/avril 72); Penticton, B.C. (May/mai 72); Heritage Museum, Dartmouth, N.S. (Jan/janv—Feb/févr 73).

PAULINE MARCOTTE (Peinture/Painting) 1920, St-Raymond, Qué. HABITE/LIVES: Québec PRIX & HONNEURS/AWARDS & HONOURS: Prix de dessin et de peinture à l'Ecole des Beaux-Arts de Québec/Drawing and Painting prizes, Ecole des Beaux-Arts, Québec MEDIUM: Sérigraphie, huile, acrylique, crayon, encre de Chine, fusain/Serigraphy, oil, acrylic, pencil, India ink, charcoal.

EX—1: Galerie du Palais Montcalm, Québec (29 II—4 III 73).

MARIE-ANASTASIE 1909, Mont-Laurier, Qué. HABITE/LIVES: Montréal FORMATION/TRAINING: Ecole des Beaux-Arts de Montréal; Institut des Arts Graphiques, Montréal PRIX & HONNEURS/AWARDS & HONOURS: Bourse de Recherches du ministère des Affaires culturelles du Québec, 1966, 1969/Research Grant, Quebec Ministry of Cultural Affairs, 1966, 1969 MEDIUM: Huile, encre, eau-forte/Oil, ink, etching.

EX—1: La Salle Claude Champagne, Montréal (24 V—23 VI 72); Centre Culturel Gosselin, Jonquière, Qué. (13 X—4 XI 72).

GROUPE/GROUP: "Salon des Métiers d'Art".

JACK MARKLE (Sculpture, conceptual/Sculpture, conceptuel) 1939 LIVES/HABITE: Toronto TRAINING/FORMATION: Self-taught/Autodidacte MEDIUM: Neon, toilet bowl, arborite, photos, flashing mechanism/Néon, bol de toilette, arborite, photo, mécanisme étincelant.

EX—4: The Electric Gallery, Toronto (Aug/août 72).

1 MARCOTTE

2 J. MARKLE *Goodbye* Photo: Electric Gallery, Toronto

3 MANN-BUTUK

4 MARIE-ANASTASIE *Eclatement (32" x 28")*

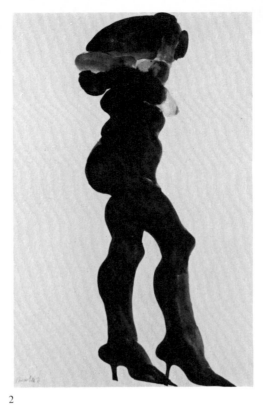

1

2

3

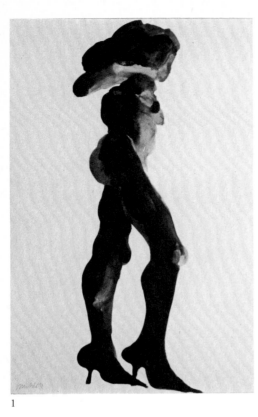

4

5

6

ROBERT MARKLE (Painting, drawing/ Peinture, dessin) 1936, Hamilton, Ont. LIVES/HABITE: Toronto MEDIUM: Coloured ink, acrylic, tempera/Encre de couleur, acrylique, détrempe.

EX–1: Isaacs Gallery, Toronto (18 V–6 VI 72).

GROUP/GROUPE: "Art for All"; "Toronto Painting"; "Annual Exhibition of Contemporary Canadian Art".

SAM MARKLE 1932, Winnipeg LIVES/HABITE: Toronto TRAINING/FORMATION: Self-taught/Autodidacte MEDIUM: Mixed media/Multi-média.

EX–5: The Electric Gallery, Toronto (Jul/juil 72).

LAUREAT MAROIS 1949, St-Ephrem-de-Beauce, Qué. HABITE/LIVES: Québec FORMATION/TRAINING: Ecole des Beaux-Arts de Québec; Univ Laval, Ste-Foy, Qué. MEDIUM: Sérigraphie/Serigraphy.

EX–1: Galerie d'Art Benedek-Grenier, Québec (4 III–14 III 73); Centre Culturel de Jonquière, Qué. (avril/Apr 73); La Maison des Arts La Sauvegarde, Montréal (26 V–26 VI 73).

GROUPE/GROUP: "Salon des Métiers d'Art"; "Association des Graveurs du Québec à l'Etable"; Musée des Beaux-Arts de Montréal (11 X–5 XI 72).

* **Voir section couleur/ See colour section**

1 R. MARKLE *High Yellow Stripper Series: Her Final Moment, 1971* Photo: Lyle Wachovsky for Isaacs Gallery, Toronto

2 R. MARKLE *High Yellow Stripper Series: Large Strut, 1971* Photo: Lyle Wachovsky for Isaacs Gallery, Toronto

3 R. MARKLE *High Yellow Stripper Series: Walking Close, 1971* Photo: Lyle Wachovsky for Isaacs Gallery, Toronto

4 S. MARKLE *Spreader, 1971* Photo: Electric Gallery, Toronto

5 S. MARKLE *Still Life No. 1, 1970* Photo: Electric Gallery, Toronto

6 MAROIS

1

2

MARCEL MAROIS (Tapisseries, gravure/
Hangings, printmaking) 1949, St-Ephrem-de-
Beauce, Qué. HABITE/LIVES: Québec
FORMATION/TRAINING: Ecole des Beaux-
Arts de Québec ENSEIGNE/TEACHES: Univ
Québec, Chicoutimi MEDIUM: Sérigraphie,
tapisserie/Serigraphy, tapestry.

EX—2: Maison Chevalier de la Place Royale,
Québec (juil/Jul 72).

GROUPE/GROUP: "Les Moins de 35"; Galerie
Benedek-Grenier, Québec (avril/Apr 73);
"Association des Graveurs du Québec à l'Etable"
Musée des Beaux-Arts, Montréal (11 X—5 XI
72).

3

DOUGLAS WILLIAM MARTIN (Painting,
printmaking, drawing/Peinture, gravure, dessin)
1948 LIVES/HABITE: Toronto MEDIUM:
Acrylic, oil/Acrylique, huile.

EX—1: Victoria College, Univ Toronto,
Toronto (2 X—20 X 72) GROUP/GROUPE:
Memorial Univ, St. John's, Nfld. (15 IX—12
X 73).

*** See colour section/ Voir section couleur**

JACQUES MARTIN (Painting, sculpture,
drawing/Peinture, sculpture, dessin) 1952,
Edmundston, N.B. LIVES/HABITE: Edmunds-
ton, N.B. TRAINING/FORMATION: Collège-
St-Louis-Maillet, Edmundston MEDIUM: Ink,
crayon, acrylic, felt pen, gouache, plaster/
Encre, crayon de cire, acrylique, plume feutre,
gouache, plâtre.

EX—3: with/avec **L. CHARETTE, R. SAU-
CIER**, Galerie Colline, Edmundston, N.B.
(17 II—2 III 73).

4

1 D. MARTIN *Atomic Crucifixion, 1971*

2 D. MARTIN *Sea Magic*

3 M. MAROIS *Médie (détail central), 1972
(30" x 72")*

4 J. MARTIN *L'Espace et Nous, 1972*
Photo: Studio Laporte for Gallery Colline,
Edmundston, N.B.

1

2

3

4

5

RON MARTIN (Painting/Peinture) 1943, London, Ont. LIVES/HABITE: Toronto TRAINING/FORMATION: H.B. Beal Technical School, London, Ont. MEDIUM: Acrylic/Acrylique.

EX–1: Carmen Lamanna Gallery, Toronto (30 XII 72–18 I 73).

EX–5: Carmen Lamanna Gallery, Toronto (21 VI–31 VII 72).

GROUP/GROUPE: Carmen Lamanna Gallery, Toronto (14 XII–28 XII 72); "Diversity".

CAROL MARTYN (Painting/Peinture) 1916, Stratford, Ont. LIVES/HABITE: Toronto TRAINING/FORMATION: Instituto Allende, San Miguel de Allende, Mexico AWARDS & HONOURS/PRIX & HONNEURS: Canada Council Grant, 1972/Bourse du Conseil des Arts du Canada, 1972 MEDIUM: Acrylic, pastel, mixed media/Acrylique, pastel, multi-média.

EX–1: "Carol Martyn" Aggregation Gallery, Toronto (31 III–19 IV 73).

GROUP/GROUPE: "Gallery Artists" Aggregation Gallery, Toronto (24 X–11 XI 72); "5th Annual Christmas Show" Aggregation Gallery, Toronto (5 XII–23 XII 72); "Ontario Society of Artists National Juried Show" Toronto (1973); "Inaugural Exhibition" Aggregation Gallery, Toronto (3 X–21 X 72); "Opening Group Show" Vehicule Art, Montreal (1972).

WILLIAM MASON-APPS (Sculpture, painting/Sculpture, peinture) 1928, Kent, Eng. LIVES/HABITE: Toronto TRAINING/FORMATION: Coventry Art School, Coventry, Eng.; Hammersmith Art School, Eng. MEDIUM: Oil, gouache/Huile, gouache.

GROUP/GROUPE: "Art of the Dance" O'Keefe Centre, Toronto (14 V–30 VI 73); "Canadian Opera Women's Committee Art Auction" Royal York Hotel, Toronto; "Concours International de la Palme d'Or des Beaux-Arts" International Arts Guild, Monte Carlo, Monaco (1973).

1 R. MARTIN *Bright Red No. 3, 1972 (84" x 72")* Photo: Carmen Lamanna Gallery, Toronto

2 MATHUR *Screen No. 4, 1972*

3 MARTYN *Time Track*

4 MASON-APPS *Group Dancing (24" x 30")*

5 MARTYN *Hate*

FLORENCE MATHUR (Painting/Peinture) 1934 LIVES/HABITE: Ancaster, Ont. TRAINING/FORMATION: Pratt Institute, New York; Academy of Fine Arts, Florence, Italy; Sir George Williams Univ, Montreal MEDIUM: Acrylic/Acrylique GROUP/GROUPE: "Annual Exhibition of Contemporary Canadian Art".

BRYAN MAYCOCK (Painting, drawing, printmaking/Peinture, dessin, gravure) 1944 LIVES/HABITE: Lambeth, Ont. TRAINING/FORMATION: Bath Academy of Art, Corsham, Eng. MEDIUM: Acrylic, crayon, lithography, wood, plexiglas, sponge, metal fittings, ink, rope, aluminum, watercolour, serigraphy, collage/Acrylique, crayon de cire, lithographie, bois, plexiglas, éponge, ferrures, corde, aluminium, aquarelle, sérigraphie, collage.

EX—1: "Recent Works" McIntosh Gallery, Univ Western Ontario, London, Ont. (10 I—4 II 73) GROUP/GROUPE: "SCAN"; "Canadian Printmakers Showcase"; "33rd Annual Western Ontario Art Exhibition" London, Ont. (10 I—4 II 73).

MICHEL Z. MAZUREK (Peinture, gravure, sculpture/Painting, printmaking, sculpture) 1941, Poland HABITE/LIVES: Outremont, Qué. FORMATION/TRAINING: Académie des Beaux-Arts, Breslau, Poland; Ecole des Beaux-Arts de Montréal; Sir George Williams Univ, Montréal MEDIUM: Détrempe, lithographie, estampe, huile, textiles, verre, encre, métal/Tempera, lithography, woodcut, oil, textiles, glass, ink, metal.

EX—1: "Zizanie" Galerie l'Ezotérik, Montréal (1 IX—30 IX 72) GROUPE/GROUP: "Foyer des Arts" T. Eaton Co Ltée, Montréal (avril/Apr 73).

CATHARINE McAVITY (Painting, drawing, printmaking/Peinture, dessin, gravure) 1915, Moncton, N.B. LIVES/HABITE: St. John, N.B. TRAINING/FORMATION: Mount Allison Univ, Sackville, N.B.; Sunbury Shores Arts and Nature Centre, St. Andrews, N.B. AWARDS & HONOURS/PRIX & HONNEURS: Purchase Awards, Univ New Brunswick Acquisition Exhibitions, 1972, 1973/Prix d'acquisition, Expositions-Ventes de l'Univ Nouveau Brunswick, 1972, 1973 MEDIUM: Acrylic, watercolour, etching, silkscreen, India ink, oil/Acrylique, aquarelle, eau-forte, sérigraphie, encre de Chine, huile.

EX—1: The Little Gallery, Univ New Brunswick, St. John, N.B. (1 X—14 X 72); Univ New Brunswick, Fredericton, N.B. (1 XI—22 XI 72).

GROUP/GROUPE: "Artists of the Province" Cassel Galleries, Fredericton, N.B. (Oct/oct—Nov/nov 72); "December Choice" Morrison Gallery, St. John, N.B. (4 XII—23 XII 72); "City Hall Purchase Exhibition" St. John, N.B. (29 I—10 II 73); "New Brunswick Artists '73" Cassel Galleries, Fredericton, N.B. (13 II—17 III 73); Art Centre, Univ New Brunswick, Fredericton, N.B. (18 IV—17 V 73); "Maritime Art Association Exhibition" Halifax, N.S. (May/mai 73).

1

2

3

4

1 McAVITY *Red by Blue, 1971 (36" x 48")*

2 McAVITY *Cryssalids, 1972 (22" x 28")*

3 MAZUREK *Jean Guy, 1971*

4 MAYCOCK *Red over Green Cubiform, 1970*

1

2

3

4

5

WILLIAM C. McCARGAR (Painting/Peinture) LIVES/HABITE: Regina TRAINING/FORMATION: Self-taught/Autodidacte MEDIUM: Oil/Huile EX—3: "Windmills, Wagons and Railroads" with/avec **F. MOULDING, F. CICANSKY**, Dunlop Art Gallery, Regina (10 II—4 III 73) GROUP/GROUPE: "Simpsons Centennial Exhibition" Regina (3 X—14 X 72).

JAMES ALEXANDER McCRAE (Painting, printmaking, sculpture/Peinture, gravure, sculpture) 1946, Toronto LIVES/HABITE: Toronto TRAINING/FORMATION: York Univ, Toronto; Ontario College of Art, Toronto MEDIUM: Watercolour, acrylic, lithography, linocut, woodcut, etching, bronze, cement, felt pen, pencil/Aquarelle, acrylique, lithographie, gravure sur linoléum, estampe, eau-forte, bronze, ciment, plume de feutre, crayon.

GROUP/GROUPE: "Scholarship Show" Ontario College of Art, Toronto (17 IV—18 IV 73).

WILLIAM McELCHERAN (Sculpture) 1927, Toronto LIVES/HABITE: Toronto TRAINING/FORMATION: Ontario College of Art, Toronto MEDIUM: Wood, bronze, stone, plastic, collage, reliefs, photographs/Bois, bronze, pierre, plastique, collage, relief, photographies.

EX—1: Roberts Gallery, Toronto (9 IV—29 IV 73).

GROUP/GROUPE: "Annual Exhibition of Contemporary Canadian Art"; "Art for All"; Sculptors' Society of Canada, Scarborough College, Toronto (5 XI—27 XI 72); Sculptors' Society of Canada, Toronto-Dominion Centre, Toronto (15 X—3 XI 72); "Artists Choice" Roberts Gallery, Toronto (Dec/déc 72).

6

7

8

MARIE McGILL (Painting, hangings/Peinture, tapisseries) 1926, Vancouver LIVES/HABITE: Vancouver TRAINING/FORMATION: Univ British Columbia; Vancouver School of Art; Douglas College, New Westminster, B.C.; International School of Art, Salzburg, Austria; König School of Art, Munich, Germany AWARDS & HONOURS/PRIX & HONNEURS: Best Painting and Best of Show, North Vancouver Arts Council Juried Show, 1971/ Meilleure Peinture et Prix d'excellence, Exposition-concours du North Vancouver Arts Council, 1971 MEDIUM: Acrylic, oil, watercolour, wool/Acrylique, huile, aquarelle, laine.

GROUP/GROUPE: "Fabric Arts Guild Juried Show" Vancouver (1972); New Westminster Arts Council (Oct/oct 72); "Frames & Things" Back Room Gallery, Victoria (Dec/déc 72); "Annual Juried Show of Fabric Arts" Vancouver Public Library, Vancouver (Mar/mars 73).

NORMAN McLAREN (Printmaking/Gravure) 1914, Sterling, Scotland LIVES/HABITE: Montreal TRAINING/FORMATION: Univ Montréal, Montréal AWARDS & HONOURS/ PRIX & HONNEURS: Medal from Royal Academy of Arts of Canada/Médaille de l'Académie Royale des Arts du Canada MEDIUM: Serigraphy/Sérigraphie.

EX-1: Gallery Pascal, Toronto (9 IX–21 IX 72).

1 McCRAE *Turn Me On*

2 McCARGAR *Two Sentinels*

3 McELCHERAN *Gogologo, 1973*

4 McELCHERAN *Ubi Homo Ibi Insula, 1973*

5 McELCHERAN *Vanitas Vanitatis, 1973*

6 McLAREN *Linescape, 1971 (20" x 26")*
Photo: La Guilde Graphique, Montreal

7 McLAREN *Airborne, 1971 (20" x 26")*
Photo: La Guilde Graphique, Montreal

8 McGILL *Olympic Peninsula No. 9*

1 MENSES Photo: Galerie Martal, Montreal

2 MELLES *Approaching Storm*

3 McLEAN *Green Meadows*

4 MELLES *Teardrop*

ROBERT McLEAN (Painting/Peinture) 1933, Wabamun Lake, Alta. LIVES/HABITE: Edmonton TRAINING/FORMATION: Univ Alberta MEDIUM: Oil, acrylic/Huile, acrylique.

EX—2: Hudsons Bay Co., Edmonton (Oct/oct 72).

GROUP/GROUPE: Edmonton Art Gallery (Nov/nov 72); Galerie Romanov, Edmonton (1 II—28 II 73); Edmonton Library (3 II—4 II 73).

HENK MELLES (Painting, sculpture, drawing/Peinture, sculpture, dessin) 1943, Netherlands LIVES/HABITE: Toronto TRAINING/FORMATION: Univ Michigan MEDIUM: Oil, ink, canvas, steel, plexiglas, copper, screen, wood, mosaic, bones/Huile, encre, toile, acier, plexiglas, cuivre, écran, bois, mosaïque, os.

EX—1: "Visible Traces" Patmos Gallery, Toronto (11 V—8 VI 73).

GROUP/GROUPE: "Hodgepodge" Patmos Gallery, Toronto (June/juin—Sept/sept 72); "Butterflies" Patmos Gallery (Nov/nov 72).

JAN MENSES (Painting, drawing/Peinture, dessin) 1933, Rotterdam, Netherlands LIVES/HABITE: Montreal TRAINING/FORMATION: Academy of Fine Arts, Rotterdam AWARDS & HONOURS/PRIX & HONNEURS: Prizes, Concours Artistiques de la Province de Québec, 1965, 1971; Award, "Perspective '67" Toronto, 1967; Hadassah Exhibitions, Montreal: First Prize, Painting, 1967, First Prize, Painting, 1969, Second Prize, Painting, 1970, First Prize, Painting, 1971; Tigert Award, Ontario Society of Artists, 1972; Canada Council Grants, 1966, 1967; Canada Council Senior Arts Fellowships, 1969, 1971; Purchase Award, "Survey '68" Montreal Museum of Fine Arts, 1968; Purchase Award, Musée d'Art Contemporain, Montreal, 1966; Purchase Award, "Imago Exhibition", Montreal, 1971/Prix aux Concours Artistiques de la Province de Québec, 1965, 1971; Prix, "Perspective '67", Toronto, 1967; Expositions Hadassah, Montréal: Premier Prix, Peinture, 1967, Premier Prix, Peinture, 1969, Deuxième Prix, Peinture, 1970, Premier Prix, Peinture, 1971; Prix Tigert, Ontario Society of Artists, 1972; Bourses du Conseil des Arts du Canada, 1966, 1967; Bourses de travail libre du Conseil des Arts du Canada, 1969, 1971; Prix d'acquisition, "Survey '68", Musée des Beaux-Arts de Montréal, 1968; Prix d'acquisition, Musée d'Art Contemporain, Montréal, 1966; Prix d'acquisition, "Imago Exhibition" Montreal, 1971 MEDIUM: Oil, acrylic, tempera, ink/Huile, acrylique, détrempe, encre.

EX—1: Galerie Martal, Montreal (14 XI—26 XI 72).

GROUP/GROUPE: Ontario Society of Artists "100 Years" Exhibition; "Art 3" Basel, Switzerland; Canadian National Exhibition, Toronto (Aug/août 72); "11th International Graphics Exhibition" Lugano, Switzerland.

MARIO MEROLA (Peinture, sculpture/Painting, sculpture) 1931, Montréal HABITE/ LIVES: Montréal FORMATION/TRAINING: Ecole des Beaux-Arts de Montréal; Ecole Supérieure des Arts Décoratifs de Paris, France PRIX & HONNEURS/AWARDS & HONOURS: Premier Prix, Concours pour l'exécution d'une murale à l'Hôtel de LaSalle, Montréal, 1951; Bourse du gouvernement français, 1952; Premier Prix, Concours pour l'exécution d'une murale au Pavillon du Canada à l'Exposition Universelle de Bruxelles, 1957; Bourses du Conseil des Arts du Canada, 1963, 1968; Bourse de recherches du ministère des Affaires culturelles du Québec, 1972/First Prize, Mural competition for the LaSalle Hotel, Montreal, 1951; Grant from the French government, 1952; First Prize, Mural competition for the Canadian Pavilion at the Brussels World's Fair, 1957; Canada Council Grants, 1963, 1968; Research Grant from the Quebec Ministry for Cultural Affairs, 1972 MEDIUM: Bois, polymère, acrylique, gouache, contre-plaqué/Wood, polymer, acrylic, gouache, plywood.

EX—1: Galerie de Montréal, Montréal (28 XI– 23 XII 72).

CLAIRE MEUNIER (Peinture/Painting) 1928, St-Denis-sur-Richelieu, Qué. HABITE/ LIVES: Montréal FORMATION/TRAINING: Ecole des Beaux-Arts de Montréal MEDIUM: Huile/Oil.

EX—1: La Maison des Arts La Sauvegarde, Montréal (5 I–5 II 73).

*** Voir section couleur/ See colour section**

HOLLY MIDDLETON (Painting, printmaking/ Peinture, gravure) 1922, Vernon, B.C. LIVES/HABITE: Vernon, B.C. TRAINING/ FORMATION: Univ Alberta; Winnipeg School of Art; Calgary School of Technology and Art; Slade School of Art, London, Eng.; Emma Lake Workshops, Emma Lake, Sask.; Banff School of Fine Arts, Banff, Alta. AWARDS & HONOURS/PRIX & HONNEURS: All-Alberta Award, 1964; Bronze Medal, Sculpture, Vancouver, 1964/Grand Prix de l'Alberta, 1964; Médaille de bronze, Sculpture, Vancouver, 1964 MEDIUM: Oil, watercolour, acrylic, serigraphy/Huile, aquarelle, acrylique, sérigraphie.

EX—1: "Figurative Painting" Middleton Gallery, Vernon, B.C. (22 IV–3 V 73) GROUP/ GROUPE: Middleton Gallery (1 II–15 II 73).

1 MEROLA *L'exposition–Galerie de Montréal, 1972* Photo: Gabor Szilasie

2 MEUNIER *Chasse galerie, 1971 (4' x 6')*

3 MIDDLETON *Dr. Paul Spring with Mary & Daniel*

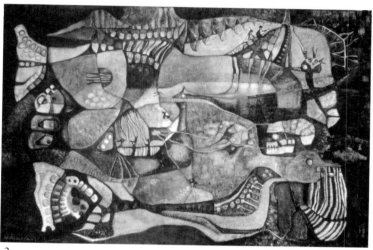

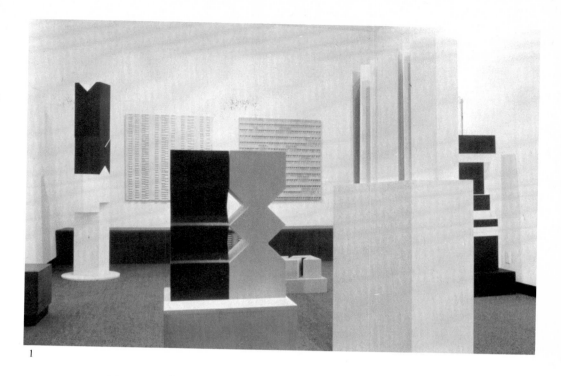

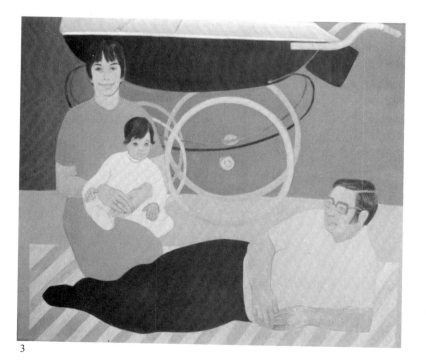

JOHN MILLER (Painting/Peinture) 1929
LIVES/HABITE: Montreal TRAINING/FOR-
MATION: Ealing Art School, London, Eng.;
Hornsey Art School, London, Eng.; Emma
Lake Workshops, Emma Lake, Sask. MEDIUM:
Acrylic, oil, glass mosaic/Acrylique, huile, mo-
saïque en verre.

EX—1: "Une Suite de 16 Illuminations en 4
Mouvements" Sir George Williams Univ Art
Gallery, Montreal (1 II—20 II 73).

GROUP/GROUPE: National Gallery, Ottawa
(juil/Jul 72).

RAILI MARJATTA MIKKANEN (Painting/
Peinture) Valkeakoski, Finland LIVES/HA-
BITE: Ottawa TRAINING/FORMATION:
Self-taught/Autodidacte MEDIUM: Oil/
Huile.

EX—1: Gallery 93, Ottawa (5 VI—30 VI 72).

EX—1: "Diabolic Elegies" CIRCULATING/
ITINERANTE: Memorial Univ Art Gallery, St.
John's, Nfld. (13 III—31 III 73); Art Gallery,
Gander International Airport, Nfld. (15 IV—
2 V 73); Arts and Culture Centre, Grand Falls,
Nfld. (15 V—9 VI 73).

VIRGINIA MITCHELL EX—1: Framecraft
Gallery, Edmonton (Apr/avril 73).

1 MILLER *My Cat Geoffrey (from "Movement No. 2")*

2 MIKKANEN *Funeral March for a Pappagallo*

3 MITCHELL *Mainstreet Sunday* Photo:
Edmonton Journal

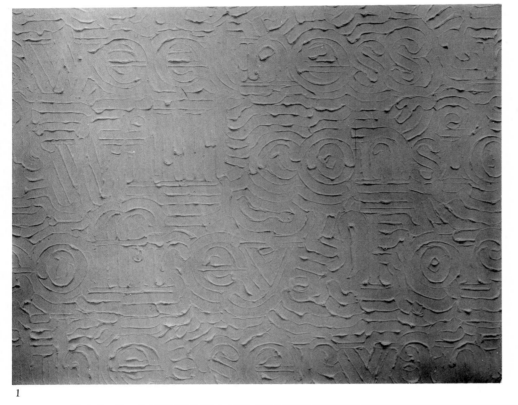

1

2

3

NUR-JEHAAN MOHAMED (Hangings, sculpture, painting/Tapisseries, sculpture, peinture) 1926, Capetown, South Africa LIVES/HABITE: Port Alberni, B.C. TRAINING/FORMATION: Self-taught/Autodidacte MEDIUM: Batik, wool collages, mixed media/Batik, collages en laine, multi-média.

EX–1: Mary Frazee Gallery, Vancouver (Nov/nov 72); Echo Centre, Port Alberni, B.C. (Nov/nov 72); Echo Centre (Apr/avril–May/mai 73).

GROUP/GROUPE: "Community Arts and Crafts Fair" Port Alberni, B.C. (June/juin 72); British Columbia Federation of Artists, Vancouver (Sept/sept 72); Toronto-Dominion Bank, Port Alberni, B.C. (Dec/déc 72); Queen Elizabeth Playhouse, Port Alberni, B.C. (Dec/déc 72).

1

GUIDO MOLINARI (Peinture, gravure/Painting, printmaking) 1933, Montréal HABITE/LIVES: Montréal ENSEIGNE/TEACHES: Sir George Williams Univ, Montréal MEDIUM: Acrylique, lithographie/Acrylic, lithography.

EX–1: "Recent Works" Memorial Univ Art Gallery, St. John's, Nfld. (22 XII 72–22 I 73).

EX–1: Galerie Jolliet, Québec (janv/Jan 73).

EX–5: avec/with **M. BARBEAU, D. BOLDUC, R. MARTIN, R. RABINOWITCH**, Carmen Lamanna Gallery, Toronto (21 VI–31 VII 72).

GROUPE/GROUP: "Process"; "Lithographs I".

*** Voir section couleur/ See colour section**

2

3

ANDRE MONGEAU (Peinture, sculpture/Painting, sculpture) 1947 HABITE/LIVES: Ste-Emélie-de-l'Energie, Qué. FORMATION/TRAINING: Ecole des Beaux-Arts de Québec; Ecole des Beaux-Arts de Montréal; Univ Québec, Montréal MEDIUM: Acrylique, aluminium, néon, moteurs électriques, bois etc./Acrylic, aluminum, neon, electrical motors, wood etc.

EX–1: La Maison des Arts La Sauvegarde, Montréal (sept/Sept 72) GROUPE/GROUP: "Les Moins de 35".

1 MOHAMED *Malay Quarters, Childhood Memory Scenes, Cape Town, S. Africa, 1973*

2 MOLINARI *Bi-triangulaire Gris-violet, 1972 (48" x 48")* Photo: Galerie Jolliet, Québec

3 MOLINARI *Multi-triangulaire, 1973 (61" x 79")* Photo: Galerie Jolliet, Québec

4 MONGEAU *Sculpture III*

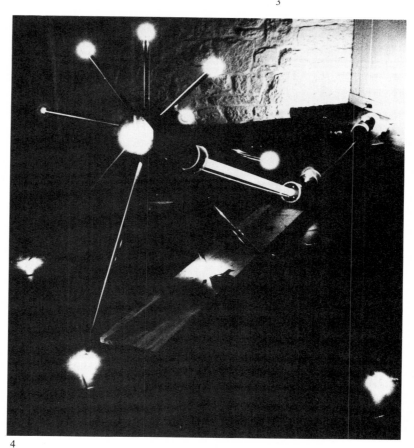

4

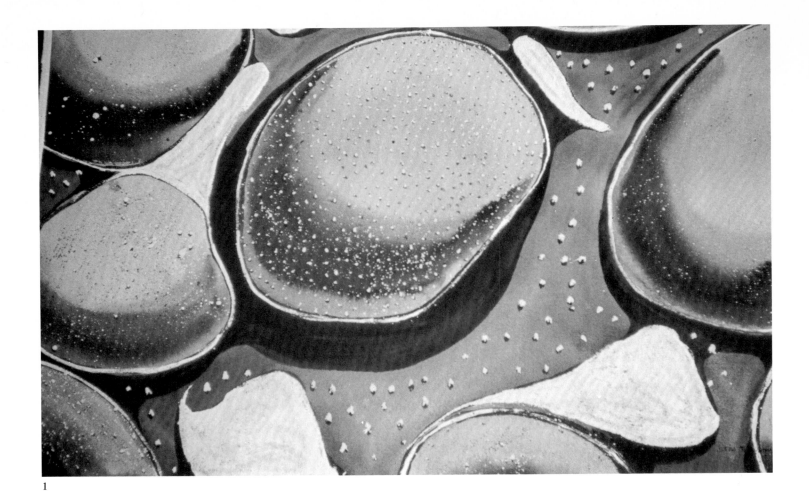

1

2

3

DAVID MOORE (Painting, printmaking/ Peinture, gravure) 1943 LIVES/HABITE: St-Hilaire, Qué. TRAINING/FORMATION: Trinity College, Dublin; Univ Quebec, Montreal; Sir George Williams Univ, Montreal AWARDS & HONOURS/PRIX & HONNEURS: National Prize for Graphic Arts, Ireland, 1972/ Prix National, arts graphiques, Irlande, 1972 MEDIUM: Acrylic/Acrylique.

EX—5: Galerie Jolliet, Quebec (Nov/nov 72) GROUP/GROUPE: Galerie Jolliet, Quebec (Oct/oct 72); "Eclosion 5" La Maison des Arts La Sauvegarde, Montreal (Apr/avril 73).

F. MOULDING (Sculpture) LIVES/HABITE: Regina MEDIUM: Miniatures in wood/Miniatures en bois EX—3: "Windmills, Wagons and Railroads" with/avec **W. McCARGAR, F. CICANSKY**, Dunlop Art Gallery, Regina (10 II— 4 III 73).

DORIS MURRAY (Painting/Peinture) 1916 LIVES/HABITE: London, Ont. TRAINING/ FORMATION: Smith College, Northampton, Mass. MEDIUM: Watercolour/Aquarelle.

EX—1: Glen Gallery, London, Ont. (16 IX— 14 X 72); Scarborough College, Univ Toronto, Toronto (21 X—26 X 72).

GROUP/GROUPE: "Southwest 33".

1 MURRAY *Sea Forms*

2 MOORE *Eclosion No. 4, 1972 (45" x 60")* Photo: Galerie Jolliet, Québec

3 MOULDING

ROBERT NADON (Peinture/Painting) 1938, Montréal HABITE/LIVES: Montréal FOR-MATION/TRAINING: Ecole des Beaux-Arts de Montréal; National Academy of Fine Arts, New York ENSEIGNE/TEACHES: Univ Laval, Ste-Foy, Qué. MEDIUM: Huile/Oil.

EX−1: Galerie Georges Dor, Longueuil, Qué. (26 IV−20 V 73).

EX−2: avec/with **MAURICE LEMIEUX**, La Maison des Arts La Sauvegarde, Montréal (17 XI 72−1 I 73).

GROUPE/GROUP: "Formoptic" Terre des Hommes, Montréal (juil/Jul 72).

JEANETTE NESTEL (Sculpture, painting/Sculpture, peinture) 1923, Poland LIVES/HABITE: Toronto TRAINING/FORMA-TION: Ontario College of Art, Toronto MEDIUM: Bronze, resin, stone, oil, cement/Bronze, résine, pierre, huile, ciment.

EX−1: Gallery Green, Barrie, Ont. (May/mai 73).

EX−3: with/avec **LEO KLAUSNER, TAMANA JAWORSKA**, Estée Gallery, Toronto (7 IV−28 IV 73).

GROUP/GROUPE: Estée Gallery, Toronto (Dec/déc 72); Seneca College, Toronto (Mar/

mars 73); "Aviva Art Show" Toronto (Mar/mars−Apr/avril 73); Simpsons Gallery, Toronto (Apr/avril 73); Evans Gallery, Toronto (May/mai 73); Estée Gallery, Toronto (May/mai 73).

N.E. THING COMPANY see/voir **IAIN BAXTER**

1 NESTEL *Whisper, 1972*

2 NESTEL *Woman of Managua*

3 NADON *Audience au plein de l'espace, 1972*

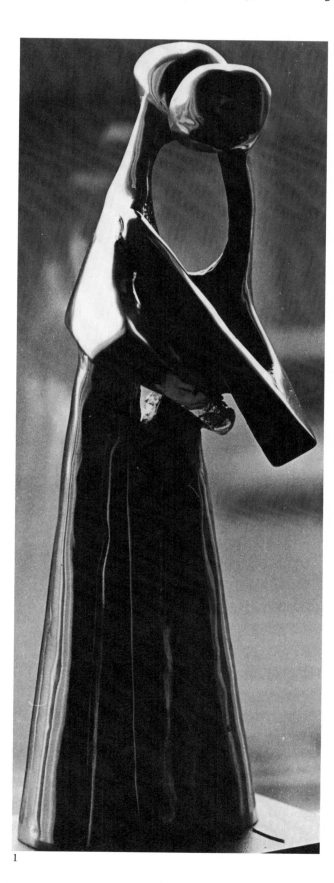

1

2

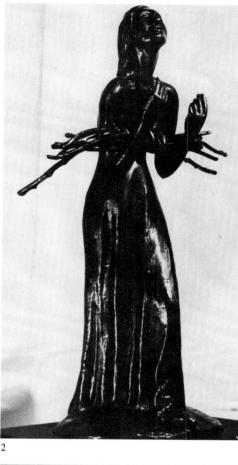

3

1

4

2

3

JEAN NEUHOF (Painting/Peinture) 1934, Maastricht, Netherlands LIVES/HABITE: Montreal MEDIUM: Acrylic, gouache/Acrylique, gouache EX–1: Galerie de la Société des Artistes Professionnels du Québec, Montreal (21 XI–16 XII 72); Waddington Galleries, Montreal (May/mai 73).

KEN NICE (Sculpture) 1949, Toronto LIVES/HABITE: Toronto TRAINING/FORMATION: Ontario College of Art, Toronto MEDIUM: Fiberglas/Fibre de verre.

GROUP/GROUPE: "Sculptors' Society of Canada" Toronto-Dominion Centre (15 X–3 XI 72); "Sculptors' Society of Canada" Scarborough College, Toronto (5 X–27 X 72); Shaw-Rimmington Gallery, Toronto (Jan/janv 73).

MAX NIFFELER (Sculpture) 1934, Lucerne, Switzerland LIVES/HABITE: Toronto TRAINING/FORMATION: Ecole des Beaux-Arts de Montréal; Montreal Museum School of Art and Design AWARDS & HONOURS/PRIX & HONNEURS: Eedee Design Award, Ontario Ministry of Industry & Tourism, 1972/Prix de dessin Eedee, Ministère de l'Industrie et du Tourisme de l'Ontario, 1972.

EX–4: Ontario Association of Architects, Toronto (Spring/printemps 73).

GROUP/GROUPE: "Art 3" Basel, Switzerland; Ontario Society of Artists "100 Years" Exhibition; "Exhibit '72" Beth Zion Synagogue, Montreal; "Estival '72" Galerie Espace, Montreal; "Exhibit '73" Beth Zion Synagogue, Montreal; Shaw-Rimmington Gallery, Toronto (1973); Gallery O, Toronto (1973).

1 NICE

2 NIFFELER *Cubus L, 1971*

3 NISKA *Oracle*

4 NEUHOF *Levels of Consciousness*

1

NISKA (FRANCOIS LORTIE) 1940 HA-BITE/LIVES: Mont-Tremblant, Qué. FOR-MATION/TRAINING: Autodidacte/Self-taught PRIX & HONNEURS/AWARDS & HONOURS: Prix de peinture, Septième Fête Internationale de la Côte d'Azur, Cannes, 1971; Lauréat, Quatrième Grand Salon International de Charleroi, Belgique; Lauréat, Haute Académie Littéraire et Artistique de France, 1971; Prix de Paris, 1971; Premier Prix de Peinture, Festival International d'Auvillar, France, 1971–72/Prize for painting, Seventh International Festival of the Côte d'Azur, Cannes, 1971; Laureate of the Fourth International Grand Salon of Charleroi, Belgium; Laureate of the High Academy of Literature and Arts of France, 1971; "Prix de Paris", 1971; First Prize, Painting, International Festival of Auvillar, France, 1971–72.

EX–1: La Chasse-Galerie, Toronto (9 IV–19 IV 72).

GROUPE/GROUP: "Exposition Internationale de Dessin et Gravure de l'Accademia Leonardo da Vinci" Rome (7 X–16 X 72); "Grand Prix International d'Art Contemporain de Monaco" Palais du Congrès, Monaco (15 XI–3 XII 72); "Sixième Exposition Internationale d'Amiens" Musée de Picardie, France; La Vecchia Bottega, Siena, Italie (3 III–14 III 73); "XXII Exposition Internationale d'Art Contemporain" Circeo, Italie (1972).

LOUIS DE NIVERVILLE (Painting/Peinture) 1933, Andover, Eng. LIVES/HABITE: Toronto TRAINING/FORMATION: Self-taught/Auto-didacte AWARDS & HONOURS/PRIX & HONNEURS: Toronto Art Directors' Club Gold Medal, 1960; Canada Council Senior Arts Fellowship, 1964/Médaille d'Or du Toronto Art Directors' Club, 1960; Bourse de travail libre du Conseil des Arts du Canada, 1964 TEACHES/ENSEIGNE: Humber College, Toronto MEDIUM: Sprayed acrylic/Acrylique pulvérisée.

EX–1: Jerrold Morris Gallery, Toronto (24 III– 7 IV 73).

*** Voir section couleur/See colour section**

1 M. NOEL *Femme au Rouge à Lèvres* *(24" x 20")*

2 DE NIVERVILLE *King of the Castle* *(60" x 96")*

3 DE NIVERVILLE *The Adjutant* *(36" x 48")*

2

3

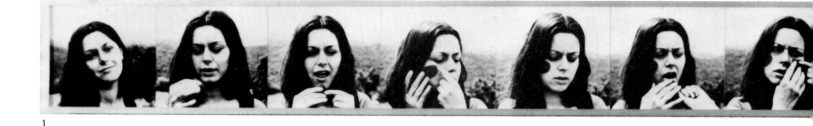

1

JEAN NOEL (Sculpture, gravure, conceptuel/ Sculpture, printmaking, conceptual) 1938, Montréal HABITE/LIVES: Montréal FOR-MATION/TRAINING: Ecole des Beaux-Arts de Montréal PRIX & HONNEURS/AWARDS & HONOURS: Bourse de recherches du Conseil des Arts du Canada, 1967/Canada Council Research Grant, 1967 MEDIUM: Plastique, toile, plexiglas, lithographie, banderoles/Plastic, canvas, plexiglas, lithography, banners.

EX—1: Carmen Lamanna Gallery, Toronto (3 III–22 III 73) GROUPE/GROUP: "Pack Sack"; "Diversity".

MARIE-JOSEE NOEL (Peinture/Painting) 1954, Montréal HABITE/LIVES: Ville Laval, Qué. FORMATION/TRAINING: CEGEP du Vieux-Montréal MEDIUM: Gouache, huile/ Gouache, oil GROUPE/GROUP: "Les Moins de 35".

***Illustration, page 139**

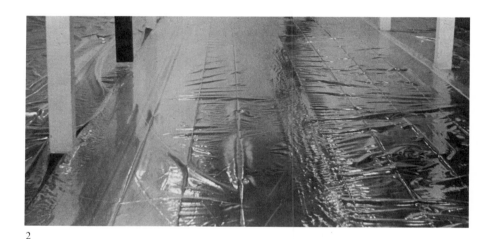

2

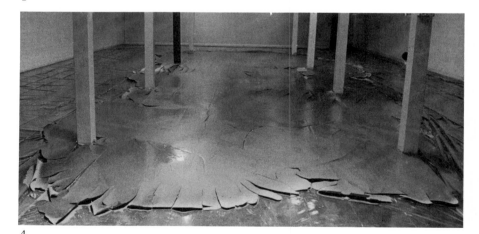

4

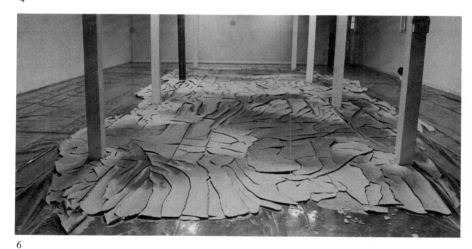

6

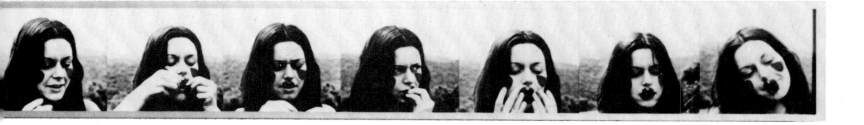

3

5

7

GUNTER NOLTE (Sculpture) 1938, Germany LIVES/HABITE: Montreal MEDIUM: Polyethylene, white clay, wooden beams/Polyéthilène, argile blanche, poutres de bois.

EX–1: A Space Gallery, Toronto (26 IX–7 X 72).

EX–3: with/avec **J. HEWARD**, **B. VAZAN**, Vehicule Art, Montreal (1 V–20 V 73).

GROUP/GROUPE: "Plastic Fantastic".

1 J. NOEL *Nadine et ses Gentils Coquelicots (7" x 132")* Photo: Carmen Lamanna Gallery, Toronto

2 NOLTE *No. 1: Installation Day*
Photo: A Space, Toronto

3 NOLTE *No. 2: Day After*
Photo: A Space, Toronto

4 NOLTE *No. 3: Day After That*
Photo: A Space, Toronto

5 NOLTE *No. 4: Fourth Day*
Photo: A Space, Toronto

6 NOLTE *No. 5: Fifth Day*
Photo: A Space, Toronto

7 NOLTE *No. 6: Last Day of the Show*
Photo: A Space, Toronto

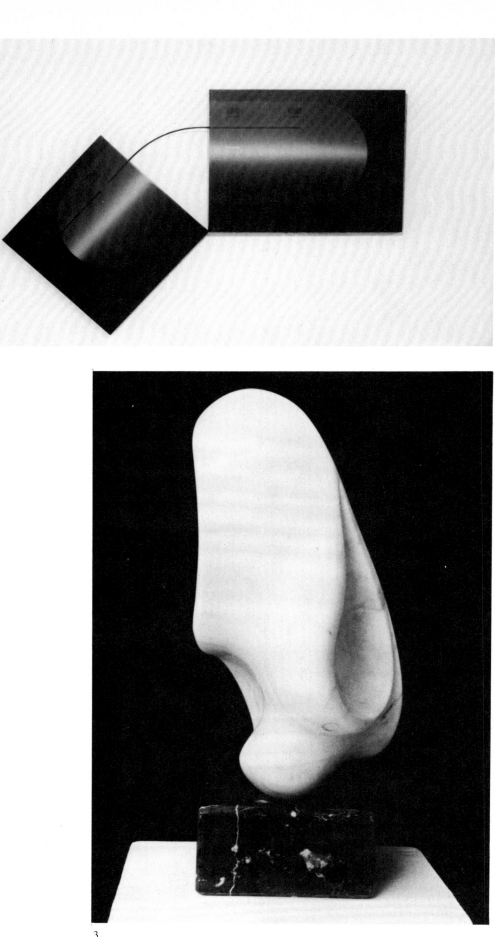

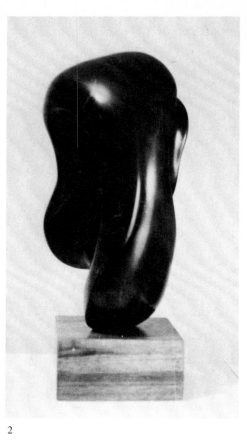

HARRY NOORDHOEK (Sculpture) 1909, Moers, Germany LIVES/HABITE: Carrara, Italy AWARDS & HONOURS/PRIX & HONNEURS: Sir Otto Beit Medal for Sculpture, 1965; Acquisition Prize, Provincial Museum of Quebec, 1966; Canada Council Grant, 1967; Canada Council Short Term Grant, 1968; Renato Colombo Gold Medal, Italy, 1972/Médaille Sir Otto Beit pour sculpture, 1965; Prix d'acquisition, Musée du Québec, 1966; Bourse du Conseil des Arts du Canada, 1967; Bourse de courte durée du Conseil des Arts du Canada, 1968; Médaille d'Or Renato Colombo, Italie, 1972 MEDIUM: Bronze, marble, onyx/ Bronze, marbre, onyx.

EX−1: Galerie Le Gobelet, Montreal (18 VII− 8 VIII 72); Accademia di Cultura e Arte "Renato Colombo" Serravalle, Italy (24 IX−30 IX 72).

GROUP/GROUPE: International Sculpture Section, "National Marble Show" Carrara, Italy (1 VII−31 VIII 72); "Nazionale Biennale di Pittura e Scultura" Oleggio, Italy (21 X− 10 XI 72).

RICHARD NORMANDIN (Gravure, peinture/ Printmaking, painting) 1934, Shawinigan, Qué. HABITE/LIVES: Trois-Rivières, Qué. FORMATION/TRAINING: Ecole des Beaux-Arts de Montréal MEDIUM: Acrylique/Acrylic.

EX−1: Centre Culturel de Shawinigan, Qué. (4 II−13 II 73); Galerie d'Art les Gens de mon Pays, Ste-Foy, Qué. (11 II−21 II 73).

EX−4: avec/with **N. BRODBECK, C. GASCON, J. LACROIX,** Galerie du Parc, Trois-Rivières, Qué. (9 II−20 II 73).

GROUPE/GROUP: "Images de la Mauricie".

1 NORMANDIN *Luminescence, 1972*
 (18" x 42")

2 NOORDHOEK *Black Crusader (35 cm. x*
 20 cm. x 15 cm.)

3 NOORDHOEK *Theme on Manifest Carrara*
 Marble (18" x 12" x 9")

1

2

RALPH NUDDS (Sculpture, painting/Sculpture, peinture) 1921, Blenheim, Ont. LIVES/ HABITE: Hamilton, Ont. MEDIUM: Wax, steel, bronze, plastic, stone, oil, acrylic/Cire, acier, bronze, plastique, pierre, huile, acrylique.

EX–1: "New Sculpture in Bronze and Plastic" Reos Gallery, Hamilton, Ont. (15 VII–15 VIII 72); Reos Gallery, Hamilton, Ont. (15 I–15 II 73).

EX–2: "Tribute to Pablo Picasso" with/avec **W. NUDDS**, Niagara Falls Art Gallery & Museum, Niagara Falls, Ont. (4 III–1 IV 73).

EX–4: Three exhibitions with/Trois expositions avec **W. NUDDS, J. CAVAEL, I. LINTON**, Reos Gallery, Hamilton, Ont. (15 VIII– 15 IX 72); Reos Gallery (15 XII 72–15 I 73); Reos Gallery (15 III–31 V 73).

WALLACE NUDDS (Painting, drawing/Peinture, dessin) 1919, Blenheim, Ont. LIVES/ HABITE: Hamilton, Ont. MEDIUM: Oil, charcoal, acrylic, ink/Huile, fusain, acrylique, encre.

EX–1: Reos Gallery, Hamilton, Ont. (15 VI– 15 VII 72).

EX–2: "Tribute to Pablo Picasso" with/avec **R. NUDDS**, Niagara Falls Art Gallery & Museum, Niagara Falls, Ont. (4 III–1 IV 73).

EX–4: Three exhibitions with/Trois expositions avec **R. NUDDS, J. CAVAEL, I. LINTON**, Reos Gallery, Hamilton, Ont. (15 VIII– 15 IX 72); Reos Gallery (15 XII 72–15 I 73); Reos Gallery (15 III–31 V 73).

1 W. NUDDS *Construction 15, 1972*

2 W. NUDDS *Construction 16, 1972*

3 R. NUDDS *Faith*

4 R. NUDDS *Sustenance*

3

4

OCHS *Warrior, 1969*

PETER PAUL OCHS (Sculpture) 1931, Germany LIVES/HABITE: Delta, B.C. TRAINING/FORMATION: Académie de la Grande Chaumière, Paris; State Academy, Hamburg; Vancouver School of Art; Univ British Columbia AWARDS & HONOURS/ PRIX & HONNEURS: Canada Council Grant, 1966/Bourse du Conseil des Arts du Canada, 1966 MEDIUM: Wood/Bois.

GROUP/GROUPE: Burnaby Art Gallery, Burnaby, B.C. (Autumn/automne 72); Mido Gallery, Vancouver (8 X–28 X 72).

COLOUR SECTION /SECTION COULEUR

1 MIEKE CADOT *Dolls* Photo: La Cimaise Gallery, Toronto

2 ROSS HEWARD *John & Elfie, 1970* Photo: La Cimaise Gallery, Toronto

3 SUSAN COLLACOTT *Old British Soldiers on the Patios of Home, 1972 (3' 6" x 4' 6")*

4 DIANE BRODERICK *Petite Sensations, 1972* Photo: Univ Alberta Art Gallery and Museum, Edmonton

5 LOUIS DE NIVERVILLE *Funk, 1972-73 (72" x 72")*

6 DOUG MARTIN *Breathing Sky*

7 PETER CLARKE *Arrow, 1972*

8 PETER CLARKE *Innominata, 1972*

9 BARBARA HALL *Bacon & Eggs*

10 JEAN BEDARD *La Muraille, 1972*

11 GUIDO MOLINARI *Position Triangulaire Bleu-Orange, 1972 (48" x 96")* Photo: Galerie Jolliet, Québec

12 GILLES BOISVERT *Le Joueur de Pool, 1973 (20" x 26")*

13 REAL LAUZON *La guérilla les gars, 1972*

14 REBECCA BURKE *A Walk on the Salt Flats with Old Buck, 1973 (30" x 36")*

15 GEOFFREY HOLDSWORTH *Church Anatomy, 1972 (10" x 11")*

16 BRIAN FISHER *Cadmium Steal: Yellow*

17 JACQUES HURTUBISE *Onibabette, 1972 (48" x 96")* Photo: Galerie Jolliet, Québec

18 CHRIS HAYWARD *Omega Flow Four, (26" x 26")*

19 GERSHON ISKOWITZ *Orange/Red, 1973 (85" x 68")* Photo: T. E. Moore for Gallery Moos, Toronto

20 LAUREAT MAROIS *Sérigraphie*

21 MICHAEL DURHAM *Chrysos Anthemum, 1972*

22 SYLVIA PALCHINSKI *Pork Picnic, 1972 (33" x 16")* Photo: Aggregation Gallery, Toronto

23 JAMES SPENCER *Mountain No. 2, 1972 (12" x 16")*

24 HAROLD TOWN *Vale Variation No. 3, 1972* Photo: Michael Neill for the Mazelow Gallery, Toronto

25 CLAIRE MEUNIER *La Chasse Galerie, détail, 1971 (4' x 6')*

26 ROBERT CARMICHAEL *Expecting to Fly, 1968 (24" x 30")*

27 ANNE FINES *Petrouchkc (37" x 41")*

28 ALEXANDER WYSE *Abandon Ship Mister, 1972*

29 MARVIN JONES *Foreign Policy, 1972*

30 VINCENT TANGREDI *Peter's Neon, 1972-73* Photo: Ontario College of Art, Toronto

31 TIM WHITEN *9 x 9*

32 JIM TILEY *Variation 16, 1972 (24" x 30")*

33 MILLY RISTVEDT *Phoenix, 1973 (9' x 9')*

34 KLAAS VERBOOM *Ecology, 1971 (36" x 40")*

35 LESLIE POOLE *Prometheus (4' x 20')*

1

2

3

4

5

6

7

8

9

10

11

12

13

14

15

16

17

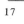

18

19

20

21

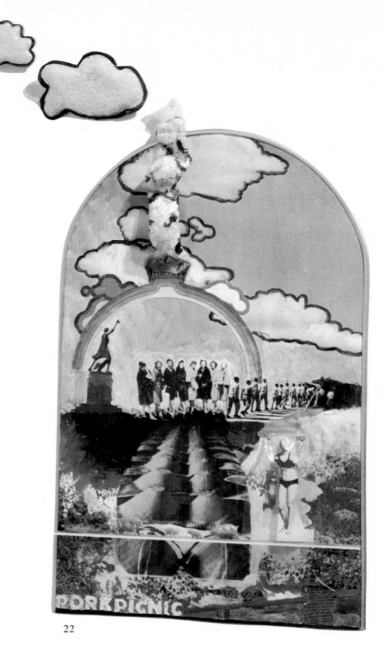

22

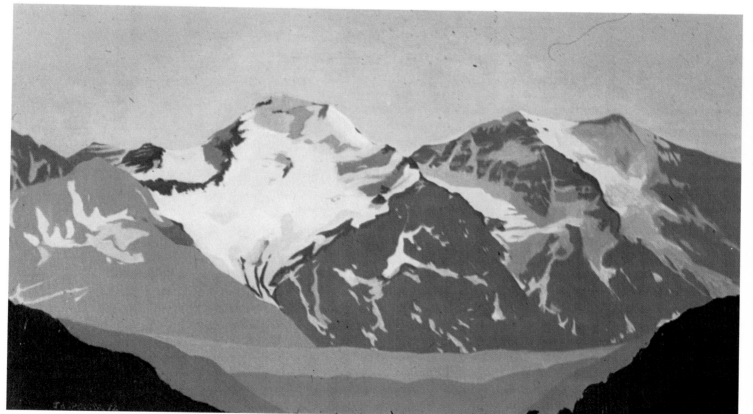

23

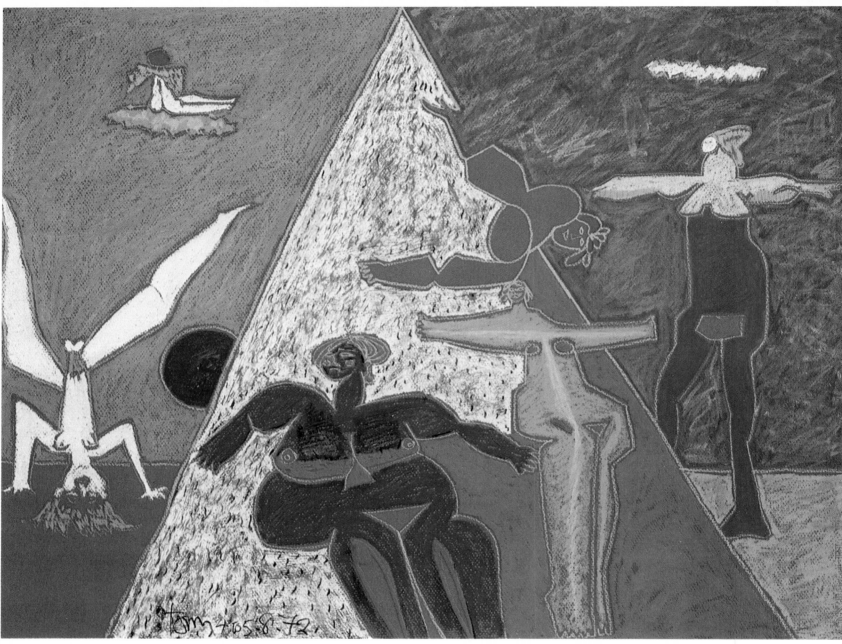

24

25

26

27

28

29

30

31

32

33

34

35

DAPHNE ODJIG see/voir **DAPHNE ODJIG BEAVON**

LEONHARD OESTERLE (Sculpture) 1915
LIVES/HABITE: Toronto TRAINING/FOR-
MATION: Kunstgewerbeschule, Zürich, Swit-
zerland MEDIUM: Limestone, bronze, soap-
stone, aluminum, volcanic rock/Pierre à chaux,
bronze, pierre de savon, aluminium, pierre vol-
canique.

EX–1: At the studio of the artist/A l'atelier de
l'artiste, Toronto (14 X–28 X 72).

EX–5: "Five Sculptors from Toronto" with/
avec **E. BOSZIN, W. LAWRENCE, J. MORO-
SAN, I. SZEBENYL**, Gallery Schonberger,
Kingston, Ont. (25 IV–9 V 73).

GROUP/GROUPE: "Sculptors' Society of
Canada" Scarborough College, Toronto (5 XI–
27 XI 72); "New Canadian Art Exhibition";
"Annual Exhibition of Contemporary Cana-
dian Art".

CLAUDIA O'FLYNN (Hangings, sculpture/
Tapisseries, sculpture) 1938, Kitchener, Ont.
LIVES/HABITE: Toronto TRAINING/FOR-
MATION: Self-taught/Autodidacte TEACHES/
ENSEIGNE: Toronto Board of Education, To-
ronto MEDIUM: Wool, wood/Laine, bois.

EX–1: Me & My Friends Gallery, Toronto (7
X–27 X 72); Evans Gallery, Toronto (1973);
Feedback Two Studio, Toronto (1973)
GROUP/GROUPE: Ontario Institute for
Studies in Education, Toronto (1973).

PAT O'HARA (Painting, drawing/Peinture,
dessin) Vancouver LIVES/HABITE: Van-
couver TRAINING/FORMATION: Univ
British Columbia; Vancouver School of Art;
School of Fine Arts, Banff, Alta. MEDIUM:
Acrylic, India ink/Acrylique, encre de Chine.

EX–1: "Old Vancouver" Exposition Gallery,
Vancouver (Nov/nov 72).

1 O'FLYNN Photo: Me and My Friends,
 Toronto

2 OESTERLE *Adam (49")*

3 O'HARA *Gastown–Gaolers Mews (16" x 24")*
 Photo: The Exposition Art Gallery, Vancouver

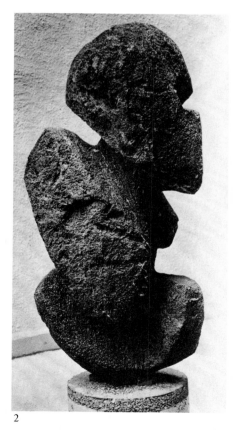

1

3

2

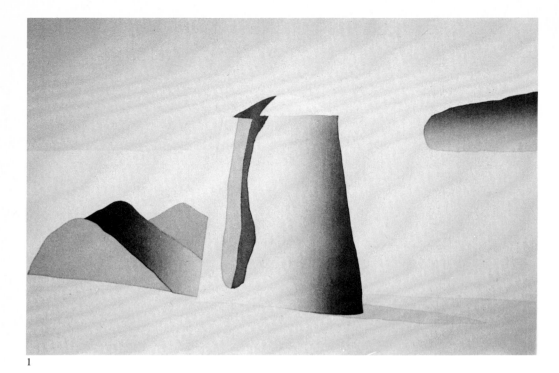

1

2

3

NELDA OMAN (Painting/Peinture) 1948, Michigan LIVES—HABITE: London, Ont. TRAINING/FORMATION: Michigan State Univ; New School of Art, Toronto MEDIUM: Acrylic/Acrylique.

EX—5: McIntosh Gallery, Univ Western Ontario, London, Ont. (25 X—26 XI 72) GROUP/GROUPE: "33rd Annual Western Ontario Exhibition".

TONI ONLEY (Painting, drawing, print-making/Peinture, dessin, gravure) 1928, Isle of Man LIVES/HABITE: Vancouver TRAINING/FORMATION: Douglas School of Art, Douglas, Isle of Man; Instituto Allende, San Miguel de Allende, Mexico TEACHES/ENSEIGNE: Univ British Columbia MEDIUM: Silkscreen, etching, pencil, oil, watercolour, acrylic, lithography/Sérigraphie, eau-forte, crayon, huile, aquarelle, acrylique, lithographie.

EX—1: Gallery Pascal, Toronto (4 XI—23 XI 72); "Ten Years of Painting—1962-72" Bau-XI Gallery, Vancouver (25 IX—6 X 72).

GROUP/GROUPE: "Prints by Painters of British Columbia"; "XXXVI Venice Biennale" (Summer/été 72); "Norwegian International Print Biennale" Fredrikstad, Norway; "Tenth International Exhibition of Graphic Art" Ljubljana, Yugoslavia (4 VI—31 VIII 72); "Canadian Printmakers Showcase"; "Art for All"; "Process"; "Spring Showing" Gallery 1640, Montreal (2 VI—10 VII 73).

OSHOOWEETOOK (Sculpture) LIVES/HABITE: Cape Dorset, N.W.T. MEDIUM: White stone/Pierre blanche EX—1: Gallery of Eskimo Art, Canadian Guild of Crafts, Montreal (Mar/mars 73).

PETER OSICKA (Painting, printmaking/Peinture, gravure) 1950, Czechoslovakia LIVES/HABITE: London, Ont. TRAINING/FORMATION: Fanshawe College, London, Ont. MEDIUM: Serigraphy, lithography, acrylic/Sérigraphie, lithographie, acrylique.

EX—1: "London Girl" Chimo House Art Gallery, London, Ont. (Aug/août 72).

GROUP/GROUPE: "Graphex I" "33rd Annual Western Ontario Exhibition"; "Progress 7" Trajectory Gallery, London, Ont. (May/mai 73).

1 ONLEY *San Carlos Tower (11 1/4" x 15 1/4")*
 Photo: Gallery Pascal, Toronto

2 OSICKA *London Girl*

3 OMAN *No. 3, 1972 (8' x 6')*

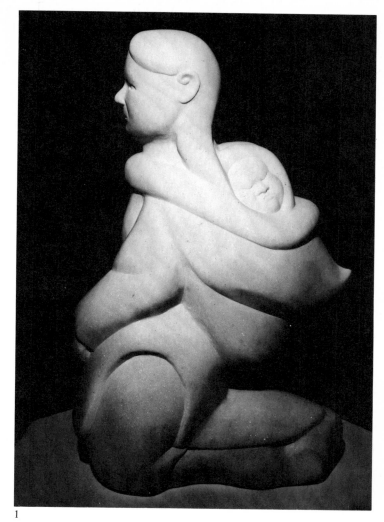

EUGENE OUCHI (Printmaking, painting/ Gravure, peinture) 1943, Vernon, B.C. LIVES/HABITE: Dundas, Ont. TRAINING/ FORMATION: Alberta College of Art, Calgary MEDIUM: Serigraphy, etching, embossing, graphite/Sérigraphie, eau-forte, embossé, mine de plomb.

EX–3: "Three Young Canadians" with/avec **G. ZELDIN, J. SPENCER,** Art Gallery of Brant, Brantford, Ont. (7 IX–1 X 72).

GROUP/GROUPE: "Canadian Printmakers Showcase"; "Burnaby Print Show"; "International Graphics"; "XXXVI Venice Biennale" (Summer/été 72); "Graphex I"; "The Great Canadian Super Show of Great Canadian Ideas"; "Western Canada" Gallery 1640, Montreal (3 III–31 III 73).

VIOLET OWEN (Drawing, painting/Dessin, peinture) 1930, Edmonton LIVES/HABITE: Edmonton TRAINING/FORMATION: Ontario College of Art, Toronto; Vancouver School of Art MEDIUM: Chalk, acrylic/Craie, acrylique.

EX–2: with/avec **M. GREENSTONE,** Nancy Poole's Studio, London, Ont. (27 V–27 VI 72).

EX–3: with/avec **M. GREENSTONE, A. VARGA,** Nancy Poole's Studio, Toronto (3 IX–27 IX 72).

GROUP/GROUPE: "West '71"; "Stephen Greene's Workshop" Edmonton Art Gallery (Oct/oct 72); "Directors Choice" Edmonton Art Gallery (Nov/nov 72).

ARIJA OZOLS (Painting/Peinture) Latvia LIVES/HABITE: Toronto TRAINING/FORMATION: Univ Los Andes, Venezuela MEDIUM: Acrylic, oil/Acrylique, huile EX–1: "Retrospective" Niagara Falls Art Gallery & Museum, Niagara Falls, Ont. (6 V–1 VI 73).

1 OSHOOWEETOOK *Mother and Child* Photo: Innuit Gallery, Toronto

2 OZOLS *Under the Ocean*

3 OWEN *Nude No. 5, 1971*

4 OUCHI *Made in Canada, 1971 (23" x 30")*

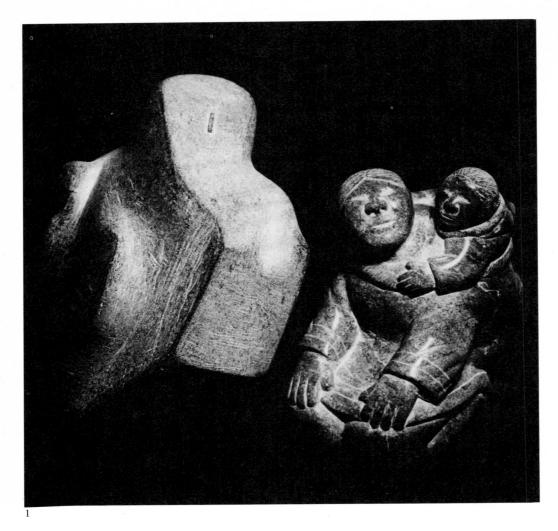

1

ANDREE PAGE (Tapisseries, sculpture/Hangings, sculpture) 1951, Baie-Comeau, Qué. HABITE/LIVES: St-François, Qué. FORMATION/TRAINING: CEGEP de Ste-Foy, Qué.; Univ Québec, Montréal MEDIUM: Plexiglas, tiges de métal, tissu, bois, laine, plumes/Plexiglas, metal rods, cloth, wood, wool, feathers.

EX—2: "Les Follies de Deux Jeunes Filles Bien" avec/with **L. CORRIVEAU**, Galerie Média, Montréal (11 IV—28 IV 73).

GROUPE/GROUP: "Les Moins de 35"; "Exposition des Caisses Populaires" Baie-Comeau, Qué.

SYLVIA PALCHINSKI (Sculpture, hangings, printmaking, drawing/Sculpture, tapisseries, gravure, dessin) 1946, Regina LIVES/HABITE: Toronto TRAINING/FORMATION: Alberta College of Art, Calgary; Instituto Allende, San Miguel de Allende, Mexico AWARDS & HONOURS/PRIX & HONNEURS: Outstanding Entry Award, Canadian Guild of Crafts Competition, Toronto, 1969; Canada Council Short-term Grant, 1971/Prix de l'oeuvre extraordinaire, Concours de la Guilde Canadienne des Métiers d'Art, Toronto, 1969; Bourse de courte durée du Conseil des Arts du Canada, 1971 MEDIUM: Stuffed canvas, stuffed satin, plastic, nylon, acrylic, serigraphy, mail art/Toile rembourée, satin rembourée, plastique, nylon, acrylique, sérigraphie, art par la poste.

EX—4: "Images: Earth/Water/Sky" with/avec **E. BARTRAM**, **B. JORDAN**, **R. SINCLAIR**, Aggregation Gallery, Toronto (19 V—14 VI 73).

GROUP/GROUPE: "SCAN"; "Postal Exhibition" Midland Group Gallery, Nottingham, Eng. (Oct/oct 72); "Inaugural Exhibition" Aggregation Gallery, Toronto (24 X—11 XI 72); "13th Annual Calgary Graphics Exhibition" Calgary (26 III—13 IV 73).

*** See colour section/ Voir section couleur**

JOHN PANGNARK (Sculpture) 1920 LIVES/HABITE: Eskimo Point, N.W.T. MEDIUM: Black stone/Pierre noire GROUP/GROUPE: "Sculpture/Inuit"; Lippel Gallery, Montreal (Oct/oct 72).

2

1 PANGNARK *Mother and Child*
 Photo: Lippell Gallery, Montreal

2 PAGE *Grape violacée, 1972*

1

2

3

1 PALCHINSKI *Sky Icon, 1972 (36" x 14" x 4 1/2")* Photo: Aggregation Gallery, Toronto

2 PALCHINSKI *Cloud Drawer, 1973 (13" x 10" x 3 1/2")* Photo: Aggregation Gallery, Toronto

3 PALCHINSKI *Intermittent Clouds, 1972 (51" x 18" x 20")* Photo: Aggregation Gallery, Toronto

DANIEL DUANE PANKO (Painting/Peinture) 1937, Fir Mountain, Sask. LIVES/HABITE: Saskatoon TRAINING/FORMATION: Saskatchewan Technical Institution, Moose Jaw, Sask. MEDIUM: Oil, acrylic/Huile, acrylique.

EX—2: with/avec DON PANKO, Thomas More Gallery, Saskatoon (15 IX—15 X 72).

GROUP/GROUPE: Mendel Art Gallery, Saskatoon (Dec/déc 72).

DON PANKO (Painting/Peinture) 1937, Fir Mountain, Sask. LIVES/HABITE: Saskatoon TRAINING/FORMATION: Saskatchewan Technical Institute, Moose Jaw, Sask. MEDIUM: Oil, acrylic/Huile, acrylique.

EX—2: with/avec DUANE PANKO, Thomas More Gallery, Saskatoon(15 IX—15 X 72).

LOUISE PANNETON (Tapisseries/Hangings) 1926, Trois-Rivières, Qué. HABITE/LIVES: Trois-Rivières, Qué. FORMATION/TRAINING: Univ Québec; Académie Julian, Paris MEDIUM: Laine/Wool EX—1: Galerie d'Art les Gens de mon Pays, Ste-Foy, Qué. (20 XI—29 XI 72).

LEONARD PARENT voir/see BASQUE

EVLYN PAYTON (Painting/Peinture) LIVES/HABITE: Toronto MEDIUM: Polymer, crushed rock, casein, conté, acrylic, oil/ Polymère, pierre concassée, caséine, conté, acrylique, huile.

EX—1: Galerie Zerca, Waterloo, Ont. (June/ juin—Jul/juil 72); Erindale College, Univ Toronto, Toronto (10 IV—10 V 73); Heliconian Club, Toronto (Mar/mars 73).

GROUP/GROUPE: "CanSave Exhibition" Ontario Science Centre, Toronto (1972); "Professional Women in the Arts and Letters" Heliconian Club, Toronto (Apr/avril—May/mai 73).

1 PANNETON *Toccata, 1971*
 (48" x 60")

2 PEDERSEN *Orange-Green*
 No. 1, 1972-73

3 PAYTON *Little House by the*
 Bay on the way to Meaford, Ont.

4 Dan PANKO *Abandoned Farm*

5 Don PANKO *Camrose, Alberta*
 Homestead

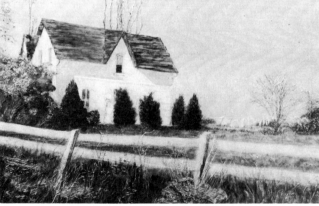

GRAHAM PEACOCK (Painting/Peinture) 1945, London, Eng. LIVES/HABITE: Edmonton TRAINING/FORMATION: Goldsmith's School of Art, London, Eng.; Leeds College of Art, Yorkshire, Eng. AWARDS & HONOURS/ PRIX & HONNEURS: Italian Government Scholarship in Painting/Bourse du gouvernement italien pour la peinture TEACHES/ENSEIGNE: Univ Alberta MEDIUM: Acrylic/ Acrylique.

GROUP/GROUPE: "West '71"; "Flair Square" Calgary (June/juin 72); "Atlantic Provinces Art Circuit"; Univ Alberta Art Gallery, Edmonton (9 X–31 X 72).

TILDE PEDERSEN (Painting/Peinture) Denmark LIVES/HABITE: London, Ont. MEDIUM: Oil/Huile EX–1: Glen Gallery, London, Ont. (24 II–17 III 73).

PEDNO (JOACHIM PEDNEAULT) (Peinture/ Painting) 1932, Isle-aux-Coudres, Qué. HABITE/LIVES: Ste-Agathe-des-Monts, Qué. FORMATION/TRAINING: Ecole de Dessin de Paris; Centre d'Art de Ste-Foy, Qué.; Ecole des Beaux-Arts de Montréal MEDIUM: Huile, acrylique, gouache/Oil, acrylic, gouache.

EX–1: La Maison des Arts La Sauvegarde, Montréal (16 II–19 III 73).

1

2

3

1 PEACOCK *Striation No. 14* 1972 (36" x 84")

2 PEDNO *La Grande Catherine* 1972 (30" x 24")

3 PEDNO *Coquette voirolle, 1970* (14" x 20")

ALFRED PELLAN (Peinture, gravure/ Painting, printmaking) 1906, Québec HABITE/LIVES: Laval, Qué. FORMATION/ TRAINING: Ecole des Beaux-Arts de Québec; Académie de la Grande Chaumière, Paris; Ecole Nationale Supérieure des Beaux-Arts, Paris; Académie Ranson, Paris PRIX & HONNEURS/AWARDS & HONOURS: Bourses de la Province de Québec, 1926, 1930; Premier Prix de peinture, Ecole Nationale Supérieure des Beaux-Arts de Paris, 1928; Premier Prix, Première Grande Exposition d'Art Mural, Paris, 1935; Premier Prix, Soixante-cinquième Exposition du Printemps, Musée des Beaux-Arts de Montréal, 1948; Bourse de la Société Royale du Canada, 1953/Province of Quebec Bursaries, 1926, 1930; First Prize for Painting, Ecole Nationale Supérieure des Beaux-Arts de Paris, 1928; First Prize, First Great Exhibition of Mural Art, Paris, 1935; First Prize, 65th Annual Spring Exhibition, Montreal Museum of Fine Arts, 1948; Royal Society of Canada Scholarship, 1953 MEDIUM: Huile, acrylique, sérigraphie/Oil, acrylic, silkscreen.

EX−1: "Pellan" Organisée par/Organized by le Musée du Québec ITINERANTE/CIRCULATING: Musée du Québec, Québec (7 IX−8 X 72); Musée des Beaux-Arts de Montréal (20 X−26 XI 72); La Galerie nationale/National Gallery, Ottawa (7 XII 72−8 I 73).

GROUPE/GROUP: "Graphisme"; "Process".

ANDRE PELLETIER (Peinture/Painting) 1943, Québec HABITE/LIVES: Québec FORMATION/TRAINING: Ecole des Beaux-Arts de Québec; Univ Laval, Québec PRIX & HONNEURS/AWARDS & HONOURS: Prix du ministère des Affaires culturelles du Québec, 1964; Prix du Consul des Etats-Unis, 1964; Quatrième Prix, Section Arts décoratifs, "Expo-Québec", 1965; Premier Prix, Section Dessin, "Expo-Québec", 1967; Deuxième Prix, Peinture, Concours de l'Université Laval, 1969/Prize from the Quebec Ministry for Cultural Affairs, 1964; Award from the United States Consul, 1964; Fourth Prize, Decorative Arts Section, "Expo-Québec", 1965; First Prize, Drawing Section, "Expo-Québec", 1967; Second Prize, Painting, Laval University Competition, 1969 MEDIUM: Huile/Oil.

EX−1: Galerie Benedek-Grenier, Québec (28 III−3 IV 73); "Kaleidéspace" Galerie du Palais Montcalm, Québec (4 X−15 X 72).

EX−3: Galerie d'Art les Gens de mon Pays, Ste-Foy, Qué. (24 II−8 III 73).

EX−5: Séminaire St-Georges-de-Beauce, Qué. (14 III−17 III 73); Au Germoir, Montmagny, Qué. (2 V−5 V 73).

GROUPE/GROUP: Maison Chevalier, Québec (automne/Autumn 72); "Les Moins de 35".

1 PELLAN *Costumes de théâtre/Theatre Costumes*
 Photo: Henry Koro, La Guilde Graphique, Montréal

2 PELLAN *Polychromée T, 1972 (23" x 35")*
 Photo: La Guilde Graphique, Montréal

3 A. PELLETIER *Ornoir, 1972 (18 1/2" x 20 1/2")*

4 A. PELLETIER *Emersion, 1972 (20" x 36")*

JACQUES PELLETIER (Peinture, dessin/ Painting, drawing) 1951 HABITE/LIVES: Edmundston, N.B. FORMATION/TRAIN- ING: Collège St-Louis-Maillet, Edmundston, N.B. MEDIUM: Collage.

EX—1: Galerie Colline, Edmundston, N.B. (13 I—26 I 73) GROUPE/GROUP: Centre Civique de Rimouski, Qué. (31 VII—2 VIII 72).

WILLIAM PEREHUDOFF (Painting/Pein- ture) 1919, Langham, Sask. LIVES/HA- BITE: Saskatoon TRAINING/FORMA- TION: Colorado Springs Fine Arts Center; Ozenfant School of Art, New York; Car- negie Institute of Technology, Pittsburgh, Penn.; Emma Lake Workshop, Emma Lake, Sask. MEDIUM: Acrylic/Acrylique.

EX—1: Edmonton Art Gallery, Edmonton (14 XII 72—21 I 73); Dunlop Art Gallery, Regina (10 III—1 IV 73).

EX—3: with/avec **D. KNOWLES, H. LEROY**, Waddington Galleries, Montreal (26 VIII— 15 IX 72).

GROUP/GROUPE: Agnes Etherington Art Centre, Queen's Univ, Kingston (Autumn/ automne 72); "West '71"; "Art for All"; "Directors Choice" Edmonton Art Gallery (Nov/nov 72); "North Saskatchewan Juried Show".

MICHEL PERRIN (Peinture/Painting) 1932, Lyon, France HABITE/LIVES: Montréal FORMATION/TRAINING: Ecole Nationale des Beaux-Arts de Lyon, France; Ecole des Arts décoratifs de Paris MEDIUM: Huile/Oil.

EX—1: "Neige et épures" Galerie l'Art français, Montréal (21 XI—7 XII 72); "Horizons Cana- diens" Galerie l'Indifférent, Lyon, France (9 II—9 III 73).

BRUNO PESTICH (Painting, printmaking/ Peinture, gravure) 1937, Zadar, Yugoslavia LIVES/HABITE: London, Ont. TRAINING/ FORMATION: Univ Zagreb, Yugoslavia; Fanshawe College, London, Ont. MEDIUM: Acrylic, oil, linocut, etching, woodcut, litho- graphy/Acrylique, huile, gravure sur linoléum, eau-forte, estampe, lithographie.

GROUP/GROUPE: "Festival of Crafts" Stratford Armouries, Stratford, Ont. (Jul/juil 72); The Old Theatre, Chatham, Ont. (Oct/ oct 72); London Public Library & Art Museum, London, Ont. (Dec/déc 72); "Southwest 33".

1 PESTICH *Prometheus, 1972*

2 PEREHUDOFF *Orpheus No. 5, 1971 (44 1/4" x 18")* Photo: Waddington Galleries, Montreal

3 J. PELLETIER *La Marche de l'homme* Photo: Galerie Colline, Edmundston, N.B.

4 PERRIN *Sur le mont Saint-Hilaire, 1972*

1 PETERS

2 PICHE *1972 (24" x 14")* Photo: Yvan Boulerice

3 POIRIER *Nature morte aux fruits, 1972*

4 PHILLIPS *Untitled (36" x 72")*

KENNETH PETERS (Painting, drawing/ Peinture, dessin) 1939, Regina LIVES/HABITE: Montréal TRAINING/FORMATION: Univ Saskatchewan, Regina; Emma Lake Workshops, Emma Lake, Sask. AWARDS & HONOURS/PRIX & HONNEURS: Second Prize, Vancouver Purchase Exhibition, 1963; Saskatchewan Arts Board Travel Grant, 1965; Saskatchewan Arts bursaries, 1965, 1966; Award, Winnipeg Show, 1966; First Prize, Hadassah Art Auction, Winnipeg, 1967; Canada Council Travel Grants, 1962, 1967, 1968, 1969; Canada Council Short-term Grants, 1969, 1972; Prize, Province of Quebec Art Competition, 1971/Deuxième prix, Exposition-Vente de Vancouver, 1963; Bourse de voyage du Saskatchewan Arts Board, 1965; Bourses de perfectionnement de la Saskatchewan, 1965, 1966; Prix au Winnipeg Show, 1966; Premier prix, Enchères d'oeuvres d'art Hadassah, Winnipeg, 1967; Bourses de voyage du Conseil des Arts du Canada, 1962, 1967, 1968, 1969; Bourses de courte durée du Conseil des Arts du

Canada, 1969, 1972; Prix, Concours Artistiques de la Province du Québec, 1971 MEDIUM: Plastic, vinyl, plexiglas, acrylic, pastel, paper/ Plastique, vinyle, plexiglas, acrylique, pastel, papier.

EX−1: Galerie Martal, Montreal (14 III−31 III 73); Galerie de la S.A.P.Q., Montreal (8 III−30 III 73).

GROUP/GROUPE: Galerie de la S.A.P.Q., Montreal (7 X−15 XI 72); Vehicule Art, Montreal (Apr/avril 73).

EDWARD O. PHILLIPS (Drawing, painting/Dessin, peinture) 1931 LIVES/HABITE: Montreal TRAINING/FORMATION: McGill Univ, Montreal; Univ Montréal; Boston Univ; Harvard Univ; Montreal Museum of Fine Arts MEDIUM: Acrylic, pencil, ink/Acrylique, crayon, plume.

EX−1: Studio 23, St-Sauveur-des-Monts, Que. (21 X−14 XI 72) GROUP/GROUPE: Studio 23, St-Sauveur-des-Monts, Que. (17 VI−8 VII 72); "Society of Canadian Artists Fifth Annual Open Juried Exhibition" Toronto (6 X−19 X 72); "Ontario Society of Artists 101st Annual Open Exhibition".

REYNALD PICHE (Peinture, sculpture/ Painting, sculpture) 1929, Québec HABITE/ LIVES: Côteau-du-Lac, Qué. FORMATION/ TRAINING: Ecole des Beaux-Arts de Montréal ENSEIGNE/TEACHES: Univ Québec MEDIUM: Pastel, acrylique, aluminium/Pastel, acrylic, aluminum.

GROUPE/GROUP: "Oeuvres Récentes" Musée des Beaux-Arts de Montréal, Galerie l'Etable (juin/June 72); Galerie de la S.A.P.Q., Montréal (7 X−15 XI 72).

STANSJE PLANTENGA (Dessin, peinture, gravure/Drawing, painting, printmaking) 1947 HABITE/LIVES: Montréal FORMATION/TRAINING: Ecole des Beaux-Arts de Montréal MEDIUM: Huile, eau-forte, sérigraphie, lino/Oil, etching, silkscreen, linocut GROUPE/GROUP: "Les Moins de 35"; Galerie 90/40, Montréal (août/Aug 72); "L'Exposition des Femmes" Vehicule Art, Montréal (déc/Dec 72).

MARCEL POIRIER (Peinture, dessin/Painting, drawing) 1946 HABITE/LIVES: Montréal MEDIUM: Huile, acrylique, encre de Chine, crayon/Oil, acrylic, India ink, pencil.

EX–1: Caisse Populaire St-Vincent-Ferrier, Montréal (6 XI–7 XI 72); Caisse Populaire de Roxboro, Roxboro, Qué. (2 IV–27 IV 73).

JEFFREY E. POKLEN (Drawing/Dessin) 1934, Carmel, Calif. LIVES/HABITE: Rockwood, Ont. TRAINING/FORMATION: Univ California, Santa Barbara, Calif.; Cornell Univ, Ithaca, N.Y. TEACHES/ENSEIGNE: Univ Guelph, Guelph, Ont. MEDIUM: Ink/Encre GROUP/GROUPE: McLaughlin Library, Univ Guelph, Guelph, Ont. (7 II–28 II 73).

LESLIE DONALD POOLE (Painting/Peinture) 1942, Roseneath, P.E.I. LIVES/HABITE: Edmonton TRAINING/FORMATION: Prince of Wales College, Charlottetown; Univ Alberta; Yale Univ, New Haven, Conn. AWARDS & HONOURS/PRIX & HONNEURS: Canada Council Grant, 1973/Bourse du Conseil des Arts du Canada, 1973 MEDIUM: Oil, acrylic/Huile, acrylique.

EX–1: "Painting Exhibition" Organized by the artist/Organisée par l'artiste CIRCULATING/ITINERANTE: Confederation Centre Art Gallery, Charlottetown (6 II–26 II 73); Memorial Univ Art Gallery, St. John's, Nfld. (9 III–29 III 73); Mount St. Vincent Univ, Halifax (1 V–31 V 73).

* See colour section/ Voir section couleur

ROLAND POULIN (Sculpture) 1940, St. Thomas, Ont. HABITE/LIVES: Montréal FORMATION/TRAINING: Ecole des Beaux-Arts de Montréal PRIX & HONNEURS/AWARDS & HONOURS: Bourse du Conseil des Arts du Canada, 1972/Canada Council Grant, 1972 MEDIUM: Collage, lampes ultra violets, mirroirs concaves, rayons lasers/Collage, ultra violet lights, concave mirrors, laser beams.

EX–1: Musée du Québec, Québec (3 V–28 V 73); Galerie III, Montréal (31 V–14 VI 73).

GROUPE/GROUP: "Art 3" Bâle, Suisse; "SCAN"; "Création Québec" Bruxelles, Belgique (oct/Oct 72).

1

2

3

4

1 POOLE *Thursday the Seventh* (3' x 5')

2 POKLEN *Temple VI, 1973*

3 POULIN *Structure immatérielle 3* (30' x 40' x 6') Photo: Musée du Québec, Québec

4 PLANTENGA *Flaming Bushes & Biblical Allusions*

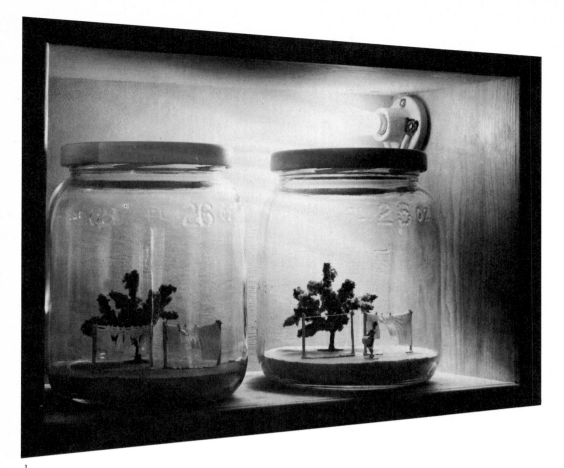

1

FERNANDE PRATTE (Peinture/Painting)
Montréal HABITE/LIVES: Pointe-aux-
Trembles, Qué. FORMATION/TRAINING:
Ecole des Beaux-Arts de Montréal; Univ Mont-
réal MEDIUM: Acrylique/Acrylic.

EX—1: Galerie l'Apogée, St-Sauveur-des-
Monts, Qué. (26 V—20 VI 72); Kensington
Fine Art Gallery, Calgary (nov/Nov 72);
Galerie d'Art Benedek-Grenier, Québec (mai/
May 73).

RICHARD PRINCE (Sculpture, painting,
drawing, conceptual/Sculpture, peinture, des-
sin, conceptuel) 1949, Comox, B.C. LIVES/
HABITE: Vancouver TRAINING/FORMA-
TION: Univ British Columbia; Emma Lake
Workshop, Emma Lake, Sask. AWARDS &
HONOURS/PRIX & HONNEURS: Canada
Council Grants, 1972, 1973/Bourses du Con-
seil des Arts du Canada, 1972, 1973 MEDIUM:
Wood, glass, electrical motor, wire, sand, plas-
tic, plaster etc./Bois, verre, moteur électrique,
fil de fer, sable, plastique, plâtre etc.

EX—2: "Directions '72" with/avec **D. ELLIS**,
Vancouver Art Gallery, Vancouver (15 XI—
31 XII 72) GROUP/GROUPE: "SCAN";
"Ivan Eyre" Burnaby Art Gallery, Burnaby,
B.C. (2 V—27 V 73).

DONALD PROCH (Drawing, sculpture, print-
making/Dessin, sculpture, gravure) LIVES/
HABITE: Winnipeg MEDIUM: Chromed metal,
fiberglas, gesso, silver point, assemblage, silk-
screen/Métal chromé, fibre de verre, gesso,
pointe d'argent, assemblage, sérigraphie
GROUP/GROUPE: "Manitoba Mainstream";
"The Legend of Asessippi" Winnipeg Art Gal-
lery, Winnipeg (18 VIII—27 IX 72).

1 PRINCE *Washing Bottles* Photo: Ted
Greenaway for Vancouver Art Gallery

2 PROCH *Side View of Motria's Hair*
Photo: Winnipeg Art Gallery

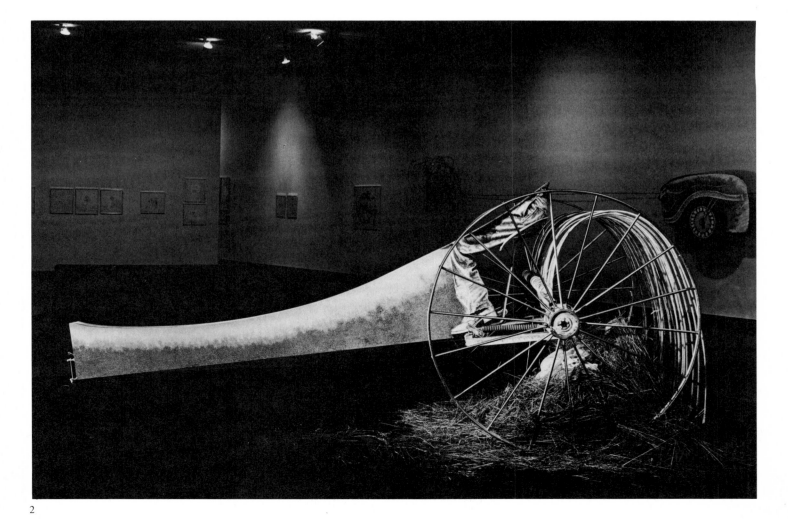

2

DOROTHY QUINTAL (Painting/Peinture)
1922, Manitoba LIVES/HABITE: Rosetown,
Sask. AWARDS & HONOURS/PRIX & HON-
NEURS: Prize, Watrous Art Salon, 1968/Prix,
Watrous Art Salon, 1968 MEDIUM: Oil, acry-
lic/Huile, acrylique GROUP/GROUPE: "A
Summer Show".

ABDUR REHMAN QURESHI (Painting/Pein-
ture) 1927, Karachi, Pakistan LIVES/HA-
BITE: Montreal TRAINING/FORMATION:
Sir George Williams Univ, Montreal; Sind Univ,
Pakistan; Univ Karachi, Pakistan; McGill Univ,
Montreal MEDIUM: Acrylic, oil, watercolour/
Acrylique, huile, aquarelle.

GROUP/GROUPE: Colbert Gallery, Montreal
(Sept/sept 72); Foyer des Arts, T. Eaton Co.
Ltd., Montreal (Sept/sept 72).

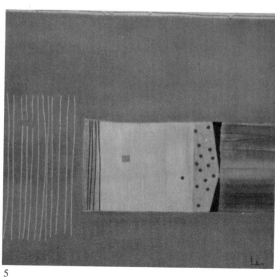

1 PROCH *Chicken Block (Detail)*
 Photo: Winnipeg Art Gallery

2 PROCH *Chicken Block*
 Photo: Winnipeg Art Gallery

3 QURESHI *Metamorphosis, 1972 (24" x 36")*

4 QUINTAL *Hot Rails, 1971*

5 PRATTE *Mur blanc gris dans le jaune, 1972
 (20" x 20")*

DAVID RABINOWITCH (Sculpture) 1943, Toronto LIVES/HABITE: New York TRAINING/FORMATION: Univ Western Ontario, London, Ont.; Ontario College of Art, Toronto MEDIUM: Aluminum, steel/Aluminium, acier.

EX−1: Carmen Lamanna Gallery, Toronto (28 X−16 XI 72).

GROUP/GROUPE: Carmen Lamanna Gallery, Toronto (11 VIII−14 IX 72); Carmen Lamanna Gallery, Toronto (14 XII−28 XII 72); "Diversity".

1 D. RABINOWITCH *Sandblasted Tubes, 1970 (14' 4" x 2 1/2")* Photo: Carmen Lamanna Gallery, Toronto

2 R. RABINOWITCH *Untitled No. 10, 1973 (12" x 12" x 10")* Photo: Carmen Lamanna Gallery, Toronto

3 RAINE *A Man and a Woman* Photo: E. H. Sleeuw

4 R. RABINOWITCH *Joan's Apple Turnover, 1969 (8' x 4')* Photo: Carmen Lamanna Gallery, Toronto

ROYDEN RABINOWITCH (Sculpture) 1943, Toronto LIVES/HABITE: New York TRAINING/FORMATION: Univ Western Ontario, London, Ont.; Ontario College of Art, Toronto MEDIUM: Steel/Acier.

EX−1: Carmen Lamanna Gallery, Toronto (24 III−12 IV 73).

EX−5: with/avec **M. BARBEAU, D. BOLDUC, R. MARTIN, G. MOLINARI,** Carmen Lamanna Gallery, Toronto (21 VI−31 VII 72).

GROUP/GROUPE: Carmen Lamanna Gallery, Toronto (11 VIII−14 IX 72); Carmen Lamanna Gallery, Toronto (14 XII−28 XII 72); "Diversity".

JOHN MICHAEL RAINE (Sculpture) 1932 LIVES/HABITE: Toronto TRAINING/FORMATION: Ecole des Beaux-Arts de Montréal; Académie Julian, Paris MEDIUM: Fiberglas/Fibre de verre.

EX−2: with/avec **JOAN WILLSHER-MARTEL,** Gallery House Sol, Georgetown, Ont. (21 X−9 XI 72).

GROUP/GROUPE: "Sculptors' Society of Canada" Toronto-Dominion Centre, Toronto (15 X−3 XI 72); "Sculptors' Society of Canada" Scarborough College, Toronto (5 XI−27 XI 72); Shaw-Rimmington Gallery, Toronto (Feb/févr 73).

1

2

4

3

1 RAPP *Parthogenesis, 1973*
Photo: House of Fine Art,
Lethbridge, Alta.

2 RAPHAEL *Passion Flower
(20" x 26")*

3 RAY *Great Flood, 1973
(17 3/8" x 23 1/2")* Photo:
Aggregation Gallery, Toronto

4 RAY *The Mating Season, 1973*
Photo: Aggregation Gallery,
Toronto

2

3

4

SHIRLEY RAPHAEL (See also/Voir aussi CANADA BANNERS CO.) (Printmaking, hangings, sculpture/Gravure, tapisseries, sculpture) 1937, Montreal LIVES/HABITE: Montreal TRAINING/FORMATION: Univ Southampton, New York; Boston Univ; Ecole des Beaux-Arts de Montréal; Univ Calgary; Instituto Allende, San Miguel de Allende, Mexico; Sir George Williams Univ, Montreal MEDIUM: Silkscreen, etching, lithography, nylon/Sérigraphie, eau-forte, lithographie, nylon.

EX–1: London Public Libraries, London, Ont. (May/mai–Jul/juil 72).

EX–2: See/Voir **CANADA BANNERS CO.**

EX–3: "Canada Banners and Hannah Franklin" with/avec **R. VENOR, H. FRANKLIN,** Saidye Bronfman Centre, Montreal (12 III–2 IV 73).

GROUP/GROUPE: "Canadian Printmakers Showcase"; "SCAN"; "Association des Graveurs du Québec à l'Etable"; "Graff"; "Christmas Show" Art Gallery of Ontario, Toronto (Dec/déc 72); "Grafik"; "Society of Canadian Artists Show" Shaw-Rimmington Gallery, Toronto (3 II–18 II 73).

OTTO RAPP (Painting/Peinture) 1944, Austria LIVES/HABITE: Lethbridge, Alta. TRAINING/FORMATION: Self-taught/Autodidacte MEDIUM: Acrylic/Acrylique.

EX–1: House of Fine Art, Lethbridge, Alta. (June/juin 72).

CARL RAY (Drawing/Dessin) 1943, Sandy Lake, Ont. LIVES/HABITE: Sandy Lake, Ont. TRAINING/FORMATION: Self-taught/Autodidacte AWARDS & HONOURS/PRIX & HONNEURS: Canada Council Grant, 1969/Bourse du Conseil des Arts du Canada, 1969 MEDIUM: Ink/Encre.

EX–1: Aggregation Gallery, Toronto (14 XI–2 XII 72); Terryberry Library, Hamilton, Ont. (Apr/avril 73).

GROUP/GROUPE: Univ Minnesota, Duluth, Minn. (1972); "Gallery Artists" Aggregation Gallery, Toronto (Apr/avril 73); "Northern Ontario Art Tour, 1972" Organised by/Organisée par Department of Indian Affairs & Northern Development.

1

GORDON RAYNER (Painting, printmaking/Peinture, gravure) 1935, Toronto LIVES/HABITE: Toronto TRAINING/FORMATION: Self-taught/Autodidacte TEACHES/ENSEIGNE: New School of Art, Ontario College of Art, York Univ MEDIUM: Acrylic, lithography, silkscreen/Acrylique, lithographie, sérigraphie.

EX—1: "Artist with His Work" Art Gallery of Windsor, Windsor, Ont. (18 III—1 IV 73).

EX—1: Isaacs Gallery, Toronto (1 III—20 III 73).

GROUP/GROUPE: "Toronto Painting"; "Lithographs I"; "Art for All"; "Graphex I".

WALTER REDINGER (Sculpture) 1940, Wallacetown, Ont. LIVES/HABITE: West Lorne, Ont. TRAINING/FORMATION: H.B. Beal Technical School, London, Ont.; Meinzinger Art School, Detroit, Mich.; Ontario College of Art, Toronto AWARDS & HONOURS/PRIX & HONNEURS: First Prize, Sculpture, "Survey '67" Montreal Museum of Fine Arts, 1967; Canada Council Grants, 1968, 1969, 1970, 1971/Premier Prix, Sculpture, "Survey '67" Musée des Beaux-Arts de Montréal, 1967; Bourses du Conseil des Arts du Canada, 1968, 1969, 1970, 1971 MEDIUM: Fiberglas/Fibre de verre.

EX—1: "Les Sculptures en Plastique" Saidye Bronfman Centre, Montreal (19 IV—11 VI 73); Isaacs Gallery, Toronto (24 V—12 VI 73).

GROUP/GROUPE: "Diversity"; "Art for All"; "Plastic Fantastic"; Marquis Gallery, Univ Saskatchewan, Saskatoon (1972); Venice Biennale (Summer/été 72); St. Catharines Art Council, St. Catharines, Ont. (2 II—25 II 73).

REINHARD REITZENSTEIN (Conceptual/Conceptuel) 1949, Uelzen, Germany LIVES/HABITE: Toronto MEDIUM: Wood, rope, wire, photographs, ashes/Bois, corde, fil de fer, photographies, cendres EX—4: with/avec: **J. DELAVALLE, Y. COZIC, T. DEAN,** Carmen Lamanna Gallery, Toronto (14 IV—3 V 73).

2

3

1 RAYNER *Saharapproach, 1972
 (60" x 48")* Photo: Lyle
 Wachovsky for Isaacs Gallery,
 Toronto

2 RAYNER *Aurora, 1972 (48" x
 60 1/2")* Photo: J. Ayriss for
 Isaacs Gallery, Toronto

1

2

1

2

3

4

DAVID RIFAT (Drawing/Dessin) 1934, Edinburgh, Scotland LIVES/HABITE: Toronto TRAINING/FORMATION: Edinburgh College of Art, Edinburgh, Scotland MEDIUM: Pencil/Crayon.

EX–1: "Recent Drawings" Ontario Institute for Studies in Education, Toronto (12 VI–29 VI 72); Hart House Gallery, Toronto (1 VII–30 VII 72).

GROUP/GROUPE: "Canadian Arts" Stratford, Ont.; "Graphex I"; "A Land for People" Forum Theatre, Ontario Place, Toronto (1972).

TOM W. RISHEL (Conceptual/Conceptuel) LIVES/HABITE: Halifax TEACHES/ENSEIGNE: Dalhousie Univ, Halifax MEDIUM: Information Environments/Environnements d'information.

EX–1: Streetcorner Imageworks Galleries, Cambridge, Mass. (Aug/août 72); Dalhousie Univ Art Gallery, Halifax (23 I–4 II 73).

GROUP/GROUPE: Carpenter Center, Harvard Univ (Aug/août–Sept/sept 72).

FRANCINE RICHMAN (Sculpture) 1929 LIVES/HABITE: Montreal TRAINING/FORMATION: Montreal Museum of Fine Arts MEDIUM: Marble, onyx, limestone, bronze/Marbre, onyx, calcaire, bronze GROUP/GROUPE: Lethbridge Centre, Montreal (4 V–2 VI 72); "Estival '72" Galerie Espace, Montreal (31 V–30 IX 72).

1 RICHMAN *The Localist*

2 RICHMAN *Duality (22")*

3 RISHEL *1972*

4 RIFAT

MILLY RISTVEDT (Painting/Peinture)
1942, Kimberley, B.C. LIVES/HABITE:
Shanty Bay, Ont. TRAINING/FORMATION:
Vancouver School of Art AWARDS & HON-
OURS/PRIX & HONNEURS: Canada Coun-
cil Bursaries, 1967, 1969, 1971, 1972; Pur-
chase Award, Twelfth Winnipeg Biennale,
1970/Bourses du Conseil des Arts du Canada,
1967, 1969, 1971, 1972; Prix d'acquisition,
Douzième Biennale de Winnipeg, 1970 ME-
DIUM: Acrylic/Acrylique.

EX—2: with/avec **H. SAXE**, Musée d'Art Con-
temporain, Montreal (8 IV—13 V 73).

GROUP/GROUPE: "Diversity"; "Staff Show"
Montreal Museum of Fine Arts (24 I—17 II 73);
Carmen Lamanna Gallery, Toronto (25 IV—
18 V 73).

*** See colour section/ Voir section couleur**

MARLYS VANGO RIVARD (Painting/
Peinture) 1928, Edmonton LIVES/HABITE:
Saskatoon TRAINING/FORMATION:
Univ Alberta, Edmonton MEDIUM: Pastel,
watercolour, oil, acrylic/Pastel, aquarelle,
huile, acrylique GROUP/GROUPE: "A
Summer Show".

DANIEL ROBERGE (Peinture/Painting)
1952, Victoriaville, Qué. HABITE/LIVES:
Montréal FORMATION/TRAINING: Univ
Québec à Trois-Rivières et à Montréal ME-
DIUM: Acrylique/Acrylic EX—3: Victoria-
ville, Qué. (12 IV—25 IV 72) GROUPE/
GROUP: "Les Moins de 35".

1 ROBERGE *CLETS II, 1972 (22" x 28")*

2 RISTVEDT *Phoenix, 1973 (9' x 9')*

3 ROBERGE *Avec un titre I, 1973 (18" x 24")*

4 RIVARD *Paster Goos, 1972 (32" x 40")*

LOUISE ROBERT (Peinture/Painting) 1941, Montréal HABITE/LIVES: Montréal FORMATION/TRAINING: Autodidacte/Self-taught MEDIUM: Huile, encre/Oil, ink.

EX—4: "Nouveaux Artistes de la Galerie" avec/with **G. BASTIEN, Y. TRUDEAU, M. TANOBE**, Galerie l'Art français, Montréal (8 I—30 I 73).

GROUPE/GROUP: La Société des Artisans, Montréal (15 III—15 IV 73).

HUGH D. ROBERTSON (Painting/Peinture) 1900 LIVES/HABITE: Hamilton, Ont. TRAINING/FORMATION: McGill Univ, Montreal MEDIUM: Oil, watercolour/Huile, aquarelle.

GROUP/GROUPE: "Annual Exhibition of Contemporary Canadian Art"; "Canadian Arts" Stratford, Ont.; "Canadian Society of Painters in Watercolour" Ontario Insitute for Studies in Education, Toronto; O'Keefe Centre, Toronto (Nov/nov 72); Rodman Hall, St. Catharines, Ont. (Mar/mars 73).

ROB ROBINSON (Sculpture, conceptual/ Sculpture, conceptuel) LIVES/HABITE: Toronto MEDIUM: Plywood, acrylic, rope, plaster, photographs/Contre-plaqué, acrylique, corde, plâtre, photographies GROUP/ GROUPE: "Information and Perception" Gallery 76, Ontario College of Art, Toronto (24 III—23 IV 73).

1 ROBINSON *Glare Device*
2 ROBINSON
3 ROBERTSON *Storm Clouds over the Christian Islands*
4 ROBERT

1

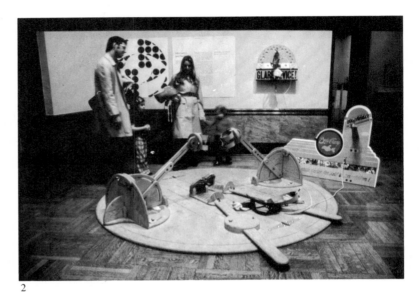

2

3

4

GEOFFREY A. ROCK (Painting/Peinture) 1923, Birmingham, Eng. LIVES/HABITE: Port Washington, B.C. TRAINING/FORMA-TION: Birmingham College of Art, Birmingham, Eng.; Central School of Arts and Crafts, London, Eng. AWARDS & HONOURS/PRIX & HONNEURS: British Columbia Government Grant, 1967/Bourse du gouvernement de la Colombie-Britannique, 1967 MEDIUM: Oil/Huile.

EX—1: Alex Fraser Gallery, Vancouver (5 IV—19 IV 73).

GROUP/GROUPE: "Annual Exhibition of Contemporary Canadian Art"; "Art for All".

CLEMENT RODRIGUE (Dessin, peinture, sculpture/Drawing, painting, sculpture) Thetford Mines, Qué. HABITE/LIVES: Rimouski, Qué. FORMATION/TRAINING: Institut d'Art Photographique de Montréal MEDIUM: Huile, émail, terre cuite/Oil, enamel, terra cotta.

EX—1: "Peintures et Emaux" Salon des Artistes Canadiens, Rimouski, Qué. (nov/Nov 72).

ETHEL ROSENFIELD (Sculpture) 1910, Poland LIVES/HABITE: Montreal TRAINING/FORMATION: Ecole des Beaux-Arts de Montréal MEDIUM: Limestone, marble, bronze/Calcaire, marbre, bronze.

EX—1: "Retrospective" Galerie Espace, Montreal (18 X—18 XI 72).

2

3

1 ROCK *Lee Harrison (29" x 17")*

2 ROSENFIELD *Easter Island* Photo: Yvan Valée

3 RODRIGUE *Fin d'après-midi (8" x 10")* Photo: Salon des Artistes Canadiens

1

2

1 ROSENTHAL *Embrace* *(22" x 28")*

2 ROSENTHAL *Alternate Image* *(22" x 28")*

3 ROSENTHAL *Doors* *(20" x 30")*

JOE ROSENTHAL (Painting, sculpture, drawing/Peinture, sculpture, dessin) 1921, Romania LIVES/HABITE: Toronto TRAINING/FORMATION: Central Technical School, Toronto; Ontario College of Art, Toronto **AWARDS & HONOURS/PRIX & HONNEURS:** Canada Council Grant, 1969; Coutts-Hallmark Purchase Award, Ontario Society of Artists 101st Annual Exhibition, 1973/Bourse du Conseil des Arts du Canada, 1969; Prix d'acquisition Coutts-Hallmark, 101e Exposition Annuelle de l'Ontario Society of Artists MEDIUM: Ink and wash, oil, chalk/Encre et lavis, huile, craie.

EX−1: Scarborough Public Library, Toronto (Sept/sept−Oct/oct 72); Merton Gallery, Toronto (14 XI−2 XII 72).

GROUP/GROUPE: "Ontario Society of Artists 101st Annual Exhibition"; "Art of the Dance".

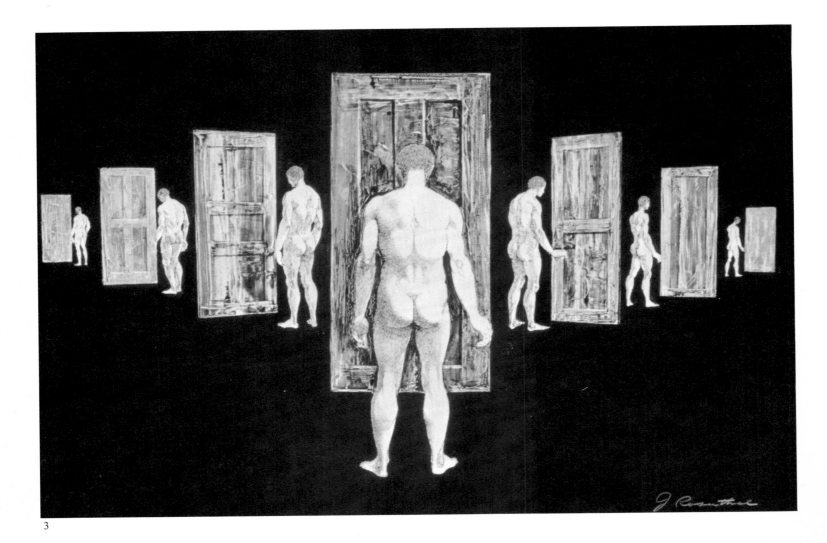

3

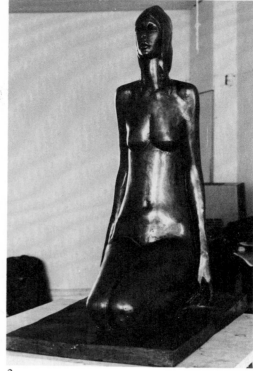

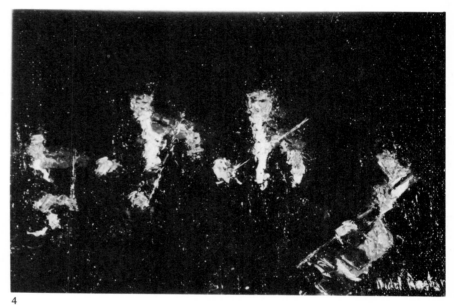

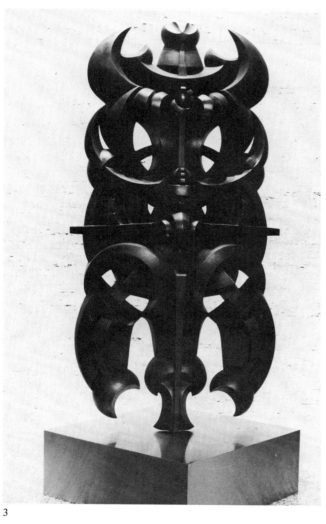

1 ROSTAND *Jardin à Vienne* (5" x 7")

2 ROSENZWEIG *The Kneeling, 1972* (2' x 1' x 2')

3 ROSENZWEIG *The Symbol, 1971-72* (7' 8" x 3' x 1')

4 ROSTAND *Quatuor* (4 3/4" x 6 3/4")

VLADIMIR ROSENZWEIG (Sculpture) 1934 LIVES/HABITE: Toronto TRAINING/FORMATION: Univ Bratislava, Czechoslovakia MEDIUM: Bronze, resin/Bronze, résine.

GROUP/GROUPE: "Sculptors' Society of Canada" Toronto-Dominion Centre, Toronto (15 X–3 XI 72); "Sculptors' Society of Canada" Scarborough College, Toronto (5 XI–27 XI 72); Hospital for Sick Children, Toronto (Nov/nov 72).

MICHEL ROSTAND (Peinture/Painting) 1895, Nice, France HABITE/LIVES: Montréal FORMATION/TRAINING: Ecole des Beaux-Arts de Nice, France; Univ Vienne MEDIUM: Huile, gouache, pastel, aquarelle/ Oil, gouache, pastel, watercolour EX–1: Dominion Gallery, Montréal (19 IV–12 V 73) GROUPE/GROUP: "National Miniature Art Show" Nutley, New Jersey (8 IV–6 V 73).

183

COLETTE ROUSSEAU (Dessin, peinture/ Drawing, painting) Baie-des-Sables, Qué. HABITE/LIVES: Rimouski, Qué. FORMATION/ TRAINING: Bart School, Québec MEDIUM: Aquarelle, encre, stylo, crayon, gouache, pastel/Watercolour, ink, ball-point pen, pencil, gouache, pastel.

EX—1: Musée Régional de Rimouski, Qué. (5 II—28 II 73); Maison du Notaire, Rimouski, Qué. (12 IV—24 IV 73); Centre Culturel d'Amqui, Qué. (18 III—25 III 73).

PAUL ROUSSEAU (Peinture, dessin, gravure/ Painting, drawing, printmaking) 1938, Montréal HABITE/LIVES: Montréal FORMATION/TRAINING: Ecole des Beaux-Arts de Montréal MEDIUM: Gouache, huile, lino, crayon/Gouache, oil, linocut, pencil GROUPE/ GROUP: "Les Moins de 35".

CLAUDE ROUSSEL (Sculpture) 1930, Edmundston, N.B. HABITE/LIVES: Moncton, N.B. FORMATION/TRAINING: Ecole des Beaux-Arts de Montréal PRIX & HONNEURS/AWARDS & HONOURS: Prix du concours pour la sculpture de l'Hôtel de ville de St-Jean, 1972/Prize, Sculpture contest, Saint John City Hall, 1972 ENSEIGNE/ TEACHES: Univ Moncton, N.B. MEDIUM: Plexiglas, résines de polyester et epoxy, bois, bronze, aluminium, contre-plaqué, styrofoam/ Plexiglas, polyester and epoxy resins, wood, bronze, aluminum, plywood, styrofoam.

EX—1: La Galerie d'Art de Restigouche, Campbellton, N.B. (17 XI—8 XII 72).

GROUPE/GROUP: Galerie d'Art de l'Univ Moncton, N.B. (juil/Jul 72); "Plastics Today" Royal York Hotel, Toronto (16 X—19 X 72); "Purchase Awards Exhibition" City Hall, St. John, N.B. (janv/Jan 73); Galerie d'Art de l'Univ Moncton, N.B. (févr/Feb 73).

1 C. ROUSSEAU
2 C. ROUSSEAU
3 P. ROUSSEAU
4 ROUSSEL *Harengs fumés, 1971*
5 ROUSSEL *Bric à Brac*

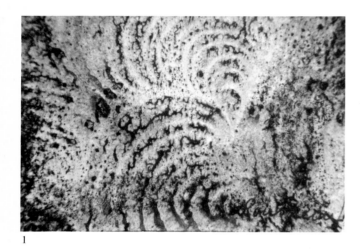

1

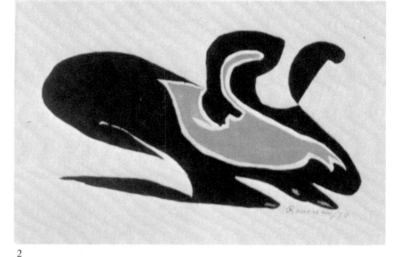

2

4

3

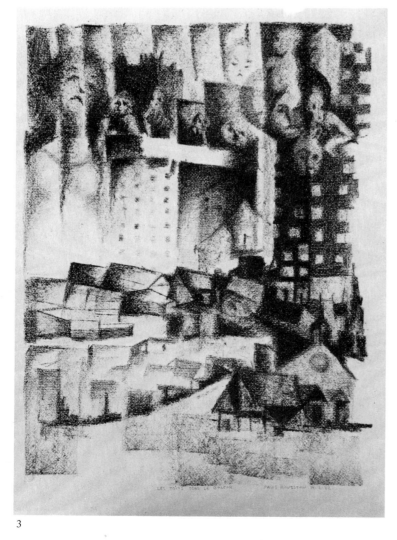

5

1

FRANK W. ROWLEY (Drawing/Dessin)
1908, England LIVES/HABITE: Toronto
TRAINING/FORMATION: Self-taught/Auto-
didacte MEDIUM: Coloured pencil/Crayon
de couleur.

EX−1: Art Gallery of Hamilton, Hamilton,
Ont. (1972); Art Gallery of Brant, Brantford,
Ont. (1972).

GROUP/GROUPE: "Huronia Art Festival"
Barrie, Ont. (1972); "Festival of Grapes" Sil-
ver Creek, N.Y. (1972); "Hadassah Art Auc-
tion" Inn-on-the-Park, Toronto (Apr/avril 73).

ALICE ROY (Gravure/Printmaking) HA-
BITE/LIVES: Ste-Foy, Qué. MEDIUM: Séri-
graphie/Silkscreen EX−1: Galerie Benedek-
Grenier, Québec (13 II−23 II 73).

1 ROWLEY

2 ROWLEY *Mirror of Spring*

3 ROWLEY

4 A. ROY *Le Temps est inréfinissable*
 (24" x 30")

5 A. ROY *Sur l'autre versant*

2

3

4

5

1

2

MARIO ROY (Peinture/Painting) 1953, Baie-Comeau, Qué. HABITE/LIVES: Québec FORMATION/TRAINING: Autodidacte/Self-taught MEDIUM: Huile/Oil.

EX–1: Restaurant le Chantauteuil, Québec (1 XII–15 XII 72) GROUPE/GROUP: "Les Moins de 35".

GEORGE E. RUSSELL (Painting, print-making/Peinture, gravure) 1933 LIVES/HA-BITE: Montreal TRAINING/FORMATION: Univ Saskatchewan, Saskatoon; Sir George Williams Univ, Montreal MEDIUM: Acrylic, seri-graphy/Acrylique, sérigraphie.

EX–3: with/avec **M. BREWSTER, T. McIN-**

TYRE, Firehouse Gallery, Nassau Community College, New York (25 II–11 III 73).

GROUP/GROUPE: "Simpsons Centennial Exhibition" Regina (Oct/oct 72); "Kingston Spring Exhibition"; "Flair Square" Calgary (June/juin 72).

3

ST. CLAIR *Nipissing Shoreline, 1971-72 (29 7/8" x 24")* Photo: J. Ayriss for Aggregation Gallery, Toronto

HUIBERT SABELIS (Painting/Peinture)
1942, Wageningen, Netherlands LIVES/HA-
BITE: Toronto TRAINING/FORMATION:
Minneapolis School of Fine Arts, Minneapolis,
Minn. MEDIUM: Acrylic/Acrylique.

EX-1: Philippine National Museum, Manila,
Philippines (15 XII-31 XII 72); Manila Hilton
Art Gallery, Manila, Philippines (8 I-23 I 73).

GROUP/GROUPE: "Bridge Exhibition"
O'Keefe Centre, Toronto (30 V-3 VII 73);
"IVe Concours International pour la Palme
d'Or des Beaux-Arts" Monte Carlo (31 VIII-
8 IX 72); "5th Annual Exhibition" Society of
Canadian Artists, Eatons, Toronto (1972);
Evans Gallery, Toronto (Mar/mars 73); "Art of
the Dance" O'Keefe Centre, Toronto (14 V-
30 VI 73).

BRUCE ST. CLAIR (Painting/Peinture)
1945, Galt, Ont. LIVES/HABITE: Toronto
TRAINING/FORMATION: Ontario College
of Art, Toronto MEDIUM: Oil/Huile.

EX-1: "Recent Paintings" Aggregation Gallery,
Toronto (21 IV-10 V 73).

GROUP/GROUPE: "Inaugural Exhibition"
Aggregation Gallery, Toronto (3 X-21 X 72);
"Annual Christmas Exhibition" Aggregation
Gallery, Toronto (5 XII-23 XII 72); "Kingston
Spring Exhibition"; "SCAN".

1 ST. CLAIR *Pinecone, 1972 (9" x 7")*
Photo: J. Ayriss for Aggregation Gallery,
Toronto

2 H. SAVAGE *One for Science* Photo:
Edmonton Journal

GEORGINE ST-LAURENT-TURCOTTE (Gravure, dessin, peinture/Printmaking, drawing, painting) HABITE/LIVES: Québec FORMATION/TRAINING: Univ Laval, Québec MEDIUM: Relief, eau-forte, lithographie, sérigraphie/Relief, etching, lithography, serigraphy GROUPE/GROUP: Musée du Québec, Québec (janv/Jan 73); "Les Moins de 35".

SUSAN SARNER (Painting, drawing, printmaking/Peinture, dessin, gravure) 1947, Montreal LIVES/HABITE: Toronto TRAINING/FORMATION: Ontario College of Art, Toronto AWARDS & HONOURS/PRIX & HONNEURS: First Prize, Mixed media, Toronto City Hall Outdoor Exhibition, 1972/Premier Prix, Multi-média, Exposition en plein air de l'Hôtel de Ville de Toronto, 1972 MEDIUM: Oil, watercolour, silkscreen/Huile, aquarelle, sérigraphie.

EX—1: "Watercolour Show" Jerrold Morris Gallery, Toronto (2 XII—23 XII 72).

GROUP/GROUPE: "Outdoor Exhibition" City Hall, Toronto (1972); "Annual Christmas Exhibition" Aggregation Gallery, Toronto (5 XII—23 XII 72); "Gallery Artists" Aggregation Gallery, Toronto (Apr/avril 73).

ROBERT SAUCIER (Sculpture) 1951, Baker Brook, N.B. HABITE/LIVES: Baker Brook, N.B. FORMATION/TRAINING: Collège St-Louis-Maillet, Edmundston, N.B. MEDIUM: Contre-plaqué, tilleul, acajou, métal, plâtre, ciment, bronze/Plywood, lime-tree, mahogany, metal, plaster, cement, bronze.

EX—3: avec/with **J. MARTIN, L. CHARETTE,** Galerie Colline, Edmundston, N.B. (17 II—2 III 73).

HARRY SAVAGE 1940, Camrose, Alta. LIVES/HABITE: Edmonton TRAINING/FORMATION: Alberta College of Art, Calgary; Brooks School of Photography, Santa Barbara, Calif. TEACHES/ENSEIGNE: Univ Alberta.

EX—1: "8 Cents Worth of Canada (and a few sense more)" Edmonton Art Gallery, Edmonton (4 II—27 II 73).

EX—4: "Commentaries on Urban Man" with/avec **R. KOSTYNIUK, M. JONES, D. BESANT,** Confederation Art Gallery, Charlottetown, P.E.I. (7 XI—25 XI 72).

GROUP/GROUPE: "Alberta Contemporary Drawings".

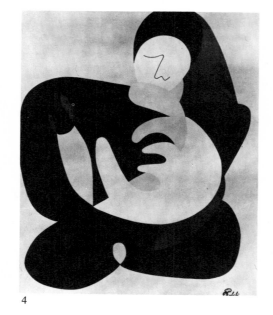

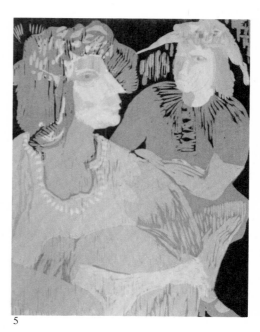

1 SARNER *Woman as Reflection I, 1972 (13" x 18")*

2 SARNER *Girl and Plant*

3 SAUCIER *Ainsi va notre société, 1973* Photo: Studio Laporte for Galerie Colline, Edmundston, N.B.

4 SABELIS *Obsession of the Hand*

5 ST. LAURENT *Cause toujours, 1972*

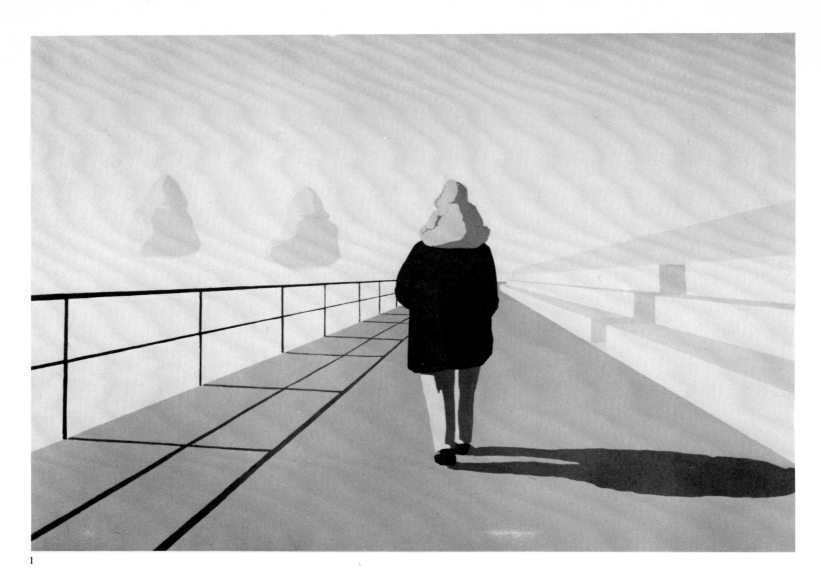

1

2

ISOLDE SAVAGE (Hangings/Tapisseries) 1939 LIVES/HABITE: Halifax, N.S. MEDIUM: Jute GROUP/GROUPE: "Discover Canada Exhibition" Space Museum, Los Angeles, Calif. (15 XI 72–4 II 73).

ROGER SAVAGE (Painting, printmaking/Peinture, gravure) 1941, Windsor, Ont. LIVES/HABITE: Halifax TRAINING/FORMATION: Mount Allison Univ, Sackville, N.B. AWARDS & HONOURS/PRIX & HONNEURS: Canada Council Grant, 1970/Bourse du Conseil des Arts du Canada, 1970 MEDIUM: Gum tempera, watercolour, serigraphy/Détrempe à la gomme, aquarelle, sérigraphie.

EX–1: Neptune Theatre, Halifax (12 VIII–31 VIII 72) GROUP/GROUPE: "Painters of Nova Scotia" Robertson Galleries, Ottawa (1 VI–17 VI 72); "Third British International Print Biennale" Bradford, Eng. (Jul/juil–Sept/sept 72); "New Talent in Printmaking" Marlborough-Godard Gallery, Montreal (8 VIII–31 VIII 72); "56th Annual Exhibition" Society of Canadian Painter-Etchers and Engravers; Glenbow-Alberta Gallery, Calgary (18 I–11 II 73).

1 R. SAVAGE *Sunday Morning Walk, 1971* *(20" x 30 3/8")*

2 I. SAVAGE *Wall Hanging No. 60, 1971* *(68" x 72")* Photo: Lavers

3 R. SAVAGE *Three O'Clock Tractor, 1971* *(20" x 30 3/8")*

4 R. SAVAGE *Isolde and Cow, 1972* *(17 1/4" x 30 5/6")*

3

4

1

2

ROBERT SAVOIE (Peinture, gravure, sculpture/Painting, printmaking, sculpture) 1939, Québec HABITE/LIVES: Montréal FORMATION/TRAINING: Ecole des Beaux-Arts de Montréal; Institut des Arts Graphiques de Montréal; Chelsea School of Art, London, Eng. PRIX & HONNEURS/AWARDS & HONOURS: Bourse du Conseil des Arts du Canada, 1963/ Canada Council Grant, 1963 MEDIUM: Acrylique, sérigraphie, plexiglas/Acrylic, serigraphy, plexiglas.

EX—1: Galerie l'Apogée, St-Sauveur-des-Monts, Qué. (déc/Dec 72).

EX—5: avec/with **R.VILDER, M. HIRSCHBERG, S. MARKLE, A. SAMCHUK**, Electric Gallery, Toronto (juil/Jul 72).

GROUPE/GROUP: "Art 3" Bâle, Suisse; "Grafik"; "Eight Canadian Printmakers"; "Third Annual Exhibition of Contemporary Professional Quebec Artists" Dawson College, Montréal (5 IV—17 IV 73); "Canadian Printmakers Showcase".

RITA SCALABRINI (Peinture/Painting) HABITE/LIVES: Montréal FORMATION/TRAINING: Ecole des Beaux-Arts de Québec; Ecole des Beaux-Arts de Montréal; Univ Montréal; Ecole du Louvre, Paris MEDIUM: Acrylique/Acrylic.

EX—1: Galerie d'Art Benedek-Grenier, Québec (19 IV—29 IV 73); La Chasse-Galerie, Toronto (22 III—29 III 73).

1 SAVOIE

2 SAVOIE

3 SCALABRINI

4 SCOTT *Untitled, 1972 (18" x 24")*

5 SCHLEIN *Torso (20 1/2")*

6 SCHLEIN *Two Faces of Eve (11 1/2")*

3

4

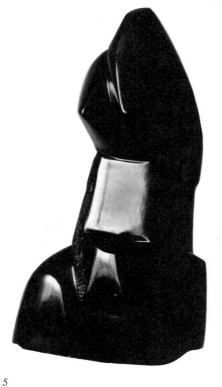

5

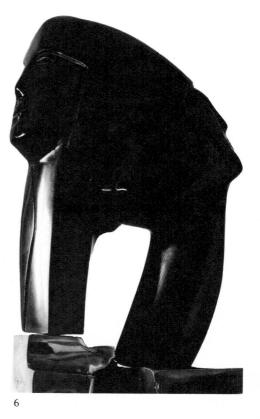

6

BERNARD SCHIELE (Photographie, conceptuel/Photography, conceptual) 1943, France HABITE/LIVES: Montréal FORMATION/TRAINING: Ecole des Beaux-Arts de Montréal PRIX & HONNEURS/AWARDS & HONOURS: Prix, "Beaux-Arts 70" Montréal; Trophée Martha Allen, 1966/Award, "Beaux-Arts 70" Montreal; Martha Allen Trophy, 1966 MEDIUM: Procédé photographique/Photographic process.

EX—1: Boutique Soleil, Montréal (1 IX—5 X 72); Musée d'Art Contemporain, Montréal (juin/June 72).

EX—3: La Maison des Arts La Sauvegarde, Montréal (26 V—26 VI 72).

GROUPE/GROUP: "Formoptic" Terre des Hommes, Montréal (20 VII—5 IX 72).

LILYAN SCHLEIN (Sculpture) Toronto LIVES/HABITE: Toronto MEDIUM: Bronze, soapstone/Bronze, stéatite EX—2: Estée Gallery, Toronto (Mar/mars 73).

MARIAN SCOTT (Painting/Peinture) 1906 LIVES/HABITE: Montreal TRAINING/FORMATION: Ecole des Beaux-Arts de Montréal; Slade School of Art, London, Eng. MEDIUM: Acrylic/Acrylique.

GROUP/GROUPE: Thomas More Institute, Montreal (Nov/nov 72); "Salon des Métiers d'Art"; "Third Annual Exhibition of Contemporary Professional Quebec Artists" Dawson College, Montreal (5 IV—17 IV 73).

1 SCHIELE
2 SCHIELE
3 SCHIELE

1

2

3

1

2

KARL SEDMINA (Drawing, sculpture, conceptual/Dessin, sculpture, conceptuel) 1950, Czechoslovakia LIVES/HABITE: Toronto TRAINING/FORMATION: People's Art Workshop, Zilina, Czechoslovakia; People's Art Workshop, Bratislava, Czechoslovakia; New School of Art, Toronto AWARDS & HONOURS/PRIX & HONNEURS: Canada Council Award, 1971/Bourse du Conseil des Arts du Canada, 1971 TEACHES/ENSEIGNE: Alpha Experimental School, Toronto MEDIUM: Photographs, drawings, models of a work/Photographies, dessins, modèles d'une oeuvre.

EX−1: "Evidence of Procedure" A Space, Toronto (15 X−31 X 72) GROUP/GROUPE: "Seventh Annual Show" New School of Art, Toronto (1972).

SEYMOUR SEGAL (Painting, drawing/Peinture, dessin) 1933, Montreal LIVES/HABITE: London, Eng. TRAINING/FORMATION: Ecole des Beaux-Arts de Montréal; Ein Hod Artists' Village, Israel MEDIUM: Oil/Huile.

EX−1: Galerie Martal, Montreal (31 X−14 XI 72); Centre Culturel Canadien, Paris (23 XII 72−7 I 73).

FERNAND SEGUIN (Sculpture, peinture/Sculpture, painting) 1927, Pittsfield, N.Y. HABITE/LIVES: Montréal FORMATION/TRAINING: Ecole des Beaux-Arts de Montréal MEDIUM: Métal, plexiglas/Metal, plexiglas.

EX−2: avec/with J. JENICEK, Galerie l'Art français, Montréal (17 II−3 III 73).

EX−5: "Groupe de Sculpteurs" avec/with P. DINEL, A. VAILLANCOURT, J. NOEL, Y. TRUDEAU, Galerie l'Art français, Montréal (juin/June 73).

GROUPE/GROUP: La Cité des Jeunes de Vaudreuil, Qué. (1972).

JEAN-PIERRE SEGUIN (Peinture, sculpture/Painting, sculpture) 1951, Montréal HABITE/LIVES: Verdun, Qué. FORMATION/TRAINING: CEGEP de Vieux-Montréal; Univ Québec, Montréal; Ecole des Beaux-Arts de Montréal MEDIUM: Acrylique, plexiglas/Acrylic, plexiglas.

GROUPE/GROUP: "Les Moins de 35"; Plaza Alexis Nihon, Montréal (mars/Mar 73).

1 SEDMINA *Installation shot/Photo de l'exposition*

2 SEDMINA

3 J. SEGUIN *Multiple No. 1, 1972*

4 F. SEGUIN *Montre de Torpilleur, 1972*

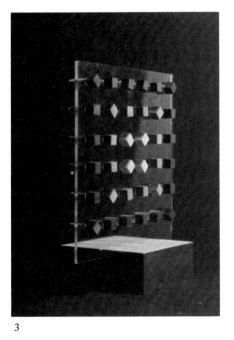

3

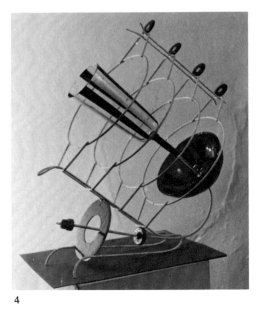

4

SENGGIH (HENK KREGER) (Painting, sculpture/Peinture, sculpture) 1914, Indonesia LIVES/HABITE: Toronto TRAINING/FORMATION: Institute for Arts and Crafts, Amsterdam; National Institute for the Education of Art Teachers, Amsterdam MEDIUM: Oil, wood, metal, concrete/Huile, bois, métal, béton.

EX–4: with/avec **W. ANDERSON, L. GUDERNA, J. HOVADIK**, D & H Art Gallery, Toronto (Feb/févr 73).

SIGMUND SERAFIN (Painting/Peinture) 1920 LIVES/HABITE: Toronto TRAINING/FORMATION: Ontario College of Art, Toronto AWARDS & HONOURS/PRIX & HONNEURS: Prize/Prix, Exhibition of Chicago Art, Chicago, 1958 MEDIUM: Acrylic, watercolour/Acrylique, aquarelle.

GROUP/GROUPE: "CanSave Exhibition" Ontario Science Centre, Toronto (June/juin 72); "Canadian Arts" Stratford, Ont.; "Annual Exhibition of Contemporary Canadian Art".

HELEN SEWELL (Drawing, painting/Dessin, peinture) 1906, Toronto LIVES/HABITE: Toronto TRAINING/FORMATION: Ontario College of Art, Toronto AWARDS & HONOURS/PRIX & HONNEURS: Governor-General's Medal/Médaille du Gouverneur Général MEDIUM: Oil, charcoal, pastel/Huile, fusain, pastel.

GROUP/GROUPE: "Professional Women in the Arts and Letters" Toronto Heliconian Club, Toronto (Apr/avril—May/mai 73).

1

2

3

4

1 SEGAL *News at Ten, 1972 (40" x 36")*
 Photo: Galerie Martal, Montreal

2 SEWELL *Yorkville in the Springtime, 1968 (20" x 24")*

3 SERAFIN *Pigeon Roost, 1972 (18" x 27")*

4 SENGGIH *Man, Snake & Banner, 1969*

1

3

IRENE SHAVER (Painting/Peinture) 1898, Ontario LIVES/HABITE: Montreal TRAINING/FORMATION: Montreal Museum of Fine Art MEDIUM: Oil/Huile.

EX—1: The Art Centre, Cowansville, Que. (Oct/oct 72).

EX—2: with/avec **E.J. SMITH**, Eatons Art Gallery, Montreal (24 I—30 I 73).

EX—4: with/avec **A. DUFFY, G. GOLDSMITH, A. KNOX**, Gallery 93, Ottawa (25 IX—16 X 72).

GROUP/GROUPE: Place Ville-Marie, Montreal (May/mai 73).

SHELLEY GRAVES SHAW Toronto LIVES/HABITE: Toronto TRAINING/FORMATION: Ontario College of Art, Toronto AWARDS & HONOURS/PRIX & HONNEURS: Acme Foundation Grant, 1970; Canada Council Grant, 1971/Bourse de la Fondation Acme, 1970; Bourse du Conseil des Arts du Canada, 1971 MEDIUM: Pencil, ink, watercolour, silverpoint, acrylic/Crayon, encre, aquarelle, pointe d'argent, acrylique. EX—1: Victoria College, Univ Toronto, Toronto (25 III—13 IV 73).

DAVID JOHN SHONE (Painting/Peinture) 1941, Kingston-Upon-Thames, Eng. LIVES/HABITE: Edmonton TRAINING/FORMATION: Kingston College of Art, Eng.; London College of Printing & Graphic Art, London, Eng. MEDIUM: Acrylic, oil/Acrylique, huile.

EX—1: Calgary Galleries, Calgary (16 II—10 III 73) GROUP/GROUPE: "Sixth Annual Watrous Art Exhibition".

4

1 SHAW *Trees, 1970* Photo: R. A. Stringer

2 SHAVER

3 SHONE *Woman in Doctor's Waiting Room, 1972 (24" x 30")*

4 SHONIKER *Schefflera (48" x 36")* Photo: Merton Gallery, Toronto

CLAIRE SHONIKER (Painting/Peinture) 1931, Toronto LIVES/HABITE: Toronto TRAINING/FORMATION: Ontario College of Art, Toronto; Instituto Allende, San Miguel de Allende, Mexico AWARDS & HONOURS/ PRIX & HONNEURS: International Grand Prize, Union Féminine Artistique et Culturelle, Vichy, France, 1960; Hors Prize, Algiers International Competition, 1960/Grand Prix International de l'Union Féminine Artistique et Culturelle, Vichy, France, 1960; Prix Hors, Concours International d'Alger, 1960 MEDIUM: Acrylic/Acrylique.

EX–1: Merton Gallery, Toronto (22 I–10 II 73) GROUP/GROUPE: "Annual Exhibition of Contemporary Canadian Art".

RON SHUEBROOK (Printmaking, painting, sculpture/Gravure, peinture, sculpture) 1943 LIVES/HABITE: Wolfville, N.S. TRAINING/ FORMATION: Kutztown State College, Penn.; Haystack Mountain School of Arts and Crafts, Deer Isle, Maine; Kent State Univ, Ohio AWARDS & HONOURS/PRIX & HONNEURS: Honour Prize for painting, Kutztown State College, 1965; R.L. Donaghy Prize for drawing, Kent State Univ, 1971/Prix d'Honneur, peinture, Kutztown State College, 1965; Prix de dessin R.L. Donaghy, Kent State Univ, 1971 TEACHES/ENSEIGNE: Acadia Univ, Wolfville, N.S. MEDIUM: Acrylic/Acrylique.

EX–1: Canton Art Institute, Canton, Ohio, U.S.A. (1972); "Recent Work" Marquis Gallery, Univ Saskatchewan, Saskatoon (28 V–8 VI 73).

GROUP/GROUPE: Mansfield Art Centre, Ohio (1972); Kent State Univ, Ohio (1972); "Another Eleven Saskatchewan Artists"; "North Saskatchewan Juried Show".

TATIANA SIENKIEWICZ (Peinture, dessin/ Painting, drawing) 1906, Bolgrad, Russia HABITE/LIVES: St-Jean, Qué. FORMATION/ TRAINING: Ecole Nationale Supérieure des Arts Décoratifs de Paris PRIX & HONNEURS/ AWARDS & HONOURS: Premier Prix au Concours des Affiches du ministère de l'Agriculture de Roumanie, 1934; Premier Prix à l'Exposition Républicaine, Kichinev, U.R.S.S., 1941/ First Prize, Romanian Ministry of Agriculture Poster Contest, 1934; First Prize, Republican Exhibition, Kichinev, U.S.S.R., 1941 MEDIUM: Huile, pastel, aquarelle, gouache/Oil, pastel, watercolour, gouache.

1

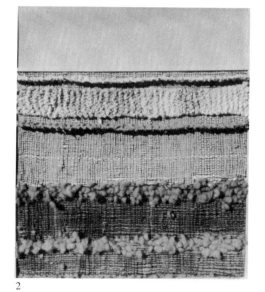

2

EX–1: Centre Communautaire de l'Université de Montréal (18 V–2 VI 72) GROUPE/ GROUP: "Festival Accord" Centre Germano-Canadien, Montréal (mars/Mar 73).

CAROLE SIMARD-LAFLAMME (Tapisseries/Hangings) 1945, Baie-St-Paul, Qué. HABITE/LIVES: St-Lambert, Qué. FORMATION/TRAINING: Ecole des Beaux-Arts de Québec; Univ Laval; Univ Québec PRIX & HONNEURS/AWARDS & HONOURS: Bourse du ministère des Affaires culturelles du Québec, 1971/Quebec Ministry for Cultural Affairs Grant, 1971 MEDIUM: Laine, textiles/Wool, textiles.

GROUPE/GROUP: "Festival folklorique de Baie-St-Paul" Charlevoix, Qué.; "Salon des Métiers d'Art".

3

4

1 SHUEBROOK *Untitled, 1972 (50" x 60")*

2 SIMARD-LAFLAMME

3 SIENKIEWICZ *Le Matin dans les Montagnes, 1971 (16" x 20")*

4 SIMARD-LAFLAMME

1

2

3

LEONARD SIMARD (Dessin, peinture, sculpture/Drawing, painting, sculpture) 1933, Lac-St-Jean, Qué. HABITE/LIVES: Roberval, Qué. FORMATION/TRAINING: Ecole des Beaux-Arts de Montréal MEDIUM: Huile, fusain, pastel, argile/Oil, charcoal, pastel, clay EX—1: Centre Culturel de Verdun, Qué. (7 III—2 IV 73).

SYLVIA SIMARD (Peinture/Painting) 1946, Arvida, Qué. HABITE/LIVES: Ste-Foy, Qué. FORMATION/TRAINING: Autodidacte/Self-taught MEDIUM: Acrylique, huile, collage/Acrylic, oil, collage.

EX—1: Galerie Martinez, Cannes, France (mai/May 73).

GROUPE/GROUP: "Les Moins de 35"; "Les Artisans Coopvie" Montréal (3 IV—7 IV 73); Séminaire St-Georges de Beauce, Qué. (10 III—18 III 73); "Au Germoir" Montmagny, Qué. (mai/May 73); Galerie d'Art Benedek-Grenier, Québec (avril/Apr 73).

HENRY J. SIMPKINS (Painting/Peinture) 1906, Winnipeg LIVES/HABITE: Dorval, Qué. TRAINING/FORMATION: Winnipeg School of Art MEDIUM: Oil, watercolour/Huile, aquarelle EX—1: Wallack Gallery, Ottawa (17 X—28 X 72); Kastel Gallery, Montreal (5 IV—21 IV 73).

CLAIRE SINCLAIR (Painting/Peinture) 1931, Glasgow, Scotland LIVES/HABITE: Toronto TRAINING/FORMATION: Self-taught/Autodidacte MEDIUM: Watercolour/Aquarelle.

EX—1: Canadian Imperial Bank of Commerce, Toronto (Oct/oct 72) GROUP/GROUPE: Kar Gallery, Toronto; Estée Gallery, Toronto (Apr/avril 73).

1 SIMPKINS *Steaming Up (29 1/2" x 20 1/2")*

2 C. SINCLAIR *Peaches, Grapes and Plums*

3 L. SIMARD *La Ferme Desbiens, 1972 (16" x 20")*

4 S. SIMARD *L'Amour m'emporte, 1972*

5 S. SIMARD *Analyse d'une Femme, 1972*

4

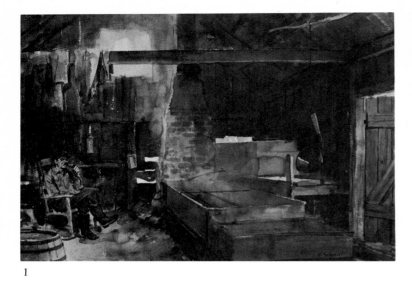

5

ROBERT SINCLAIR (Painting, sculpture, drawing/Peinture, sculpture, dessin) 1942, Saltcoats, Sask. LIVES/HABITE: Edmonton TRAINING/FORMATION: Univ Manitoba, Winnipeg; Univ Iowa AWARDS & HONOURS/ PRIX & HONNEURS: E.T. Greenshields Memorial Foundation Grants, 1969, 1970; Canada Council Grant, 1970/Bourses de la Fondation commémorative E.T. Greenshields, 1969, 1970; Bourse du Conseil des Arts du Canada, 1970 TEACHES/ENSEIGNE: Univ Alberta MEDIUM: Acrylic, plexiglas constructions, watercolour/Acrylique, constructions en plexiglas, aquarelle.

EX—1: Edmonton Art Gallery, Edmonton (10 XII 72—2 II 73); Aggregation Gallery, Toronto (19 V—4 VI 73); Peter Whyte Gallery, Banff, Alta. (1973).

EX—3: "A Prairie Sweet" with/avec **A. WILSON, H. HOUSE**, Glenbow-Alberta Institute, Edmonton (1 III—13 IV 73).

EX—4: "Images: Earth/Water/Sky" with/avec **S. PALCHINSKI, E. BARTRAM, B. JORDAN**, Aggregation Gallery, Toronto (12 V—31 V 73).

GROUP/GROUPE: "Kingston Spring Exhibition"; Burnaby Art Gallery, Burnaby, B.C. (1972); "Inaugural Exhibition" Aggregation Gallery, Toronto (3 X—21 X 72); Univ Alberta Art Gallery, Edmonton (9 X—31 X 72); "For an Independent Hairy Hill" Edmonton Art Gallery, Edmonton (3 XII—23 XII 72); "Alberta Contemporary Drawings".

1 R. SINCLAIR *To Winnipeg (6 1/2" x 5")* Photo: Aggregation Gallery, Toronto

2 R. SINCLAIR *Summertime Road, 1971 (8" x 9" x 8")* Photo: J. Ayriss for Aggregation Gallery, Toronto

1

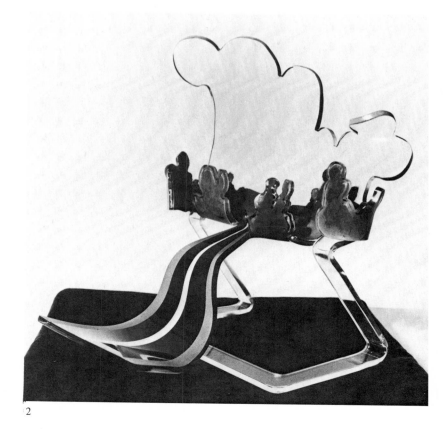

2

PAVEL SKALNIK (Peinture, gravure/Painting, printmaking) 1941, Prague, Czechoslovakia HABITE/LIVES: Moncton, N.B. FORMATION/TRAINING: Ecole Professionnelle d'Artisanat de Prague; Académie des Beaux-Arts de Prague; Ecole Nationale Supérieure des Arts Décoratifs de Paris PRIX & HONNEURS/AWARDS & HONOURS: Prix de l'International Arts Guild, Monte Carlo, 1969/Prize from the International Arts Guild, Monte Carlo, 1969 MEDIUM: Acrylique, huile, eau-forte, sérigraphie/Acrylic, oil, etching, serigraphy.

EX−1: Galerie d'Art de l'Université de Moncton, N.B. (29 XI−20 XII 72).

EX−2: "Coutellier−Skalnik" avec/with **F. COUTELLIER**, William Ganong Hall, Univ Nouveau-Brunswick, St. John, N.B. (22 X−4 XI 72).

EX−3: Centre Rothmans, Moncton, N.B. (16 III−6 IV 73).

GROUPE/GROUP: Vaux-sur-Aure, France (juin/June 72); Caen, France (5 VII−15 VII 72); Edmonton Art Gallery (17 IV−12 IX 72); Galerie Colline, Edmundston, N.B. (22 IX−30 IX 72); Lille, France (nov/Nov 72); "New Brunswick Artists"; The Little Gallery, Univ Nouveau-Brunswick, Fredericton (1972); "December Choice" Morrison Art Gallery, St. John, N.B. (déc/Dec 72); Phoenix Galleries, Charlottetown (26 III−14 IV 73).

GORD SMITH (Sculpture) 1937 LIVES/HABITE: Victoria MEDIUM: Stainless steel, bronze/Acier inoxydable, bronze.

GROUP/GROUPE: "Operation Multiple" Galerie Espace, Montreal (31 V−30 IX 72); "Convocation '73" Simon Fraser Univ, Vancouver (8 V−1 VI 73); Zan Art Gallery, Victoria (17 V−18 VI 73).

1 SKALNIK *Tête beige, 1972 (16" x 20")*

2 SKALNIK *Tête grafitti brune, 1972 (16" x 12")*

3 G. SMITH *Two Circles* Photo: Zan Art Gallery, Victoria

4 G. SMITH *Bird Form* Photo: Zan Art Gallery, Victoria

1

2

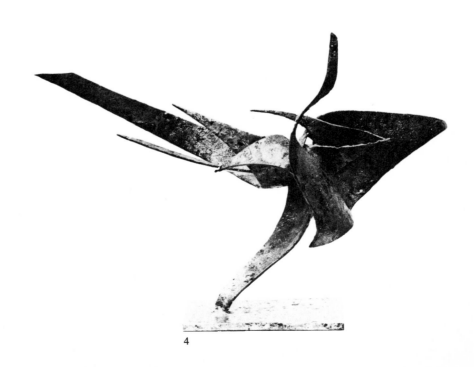

3

4

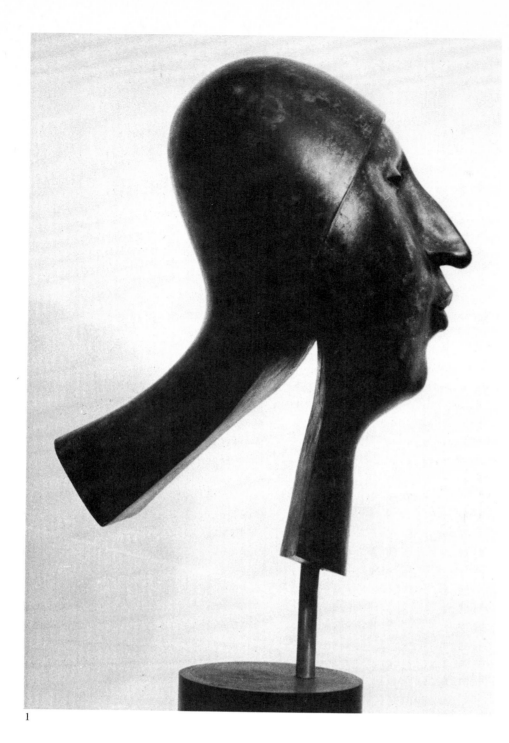

1

JOHN IVOR SMITH (Sculpture) 1927, London, Eng. LIVES/HABITE: Montreal TRAINING/FORMATION: Montreal Museum of Fine Arts, Montreal AWARDS & HONOURS/PRIX & HONNEURS: Prizes, Province of Quebec Art Contest, 1956, 1959; Canada Council Junior Fellowship, 1957; Prizes in Winnipeg Show, 1959, 1960, 1961; Grand Centennial Award, Montreal Spring Exhibition, 1960; Award, Vancouver Contemporary Exhibition, 1962; Canada Council Senior Fellowships, 1967, 1969/Prix aux Concours Artistiques de la Province de Québec, 1956, 1959; Bourse du Conseil des Arts du Canada, 1957; Prix au Winnipeg Show, 1959, 1960, 1961; Grand Prix du Centenaire, Salon du Printemps, Montréal, 1960; Prix, Vancouver Contemporary Exhibition, 1962; Bourses de travail libre du Conseil des Arts du Canada, 1967, 1969 TEACHES/ENSEIGNE: Sir George Williams Univ, Montreal MEDIUM: Fiberglas/Fibre de verre.

EX−1: Isaacs Gallery, Toronto (30 X−13 XI 72) GROUP/GROUPE: "Art for All"; "Plastic Fantastic".

PEGGY SMITH (Painting, drawing/Peinture, dessin) 1935, O'Leary, P.E.I. LIVES/HABITE: St. John, N.B. TRAINING/FORMATION: Mount Allison Univ, Sackville, N.B.; Univ Toronto MEDIUM: Oil, beeswax, varnish, India ink/Huile, cire d'abeilles, vernis, encre de Chine.

EX−4: "Four Island Artists" with/avec **D. MORRIS, G. READ-BARTON, B. BUGDEN,** Confederation Centre Art Gallery, Charlottetown (May/mai 73).

GROUP/GROUPE: "New Brunswick Artists"; "New Brunswick Artists '73" Cassel Galleries, Fredericton (13 II−17 III 73).

DAWN SNELL (Drawing, painting/Dessin, peinture) 1928, Peterborough, Ont. LIVES/HABITE: Lyn, Ont. TRAINING/FORMATION; Central Technical School, Toronto; Montreal Museum of Fine Arts MEDIUM: Ink, acrylic, gouache, watercolour/Encre, acrylique, gouache, aquarelle.

EX−2: with/avec **R. WINSLOW,** Gallery 93, Ottawa (27 XI−31 XII 72).

1 J. SMITH *Variation No. 1 (Patrician), 1967 (26")* Photo: Isaacs Gallery, Toronto

2 P. SMITH *King Square, 1971*

3 SNELL *Goose Girl*

2

3

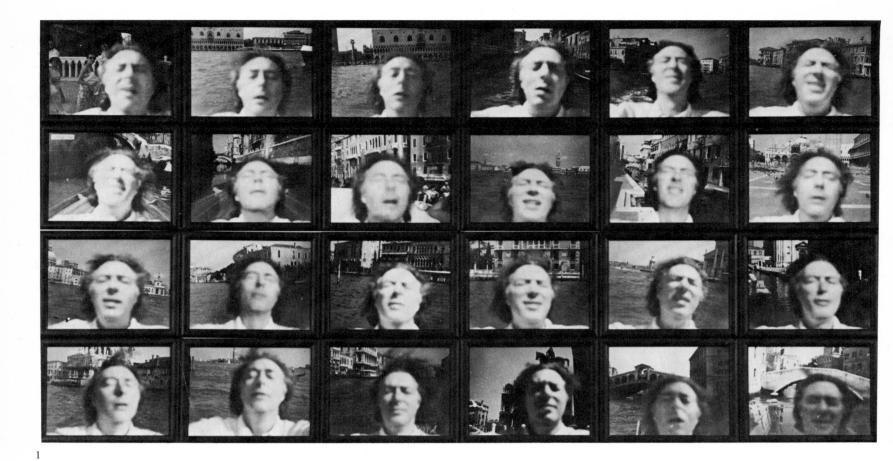

1

GARRY SNELLING (Painting, sculpture/ Peinture, sculpture) LIVES/HABITE: Toronto TRAINING/FORMATION: Ontario College of Art, Toronto GROUP/GROUPE: "Information and Perception" Gallery 76, Ontario College of Art, Toronto (24 III– 23 IV 73).

MICHAEL SNOW (Painting, sculpture, conceptual/Peinture, sculpture, conceptuel) 1929, Toronto LIVES/HABITE: Toronto TRAINING/FORMATION: Ontario College of Art, Toronto AWARDS & HONOURS/PRIX & HONNEURS: First Prize, Winnipeg Show, 1958; Canada Council Grant, 1959; Prize, Henry Street Settlement Exhibition, 1964; Canada Council Senior Fellowship, 1966/Premier Prix, Winnipeg Show, 1958; Bourse du Conseil des Arts du Canada, 1959; Prix de l'exposition "Henry Street Settlement", 1964; Bourse de travail libre du Conseil des Arts du Canada, 1966 MEDIUM: Film, photographs, video, aluminum, lead etc./Film, photographies, vidéo,

EX–1: Center for Inter-American Relations, New York (15 XI–31 XII 72); Anna Leonowens Gallery, Nova Scotia College of Art & Design, Halifax (15 I–30 I 73).

GROUP/GROUPE: "Lithographs I"; "Art for All"; "Toronto Painting"; "Diversity"; Film Festival, Pesaro, Italy (Sept/sept 72).

2

3

STELIO SOLE (Peinture/Painting) 1932, Caracas, Venezuela HABITE/LIVES: Sesto St. Giovanni, Italie FORMATION/TRAINING: Accademia di Belle Arti, Milan; Accademia di Belle Arti, Venezia, Italie PRIX & HONNEURS/AWARDS & HONOURS: Bourse du Conseil des Arts du Canada, 1966; Bourse du ministère des Affaires culturelles du Québec, 1972/Canada Council Grant, 1966; Quebec Ministry of Cultural Affairs Bursary, 1972 MEDIUM: Acrylique, détrempe/Acrylic, tempera.

EX–1: Studio 2, Sesto St. Giovanni, Italie (nov/Nov 72).

EX–5: Centre Culturel de Trois-Rivières, Qué. (févr/Feb 73).

DANIEL SOLOMON (Painting/Peinture) 1945, Kansas LIVES/HABITE: Toronto TRAINING/FORMATION: Univ Oregon AWARDS & HONOURS/PRIX & HONNEURS: Canada Council Short Term Grant, 1969; Canada Council Arts Bursary, 1970/Bourse de courte durée du Conseil des Arts du Canada, 1969; Bourse de perfectionnement du Conseil des Arts du Canada, 1970 MEDIUM: Acrylic, pastel, collage/Acrylique, pastel, collage GROUP/GROUPE: "Art for All".

1 SNOW *Venetian Blind, 1970 (50" x 94")* Photo: J. Ayriss for Isaacs Gallery, Toronto

2 SOLE *Elément Spatial, 1972* Photo: Claudio Vermi

3 SNELLING

1 SOLOMON *Musical Space
No. 2, 1972 (44 1/2" x
70")* Photo: Lyle
Wachovsky for Isaacs
Gallery, Toronto

2 SOLOMON *Voodoo, 1973
(35 1/2" x 47")* Photo:
Lyle Wachovsky for Isaacs
Gallery, Toronto

1

2

SOLOMON *Whitesway, 1973 (84" x 58 1/2")* Photo: Lyle Wachovsky for Isaacs Gallery, Toronto

JAMES SPENCER (Painting, drawing/Peinture, dessin) 1940, Toronto LIVES/HABITE: Toronto TRAINING/FORMATION: Acadia Univ, Wolfville, N.S.; Ontario College of Art, Toronto AWARDS & HONOURS/PRIX & HONNEURS: Canada Council Grants, 1967, 1971, 1972; Brantford Expositor Award, 1972/ Bourses du Conseil des Arts du Canada, 1967, 1971, 1972; Prix du Brantford Expositor, 1972 MEDIUM: Acrylic, pencil, ink, oil, photographs/Acrylique, crayon, encre, huile, photographies.

EX–1: "Waves" Hart House, Univ Toronto, Toronto (28 XI–17 XII 72).

EX–3: "Three Young Canadians" with/avec **G. ZELDIN, E. OUCHI**, Art Gallery of Brant, Brantford, Ont. (7 IX–1 X 72).

GROUP/GROUPE: "Graphex I"; "Open Juried Show" Art Gallery of Brant, Brantford, Ont. (1972).

*** See colour section/ Voir section couleur**

SALLY SPECTOR (Drawing/Dessin) 1946, Michigan City, Ind. LIVES/HABITE: Outremont, Qué. TRAINING/FORMATION: Univ Chicago, Ill. MEDIUM: Ink/Encre.

EX–1: Me and My Friends Gallery, Toronto (4 V–1 VI 73) GROUP/GROUPE: "Fairview Centre Exhibition" Pointe-Claire, Qué. (May/ mai 73).

PAUL SOULIKIAS (Peinture/Painting) 1926, Volos, Greece HABITE/LIVES: Montréal FORMATION/TRAINING: Autodidacte/ Self-taught MEDIUM: Huile, aquarelle, fusain/ Oil, watercolour, charcoal.

EX–1: Galerie l'Art français, Montréal (1 VII–31 VIII 73); Galerie l'Art français, Montréal (7 III–24 III 73).

1 SOULIKIAS *Les Laurentides (28" x 36")*
Photo: Galerie l'Art français, Montréal

2 SOULIKIAS *Ste-Agathe (28" x 36")*
Photo: Galerie l'Art français, Montréal

3 SPECTOR *Daphne, 1971 (15 1/2" x 11 1/4")*

4 SPECTOR *After Giovanni Bellini–Two Young Venetians, 1972 (15 1/2" x 22 1/2")*

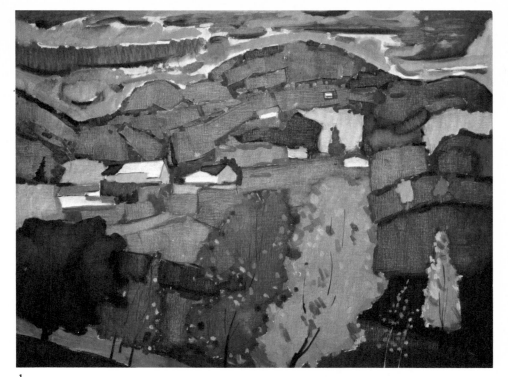

1

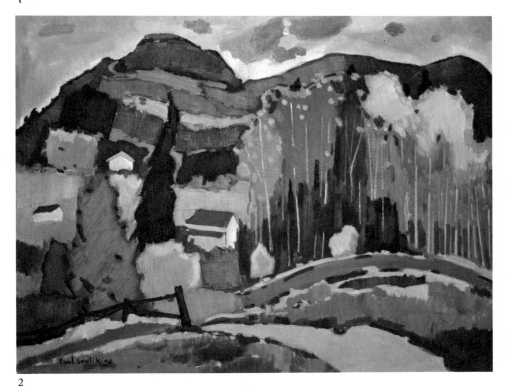

2

3

4

1

2

1 SPENCER *Wave No. 4, 1972-73 (108" x 144")*
 Photo: The National Gallery of Canada

2 SPENCER *Wave No. 2, 1972 (108" x 132")*
 Photo: Lyle Wachovsky

1

2

3

4

KARL GROENIG SPITAL (Painting/Peinture) 1945, Herne, W. Germany LIVES/HABITE: Moncton, N.B. TRAINING/FORMATION: Montreal Museum of Fine Arts MEDIUM: Acrylic/Acrylique GROUP/GROUPE: Galerie d'Art de l'Université de Moncton, Moncton, N.B. (6 II–25 II 73).

TONY E. STAPPELLS (Sculpture) 1932, Toronto LIVES/HABITE: Toronto TRAINING/FORMATION: Ontario College of Art, Toronto; Alfred Univ, N.Y.; Edinburgh College of Art, Edinburgh, Scotland MEDIUM: Bronze, fiberglas, stained glass, stone, wood/ Bronze, fibre de verre, verrières, pierre, bois.

EX–1: Commerce Court, Toronto (15 XII 72–15 I 73); Bishop Strachan School, Toronto (29 I–31 I 73); Montreal Trust, Toronto (2 III–15 III 73).

GROUP/GROUPE: "Great Canadian Super Show of Great Canadian Ideas"; Plastic Society of Canada, Royal York Hotel, Toronto (Oct/oct 72); "Sculptors' Society of Canada" Scarborough College, Toronto (5 XI–27 XI 72); East General Hospital, Toronto (15 XI–15 XII 72); Seneca College, Toronto (Dec/ déc 72–Mar/mars 73).

LOIS STEEN (Drawing, painting/Dessin, peinture) 1934, London, Ont. LIVES/HABITE: Toronto TRAINING/FORMATION: H.B. Beal Technical School, London, Ont.; Ontario College of Art, Toronto; Banff School of Fine Arts, Banff, Alta. AWARDS & HONOURS/PRIX & HONNEURS: Canada Council Materials Grant, 1967; Canada Council Short-term Grant, 1973/Bourse de frais du Conseil des Arts du Canada, 1967; Bourse de courte durée du Conseil des Arts du Canada, 1973 MEDIUM: Acrylic, pencil, ink/Acrylique, crayon, encre.

EX–1: Merton Gallery, Toronto (5 III–24 III 73).

1 SPITAL *Ruby's Place*

2 STEEN *Epic Series No. 3 To C.T.S. (24" x 32")*

3 STAPPELLS *Printemps, 1973 (14" x 14" x 12")*

4 STAPPELLS *Ice Palace (18" x 12" x 12")*

1

TOBIE STEINHOUSE (Painting, printmaking/ Peinture, gravure) Montreal LIVES/HABITE: Montreal TRAINING/FORMATION: Sir George Williams Univ, Montreal; Art Students' League, New York; Ecole des Beaux-Arts de Paris; Académie de la Grande Chaumière, Paris AWARDS & HONOURS/PRIX & HONNEURS: First Prize, Spring Show, Montreal Museum of Fine Arts, 1963; First Prize, National Council of Jewish Women, Ottawa, 1965; Centennial Medal, 1967/Premier Prix, Salon du Printemps, Musée des Beaux-Arts de Montréal, 1963; Premier Prix, Conseil National des Femmes Juives du Canada, Ottawa, 1965; Médaille du Centenaire, 1967 MEDIUM: Etching/Eauforte.

GROUP/GROUPE: "Songes et Lumière" La Guilde Graphique, Montreal (May/mai—June/ juin 72); "International Graphics"; "Canadian Printmakers Showcase"; "Association des Graveurs du Québec à l'Etable" Montreal Museum of Fine Arts; "Neuvième Biennale Internationale d'Art de Menton" France (Jul/juil—Sept/ sept 72); "12th Annual Calgary Graphics Exhibition"; "Third British International Print Biennale" Bradford, Eng. (Jul/juil—Sept/sept 72); "Canadian Society of Painter-Etchers and Engravers" London Public Library & Art Museum, London, Ont. (Nov/nov 72); Galerie du Parc, Trois-Rivières, Que. (Dec/déc 72); Dawson College, Montreal (Apr/avril 73); National Council of Jewish Women, Ottawa (Apr/avril 73); Sir George Williams Univ, Montreal (May/ mai 73); Galerie les Deux B, Montreal (May/ mai—June/juin 73).

1 STEINHOUSE *Quelconque une solitude, 1971* Photo: Progress Photo, Montreal

2 STEINHOUSE *Rouge et Noir—In memoriam Anne Savage, 1971* Photo: Progress Photo, Montreal

2

1

2

3

JOHN STREET (Printmaking, drawing, painting/Gravure, dessin, peinture) 1942, Toronto LIVES/HABITE: Montreal TRAINING/FORMATION: Ontario College of Art, Toronto MEDIUM: Serigraphy, monoprint/Sérigraphie, monogravure.

EX—1: Shaw-Rimmington Gallery, Toronto (16 X—28 X 72).

EX—3: with/avec **C. BIRT, J. CURRELLY,** Robert McLaughlin Art Gallery, Oshawa, Ont. (4 IV—27 IV 73).

GROUP/GROUPE: "Ontario Society of Artists 101st Annual Exhibition"; "Canadian Printmakers Exhibition" London Public Library & Art Museum, London, Ont. (1972).

R. LYNN STUDHAM (Gravure, peinture/Printmaking, painting) 1936, Stanley, Eng. HABITE/LIVES: Montréal FORMATION/TRAINING: Sunderland College of Art, Durham, Eng.; Royal Academy of Fine Arts, Copenhagen, Denmark MEDIUM: Acrylique, eau-forte/Acrylic, etching.

EX—1: Studio 23, St-Sauveur-des-Monts, Qué. (16 IX—10 X 72).

GROUPE/GROUP: "Premi Internacional Dibiux Joan Miró" Barcelona, Spain (1972); "Internationale Austellung Graphik" Vienna (1972); Studio 23, St-Sauveur-des-Monts, Qué. (17 VI—18 VII 72); Shaw-Rimmington Gallery, Toronto (1973); Ontario Association of Architects, Toronto (1973); Alberta College of Art, Calgary (1973); McGill Univ, Montreal (1973).

FRANCOISE SULLIVAN (Conceptuel/Conceptual) 1951, Montréal HABITE/LIVES: Montréal FORMATION/TRAINING: Ecole des Beaux-Arts de Montréal MEDIUM: Papier, photographies/Paper, photographs.

EX—1: Galerie III, Montréal (29 XII 72—15 I 73) GROUPE/GROUP: Galerie III, Montréal (mai/May 73).

1 STREET *Untitled (38" x 50")*

2 STUDHAM *Modest Gentleman, Modest Lady (12" x 16")* Photo: Educational Media Centre, McGill Univ, Montreal

3 STUDHAM *Young Ladies Running (12" x 26")* Photo: Educational Media Centre, McGill Univ, Montreal

1, 2, 3 SULLIVAN *Photos de l'Exposition/Installation shots, 1972-73*

1

IVONKA SYMANIEC SURVILLA (Painting,
drawing/Peinture, dessin) 1936, Beylorussian
S.S.R. LIVES/HABITE: Ottawa TRAINING/
FORMATION: Ecole Supérieure des Beaux-
Arts de Paris MEDIUM: Watercolour, char-
coal, India ink/Aquarelle, fusain, encre de Chine.

GROUP/GROUPE: "10th Biennial Conven-
tion of Beylorussians of North America" Bey-
lorussian Institute of Arts and Sciences in Cana-
da, Toronto (2 IX–4 IX 72).

1 SWARTZMAN *Cross Currents, 1972*

2 SWIATECKI *Cabin near Watrous Lake, 1971*

3 SURVILLA *Woman, 1972*

3

2

ROSLYN SWARTZMAN (Printmaking, paint-
ing/Gravure, peinture) 1931, Montreal
LIVES/HABITE: Montreal TRAINING/FOR-
MATION: Montreal Museum of Fine Arts;
Ecole des Beaux-Arts de Montréal AWARDS
& HONOURS/PRIX & HONNEURS: First
Prize for Painting and Third Prize for Graphic
Art, Provincial Exhibition of Painting, Photo-
graphy and Graphic Art, 1957; Second Prize,
Painting, Province of Quebec Art Competi-
tion, 1958; G.A. Reid Award, Society of Cana-
dian Painter-Etchers and Engravers, 1965/
Premier Prix pour la peinture et Troisième Prix
pour l'art Graphique, Exposition Provinciale de
Peinture, de Photographie et d'Art Graphique,
1957; Deuxième Prix, Peinture, Concours Ar-
tistiques de la Province de Québec, 1958; Prix
G.A. Reid, Society of Canadian Painter-Etchers
and Engravers, 1965 MEDIUM: Etching, bas-
relief/Eau-forte, bas-relief.

EX–1: Graphic 8 Galleries, Calgary (Autumn/
automne 72); Gallery Pascal, Toronto (14 X–
2 XI 72); Art Gallery, Mount St. Vincent Univ,
Halifax (14 IV–15 V 73); Wallack Gallery,
Ottawa (22 V–9 VI 73).

GROUP/GROUPE: "Printmakers Exhibition"
Mido Gallery, Vancouver (1 IX–6 X 72);
"Canadian Printmakers Showcase"; "Process";
"International Graphics"; "Ibizagraphic Inter-
national Print Show" Spain (Summer/été 72).

ANTONI SWIATECKI (Painting/Peinture)
1949, Poland LIVES/HABITE: Saskatoon
MEDIUM: Oil, acrylic/Huile, acrylique
GROUP/GROUPE: "Saskachimo Exhibition";
"A Summer Show".

1

2

PIERRE GEORGES TABOUILLET (Peinture/Painting) 1936 HABITE/LIVES: Sillery, Qué. FORMATION/TRAINING: Ecole ABC de Paris MEDIUM: Huile/Oil.

EX—1: Galerie du Palais Montcalm, Québec (1 XI—12 XI 72); La Chasse-Galerie, Toronto (mars/Mar—avril/Apr 73); "Chutes et Pays d'en Haut" La Caisse Populaire St-Pascal-de-Maizerets, Québec (19 II—4 III 73).

GROUPE/GROUP: "14th International Exhibition" Galerie Internationale, New York (juin/June 72); "15th International Exhibition" Galerie Internationale, New York (déc/Dec 72); "Art Contemporain International" Librairie-Galerie Crozier, Lyon, France (3 II—7 II 73); Galerie Andréann Canel, Paris (17 II—3 III 73); Bertrand Russell House, Nottingham, Eng. (mai/May 73).

ARMAND TAGOONA (Drawing, painting/Dessin, peinture) 1926 LIVES/HABITE: Baker Lake, N.W.T. EX—1: Robertson Galleries, Ottawa (Oct/oct 72) GROUP/GROUPE: "Baker Lake Prints".

1 TABOUILLET *En Route vers l'Infinie (36" x 36")*

2 TABOUILLET *Plateforme spatiale (44" x 44")*

3 TABOUILLET *Train spatial (36" x 48")*

4 TAGOONA Photo: Robertson Galleries, Ottawa

3

4

ERNESTINE TAHEDL (Peinture, sculpture/Painting, sculpture) 1940, Austria HABITE/LIVES: Mont St-Hilaire, Qué. FORMATION/TRAINING: Vienna Akademie Für Angewandte Kunst PRIX & HONNEURS/AWARDS & HONOURS: Médaille de bronze, section peinture abstraite, Exposition Internationale de Vienne, 1963; Médaille des Arts Connexes de l'Institut Royal d'Architecture du Canada, 1966; Prix du Conseil des Arts du Canada, 1967/Bronze Medal, Vienna International Exhibition of Painting, 1963; Allied Arts Medal, Royal Architecture Institute of Canada, 1966; Canada Council Arts Award, 1967 MEDIUM: Acrylique, murale en verre, sculpture en verre/Acrylic, glass mural, glass sculpture.

EX−1: Les Deux B, Galerie d'Art, St-Antoine-sur-Richelieu, Québec (28 X−20 XI 72).

JAMES TALESKI (Painting/Peinture) 1946 LIVES/HABITE: London, Ont. TRAINING/FORMATION: H.B. Beal Technical School, London, Ont. MEDIUM: Watercolour, wooden blocks, plastic, sand/Aquarelle, blocs de bois, plastique, sable.

EX−1: "Contemporary Sculptured Paintings" Glen Gallery, London, Ont. (15 XI−30 XII 72).

MIYUKI TANOBE (Peinture, dessin/Painting, drawing) 1939, Kamakura, Japan HABITE/LIVES: St-Antoine-sur-Richelieu, Qué. FORMATION/TRAINING: Ecole des Beaux-Arts de l'Univ Tokyo; Ecole Supérieure Nationale des Beaux-Arts, Paris MEDIUM: Fusain, encre de Chine, gouache, huile/Charcoal, India ink, gouache, oil.

EX−1: Centre Social, Univ Montréal (mars/Mar 73).

EX−4: "Nouveaux Artistes de la Galerie" avec/with **G. BASTIEN, L. ROBERT, Y. TRUDEAU**, Galerie l'Art français, Montréal (janv/Jan 73).

GROUPE/GROUP: Galerie l'Art français, Montréal (1 VII−31 VIII 72).

1 TALESKI *Landscape (3' x 4')*

2 TAHEDL *Horizon, 1972*

3 TANOBE *La Boulangerie de St-Antoine, 1972*

4 TANOBE *Maison à vendre Faust, 1972*

1

2

3

4

1

2

3

4

5

6

7

VINCENT TANGREDI (Painting, sculpture/ Peinture, sculpture) 1950, Campobasso, Italy LIVES/HABITE: Toronto TRAINING/FORMATION: Ontario College of Art, Toronto MEDIUM: Photography, neon, wood, graphite on canvas, glass/Photographie, néon, bois, mine de plomb sur toile, verre.

EX—2: with/avec **R. ROBINSON**, Gallery 76, Ontario College of Art, Toronto (Jul/juil 72) GROUP/GROUPE: "Information and Perception".

*** See colour section/ Voir section couleur**

KAY TAPSON (Painting, drawing/Peinture, dessin) 1922 LIVES/HABITE: London, Ont. TRAINING/FORMATION: Univ Western Ontario, London, Ont.; Doon School of Fine Art, Doon, Ont.; Fanshawe College of Applied Arts, London, Ont. MEDIUM: Acrylic, watercolour, collage/Acrylique, aquarelle, collage.

EX—1: Glen Gallery, London, Ont. (24 III—14 IV 73).

PIERRE TETREAULT (Peinture, gravure/ Painting, printmaking) 1947, Granby, Qué. HABITE/LIVES: St-Basile-Le-Grand, Qué. FORMATION/TRAINING: Ecole des Beaux-Arts de Montréal MEDIUM: Sérigraphie, aquarelle/Serigraphy, watercolour.

EX—1: "Outre-Monde" Galerie l'Ezotérik, Montréal (1 XII—29 XII 72).

EX—2: avec/with **TIN YUM LAU**, Les Ateliers du Vieux Longueuil, Longueuil, Qué. (5 X—15 X 72).

GROUPE/GROUP: "Les Moins de 35"; "Canadian Printmakers Showcase"; Galerie Place Royale, Montréal (1972); Musée des Beaux-Arts, Montréal (1972); Galerie de la Société des Artistes Professionnels du Québec (7 X—15 XI 72); "Neuvième Biennale de Menton" France (1972); "New Talents" Marlborough-Godard Gallery, Toronto (août/Aug 72).

GREG THATCHER (Printmaking/Gravure) 1949, La Jolla, Calif. LIVES/HABITE: Sanichton, B.C. TRAINING/FORMATION: Univ Victoria MEDIUM: Etching/Eau-forte.

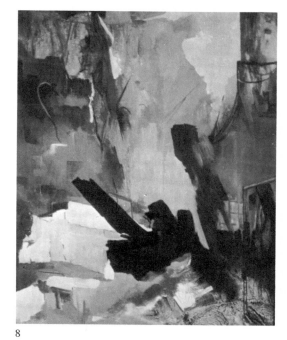

8

GROUP/GROUPE: Art Gallery of Greater Victoria (Dec/déc 72); Vancouver Art Gallery (Apr/avril 73); Art Gallery of Greater Victoria (Apr/avril 73); Univ Victoria (30 III—4 IV 73).

ODETTE THEBERGE-COTE (Peinture, gravure/Painting, printmaking) 1947 HABITE/ LIVES: Lévis, Qué. FORMATION/TRAINING: Ecole des Beaux-Arts de Montréal; Sir John Cass College, London, Eng. PRIX & HONNEURS/AWARDS & HONOURS: Prix de Vigie MEDIUM: Acrylique, sérigraphie/ Acrylic, serigraphy.

EX—1: Canada House, London, Eng. (18 X—4 X 72).

GROUPE/GROUP: Sir John Cass College, London, Eng. (juin/June 72); Centre International d'Etudes en Art Constructif, Germany (mai/May 73).

1 TETREAULT *Semence d'Eternité, 1972 (20" x 26")* Photo: La Guilde Graphique, Montréal

2 TETREAULT *En Quête d'Amour, 1972 (20" x 26")* Photo: La Guilde Graphique, Montréal

3 THEBERGE-COTE *Juin 1971 (40" x 20")*

4 THEBERGE-COTE *27 novembre 1971 (26 1/4" x 19")*

5 THEBERGE-COTE *1 décembre 1971 (36" x 20")*

6 THATCHER *Sarge, 1973*

7 THATCHER *Peek-a-Boo, I See You, 1973*

8 TAPSON *Untitled, 1972-73*

GEORGE TIESSEN (Printmaking/Gravure) LIVES/HABITE: Victoria TRAINING/FORMATION: Mount Allison Univ, Sackville, N.B.; Cornell Univ, Ithaca, N.Y. TEACHES/ENSEIGNE: Univ Victoria MEDIUM: Silkscreen/Sérigraphie GROUP/GROUPE: Zan Art Gallery, Victoria (18 V–18 VI 73).

1 TIESSEN *Four Views, 1972* Photo: Zan Art Gallery, Victoria

2 TIESSEN *B.C. Series Untitled, 1972* Zan Art Gallery, Victoria

3 TILEY *Continuum No. 12, 1970 (75" x 132")*

ANTHONY THORN (Painting/Peinture) 1927, Regina LIVES/HABITE: Toronto TRAINING/FORMATION: Univ Saskatchewan, Regina; Chicago Art Institute; Banff School of Fine Arts; Centre d'Art Sacré; Académie de la Grande Chaumière, Paris MEDIUM: Oil, acrylic, stained glass design, enamel/ Huile, acrylique, verrières, émail.

EX–1: Lillian Morrison Gallery, Toronto (Jul/juil 72).

EX–3: Galerie Moos, Montréal (10 II–24 II 73).

JIM TILEY (Painting/Peinture) 1933, London, Eng. LIVES/HABITE: Toronto TRAINING/FORMATION: Harrow School of Art; Royal College of Art, London, Eng. MEDIUM: Acrylic gesso/Gesso à l'acrylique.

EX–1: "30 Variations" Merton Gallery, Toronto (12 II–3 III 73); "Continuum Series" Memorial Univ Art Gallery, St. John's (2 IV– 26 IV 73).

EX–3: "Three Toronto Artists" McLaughlin Gallery, Oshawa (1972).

GROUP/GROUPE: "Workscene '72".

* See colour section/Voir section couleur

OSVALD TIMMAS (Painting/Peinture)
Estonia LIVES/HABITE: Toronto TRAIN-
ING/FORMATION: Univ Tartu; Atelier
Schools, Estonia and Sweden AWARDS &
HONOURS/PRIX & HONNEURS: Purchase
Award, London Art Museum, London, Ont.,
1966; Audubon Artists Medal & Award for
Creative Aquarelle, 1967; Ontario Society of
Artists Prize, 1967; John Ernst Award for
American Watercolours, 1967; Coutts-Hall-
mark Major Award for Watercolour, 1969;
New Jersey Watercolour Award, 1969; Award,
Pennsylvania Art Center, Erie, 1970; Tampold
Award, Hart House Art Gallery, Toronto, 1969;
John Labatt Ltd. Award, 1971; Harry Must
Award, New York, 1972/Prix d'acquisition du
London Art Museum, London, Ont., 1966;
Médaille et Prix d'aquarelle créatrice "Audu-
bon Artists", 1967; Prix de l'Ontario Society
of Artists, 1967; Prix de l'aquarelle améri-
caine John Ernst, 1967; Prix d'aquarelle
"Coutts-Hallmark" 1969; Prix d'aquarelle du
New Jersey, 1969; Prix, Pennsylvania Art Cen-
ter, Erie, 1970; Prix Tampold, Hart House
Gallery, Toronto, 1969; Prix John Labatt ltée.,
1971; Prix Harry Must, 1972.

EX—1: Scarborough Public Libraries, Toronto
(6 XI—29 XI 72); "New Works" Merton Gal-
lery, Toronto (10 IV—29 IV 73).

GROUP/GROUPE: "Ontario Society of Ar-
tists" Art Gallery of Ontario, Toronto (1972—
73); "Painters in Watercolour"; "Annual Ex-
hibition of Contemporary Canadian Art";
"New Canadian Art Exhibition".

SHARON RADLOFF TOKARCHUK (Hang-
ings, painting/Tapisseries, peinture) 1940,
Star City, Sask. LIVES/HABITE: Saskatoon
TRAINING/FORMATION: Univ Saskatchewan
Saskatoon MEDIUM: Acrylic, batik/Acry-
lique, batik GROUP/GROUPE: "A Summer
Show".

1

2

3

4

1 TIMMAS *The Elements*
 Photo: Merton Gallery,
 Toronto

2 THORN *Encounter, 1972*
 (48" x 54")

3 TOKARCHUK *Red*
 Tryptyk (3' x 5')

4 TIMMAS *Magenta Gorge*

217

VICTOR TOLGESY (Sculpture) 1928, Hungary LIVES/HABITE: Ottawa AWARDS & HONOURS/PRIX & HONNEURS: Canada Council Grant, 1958; First Prize, Canadian Sculpture Show, 1963; Canada Council Senior Fellowship, 1965; Sculpture Prize, Royal Canadian Academy Show, Montreal Museum of Fine Arts, 1967; Sculpture Prize, Ontario Society of Artists Show, Oshawa Art Gallery, 1970; Sculpture Prize, Society of Canadian Artists Show, Toronto, 1971; Purchase Prize, Royal Canadian Academy Show, Confederation Art Centre, Charlottetown, 1971/Bourse du Conseil des Arts du Canada, 1958; Premier Prix, Exposition de Sculpture Canadienne, 1963; Bourse de travail libre du Conseil des Arts du Canada, 1965; Prix de sculpture, Exposition de l'Académie Royale des Arts du Canada, Musée des Beaux-Arts de Montréal, 1967; Prix de sculpture, Exposition de l'Ontario Society of Artists, Oshawa Art Gallery, 1970; Prix de sculpture, Exposition de la Society of Canadian Artists, Toronto, 1971; Prix d'acquisition, Exposition de l'Académie Royale des Arts du Canada, Centre de la Confédération, Charlottetown, 1971 MEDIUM: Steel, bronze, aluminum, plastic/Acier, bronze, aluminium, plastique.

EX–1: Merton Gallery, Toronto (June/juin 72); Wells Gallery, Ottawa (June/juin 72); Merton Gallery, Toronto (16 X–28 X 72).

GROUP/GROUPE: "Ontario Society of Artists 100th Anniversary Exhibition" Toronto (1972); "Kingston Spring Exhibition"; "Ontario Society of Artists 101st Anniversary Exhibition" Hamilton, Ont. (1973).

WENDY TOOGOOD (Hangings/Tapisseries) 1947, Bristol, Eng. LIVES/HABITE: Toronto TRAINING/FORMATION: Alberta College of Art, Calgary; Instituto Allende, San Miguel de Allende, Mexico AWARDS & HONOURS/PRIX & HONNEURS: Canada Council Short Term Grant, 1970; Best Stitchery Award, Canadian Guild of Crafts Show, Toronto, 1970, 1972; Prize for Excellence, Canadian Guild of Crafts Exhibition, Toronto, 1971, 1972; Canada Council Arts Bursary, 1972, 1973/Bourse de courte durée du Conseil des Arts du Canada, 1970; Meilleur travail à l'aiguille, Exposition de la Guilde Canadienne des Métiers d'Art, Toronto, 1971, 1972; Bourse du Conseil des Arts du Canada, 1972, 1973 MEDIUM: Cloth constructions/Montages d'étoffe.

EX–1: Craft Gallery, Toronto (1 VIII–2 IX 72); Me & My Friends Gallery, Toronto (2 VI–5 VIII 73).

EX–2: "Homage to Boredom" Chuck Stake Enterprizes, Toronto (Apr/avril 73).

GROUP/GROUPE: Gallery 93, Ottawa (1972); "Canadian Guild of Crafts Show" Toronto (1972); "Kingston Spring Exhibition"; "SCAN"; "Cal-Graphics International Exhibition" Calgary (1972); Artists' Gallery, Toronto (Jul/juil 72).

1 TOOGOOD *Great Canadian Comic Book (4' x 6')*

2 TOLGESY *Welcome to Samarkand, 1972*

HAROLD TOWN (Painting, printmaking, drawing/Peinture, gravure, dessin) 1924, Toronto
LIVES/HABITE: Toronto MEDIUM: Oil, pastel, ink, gouache, collage/Huile, pastel, encre, gouache, collage.

EX–1: "French Post Cards" Fleet Gallery, Winnipeg (22 IX–28 X 72); "French Post Cards" Bau-XI Gallery, Vancouver (12 II–2 III 73); "Everton Variations" Mazelow Gallery, Toronto (16 XII 72–8 I 73); "Recent Drawings and Prints" Thielson Gallery, London, Ont. (27 I–9 II 73); "First Exhibition of New Work 1969–73" Robert McLaughlin Gallery, Oshawa, Ont. (15 V–24 VI 73).

GROUP/GROUPE: "Process"; "Painters Eleven" McIntosh Gallery, London, Ont. (1 X–22 X 72); "36th Venice Biennale" (11 VI–1 X 72); "Christmas Show" Beckett Gallery, Hamilton, Ont. (1972); McIntosh Gallery, London, Ont. (Sept/sept 72); "London Collects" London Public Art Gallery & Museum, London, Ont. (6 X–30 X 72); "Master Graphics Exhibition" London Public Art Gallery & Museum (6 IV–30 IV 73); "Toronto Painting: 1953–1965".

*** See colour section/ Voir section couleur**

1

2

1 TOWN *French Post Card, 1972* Photo: Michael Neill for Mazelow Gallery, Toronto

2 TOWN *Park No. 53, 1972* Photo: Michael Neill for Mazelow Gallery, Toronto

3 TOWN *Snap No. 10, 1972* Photo: Michael Neill for Mazelow Gallery, Toronto

3

1

2

3

1 TOUSIGNANT *Cercle Latin (72" diam.)*
 Photo: John Evans pour La Galerie nationale
 Coll: L'Artiste

2 TOUSIGNANT *Ovale, 1970 (78" x 192")*
 Photo: John Evans pour La Galerie nationale
 Coll: L'Artiste

3 TOUSIGNANT *Tryptique diagonal, 1971-72
 (12" x 114")* Photo: John Evans pour La
 Galerie nationale Coll: L'Artiste

4 TOUSIGNANT *Asperges, 1966 (44 1/2" x
 50 1/2")* Photo: John Evans pour La Galerie
 nationale Coll: L'Artiste

CLAUDE TOUSIGNANT (Peinture, sculpture, gravure/Painting, sculpture, printmaking)
1932, Montréal HABITE/LIVES: Montréal
FORMATION/TRAINING: Ecole des Beaux-Arts de Montréal; Académie Ranson, Paris
PRIX & HONNEURS/AWARDS & HONOURS:
Premier Prix, Salon de la Jeune Peinture, Montréal, 1962; Premier Prix, "Perspective '67" Toronto, 1967/First Prize, "Salon de la Jeune Peinture" Montreal, 1962; First Prize, Perspective '67, Toronto, 1967 MEDIUM: Acrylique, huile, émail, gouache/Acrylic, oil, enamel, gouache.

EX–1: Galerie Jolliet, Québec (mai/May 73);
Galerie B, Montréal (22 V–15 VI 73); "Retrospective" Musée d'Art Contemporain, Montréal (24 V–24 VI 73).

EX–1: organisée par La Galerie nationale/organized by The National Gallery, Ottawa
ITINERANTE/CIRCULATING: The National Gallery, Ottawa (12 I–11 II 73); Winnipeg Art Gallery (15 III–30 IV 73); Musée des Beaux-Arts, Montréal (25 II–24 IV 73).

GROUPE/GROUP: "Art 3" Bâle, Suisse
(22 VI–26 VI 72).

4

3

2

LEON TREMBLAY (Peinture/Painting) 1933 HABITE/LIVES: Girouxville, Alta. FORMA-TION/TRAINING: Autodidacte/Self-taught MEDIUM: Huile, aquarelle/Oil, watercolour.

GROUPE/GROUP: "Exposition d'Art des Franco-albertains" Salon d'Exposition, Collège St-Jean, Edmonton (17 II–18 II 73).

MICHELE TREMBLAY-GILLON (Peinture/Painting) 1944 HABITE/LIVES: Montréal FORMATION/TRAINING: Académie Royale des Beaux-Arts de Bruxelles, Belgique; New York School of Interior Design; Ecole Normale de St-Cloud, Paris MEDIUM: Huile, acrylique/Oil, acrylic.

EX—3: avec/with **P. GRANCHE, B. SCHIELE,** La Maison des Arts La Sauvegarde, Montréal (26 V–26 VI 72).

GROUPE/GROUP: Pavillon des Arts "Form-optic" Terre des Hommes (juil/Jul—sept/Sept 72); "Les Moins de 35".

NICOLE TREMBLAY (Peinture/Painting) 1942, Jonquière, Qué. HABITE/LIVES: Montréal FORMATION/TRAINING: Institut des Arts du Saguenay; Ecole des Beaux-Arts de Québec; Musée des Beaux-Arts de Montréal PRIX & HONNEURS/AWARDS & HONOURS: Premier Prix de Peinture aux Beaux-Arts, Section Arvida, 1963; Deuxième Prix de Peinture aux Beaux-Arts, Section Arvida, 1964; Premier Prix au Concours Maria Chapdelaine, Alma, 1964; Premier Prix au Salon du Printemps (Arvida), 1964; Premier Prix de Peinture aux Beaux-Arts (Arvida), 1965; Grand Prix au Concours 1966, Comité des Arts d'Arvida, 1966/First Prize, Painting, Ecole des Beaux-Arts (Arvida Section), 1963; Second Prize, Painting, Ecole des Beaux-Arts (Arvida Section), 1964; First Prize, Maria Chapdeleine Competition, Alma, 1964; First Prize, "Salon du Printemps", Arvida, 1964; First Prize, Painting, Ecole des Beaux-Arts (Arvida Section), 1965; Grand Prize, "Concours 1966", Comité des Arts d'Arvida, 1966 MEDIUM: Huile, acrylique, sable/Oil, acrylic, sand.

EX—1: Galerie les Gens de mon Pays, Ste-Foy, Qué. (mai/May 72); Caisse Populaire Côte des Neiges, Montréal (1972).

GROUPE/GROUP: "Société des Artisans" Montréal (1972); "Terre des Hommes" Montréal (1972); "L'Accord" Montréal (oct/Oct 72); "Les Moins de 35".

ANNE TREZE (Gravure/Printmaking) Riga, Latvia HABITE/LIVES: Montréal FORMA-TION/TRAINING: Ecole des Beaux-Arts de Montréal; Atelier Libre de Recherches Graphiques PRIX & HONNEURS/AWARDS & HONOURS: Premier Prix, Salon de la Jeune Peinture, 1961; Prix de dessin Molson, Cercle du Livre de France, 1970/First Prize, "Salon de la Jeune Peinture", 1961; Molson Prize for Design, Cercle du Livre de France, 1970 MEDIUM: Sérigraphie/Silkscreen GROUPE/GROUP: "Graphisme".

4

1 TREZE *Le Pressentiment des Cheveux bleus, 1972 (20" x 26")* Photo: La Guilde Graphique, Montréal

2 TREZE *Ondes, 1972 (20" x 26")* Photo: La Guilde Graphique, Montréal

3 L. TREMBLAY *Voiles sur Mer tourmentée* Photo: Musée Girouxville, Girouxville, Alta.

4 M. TREMBLAY-GILLON *Movement III (80" x 34" x 1 1/4")*

222

CLAUDE VALLEE (Dessin, peinture/ Drawing, painting) 1944, Valleyfield, Qué. HABITE/LIVES: St-Timothée, Qué. FORMA-TION/TRAINING: Autodidacte/Self-taught MEDIUM: Aquarelle, poèmes scripto-visuels, bandes dessinées, huile/Watercolour, scripto-visual poems, comic strips, oil.

EX—1: "Réalisme magique ou Réalités ordinaires" La Maison des Arts La Sauvegarde, Montréal (5 VIII—5 IX 72); Cinéma Elysée, Montréal (18 XI 72—18 III 73).

JOAN VAN BELKUM (Painting/Peinture) LIVES/HABITE: Medicine Hat, Alta. TRAIN-ING/FORMATION: Self-taught/Autodidacte MEDIUM: Oil, acrylic/Huile, acrylique.

EX—3: "The Great Plains—A Celebration of Light" with/avec **M. MANN-BUTUK, D. MACLEAN.** A circulating exhibition organized by the Medicine Hat Gallery Association/ Une exposition itinérante organisée par la Medicine Hat Gallery Association (Jan/janv—Feb/févr 73).

MADJA VAN DAM (Hangings/Tapisseries) 1932, Amsterdam LIVES/HABITE: Toronto TRAINING/FORMATION: Arts and Crafts School, Amsterdam MEDIUM: Textiles. EX—1: "Appliqué Hangings" Shaw-Rimmington Gallery, Toronto (31 III—27 IV 73); Egg and the Eye Gallery, Los Angeles, Calif. (May/mai—June/juin 73).

MARIE DE VANEY (Peinture/Painting) 1938, Boston HABITE/LIVES: Deux Montagnes, Qué. FORMATION/TRAINING: School of Art and Design, Montréal MEDIUM: Acrylique/Acrylic.

EX—2: avec/with **L. DUPUIS**, La Maison des Arts La Sauvegarde, Montréal (9 IX—9 X 72).

GROUPE/GROUP: "Formoptic" Terre des Hommes, Montréal (20 VII—2 IX 72).

WILLIAM VAZAN (Peinture, conceptuel/ Painting, conceptual) 1933, Toronto HA-BITE/LIVES: Montréal FORMATION/ TRAINING: Ontario College of Art, Toronto MEDIUM: Topographies, vidéo, diapositives, cartes, ruban nylon, acrylique/Earth art, video, slides, maps, nylon tape, acrylic.

EX—1: "Topographies" Musée d'Art Contemporain, Montréal (10 XII 72—28 I 73); "Angelo Deaquino Presents" Rio de Janeiro, Brazil (avril/ Apr 73); Vehicule Art, Montréal (1 V—19 V 73).

GROUPE/GROUP: "Realism: Emulsion and Omission"; "SCAN"; "Land Art Documentation" House of Arts, Brno, Czechoslovakia (juil/Jul—août/Aug 72); "Montreal: Plus or Minus? " Musée des Beaux-Arts de Montréal (juin/June—juil/Jul 72); "Communications" Museum of Fine Arts, Sydney, Australia (août/Aug 72); "Re-Cycle" Tokiwa Gallery, Tokyo, Japan (sept/Sept 72); "Postal Exhibition" Midland Group Gallery, Nottingham, Eng. (oct/Oct 72); "Opus Demercificandi" Centro Tool, Milan, Italy (oct/Oct 72); "International Cyclopaedia of Plans and Occurrences" Commonwealth Univ, Richmond, Va. (mars/Mar 73); Galerie B, Montréal (avril/Apr 73).

1 VAZAN *Low-tide Sandform, Prince Edward Island, 1969* (18')

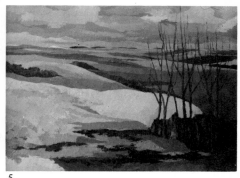

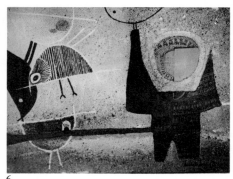

2 VALLEE *Ma Grandmère en Prières, 1973* (22" x 28")

3 VAN DAM *Come as You Are*

4 DE VANEY *1973* (34" x 48")

5 VAN BELKUM Photo: Medicine Hat Gallery Association, Medicine Hat, Alta.

6 N. TREMBLAY *Les Oiseaux du Paradis, 1971*

1

2

ROBERT VENOR (voir aussi/see also CANADA BANNERS COMPANY) (Peinture, sculpture, tapisseries/Painting, sculpture, hangings) 1931, Montréal HABITE/LIVES: Dollard-des-Ormeaux, Qué. FORMATION/TRAINING: Ecole des Beaux-Arts de Montréal; Sir George Williams Univ, Montréal PRIX & HONNEURS/ AWARDS & HONOURS: Prix du Consul Général de France (Section peinture), 1960; Bourse du Conseil des Arts du Canada, 1969/Prize of the Consul-General of France (Painting cate-

gory), 1960; Canada Council Grant, 1969 MEDIUM: Huile, acrylique, vinyle, nylon/Oil, acrylic, vinyl, nylon.

EX–1: "Sculpture and Banners Exhibition" Art Gallery of Ontario, Toronto (1972).

EX–2: voir/see **CANADA BANNERS COMPANY.**

EX–3: avec/with **S. RAPHAEL, H. FRANKLIN**, Saidye Bronfman Centre, Montréal (12 III–2 IV 73).

GROUPE/GROUP: "New Media Art" Canadian National Exhibition, Toronto (août/Aug 72); "Grafik"; "Association des Graveurs du Québec à l'Etable" Musée des Beaux-Arts de Montréal (oct/Oct 72); "Faculty Exhibition" Saidye Bronfman Centre, Montréal (sept/Sept 72); "Eight Canadian Printmakers".

*** Illustration: voir/see CANADA BANNERS COMPANY.**

KLAAS VERBOOM (Painting/Peinture) 1948, London, Ont. LIVES/HABITE: London, Ont. TRAINING/FORMATION: Ontario College of Art, Toronto AWARDS & HONOURS/PRIX & HONNEURS: Purchase Award, Western Ontario Exhibition, 1972/Prix d'acquisition de l'Exhibition de Western Ontario, 1972 MEDIUM: Acrylic, oil/Acrylique, huile.

EX–4: "The Young Realists" with/avec **B. JONES, G. HOLDSWORTH, H. AALTO**, Nancy Poole's Studio, London, Ont. (3 II– 20 II 73).

GROUP/GROUPE: Nancy Poole's Studio, Toronto (3 II–3 III 73).

*** See colour section/Voir section couleur**

3

4

ROGER VILDER Sculpture, peinture/ Sculpture, painting) 1938, Beyrouth, Lebanon FORMATION/TRAINING: Ecole des Beaux-Arts de Montréal; Sir George Williams Univ, Montréal; McGill Univ, Montréal PRIX & HONNEURS/AWARDS & HONOURS: Bourses du Conseil des Arts du Canada, 1968, 1969, 1970, 1971; Bourse d'aide à la création du gouvernement du Québec, 1969/Canada Council Grants, 1968, 1969, 1970, 1971; Quebec Government's "Aide à la création" Bursary, 1969 MEDIUM: Bois, chaînes, moteurs, ressorts, métal/Wood, chains, motors, springs, metal.

EX—1: "Roger Vilder" Centre Culturel Canadien, Paris (15 II—11 III 73); Galerie M, Bochum, Germany (1973); Galerie Ernst, Hannover, Germany (1973); Galerie La Polena, Geneva, Italy (1973); Glasmeier, Germany (1973); Atelier Gelsenkirchen, Germany (1973); Burgermeister Ludwig-Reichert-Haus, Ludwigshafen, Germany (1973).

EX—5: avec/with **M. HIRSCHBERG, S. MARKLE, R. SAVOIE, A. SAMCHUK**, The Electric Gallery, Toronto (juil/Jul 72).

GROUPE/GROUP: Art Gallery of York Univ, Toronto (1972); Robert McLaughlin Gallery, Oshawa, Ont. (1972); Rothman's Art Gallery, Stratford, Ont. (1972); Owens Art Gallery, Sackville, N.B. (1972); Vancouver Art Gallery (1973); Winnipeg Art Gallery (1973); New Brunswick Museum, St. John (1973).

MONIQUE VOYER (Peinture/Painting) 1928 HABITE/LIVES: Montréal FORMATION/TRAINING: Ecole des Beaux-Arts de Montréal; Ecole Nationale Supérieure des Beaux-Arts, Paris; Univ Québec, Montréal PRIX & HONNEURS/AWARDS & HONOURS: Premier prix de peinture, Ecole des Beaux-Arts de Montréal; Prix de peinture, Exposition Provinciale, Québec/First Prize (Painting), Ecole des Beaux-Arts de Montréal; Prize (Painting).

Provincial Exhibition, Quebec ENSEIGNE/ TEACHES: CEGEP du Vieux-Montréal MEDIUM: Acrylique/Acrylic.

EX—1: Galerie l'Apogée, St-Sauveur-des-Monts, Qué. (11 XI—7 XII 72).

MARGOT WAWRA (Sculpture, painting, drawing/Sculpture, peinture, dessin) 1923, Landsberg, Germany LIVES/HABITE: Saskatoon TRAINING/FORMATION: Univ Saskatchewan, Saskatoon; Univ California, Los Angeles MEDIUM: Wood, plexiglas, marble, iron, nylon string, mirrors, acrylic, pencil, collage/Bois, plexiglas, marbre, fer, corde de nylon, mirroirs, acrylique, crayon, collage.

EX—1: Saskatoon Public Library, Saskatoon (16 I —3 II 73) GROUP/GROUPE: "West '71"; "Northern Saskatchewan Juried Show"; Mendel Art Gallery, Saskatoon (Sept/sept 72).

1 VERBOOM *The Steer, 1971 (32" x 44")*

2 VERBOOM *Winter Willow, 1973 (32" x 44")*

3 VOYER *Ondes végétales, 1972 (6" x 4")* Photo: N. Meunier

4 VOYER *Solitaire aux Quatre Vents, 1972 (12" x 14")* Photo: N. Meunier

5 VILDER *Contractions, 1970* Photo: Electric Gallery, Toronto

6 WAWRA *Abstract with Hole (24")* Photo: Mara Art Studio, Saskatoon

5

6

1

ALICE WAYWELL (Painting/Peinture) Manchester, Eng. LIVES/HABITE: Oakville, Ont. TRAINING/FORMATION: Ontario College of Art, Toronto AWARDS & HONOURS/PRIX & HONNEURS: University Women's Club Show, Oakville, Ont., 1968; Award for Best Watercolour, Autumn Festival of Arts, Toronto, 1968; Award of Merit for Best Painting, Oakville Art Society, 1969; Award for Best Watercolour, Toronto City Hall Show, 1970/ Exposition "University Women's Club" Oakville, Ont., 1968; Premier Prix d'Aquarelle, Festival Automnal des Arts, Toronto, 1968; Prix de Mérite, Oakville Art Society, 1969; Premier Prix d'Aquarelle, Exposition de l'Hôtel de Ville de Toronto, 1970 MEDIUM: Watercolour/ Aquarelle.

EX—2: with/avec F. HUGHES, Centennial Gallery, Oakville, Ont. (31 X–13 XI 72); The Third Gallery, Toronto (16 XI–2 XII 72).

GROUP/GROUPE: Canadian Arts, Stratford, Ont. (June/juin 72); "Aviva Art Auction" Inn-on-the-Park, Toronto (Apr/avril 73).

ALAN WEINSTEIN (Printmaking, painting/ Gravure, peinture) 1939, Toronto LIVES/ HABITE: Teeswater, Ont. TRAINING/FORMATION: Ecole du Louvre, Paris; Princeton Univ; Iowa State Univ MEDIUM: Acrylic, chalk, collage/Acrylique, craie, collage.

EX—1: "Processional" Holy Blossom Temple, Toronto (3 XI–30 XI 72).

EX—2: "Processional" with/avec E. BARTRAM, London Public Library & Art Museum, London, Ont. (6 X–30 X 72) GROUP/GROUPE: "Graphex I".

JEANNETTE WEISS (Peinture/Painting) 1934 HABITE/LIVES: Sherbrooke, Qué. MEDIUM: Aluchromie EX—1: Galerie Art Pictural, Sherbrooke, Qué. (11 XI–11 XII 72); Univ Laval, Québec (avril/Apr 73); Centre Communautaire, Univ Montréal (janv/Jan 73); Auditorium Dufour, Chicoutimi, Qué. (20 V– 5 VI 73).

GROUPE/GROUP: "Exhibition de La Société des Artistes Professionnels de Québec" Place Bonaventure, Montréal (déc/Dec 72); Galerie de la S.A.P.Q., Montréal (7 XI–15 XI 72).

1 WEINSTEIN Conquistador (21" x 15")

2 WEISS Aluchromie (3' x 4')

3 WAYWELL Night Sky Happening (26" x 34")

2

3

1

2

COLETTE WHITEN (Sculpture, conceptual/ Sculpture, conceptuel) 1945, Birmingham, Eng. LIVES/HABITE: Toronto TRAINING/ FORMATION: Ontario College of Art, Toronto MEDIUM: Wood, concrete, rope, chains, foam rubber, plaster, men, photographs/Bois, béton, corde, chaînes, mousse de caoutchouc, plâtre, hommes, photographies.

EX–1: Agnes Etherington Art Centre, Queen's Univ, Kingston, Ont. (7 I–28 I 73); Carmen Lamanna Gallery, Toronto (20 I–8 II 73).

EX–3: with/avec **I. CARR-HARRIS, R. FONES**, Carmen Lamanna Gallery, Toronto (16 IX– 5 X 72).

1 C. WHITEN *Structure No. 8 (Nos. 1, 2, 3, 4), 1972* Photo: Carmen Lamanna Gallery, Toronto

2 C. WHITEN Photo: Carmen Lamanna Gallery Toronto

3 C. WHITEN *Structure No. 7, 1972 (67" x 136" x 37")* Photo: Carmen Lamanna Gallery, Toronto

3

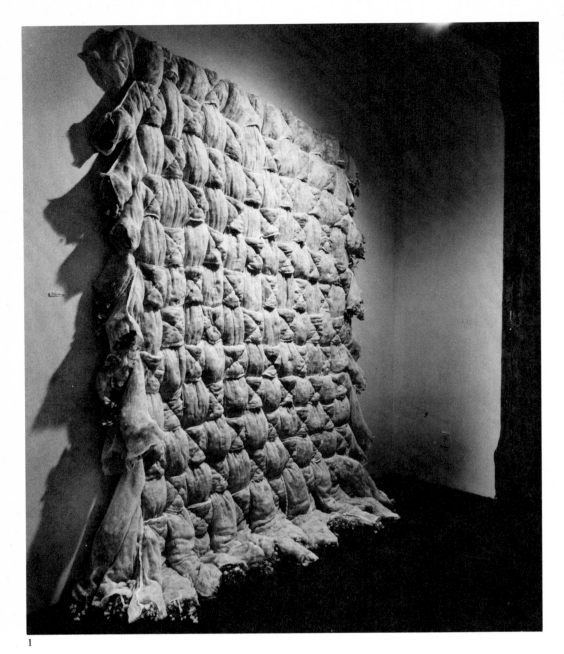

TIM WHITEN (Sculpture, drawing/Sculpture, dessin) 1941, Inkster, Mich. LIVES/HABITE: Toronto TRAINING/FORMATION: Central Michigan Univ; Univ of Oregon TEACHES/ENSEIGNE: York Univ, Toronto MEDIUM: Graphite, ink, vinyl, stone, leather, wood, bronze, fur, rope/Mine de plomb, encre, vinyle, pierre, cuir, bois, bronze, fourrure, corde.

EX−1: Art Gallery of York Univ, Toronto (11 IX−29 IX 72); Morris Gallery, Toronto (9 IX−23 IX 72).

*** See colour section/Voir section couleur**

AN WHITLOCK (Hangings/Tapisseries) 1944, Guelph, Ont. LIVES/HABITE: Toronto TRAINING/FORMATION: Ontario College of Art, Toronto AWARDS & HONOURS/PRIX & HONNEURS: Canada Council Grant, 1971/ Bourse du Conseil des Arts du Canada, 1971 MEDIUM: Cheesecloth, foam rubber, recycled stuffing, threads, ground underpants/Gaze, mousse de caoutchouc, vieilles bourrures, fils, caleçons moulus.

EX−1: Aggregation Gallery, Toronto (10 III− 29 III 73).

GROUP/GROUPE: "SCAN"; "Inaugural Exhibition" Aggregation Gallery, Toronto (3 X− 21 X 72); "Gallery Artists" Aggregation Gallery, Toronto (24 X−11 XI 72).

1 WHITLOCK *Fast Piece, 1972 (96" x 83" x 9")* Photo: Aggregation Gallery, Toronto

2 T. WHITEN *4 Plus 3, 1971-72 (8" x 24" x 13 3/4")* Photo: Neil Newton

3 T. WHITEN *Extended 8, 1972* Photo: Neil Newton

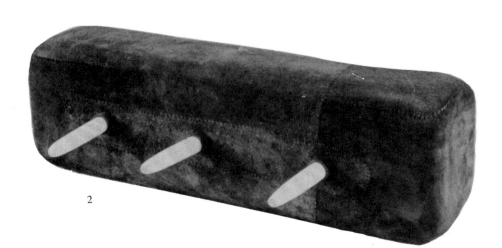

H.W. WHITWELL (Painting, printmaking, drawing/Peinture, gravure, dessin) 1911 LIVES/HABITE: Ingersoll, Ont. TRAINING/ FORMATION: Doon School of Fine Arts, Doon, Ont.; Western Art League, London, Ont. MEDIUM: Oil, monoprint, aluminum plate, ink/Huile, monogravure, plaques d'aluminium, encre EX–1: Ingersoll Inn, Ingersoll, Ont. (Nov/nov 72).

CAROLINE WICKHAM (Hangings, painting, ceramics/Tapisseries, peinture, céramique) 1945, Montreal LIVES/HABITE: Toronto TRAINING/FORMATION: Sheridan College School of Design, Oakville, Ont.; The New School of Art, Toronto MEDIUM: Batik, textiles, oil, acrylic, earthenware/Batik, textiles, huile, acrylique, faïence.

EX–2: with/avec **K. LEBOURDAIS**, Crafts Gallery, Toronto (1 V–31 V 73).

1 WHITWELL *Sun, Wind, and Rain, 1972*

2 WICKHAM *Quilted Banner, detail, 1972*

3 WICKHAM *Rainbow Series–Orange, 1973*

4 WICKHAM *Rainbow Quest, 1972*

1

2

3

4

1

2

SALLY WILDMAN (Painting, drawing, conceptual/Peinture, dessin, conceptuel) 1939, England LIVES/HABITE: Toronto TRAINING/FORMATION: Ontario College of Art, Toronto; Goldsmith's College of Art, London, Eng. MEDIUM: Acrylic, ink, pencil/Acrylique, encre, crayon.

EX–1: "Sally Wildman Paintings" Robert McLaughlin Gallery, Oshawa, Ont. (16 I– 4 II 73).

GROUP/GROUPE: "Annual Exhibition of Contemporary Canadian Art"; Ontario Society of Artists "100 Years" Exhibition; "SCAN"; "Artist's Choice" Roberts Gallery, Toronto (24 I– 3 II 73).

JON WILKINSON (Drawing, painting/Dessin, peinture) 1940 LIVES/HABITE: Hamilton, Ont. TRAINING/FORMATION: Self-taught/ Autodidacte MEDIUM: Pencil, watercolour, dry brush/Crayon, aquarelle, pinceau sec.

EX–1: Galt Public Library and Gallery, Galt, Ont. (28 VIII–10 IX 72).

GROUP/GROUPE: F.A.R. Gallery, New York (12 VI–15 VII 72); McMaster Univ Art Gallery, Hamilton, Ont. (20 VII–18 VIII 72); "Graphex I"; Canadian Arts, Stratford, Ont. (June/juin 72); "Annual Exhibition of Contemporary Canadian Art".

1 WILKINSON *Two-Seater*

2 WILKINSON *Flat-Out*

1

2

JOHN WILL Drawing, printmaking/Dessin, gravure) 1939, Waterloo, Iowa LIVES/HABITE: Calgary TRAINING/FORMATION: Univ Iowa; Rijksacademie Von Beeldende Kunston, Amsterdam TEACHES/ENSEIGNE: Univ Calgary MEDIUM: Charcoal, etching, intaglio/Fusain, eau-forte, intaille.

GROUP/GROUPE: "West '71"; "Canadian Printmakers Showcase"; "The Great Canadian Super Show of Great Canadian Ideas"; "Midwest Graphics" Wisconsin (1973); "1st Miami Graphics Biennial" Florida (1973); "Graphics 73" Univ Western New Mexico; "National Collection of Fine Arts" Washington, D.C. (1973); "13th Annual Calgary Graphics Exhibition"; "National Exhibition of Prints and Drawings" Dickinson State Univ, Iowa.

4

1 WILDMAN *Wilfrid Laurier, 1972*

2 WILDMAN *A Solitary Mister, 1971*

3 WILL *Apples, 1972*

4 WILL *S. B., 1972*

3

AL WILSON (Sculpture, painting/Sculpture, peinture) LIVES/HABITE: Calgary MEDIUM: Wood, watercolour, aluminum, etching, plastic/Bois, aquarelle, aluminium, eau-forte, plastique.

EX—3: "A Prairie Sweet" with/avec **H. HOUSE, B. SINCLAIR**, Glenbow-Alberta Art Gallery, Calgary (1 III–1 IV 73).

BUNNY WILSON (Sculpture, painting/Sculpture, peinture) 1934, Kingston, Jamaica LIVES/HABITE: Toronto TRAINING/FORMATION: Self-taught/Autodidacte MEDIUM: Oil, bronze, stone, fiberglas, plexiglas/Huile, bronze, pierre, fibre de verre, plexiglas.

EX—2: with/avec **J. JOEL**, Shaw-Rimmington Gallery, Toronto (2 X–15 X 72).

GROUP/GROUPE: "Art for All"; "Fredericton Artists"; "Sculptors' Society of Canada" Toronto-Dominion Centre, Toronto (15 X–3 XI 72); "Sculptors' Society of Canada" Scarborough College, Toronto (5 XI–27 XI 72).

1 A. WILSON Photo: Glenbow-Alberta Institute, Calgary

2 B. WILSON *Yin-Yang Harmonizing* Photo: Colin G. Daniels

3 B. WILSON *Instinct–Maternal* Photo: Colin G. Daniels

JEAN WISHART (Painting/Peinture) LIVES/ HABITE: Hamilton, Ont. TRAINING/FOR- MATION: Ontario College of Art, Toronto; Art Students' League, New York; Slade School of Art, London, Eng. MEDIUM: Watercolour/ Aquarelle.

EX–5: "Third Area Invitational Show" with/ avec **R. POTTRUFF, D. TONKIN, W. PRIT- CHARD, C. PRITCHARD,** Art Gallery of Brant, Brantford, Ont. (4 VIII–3 IX 72).

GROUP/GROUPE: "Annual Exhibition of Contemporary Canadian Art"; Canadian Arts, Stratford, Ont. (June/juin 72).

HARRY WOHLFARTH (Drawing, printmak- ing, painting, sculpture/Dessin, gravure, pein- ture, sculpture) 1921 LIVES/HABITE: Ed- monton TRAINING/FORMATION: Art Aca- demy, Dresden, Germany; Univ Guanajuato, Mexico AWARDS & HONOURS/PRIX & HONNEURS: Alberta Government Achieve- ment Awards, 1970, 1972; Gold Medal, Inter- national Leonardo da Vinci Academy, 1971; Gold Medal, Tiberian Academy, Rome, 1970; Gold Medal, International Academy of Letters, Arts and Sciences, Rome, 1972/Prix d'encou- ragement du gouvernement de l'Alberta, 1970, 1972; Médaille d'Or, Académie Internationale Leonardo Da Vinci, 1971; Médaille d'Or, Aca- démie Tibérienne, Rome, 1970; Médaille d'Or, Académie Internationale des Lettres, des Arts et des Sciences, Rome, 1972 TEACHES/EN- SEIGNE: Univ Alberta MEDIUM: Litho- graphy, etching, acrylic, steel, bronze/Litho- graphie, eau-forte, acrylique, acier, bronze.

EX–1: Lefebvre Gallery, Edmonton (1 I– 31 I 73) GROUP/GROUPE: "Alberta Con- temporary Drawings".

EVELYN WOJTOWICZ (Painting/Peinture) 1926, Dry River, Man. LIVES/HABITE: Lethbridge, Alta. TRAINING/FORMATION: Self-taught/Autodidacte MEDIUM: Oil/Huile.

EX–1: "Western Scenes" House of Fine Art, Lethbridge, Alta. (Feb/févr 73).

1 WOHLFARTH *Ulysses at the Bacchanal*

2 WISHART *Winter Fallow*

3 WOJTOWICZ *Prairie Snowstorm*

1

2

3

1

MARGARET E. WOODHOUSE (Painting/
Peinture) 1933, Torrance, Calif. LIVES/HA-
BITE: Port Colborne, Ont. TRAINING/FOR-
MATION: State Univ of New York, Buffalo,
N.Y.; Millard Fillmore College, Buffalo, N.Y.
AWARDS & HONOURS/PRIX & HONNEURS:
First Prize, Allentown Art Exhibition, Buffalo,
N.Y., 1965; Best of Show, Tonawanda, N.Y.,
1965; Prize, Niagara District Art Association
Show, Niagara Falls, Ont., 1967; Second Prize,
Williamsville, N.Y., 1968; Best Painting, Au-
tumn Festival of Art, Toronto, 1968; Second
Prize, Niagara-on-the-Lake, Ont., 1970/Premier
Prix, Allentown Art Exhibition, Buffalo, N.Y.,
1965; Prix de la meilleure oeuvre, Tonawanda,
N.Y., 1965; Prix, Niagara District Art Associa-
tion Show, Niagara Falls, Ont., 1967; Deu-
xième Prix, Williamsville, N.Y., 1968; Meilleure
toile, Festival Automnal des Arts, Toronto,
1968; Deuxième Prix, Exposition de Niagara-
on-the-Lake, Ont., 1970 MEDIUM: Oil, col-
lage, watercolour/Huile, collage, aquarelle.

EX—1: Lillian Morrison Gallery, Toronto (14 X—
26 X 72) GROUP/GROUPE: Rodman Hall,
St. Catharines, Ont. (29 XII 72—16 I 73); Rod-
man Hall, St. Catharines, Ont. (2 III—25 III 73).

ALEXANDER WYSE (Sculpture, painting/
Sculpture, peinture) 1938, Gloucester, Eng.
LIVES/HABITE: Ottawa TRAINING/FOR-
MATION: Cheltenham College of Art, Chel-
tenham, Eng.; Royal College of Art, London,
Eng. MEDIUM: Wood, oil, ink, glass, tin,
assemblages/Bois, huile, encre, verre, fer-blanc,
assemblages.

EX—1: Arwin Galleries, Detroit, Mich. (16 X—
1 XI 72).

*** See colour section/ Voir section couleur**

1 WYSE *Spray Cloud, 1970*

2 WYSE *Some Apple, 1971*

3 WOODHOUSE *Lost Horizon, 1970 (8" x 8")*

2

3

1

2

1 YATES *Regina Riot (1935), 1972 (26" x 40")* 2 YATES *Two Space Regina Riot (1935), 1972 (26" x 80")*

1

2

3

1 YATES *Portable Canadian Hero 2 (1935),*
 1972 (84" x 132")

2 YEREX *1972*

3 YATES *Three Space Regina Riot 1935, 1972*
 (78" x 40")

NORMAN YATES (Drawing, painting/Dessin, peinture) 1923, Calgary LIVES/HABITE: Edmonton TRAINING/FORMATION: Ontario College of Art, Toronto TEACHES/ENSEIGNE: Univ Alberta MEDIUM: Pencil, ink, acrylic, tin, plastic/Crayon, encre, fer-blanc, acrylique, plastique.

EX–1: Edmonton Art Gallery (25 III–24 IV 73).

GROUP/GROUPE: "SCAN"; "For an Independent Hairy Hill"; "Alberta Contemporary Drawings"; "Alberta Artists" Banff School of Fine Arts, Banff, Alta. (Feb/févr 73); "Media Show" Univ Alberta Art Gallery, Edmonton (5 II–10 II 73); "Faculty Show" Univ Alberta Art Gallery, Edmonton (9 X–31 X 72).

ELTON YEREX (Painting/Peinture) 1935, Neepawa, Man. LIVES/HABITE: Guelph, Ont. TRAINING/FORMATION: Univ Manitoba; Univ Michigan AWARDS & HONOURS/PRIX & HONNEURS: Purchase Award/Prix d'acquisition, Willistead Art Gallery, Detroit, Mich.; Award/Prix, Freedom Festival, Tom Thomson Art Gallery, Owen Sound, Ont. MEDIUM: Acrylic/Acrylique.

EX–1: Mushroom Gallery, Windsor, Ont. (29 IV–27 V 73) GROUP/GROUPE: "Kingston Spring Exhibition"; Art Gallery, Univ Guelph, Guelph, Ont. (7 II–28 II 73); "Southwest 33".

1

2

3

RUSSELL M. YURISTY (Painting, drawing, sculpture/Peinture, dessin, sculpture) 1936, Goodeve, Sask. LIVES/HABITE: Silton, Sask. TRAINING/FORMATION: Univ Saskatchewan, Saskatoon; Univ Wisconsin, Madison, Wisc. AWARDS & HONOURS/PRIX & HONNEURS: Grand Award, Saskatoon Exhibition, 1963; Most promising student Award, Saskatoon Exhibition, 1964; Second Prize in Watercolour, Saskatoon Exhibition, 1964; Canada Council Awards, 1972, 1973/Grand Prix, Exposition de Saskatoon, 1963; Prix de l'étudiant le plus prometteur, Exposition de Saskatoon, 1964;

Deuxième Prix d'Aquarelle, Exposition de Saskatoon, 1964; Bourses du Conseil des Arts du Canada, 1972, 1973 MEDIUM: Ink, paper/ Encre, papier.

EX–1: Graphic 8 Galleries, Calgary (14 II– 28 II 73).

GROUP/GROUPE: "Another Eleven Saskatchewan Artists"; "West '71"; "A June Show"; Musée d'Art Moderne de la Ville de Paris (Summer/été 73); Norman Mackenzie Art Gallery, Regina (28 I–19 II 73).

1 YURISTY *Dapple Greys with Hay Rack, 1973*
 Coll: The Artist

2 YURISTY *Sampling the New Batch, 1973*
 Coll: Canada Council

3 YURISTY *Space Ship, 1973 (11" x 9" x 5")*

4 YURISTY *Ram House (11" x 7" x 7")*

4

1

ZDENEK ANTHONY ZADAK (Drawing, painting/Dessin, peinture) 1918, Prague, Czechoslovakia LIVES/HABITE: Vancouver TRAINING/FORMATION: Univ Prague MEDIUM: Oil, watercolour, graphics, ink, etching/ Huile, aquarelle, graphiques, encre, eau-forte.

EX−1: "The Three Worlds of Z.A. Zadak" Exposition Gallery, Vancouver (5 X−18 X 72).

E. PULVER ZAJFMAN (Hangings/Tapisseries) 1948, Toronto TRAINING/FORMATION: Self-taught/Autodidacte MEDIUM: Satin, cheesecloth, jute, wool, mirrors/Satin, gaze, jute, laine, miroirs.

EX−2: with/avec **B. ASTMAN**, Me & My Friends Gallery, Toronto (1 VI−1 VII 72); Scarborough Public Library, Scarborough, Ont. (6 XII−30 XII 72); Don Heights Unitarian Congregation, Scarborough, Ont. (Jan/ janv 73).

DIK ZANDER (Sculpture) 1943, Berlin, Germany LIVES/HABITE: Kendal, Ont. TRAINING/FORMATION: Ontario College of Art, Toronto; Univ Toronto MEDIUM: Aluminum, wood, vinyl/Aluminium, bois, vinyle.

EX−1: Albert Campbell Branch, Scarborough Public Libraries, Toronto (1972); Glendon College, York Univ, Toronto (1972); Aggregation Gallery, Toronto (17 II−8 III 73).

GROUP/GROUPE: "Kingston Spring Exhibition"; "Artario"; "Inaugural Exhibition" Aggregation Gallery, Toronto (3 X−21 X 72).

EDWARD ZELENAK (Sculpture) 1940, St. Thomas, Ont. LIVES/HABITE: West Lorne, Ont. TRAINING/FORMATION: Meiszinger Art Institute, Detroit, Mich.; Fort Worth Art Center, Fort Worth, Texas; Ontario College of Art, Toronto MEDIUM: Fiberglas, plastic, resins/Fibre de verre, plastique, résines.

EX−1: Carmen Lamanna Gallery, Toronto (4 V−24 V 73) GROUP/GROUPE: "Diversity".

1 ZANDER *Fenestration Series, 1971 (22" x 16" x 6")* Photo: J. Ayriss for Aggregation Gallery, Toronto

2 ZAJFMAN *White Cord and Mirror, 1972 (2' x 2 1/2')*

3 ZADAK *Barn−Early Morning*

2

3

PETER J. ZIELKE (Painting, drawing/Peinture, dessin) 1937, Berlin LIVES/HABITE: Edmonton TRAINING/FORMATION: Self-taught/Autodidacte MEDIUM: Oil on hardboard, ink/Huile sur bois, encre.

EX−1: Prince Rupert Museum, Prince Rupert, B.C. (Sept/sept 72); The Arts and Crafts Gallery, Smithers, B.C. (Oct/oct 72); Walsh Art Gallery, Red Deer, Alta. (Nov/nov 72); Gordon Galleries, Prince George, B.C. (Nov/nov–Dec/déc 72); Friends of Berlin Club House, Edmonton (Dec/déc 72); Galerie Romanov, Edmonton (Jan/janv 73).

GROUP/GROUPE: "West '71"; "World Art Show" Edmonton Art Gallery (Feb/févr–Mar/mars 73).

JOANNE ZIGER (Gravure/Printmaking) 1951, Montréal HABITE/LIVES: Montréal FORMATION/TRAINING: Sir George Williams Univ, Montréal MEDIUM: Gravure sur linoléum/Linocut.

GROUPE/GROUP: "Les Moins de 35"; "Student Show" Weissman Gallery, Sir George Williams Univ, Montréal (1972).

SISTER M. SALERIA ZUNTI (Painting/Peinture) 1916, Luseland, Sask. LIVES/HABITE: Saskatoon TRAINING/FORMATION: Univ Saskatchewan; Washington School of Art MEDIUM: Oil, acrylic, pastel/Huile, acrylique, pastel.

EX−1: Friendship Inn, Saskatoon (Nov/nov 72); Art Gallery, Co-op Centre, Saskatoon (Feb/févr 73).

GROUP/GROUPE: "A Summer Show".

LOUISE ZUROSKY (Printmaking, painting, drawing/Gravure, peinture, dessin) LIVES/HABITE: Scarborough, Ont. TRAINING/FORMATION: Ontario College of Art, Toronto MEDIUM: Acrylic, tempera, serigraphy/Acrylique, détrempe, sérigraphie.

GROUP/GROUPE: "Graphex I"; Graphic 8 Gallery, Calgary (1972); "Society of Canadian Painter-Etchers and Engravers Exhibition" London Public Library and Art Museum, London, Ont. (1 XI–29 XI 72); Fine Art Faculty, Univ Guelph, Guelph, Ont. (7 II–28 II 73); "Artforms '73" Kitchener-Waterloo Art Gallery, Kitchener, Ont. (7 VI–30 VI 73).

1

2

3

1 ZELENAK *Untitled No. 1, 1969-72 (76" x 76" x 18")* Photo: Carmen Lamanna Gallery, Toronto

2 ZIGER *Dualité, 1971*

3 ZIELKE *Moonlight in the Winter (24" x 30")*

1

2

3

4

5

1 ZUROSKY *Canadian Sucker Series No. 1*
 (26" x 36")

2 ZUROSKY *Louie's Balancing Love Rock*
 (20" x 26")

3 ZUROSKY *New Horizons (35 1/2" x 52")*

4 ZUROSKY *Our True North Strong and Free...*
 (20" x 26")

5 ZUNTI *Polarities, 1973*

GALLERIES

Only those galleries were included for which we received information of three or more individual or group exhibitions. Style of entry: name of gallery, address, director, followed by the names of artists exhibiting in shows with less than six participants and the names of exhibitions with six or more participants. Group show titles appearing in italics are included in the *Major Exhibition* listing (pages 10 to 14).

A SPACE
85 St. Nicholas St.,
Toronto, Ont.
Tom Sherman

ARTISTS EXHIBITING/ARTISTES EXPOSANTS:
B. Bozak, I. Carr-Harris, S. Cruise, R. Evans, G. Gilbert, G. Greenwood, D. Hylinski, C. Itter, R. Jacks, D. Lukas, J. McEwen, M. Morris, G. Nolte, K. Sedmina, T. Sherman, M. Sowdon, M. Spencer.

ACADIA UNIVERSITY ART GALLERY
Wolfville, N.S.
Maurie Brown

ARTISTS EXHIBITING/ARTISTES EXPOSANTS:
W. Bachinski, Canada Banners Co. GROUP/
GROUPE: *"8 Canadian Printmakers"*.

AGGREGATION GALLERY
83 Front St. E., Toronto, Ont.
D. Tuck, L. Wynick

ARTISTS EXHIBITING/ARTISTES EXPOSANTS:
G. Abel, D. Barnett, E. Bartram, M. Davies, H. Dunsmore, G. Dyck, J. Frick, C. Hayward, K. Hunt, B. Jordan, C. Martyn, S. Palchinski, C. Ray, B. St. Clair, R. Sinclair, S. Singer, A. Whitlock, D. Zander.

AGNES ETHERINGTON ART CENTRE
Queen's University,
University Ave., Kingston, Ont.
Michael Bell

ARTISTS EXHIBITING/ARTISTES EXPOSANTS:
T. Hodgson, E. Lindner, W. Sawron, G. Travers, R. Van de peer, C. Whiten. GROUP/GROUPE: *"Kingston Spring Show 1972"*; *"Realism: Emulsion and Omission"*.

ALBERT CAMPBELL LIBRARY
496 Birchmount Road,
Scarborough, Ont.

See/Voir: **SCARBOROUGH PUBLIC LIBRARIES.**

ALBERT WHITE GALLERY
25 Prince Arthur Ave.,
Toronto, Ont.

ARTISTS EXHIBITING/ARTISTES EXPOSANTS:
C. Kudryk, J. Riopelle, F. Vivenza, B. Watson.

ALBERTA COLLEGE OF ART
1301 16th Ave. NW,
Calgary, Alta.

ARTISTS EXHIBITING/ARTISTES EXPOSANTS:
M. Bates, D. Burton, V. Foster, G. Jessop, G. Kitchen, R. Moppett, F. Owen, C. Pratt, D. Sutherland. GROUP/GROUPE: *"Calgary Graphics Exhibition (13th Annual)"*; "MAKE: Ontario Textiles"; "Staff Show"; "Student Exhibition"; *"Theatre Arts Works"*.

ALICE PECK GALLERY
2100 Lakeshore Road,
Burlington, Ont.

ARTISTS EXHIBITING/ARTISTES EXPOSANTS:
G. Brender à Brandis, L. Cockburn, D. Foster, S. Gersovitz, P. Goetz, B. Irvine, S. Irvine, G. Puley, S. Schneider, J. Taylor.

ANNA LEONOWENS GALLERY
Nova Scotia College of Art & Design
6152 Coburg Road, Halifax, N.S.
Alan MacKay

ARTISTS EXHIBITING/ARTISTES EXPOSANTS:
J. Greet, F. Heisler, R. MacKenzie, D. Oppenheim, R. Peck, M. Snow. GROUP/GROUPE: "Faculty Exhibition".

ART GALLERY OF BRANT
20 Ava Road, Brantford, Ont.
M. Polidori

ARTISTS EXHIBITING/ARTISTES EXPOSANTS:
J. Hanzalek, T. Keck, E. Ouchi, R. Pottruff, C. Pritchard, W. Pritchard, W. Rowley, E. Safra, J. Spencer, D. Tonkin, G. Wale, J. Wishart, G. Zeldin. GROUP/GROUPE: *"Graphex I"*.

ART GALLERY OF GREATER VICTORIA
1040 Moss St., Victoria, B.C.
C. D. Graham

ARTISTS EXHIBITING/ARTISTES EXPOSANTS:
S. Barron, J. Caveno, M. Corneille, K. Dickerson, B. Featherston, L. Harper, D. Henson, H. Ingham, G. Jenkins, G. Melvin, M. Munsen, C. Sabiston, G. T. Sharp. GROUP/GROUPE: *"Artario '72"*; *"Image Bank Postcard Show"*; *"West '71"*.

ART GALLERY OF HAMILTON
Main St. W. at Forsyth,
Hamilton, Ont.
T. R. MacDonald

ARTISTS EXHIBITING/ARTISTES EXPOSANTS:
A. Bayefsky, A. Bell, R. Cole, C. Comfort, P. Fournier, J. Hanson. GROUP/GROUPE: *"Contemporary Canadian Art (23rd Annual Exhibition)"*; *"Ontario Society of Artists: 100 Years"*; "Sport in Art"; "Women's Art Association Exhibition".

ART GALLERY OF ONTARIO
317 Dundas St. W., Toronto, Ont.
W. J. Withrow

GROUP/GROUPE: *"Ceramic Objects"*; *"Ontario Society of Artists: 100 Years"*; *"Toronto Painting 1953-1965"*.

ART GALLERY OF ST. THOMAS & ELGIN
301 Talbot St., St. Thomas, Ont.

ARTISTS EXHIBITING/ARTISTES EXPOSANTS:
J. Gould, M. Kuczer. GROUP/GROUPE: "St. Thomas & Elgin Juried Show".

ART GALLERY OF SOUTH ESSEX
Arts Association, Leamington, Ont.
Hardev Singh

ARTISTS EXHIBITING/ARTISTES EXPOSANTS:
C. Atrens, H. Barton, C. Bice, L. Dubey, B. Ferrard, M. Franks, C. Hofmann, J. Jackson, T. Keck, A. Kelly, N. Milstein, E. Safra, K. Saltmarche, H. Singh.

ART GALLERY OF WINDSOR
Willistead Park, Windsor, Ont.
K. Saltmarche

ARTISTS EXHIBITING/ARTISTES EXPOSANTS:
C. Comfort, T. Forrestall, G. Rayner, P. Surrey, J. Wieland. GROUP/GROUPE: *"Art for All"*; *"Ontario Society of Artists: 100 Years"*; *"Southwest 33"*.

ART OF NEW RENAISSANCE GALLERY
604 Browns Line, Etobicoke, Ont.
Nick Paulich

ARTISTS EXHIBITING/ARTISTES EXPOSANTS:
S. Babus, C. Bajeux, E. Karatson, L. Kay, J. Marosan, G. Reichel, P. Ruhland, E. Seh, T. Zina.

THE ARTISTS' GALLERY
275 Richmond St. W.,
Toronto, Ont.

ARTISTS EXHIBITING/ARTISTES EXPOSANTS:
J. Barreto, J. Cave, L. Goldman, M. Horner, L. Inslam, J. Jacques, B. Kort, E. Kurls, D. Mabie, H. Schuster, V. Vaca.

ARTLENDERS REG'D
318 Victoria Ave.,
Montreal, Que.
Mrs. Mary Thompson

ARTISTS EXHIBITING/ARTISTES EXPOSANTS:
W. Allister, V. Archambault, S. Ary, H. Beament, P. Beaulieu, J. Beder, S. Bell, L. Bellefleur, A. Bieler, R. Billmeier, M. Bobak, G. Bonmati, L. Bouchard, V. Bourigaut, R. Briansky, G. Caiserman-Roth, R. Cavalli, Y. Crestohl, B. Galbraith-Cornell, F. Gardham, B. Garner, M. Hénaut, S. Hudson, H. Jones, P. Jones, M. Labbé, P. Lacelin, P. Landsley, J. Little, H. Masson, J. Mitchell, N. Petry, G. Pffeifer, M. Pigott, J. Prezament, M. Reinblatt, G. Roberts, S. Tait, F. Taylor, T. Thomas, H. Wallace, W. Winter.

ARTS AND CULTURE CENTRE
Cornerbrook, Nfld.
G. W. Neal

ARTISTS EXHIBITING/ARTISTES EXPOSANTS:
J. Allsopp, W. Bachinski, P. Dobush, J. Esler, M. Jones, J. Meanwell, R. Mikkanen, G. Morton, M. Panchal, H. Schmidt, G. Trottier, D. Wright. GROUP/GROUPE: *"Eight Canadian Printmakers"*.

ATELIERS DU VIEUX LONGUEUIL
22 ouest rue St-Charles,
Longueuil, Qué.

ARTISTS EXHIBITING/ARTISTES EXPOSANTS:
P. Archambault, R. Bergeron, T. Lau, P. Tétreault.

GALERIES

Nous n'avons tenu compte que des galeries qui nous avaient fait parvenir des renseignements sur trois (ou davantage) expositions en solo ou de groupe. Les entrées se lisent comme suit: nom de la galerie, adresse, directeur, nom des artistes exposant dans des expositions de moins de six participants et nom des expositions d'oeuvres de six artistes ou plus. Les expositions dont le titre est en italique se retrouvent dans la liste des *Expositions majeures* (de la page 10 à la page 14).

THE BANFF CENTRE
School of Fine Arts,
P. O. Box 1020, Banff, Alta.
Dr. David Leighton

ARTISTS EXHIBITING/ARTISTES EXPOSANTS:
M. Johnson. GROUP/GROUPE: *"Alberta Contemporary Drawings"*; "Exhibition of Student Works"; "Painting Division Faculty Exhibition"; "Studio Exhibition—Student Works".

BARN GALLERY
"The Long Lane",
Puslinch Rd. 35,
Morriston, Ont.

ARTISTS EXHIBITING/ARTISTES EXPOSANTS:
G. Brender à Brandis, G. Glen, T. Gregson, C. Kainz, R. Thompkins, S. Ulbricht.

BAU-XI GALLERY LITD.
555 Hamilton St.,
Vancouver, B.C.
Paul C. Wong

ARTISTS EXHIBITING/ARTISTES EXPOSANTS:
J. Caveno, K. Eloul, B. Fisher, B. Goodwin, J. Korner, R. Letendre, Lin Chien-Shih, J. Lodge, Manwoman, T. Onley, S. Paley, J. Shadbolt, G. Smith, H. Town, D. Vance, J. Wise.

BEAVERBROOK ART GALLERY
P. O. Box 605, Fredericton, N. B.
Ian G. Lumsden

ARTISTS EXHIBITING/ARTISTES EXPOSANTS:
J. Allsopp, A. Bell, R. Black, B. Brooker, J. Dine, R. Kostyniuk, D. Lepage, E. Lindner, J. Plaskett, L. Poole, T. Tascona, D. Thouberger, W. Webels, G. Wood.

BECKETT GALLERY
142 James St. S.,
Hamilton, Ont.
T. L. Beckett

ARTISTS EXHIBITING/ARTISTES EXPOSANTS:
H. Baillie, E. Brittan, M. Gattervauer, M. Greene, Kieff, D. Knowles, Okangut, F. Panabaker, A. Posa, R. Reichardt, M. Simpson, H. Town, A. Winant. GROUP/GROUPE: *"Art of the Canadian Eskimo"*.

LA BIBLIOTHEQUE CENTRALE DE PRET DU SAGUENAY-LAC-SAINT-JEAN
Alma, Qué.

ARTISTES EXPOSANTS/ARTISTS EXHIBITING:
R. Bellefleur, M. Bellerive, C. Bérubé, G. Boisvert, M. David-Chagnon, C. Deschatelets, C. Fallard, L. Giguère, M. Jean, A. Lapointe, M. Martinaud, G. Trembley. GROUPE/GROUP: "Emaux du Québec"; *"Graphisme"*; *"Pack Sack"*.

BOUTIQUE SOLEIL
430 Bonsecours,
Montréal, Qué.

ARTISTES EXPOSANTS/ARTISTS EXHIBITING:
F. Dallegret, R. Gagnon, E. Lapka, S. Leblanc, P. Lussier, B. Morisset, B. Schiele.

BURNABY ART GALLERY
6344 Gilpin St.,
Burnaby 2, B.C.

ARTISTS EXHIBITING/ARTISTES EXPOSANTS:
Ace Space Co., B. Achtemicuk, J. Allsopp, M. Boudard, A. Colville, D. Crocker, P. Eccleston, I. Eyre, G. Flores, R. Foulger, T. Howorth, B. Johnsted, W. Jule, H. Kowallek, A. Lewis-Smith, E. Lindner, D. MacLean, L. Magor, M. Mann-Butuk, N. McGovern, F. Owen, S. Piroche, V. Popov, C. Thompson, J. Van Belkum, G. Wainwright, I. Whittome, C. Winch, A. Wong. GROUP/GROUPE: "Deo Gloria II"; "Process Editions"; *"Stand Back You Fools! "*.

LA CAISSE-POPULAIRE DE SHERBROOKE-EST
Rues Bowen et King, Sherbrooke, Qué.

ARTISTES EXPOSANTS/ARTISTS EXHIBITING:
J. Bellefleur, P. Bourgault, L. Brookhouse, R. Giguère, G. Tremblay. GROUPE/GROUP: *"Artario '72"*.

CANADIAN ARTS
329 Ontario St.,
Stratford, Ont.
Eve Neidelman

ARTISTS EXHIBITING/ARTISTES EXPOSANTS:
E. Annand, H. Baillie, T. Baynard, H. Bervoets, G. Brender à Brandis, H. Carter, M. Ehlert, P. Goetz, T. Lee, D. McCarthy, R. Mackenzie, B. Nye, L. Okey, T. Pacowski, H. Palmer, M. Prittie, H. Robertson, K. Rooney, S. Serafin, M. Smith, W. Swanston, A. Waywell, J. Wilkinson.

CANADIAN FINE ARTS GALLERY
3336 Yonge St., Toronto, Ont.

ARTISTS EXHIBITING/ARTISTES EXPOSANTS:
W. Bartlett, J. Brown, K. Forbes, J. Gauthier, J. Kasyn, G. Lombol, J. Macdonald, A. Poplonski.

CANADIAN GUILD OF CRAFTS
2025 Peel St., Montreal, Que.

ARTISTS EXHIBITING/ARTISTES EXPOSANTS:
Kalvak, E. Le Gros, Nanogak, Oshoweetook, Osuitok, K. Pascal.

CARMEN LAMANNA GALLERY
840 Yonge St., Toronto, Ont.
Carmen Lamanna

ARTISTS EXHIBITING/ARTISTES EXPOSANTS:
M. Barbeau, I. Baxter (N. E. Thing Co.), K. Beveridge, D. Bolduc, I. Carr-Harris, R. Collyer, T. Cooper, Y. Cozic, T. Dean, J. Delavalle, M. Favro, R. Fones, General Idea, R. Mackenzie, R. Martin, R. Morris, P. Moscowitz, J. Noel, G. Nova, D. Rabinowitch, R. Rabinowitch, I. Sarossy, C. Whiten, E. Zelenak.

CASSELS GALLERIES
546 King St.,
Fredericton, N.B.
Joe Kashetsky, Ene Clingo

ARTISTS EXHIBITING/ARTISTES EXPOSANTS:
M. Donaldson, T. Graser, J. Kashetsky. GROUP/GROUPE: *"Artists of the Province"*; *"New Brunswick Artists"*.

CEDARBRAE PUBLIC LIBRARY
454 Markham Road,
Scarborough, Ont.

See/Voir: **SCARBOROUGH PUBLIC LIBRARIES.**

CENTENNIAL ART GALLERY
P. O. Box 2262, Halifax, N.S.
Bernard Riordon

ARTISTS EXHIBITING/ARTISTES EXPOSANTS:
S. Carver, D. Daglish, R. Fauteux, J. Hansen, N. Piliskova, B. Porter, C. Pratt, G. Trotter. GROUP/GROUPE: *"Artario 72"*.

CENTENNIAL ARTS CENTRE GALLERY
13750 88th Ave., Surrey, B.C.

ARTISTS EXHIBITING/ARTISTES EXPOSANTS:
A. Alfoldy, E. Alfoldy, R. Eckert, B. Gifford, A. Mahon, L. Olsen, H. Sidhu.

CENTENNIAL GALLERY
Oakville, Ont.

ARTISTS EXHIBITING/ARTISTES EXPOSANTS:
R. Downing, F. Hughes, A. Waywell.

CENTRE COMMUNAUTAIRE DE L'UNIVERSITE DE MONTREAL
2332 boul. Edouard Montpetit,
Montréal, Qué.

ARTISTES EXPOSANTS/ARTISTS EXHIBITING:
J. Caris, A. de Groot, T. Sienkiewicz, M. Tanobe, J. Weiss. GROUPE/GROUP: *"De Rêves et d'Encre Douce"*; *"Ukrainian-Canadian Graphic Artists Exhibition"*.

CENTRE CULTUREL CANADIEN
5 rue de Constantine,
Paris VIIe, France

ARTISTES EXPOSANTS/ARTISTS EXHIBITING:
A. Bergeron, I. Chiasson, L. Desmarchais, M. Ferron, T. Forrestall, F. Leduc, M. de Passille-Sylvestre, Y. de Passille-Sylvestre, L. Perrier, R. Vilder, R. Wolfe. GROUPE/GROUP: *"Canadian West Coast Hermetics"*; "Graff"; *"Lithographs II"*.

CENTRE CULTUREL D'ALMA
Alma, Qué.

ARTISTES EXPOSANTS/ARTISTS EXHIBITING:
M. Bellerive, G. Boisvert, J. Forest, M. Jean. GROUPE/GROUP: "Emaux du Québec"; *"Graphisme"*; *"Pack Sack"*.

CENTRE CULTUREL DE JONQUIERE
Mont Jacob, Jonquière, Lac-St-Jean, Qué.

ARTISTES EXPOSANTS/ARTISTS EXHIBITING:
L. Boutin, G. Lemieux, M. Marois, E. Poirier, M. Roy.

CENTRE CULTUREL DE SHAWINIGAN
C. P. 48 Station B, 2100 Dessaules,
Shawinigan, Qué.
Henri Blanchard

ARTISTES EXPOSANTS/ARTISTS EXHIBITING:
M. Bellerive, G. Boisvert, M. Caron, Y. Héroux, R.
Normandin, E. Schmidt.

CENTRE CULTUREL DE VERDUN
5955 Bannantyne,
Verdun, Qué.

ARTISTES EXPOSANTS/ARTISTS EXHIBITING:
M. Favreau, A. de Groot, L. Simard.

CENTRE D'ART DU MONT-ROYAL
1260 rue Remembrance,
Montréal, Qué.

ARTISTES EXPOSANTS/ARTISTS EXHIBITING:
M. Dussault, J. Goh, E. Lachapelle.

CENTRE FOR CONTEMPORARY ART
155A Roncesvalles Ave., Toronto, Ont.

ARTISTS EXHIBITING/ARTISTES EXPOSANTS:
Balatzar, K. Glaz, J. Hovadik, Rainia, H. Singh.

CHANDOO GALLERY
565 Queen St. W.,
Toronto, Ont.
J. Whincup

ARTISTS EXHIBITING/ARTISTES EXPOSANTS:
C. Bonk, J. Cowan, P. Ewart, C. Head, J. Whincup.

LA CHASSE-GALERIE
15 Glebe Road West,
Toronto, Ont.

ARTISTS EXHIBITING/ARTISTES EXPOSANTS:
R. Casavant, M. Champagne, O. Chicoine, L. Côté,
K. De Vos-Miller, Gamache, P. Henry, M. Jean, M.
Laberge, E. Lachapelle, V. Lapierre, G. La Vigueur,
P. Montpellier, Niska, R. Scalabrini.

CHRISTEL GALLERIES OF FINE ART
29 Ellesmere Road, Toronto, Ont.

ARTISTS EXHIBITING/ARTISTES EXPOSANTS:
D. Barnes, C. Hoselton, G. Hoselton, M. Keirstedd, F.
Neubacher, D. Scott, E. Stankus.

LA CIMAISE GALLERY LTD.
97 Collier St., Toronto, Ont.

ARTISTS EXHIBITING/ARTISTES EXPOSANTS:
M. Batty, C. Bonnière, S. Brody, M. Cadot, D. Camp-
bell, P. Debain, D. Geden, R. Heward, C. Hraber, M.
Malish, G. Manzu.

COBOURG ART GALLERY
18 Chapel St.,
Cobourg, Ont.
John R. Taylor

ARTISTS EXHIBITING/ARTISTES EXPOSANTS:
D. Blackwood, K. Graham, A. Samchuk. GROUP/
GROUPE: *"Grafik 72/73"*.

COLLEGE D'ALMA
Alma, Lac-St-Jean, Qué.

ARTISTES EXPOSANTS/ARTISTS EXHIBITING:
F. Bouchard, L. Dazé, M. Jolicoeur, P. Lambert.

COMMUNITY ARTS COUNCIL
315 Cordova St. W.,
Vancouver, B.C.
Elizabeth O'Kiely

ARTISTS EXHIBITING/ARTISTES EXPOSANTS:
A. Baker, E. Evans, R. Isberg.

CONFEDERATION ART GALLERY AND MUSEUM
The Fathers of Confederation Memorial Building,
Box 848, Charlottetown, P.E.I.
M. Williamson

ARTISTS EXHIBITING/ARTISTES EXPOSANTS:
S. Beck, A. Bell, D. Besant, B. Brooker, B. Bugden,
A. Colville, C. Comfort, C. Drew, E. Freifeld, W.
Frith, J. Germaine, M. Jones, J. Kashetsky, R. Kosty-
niuk, D. Le Page, E. Lindner, D. Morris, M. O'Brien,
L. Outlock, M. Pavelic, R. Percival, L. Poole, G. Read-
Barton, H. Savage, D. Smith, P. Smith, T. Tascona, P.
Walker, R. Witlock, G. Wood, H. Woolnough.

GROUP/GROUPE: *"8 Canadian Printmakers"*;
"Image Bank Postcard Show"; *"Lithographs I"*;
"Theatre Arts Works".

CONTINENTAL GALLERIES INC.
1450 Drummond St.,
Montreal, Que.

ARTISTS EXHIBITING/ARTISTES EXPOSANTS:
R. Huggins, P. Kerrigan, J. Little, T. Roberts.

CRAFT GALLERY
29 Prince Arthur Ave.,
Toronto, Ont.

ARTISTS EXHIBITING/ARTISTES EXPOSANTS:
J. Herman, L. Herman, G. Hodge, S. Hogbin, K. Le
Bourdais, D. Szava, R. Szava, W. Toogood, W. Vaitie-
kanas, A. Vanginhewen, A. Weisman, L. Weisman, C.
Wickham.

D & H GALLERY
607 Yonge St.,
Toronto, Ont.

ARTISTS EXHIBITING/ARTISTES EXPOSANTS:
W. Anderson, H. Broaderman, L. Broaderman, J. de
Santos, L. Guderna, J. Hovadik, Senggih.

DALHOUSIE UNIVERSITY ART GALLERY
Halifax, N.S.
Ernest W. Smith

ARTISTS EXHIBITING/ARTISTES EXPOSANTS:
R. Chambers, Y. Cozic, J. Delavalle, O. Fitzgerald,
N. Gray, L. Harris, R. Kostyniuk, G. Molinari, J.
Plaskett, T. Rishel, G. Wood. GROUP/GROUPE:
"Baker Lake Drawings"; *"Morbus—A Ritual"*.

DANISH ART GALLERY
3757 West 10th Ave.,
Vancouver, B.C.

ARTISTS EXHIBITING/ARTISTES EXPOSANTS:
R. Foulger, C. Pomeroy, H. Sidhu, R. Tétreault.

DARTMOUTH HERITAGE MUSEUM
Dartmouth, N.S.
G. S. Cosley

ARTISTS EXHIBITING/ARTISTES EXPOSANTS:
D. MacLean, M. Mann-Butuk, J. Van Belkum.

DAVID MIRVISH GALLERY
596 Markham St.,
Toronto, Ont.
Alkis Klonaridis

ARTISTS EXHIBITING/ARTISTES EXPOSANTS:
J. Bush, R. Murray. GROUP/GROUPE: *"Masters of
the Sixties"*.

DAWSON COLLEGE
350 Selby St.,
Westmount 215, Que.

ARTISTS EXHIBITING/ARTISTES EXPOSANTS:
R. L. Studham. GROUP/GROUPE: *"Contemporary
Professional Quebec Artists (Third Annual Exhibi-
tion)"*.

DELPHINE'S GALLERY
Vancouver, B.C.

ARTISTS EXHIBITING/ARTISTES EXPOSANTS:
Bernadette, N. Bot, V. Bulik, Delphine, J. Houston,
D. Nicolle, V. Santos, L. Trinidad.

DOMINION ART GALLERY
1438 Sherbrooke W.,
Montreal, Que.

ARTISTS EXHIBITING/ARTISTES EXPOSANTS:
S. Etrog, E. Hughes, W. Mahdy, M. Marini, F. Rich-
man, M. Rostand.

DOWNSTAIRS GALLERY
1425 Marine Dr.,
West Vancouver, B.C.
Mr. and Mrs. Ossie Ristan

ARTISTS EXHIBITING/ARTISTES EXPOSANTS:
S. Brafman, K. Brandstatter, E. Bennett, W. Ching,
R. Gerow, R. Jackson, B. Kingsmill, La Ba Dang, R.
Meechan, B. Rohne, M. Tornchuck, J. Trinidad, L.
Trinidad, C. Van Bosch, T. Warbey.

DUNKELMAN GALLERY
15 Bedford Road,
Toronto, Ont.
Ben and Yael Dunkelman

ARTISTS EXHIBITING/ARTISTES EXPOSANTS:
D. Brown, J. Drapell, S. Etrog, A. Fauteux, M. Westerlund.

DUNLOP ART GALLERY
Regina Public Library
2311 12th St., Regina, Sask.

ARTISTS EXHIBITING/ARTISTES EXPOSANTS:
M. Bolen, V. Cicansky, J. Cowin, J. Fafard, B. Hone, M. Hone, D. Knowles, W. McCargar, F. Moulding, W. Perehudoff. GROUP/GROUPE: *"Image Bank Postcard Show"; "A June Show"; "Regina Ceramics Now"; "Watercolour Painters from Saskatchewan"*.

THE DUTCH GALLERIES
619 Howe St.,
Vancouver, B.C.

ARTISTS EXHIBITING/ARTISTES EXPOSANTS:
G. Bates, B. Crawford, J. Keirstead, D. Lam, R. Okey, S. Schoneberg.

EATON'S FINE ART GALLERY
College St., Toronto, Ont.

ARTISTS EXHIBITING/ARTISTES EXPOSANTS:
B. Carr, H. Hassell, F. Henry, G. Otto, W. Price, J. Reid, T. Roberts, M. de la Puente, J. Secord, N. Small, E. Stankus, M. Stewart, D. Wright. GROUP/GROUPE: *"Society of Canadian Artists 5th Juried Show"*.

ECHO '67 CENTRE
1001 Wallace St.,
Port Alberni, B.C.
D. Russell

ARTISTS EXHIBITING/ARTISTES EXPOSANTS:
G. Bellamy, B. Bottner, M. Coulombe, M. Dick, M. Earl, M. Hardin, E. Harrison, J. Kaufman, F. Marcellus, M. McClain, N. Mohamed, I. Monson, A. Parker, G. Roth, E. Sarita, A. Snikkers, T. Van Doorn.

ECOLE DE MUSIQUE VINCENT D'INDY
Salle Claude Champagne,
200 rue Vincent d'Indy,
Outremont, Qué.

ARTISTES EXPOSANTS/ARTISTS EXHIBITING:
E. Lachapelle, M. de la Fouchardière, M. Sylvain.

EDMONTON ART GALLERY
2 Sir Winston Churchill Square,
Edmonton, Alta.
T. Penton

ARTISTS EXHIBITING/ARTISTES EXPOSANTS:
D. Bentham, E. Bres, J. Bush, D. Chester, A. Clarke-Darrah, E. Diener, N. Fiertel, G. Guillet, P. Guy, M. Haeseker, A. Janvier, D. Knowles, G. Lachaise, R. McClean, V. Owen, C. Pratt, P. Skalnik, N. Yates.

GROUP/GROUPE: *"Alberta Contemporary Drawings"; "Director's Choice"; "Diversity"; "Great Canadian Super Show of Great Canadian Ideas"; "Stephen Greene's Workshop"; "Theatre Arts Works"*.

ELCA LONDON STUDIO
4120 Badgley St.,
Montreal, Que.

ARTISTS EXHIBITING/ARTISTES EXPOSANTS:
De Marco, P. Lavarenne, Tobrasse, Yvapre.

THE ELECTRIC GALLERY
272 Avenue Road,
Toronto, Ont.

ARTISTS EXHIBITING/ARTISTES EXPOSANTS:
Z. Blazeje, J. Bordelai, R. Brousseau, L. Dworkin, R. Edwards, D. Elwood, E. Fielding, M. Hayden, M. Hirschberg, D. Jean-Louis, H. Lehr, C. Marcheschi, S. Markle, A. Samchuk, R. Savoie, M. Sector, T. Sherman, R. Vilder, S. Weisman, N. White.

EMILE WALTER GALLERIES
Vancouver, B.C.

ARTISTS EXHIBITING/ARTISTES EXPOSANTS:
Z. Grunt, Levrier, N. Yuen.

ERINDALE COLLEGE
Univ of Toronto,
3359 Mississauga Rd. N.,
Mississauga, Ont.

ARTISTS EXHIBITING/ARTISTES EXPOSANTS:
W. Bachinski, D. Blackwood, G. Cantieni, J. Currelly, F. Hollander, W.T. Kort, T. Lapierre, J. Mattor, E. Payton, M. Pratt, E. Smith. GROUP/GROUPE: *"Art of the Canadian Eskimo"*.

ESTEE GALLERY
198 1/2 Davenport Road,
Toronto, Ont.

ARTISTS EXHIBITING/ARTISTES EXPOSANTS:
R. Downing, H. Hoenigan, T. Jaworska, L. Klausner, E. Korda, M. Marini, J. Nestel, D. Passal, W. Price, P. Sager, L. Schlein, C. Sinclair, J. Zellinger.

EVANS GALLERY
124 Scollard Ave.,
Toronto, Ont.

ARTISTS EXHIBITING/ARTISTES EXPOSANTS:
M. Epstein, D. Fritz, P. l'Abbé Jones, J. Nestel, W. Perz, H. Sabelis, G. Smith, F. Tvmoshenko.

EXPOSITION ART GALLERY
151 Water St., Vancouver, B.C.
Marcia Keate Westly

ARTISTS EXHIBITING/ARTISTES EXPOSANTS:
W. Bowyer, R. Chow, D. Creighton, M. Devenyi, J. Gabanek, L. Gilling, E. Iglesias, P. O'Hara, T. Polos, W. Reed, P. Wilkie, Z. Zadak.

L'EZOTERIK
1707 rue St-Denis,
Montréal 129, Qué.
Albert A. Ostiguy

ARTISTES EXPOSANTS/ARTISTS EXHIBITING:
J. Bedard, A. Desmarchais, B. Egyedi, H. Laflamme, G. Laliberté, T. Lau, M. Mazurek, N. Moffat, I. Nair, A. Pepin, R. Proulx, P. Tétreault.

FINE ARTS GALLERY
Univ of British Columbia,
Vancouver, B.C.

ARTISTS EXHIBITING/ARTISTES EXPOSANTS:
D. Aldrich, B. Binning, J. Blodgett, A. Con, Y. Cozic, G. Dart, J. Delavalle, J. Farkas, D. Froehlich, L. Fung, J. Goodyear, M. Kuharic, S. MacPherson, C. Ross, L. Thomas. GROUP/GROUPE: *"Canadian West Coast Hermetics"; "Image Bank Postcard Show"; "Lithographs I"*.

FIVE . SIX . SEVEN GALLERY
567 Queen St. W.,
Toronto, Ont.
L. Miller, D. Cook, G. Furoy

ARTISTS EXHIBITING/ARTISTES EXPOSANTS:
D. Burton, D. Cook, G. Coughtry, G. Furoy, F. Iacobelli, D. Mabie, R. Markle, L. Miller, W. Toogood.

FLEET GALLERY
173 McDermot St.,
Winnipeg, Man.

ARTISTS EXHIBITING/ARTISTES EXPOSANTS:
G. Boisvert, B. Caslor, S. Etrog, K. Hunt, M. Kreyes, J. Snow, J. Sures, H. Town.

FOYER DES ARTS
T. Eaton Co. Ltd.,
Ouest, rue St-Catharine,
Montréal, Qué.

ARTISTES EXPOSANTS/ARTISTS EXHIBITING:
H. Abramowitz, L. Ayotte, J. Blier, G. Faulkner, S.
Kirshner, M. Mazurek, A. Qureshi, A. Sapp, R. Simp-
kins, S. Simpson, B. Smith, E. Smith, P. Trudeau, H.
Van der Aa. GROUPE/GROUP: *"Canadian Con-
temporary Exhibition of Paintings and Sculpture"*.

FRAMECRAFT GALLERY
Edmonton, Alta.

ARTISTS EXHIBITING/ARTISTES EXPOSANTS:
A. Evey, A. Janvier, V. Mitchell.

GADATSY GALLERY
112 Yorkville Ave.,
Toronto 5, Ont.
Stephen P. Gadatsy

ARTISTS EXHIBITING/ARTISTES EXPOSANTS:
H. Broudy, B. Caruso, S. Gerriets, J. Gordaneer, B.
Grison, I. McKay, R. Molz, P. Sager, W. Sawron, L.
Workman.

GAINSBOROUGH GALLERIES
611 8th Ave. SW,
Calgary, Alta.
George L. Pain

ARTISTS EXHIBITING/ARTISTES EXPOSANTS:
D. Frache, R. Genn, G. Horvath, K. Kirkby, R. Kost,
M. Lichter, H. Lyon, J. Silburt, D. Van Den Hoogen.

GALERIE ALLEN
213 Carrall St.,
Vancouver, B.C.

ARTISTS EXHIBITING/ARTISTES EXPOSANTS:
Burg, C. Casprowitz, K. Danby, R. Davidson, Forczek,
G. Freedman, M. Goldman, D. Holyoak, J. Jackovich,
F. Jorgensen, T. Kingan, M. Markham, H. Stanbridge,
M. Tobey, S. Watson.

GALERIE B
2175 rue Crescent,
Montréal, Qué.
Roger Bellemare

ARTISTES EXPOSANTS/ARTISTS EXHIBITING:
B. Goodwin, J. Heward, General Idea, C. Tousignant,
W. Vazan.

GALERIE BIENVENUE
Place Bonaventure,
Montréal, Qué.

ARTISTES EXPOSANTS/ARTISTS EXHIBITING:
J. Adams, G. Grondin, G. Lemire, I. Karacsony, A.
Riso, E. Wertheimer, G. Zuker.

GALERIE COLLINE
Pavillon St-Louis,
C. P. 426, Edmundston, N.B.
Georges Widiez

ARTISTES EXPOSANTS/ARTISTS EXHIBITING:
E. Albert, Basque, F. Bouchard, L. Charette, H. Chias-
son, F. Coutellier, L. Dazé, G. Goguen, L. Harris, M.
Jolicoeur, P. Lambert, J. Martin, J. Pelletier, G. Rac-
kus, R. Saucier, R. Savoie, P. Skalnik, A. Thériault,
W. Townsend.

GALERIE D'ART BENEDEK-GRENIER
800 Place d'Youville, Québec, Qué.
Jean Benedek, D. Marien Grenier

ARTISTES EXPOSANTS/ARTISTS EXHIBITING:
D. Angers, G. Barbeau, H. Beck, J. Benedek, M. Bour-
guignon, K. Bruneau, R. Cavalli, Y. Desrosiers, C. Du-
four, G. Hébert, J. Hurtubise, J. Lacroix, J. Lambert,
T. Y. Lau, L. Marois, G. Moisan, H. Montgrain, C. Mo-
rais, A. Ouellet, A. Pelletier, A. Roy, R. Scalabrini, B.
Simard, G. Tay, M. Tanguay, E. Tremblay, L. Tremblé,
A. Villeneuve.

GALERIE D'ART "LES GENS DE MON PAYS"
955 ave de Bourgogne, Ste-Foy, Québec 10, Qué.
J. Dumas, R. Ferron, G. Langlois, L. Michaud

ARTISTES EXPOSANTS/ARTISTS EXHIBITING:
Basque (L. Parent), M. Champagne, R. Normandin, L.
Panneton, A. Pelletier, N. Tremblay.

**LA GALERIE DE LA SOCIETE DES ARTISTES
PROFESSIONNELS DU QUEBEC**
411 rue St-Nicholas,
Vieux-Montréal 125, Qué.

ARTISTES EXPOSANTS/ARTISTS EXHIBITING:
M. Bellerive, G. Bossé, P. Bourdon, Camihou, L. Char-
pentier, F. Dallaire, R. Desautels, A. Desmarchais, A.
Dubois, M. Dussault, J. Marcoux Fortin, A. de Groot,
J. Guillemette, J. Jenicek, A. Jesenko, L. Leduc, A.
Lysak, M. Alexandre-Marsolais, J. Neuhof, K. Peters,
R. Piché, E. Prager, P. Rousseau, A. Taylor, P. Tét-
reault, J. Weiss. GROUPE/GROUP: *"Les Moins de
35"*.

GALERIE DE MONTREAL INC.
2060 Mackay,
Montréal, Qué.

ARTISTES EXPOSANTS/ARTISTS EXHIBITING:
P. Borduas, Champleau, K. Eloul, L. Gervais, A.
Glass, A. Harrison, D. Juneau, R. Letendre, M. Mero-
la, G. Montpetit, J. Mousseau, A. Pellan, J. Riopelle,
R. Savoie, Thereau, Y. Trudeau.

GALERIE DRESDNERE
130 Bloor St. W.,
Toronto 5, Ont.

ARTISTS EXHIBITING/ARTISTES EXPOSANTS:
J. Dickson, M. Kantaroff, N. Laliberté, R. Lead-
beater, F. Ross.

GALERIE DU PARC
Pavillon St-Arnaud, Parc Pie XII,
Trois-Rivières, Qué.

ARTISTES EXPOSANTS/ARTISTS EXHIBITING:
N. Brodbeck, L. Desaulniers, C. Gascon, J. Lacroix,
R. Normandin, T. Steinhouse.

GALERIE ESPACE
L'Association des Sculpteurs du Québec,
1237 rue Sanguinet, Montréal 129, Qué.

ARTISTES EXPOSANTS/ARTISTS EXHIBITING:
J. Lacroix, E. Rosenfield. GROUPE/GROUP: *"Esti-
val 72"*; *"Operation Multiple"*; *"Les Moins de 35"*.

GALERIE FORE
405 Selkirk Ave.,
Winnipeg, Man.

ARTISTES EXPOSANTS/ARTISTS EXHIBITING:
W. Allister, L. Altwerger, R. Bolt, B. Fleisher, P. Flei-
sher, J. Hambleton, J. Hanet, C. Kerwin, A. Meredith,
R. Okey, M. Pigott, S. Raphael, O. Timmas, W. Zuro.

GALERIE GAUVREAU
1194 Sherbrooke W.,
Montréal, Qué.

ARTISTES EXPOSANTS/ARTISTS EXHIBITING:
P. André, A. L'Archeveque, L. Ayotte, P. Borduas, S.
Cosgrove, F. Dallaire, M. Felteau, M. Fortin, C.
Gagnon, J. Gérome, H. Johnstone, J. Lemieux, A.
Pellan, M. Plamondon, Y. Rajotte, J. Riopelle, G.
Roberts, R. Sherriff, W. Showell, A. Tatosseau, T.
Tomalty, F. Toupin, E. Wertheimer, W. Winter.

GALERIE GEORGES DOR
19 ouest, rue St-Charles,
Longueuil, Qué.
Georges Dor

ARTISTES EXPOSANTS/ARTISTS EXHIBITING:
J. Blier, G. Contant, G. Derome, R. Giguère, J. Mar-
chessault, R. Nadon, M. Théorêt.

GALERIE GILLES CORBEIL
2175 rue Crescent,
Montréal 107, Qué.

ARTISTES EXPOSANTS/ARTISTS EXHIBITING:
S. Gecin, J. Lemieux, P. Surrey.

GALERIE JOLLIET INC.
C. P. 102, Station B,
11 Place Royale,
Québec, Qué.
Michel Giroux

ARTISTES EXPOSANTS/ARTISTS EXHIBITING:
J. Champagne, Y. Cozic, J. De Heusch, J. Hurtubise,
M. Jean, F. Leduc, P. Lussier, J. Mihalcean, G. Moli-
nari, H. Mongrain, D. Moore, C. Tousignant.

GALERIE L'APOGEE
37 rue de l'Eglise,
St-Sauveur, Qué.

ARTISTES EXPOSANTS/ARTISTS EXHIBITING:
P. Beaulieu, R. Cavalli, S. Gersovitz, C. Girard, E. Landori, P. Livernois, M. Maltais, R. Pichet, F. Pratte, R. Savoie, M. Voyer.

GALERIE L'ART FRANCAIS
370 Laurier ouest,
Montréal, Qué.
L. Lange

ARTISTES EXPOSANTS/ARTISTS EXHIBITING:
Basque (L. Parent), G. Bastien, P. Beaulieu, J. Beder, L. Blanchard, O. Bohm, J. Bonet, A. Carreau-Kingwell, S. Cosgrove, R. Dinel, C. Fauteux, M. Fortin, Friedlander, Galbraith-Cornell, Y. Gaucher, P. Genest, J. Hovadik, A. Jackson, J. Jenicek, R. Lacroix, Laporte, P. Livernois, H. Masson, J. Menses, Morvan, L. Muhlstock, J. Noël, A. Pellan, M. Perrin, J. Rhéaume, R. Richard, J. Riopelle, G. Robert, G. Roberts, F. Séguin, Sheriff-Scott, P. Soulikias, M. Tanobe, Y. Trudeau, A. Vaillancourt, R. Vincelette, Zao-Wouki.

GALERIE LES DEUX B
52 rue Principale,
St-Antoine-sur-Richelieu, Qué.
Bordeleau/Bertrand

ARTISTES EXPOSANTS/ARTISTS EXHIBITING:
O. Chicoine, Fablo, P. Faucher, Lacelin, P. Livernois, E. Tahedl, P. Trudeau.

GALERIE LIBRE
2100 rue Crescent,
Montréal, Qué.

ARTISTES EXPOSANTS/ARTISTS EXHIBITING:
G. Delrue, S. Joubert, L. Scott.

GALERIE MARTAL
1110 Sherbrooke West,
Montréal, Qué.
Mme Marta Landsman

ARTISTES EXPOSANTS/ARTISTS EXHIBITING:
M. Bellerive, M. Braitstein, L. Burnett, H. Daini, J. Dickson, S. Gersovitz, N. Laliberté, J. Menses, K. Peters, S. Segal, G. Tremblay, B. Wainwright.

GALERIE MEDIA
276 rue Sherbrooke, est,
Montréal, Qué.

ARTISTES EXPOSANTS/ARTISTS EXHIBITING:
C. Bourgeois, I. Desjardins, R. Dumais.

GALERIE MOOS
1430 Sherbrooke West,
Montréal, Qué.
Joy W. Moos

ARTISTES EXPOSANTS/ARTISTS EXHIBITING:
D. Curley, K. Danby, M. Epstein, Kieff, N. Laliberté, E. Reiback, A. Thorn.

GALERIE MORENY
1564 rue St-Denis,
Montréal, Qué.

ARTISTES EXPOSANTS/ARTISTS EXHIBITING:
G. Bastien, O. Chicoine, N. Maomi, A. Prévost, R. Richard, A. Villeneuve.

GALERIE III
Place Bonaventure,
Montréal, Qué.
Ed Kostiner, Jeanne Renaud

ARTISTES EXPOSANTS/ARTISTS EXHIBITING:
P. André, L. Benic, R. Brousseau, L. Dupuis, A. Jasmin, M. Koolen, F. Leduc, P. Markgraf, D. Nelson, K. Nelson, W. Ostrom, M. Parent, R. Poulin, R. Proby, Y. Rajotte, A. Sherriff-Scott, F. Sullivan, C. Tisari, F. Toupin.

GALERIES PLACE ROYALE WEST
Vancouver, B.C.

ARTISTS EXHIBITING/ARTISTES EXPOSANTS:
L. Macdonald, J. McGinnis, J. Mortimer, H. Pari, T. Prescott, R. Rodvik, J. Salvador.

GALLERY ELAJANA
18 Cumberland,
Toronto, Ont.

ARTISTS EXHIBITING/ARTISTES EXPOSANTS:
R. Callaghan, A. English, Lajo, V. Pearson, J. Petriska, J. Reid, J. Saarnitt, Taisia, C. Van Suchtlen.

GALLERY HOUSE SOL
45 Charles St.,
Georgetown, Ont.
G. Sommer, J. Sommer

ARTISTS EXHIBITING/ARTISTES EXPOSANTS:
H. Bervoets, C. Boulanger, C. Brainerd, G. Brender à Brandis, H. Brunt, L. Caviella, P. Caviella, C. Guettal, M. Jones, R. Kidd, F. Kuypers, D. McGuire, S. Merkur, M. Nazer, F. Nelson, J. Raine, P. Rainey, J. Reynolds, A. Roberts, P. Sybal, T. Willemse, J. Willsher-Martel.

GALLERY INGENU
577 Mt. Pleasant,
Toronto, Ont.

ARTISTS EXHIBITING/ARTISTES EXPOSANTS:
C. Adeny, I. Collins, J. Ginsberg, R. Juki, A. Millar, C. Morey, S. Sellan, S. Stellen.

GALLERY MOOS
138 Yorkville Ave.,
Toronto, Ont.
Walter Moos

ARTISTS EXHIBITING/ARTISTES EXPOSANTS:
R. Cattell, K. Danby, A. Filipovic, M. Hayden, G. Iskowitz, L. Johnson, R. Letendre, S. Russo.

GALLERY 93
93 Sparks St.,
Ottawa, Ont.
S. McMorran, J. C. Cook

ARTISTS EXHIBITING/ARTISTES EXPOSANTS:
R. Anderson, G. Boisvert, M. Braitstein, Csathi, Cumberland, Y. Dobrorvka, A. Duffy, J. Fraser, G. Goldsmith, B. Greene, Inderjeet, T. Keck, A. Knox, H. Lehman, H. MacLaren, R. Malay, R. Mikkanen, E. Moon, S. Qadri, V. Radoicic, E. Safra, I. Shaver, H. Singh, D. Snell, D. Stein, R. Webb, J. Whyte, R. Winslow.

GALLERY OF BRITISH COLUMBIA ARTS
1974 West Georgia,
Vancouver, B.C.

ARTISTS EXHIBITING/ARTISTES EXPOSANTS:
Melendy, R. Nelson, A. Ogloff.

GALLERY OF THE GOLDEN KEY
761 Dunsmuir,
Vancouver, B.C.

ARTISTS EXHIBITING/ARTISTES EXPOSANTS:
G. Alexander, M. Bates, P. Ewart, R. Huggins, J. Kasyn, G. Otto, A. Sapp.

GALLERY ON THE ROOF
Saskatchewan Power Corporation,
Scarth & Victoria,
Regina, Sask.
S. Paul Cloutier

ARTISTS EXHIBITING/ARTISTES EXPOSANTS:
S. Cloutier, A. Davey, D. Helmer, I. Kerr, S. Olah, V. Samuels, C. Watson. GROUP/GROUPE: "CARSASK".

GALLERY ONE ONE ONE
Univ Manitoba School of Art,
Winnipeg, Man.
Virgil Hammock

ARTISTS EXHIBITING/ARTISTES EXPOSANTS:
J. Allsopp, B. Achtemicuk, C. Dulces, H. Dunsmore, T. Howorth, J. Lewis-Smith, K. Lochhead, K. Schwabe.

GALLERY PASCAL
104 Yorkville Ave.,
Toronto, Ont.
D. Pascal

ARTISTS EXHIBITING/ARTISTES EXPOSANTS:
C. Bates, G. Boisvert, G. Casprowitz, W. Featherston, Y. Gaucher, A. Jarvis, T. Onley, E. Ouchi, T. Paine, J. Snow, R. Swartzman, A. Wong.

GALLERY PASCAL GRAPHICS
18 Albert St.,
Stratford, Ont.
J. Hayes

ARTISTS EXHIBITING/ARTISTES EXPOSANTS:
P. Ayot, F. Bergerson, D. Blackwood, G. Boisvert, J. Boning, R. Briansky, S. Hudson, E. Landori, J. Manning, M. Marx, N. McLaren, A. Montpetit, T. Onley, A. Pellan, G. Petit, A. Riller, R. Sanders, G. Smith, J. Snow, R. Swartzman, J. Townsend, J. Wheeler.

GALLERY SCHONBERGER
326 King St. E.,
Kingston, Ont.

ARTISTS EXHIBITING/ARTISTES EXPOSANTS:
E. Boszin, W. Lawrence, J. Marosan, L. Oesterle, I. Szebenyi.

GALLERY 76
Ontario College of Art,
76 McCaul St.,
Toronto, Ont.
L. Frazier

ARTISTS EXHIBITING/ARTISTES EXPOSANTS:
J. Batura, R. Caldwell, B. Chisholm, S. Daniels, N. de Boni, R. Eppstadt, B. Eves, S. Fairbairn, K. Finlayson, J. Fraser, K. Haynes, F. Henry, J. Higgins, S. Hutchings, J. Ingrad, D. Irvin, T. Jarema, Jeannine, A. Jordan, J. Krosnick, H. Lern, S. Martin, E. McLaughlin, P. Morley, M. Naunheimer, B. Neal, J. O'Byrne, R. Robinson, V. Tangredi. GROUP/GROUPE: *"Information and Perception"; "Women's Work".*

GALLERY 1640
1445 Crescent St.,
Montreal 107, Que.
Zoe Nitkin

ARTISTS EXHIBITING/ARTISTES EXPOSANTS:
F. Bain, C. Bates, P. Bates, T. Beament, A. Bell, T. Bidner, D. Blackwood, G. Boisvert, J. Boyd, M. Braitstein, G. Caiserman-Roth, R. Derouin, J. Dickson, J. Esler, M. Fisher, P. Gagnon, L. Genush, G. Guerin, L. Harris, D. Harvey, J. Heywood, S. Hudson, A. Kahane, H. Kiyooka, E. Landori, R. Langstadt, W. Leathers, N. Magerci, J. Manning, E. Myers, A. Notkin-Cayne, K. Van Der Ohe, T. Onley, E. Ouchi, G. Petit, E. Prager, R. Savoie, L. Simons, R. Swartzman, Taira, G. Tremblay, C. Van Vliet, B. Wainwright, H. Woolnough. GROUP/GROUPE: *"Western Canada".*

GANDER INTERNATIONAL AIRPORT
Gander, Nfld.

ARTISTS EXHIBITING/ARTISTES EXPOSANTS:
W. Bachinski, P. Dobush, E. Freifeld, M. Jones, J. Meanwell, R. Mikkanen, G. Morton, G. Wood, D. Wright. GROUP/GROUPE: *"Eight Canadian Printmakers".*

GLEN GALLERY
30 Picton St.,
London, Ont.
Joan A. Hayman

ARTISTS EXHIBITING/ARTISTES EXPOSANTS:
A. Beckley, M. Little, D. Murray, T. Pedersen, J. Taleski, K. Tapson, L. Wheeler.

GLENBOW-ALBERTA GALLERY
902 11th Ave. SW,
Calgary, Alta.

ARTISTS EXHIBITING/ARTISTES EXPOSANTS:
M. Bates, R. Carmichael, G. Casprowitz, J. Devlin, J. Fafard, S. Greene, H. House, G. Jenkins, D. Knowles, R. Kostyniuk, R. Leadbeater, E. Lindner, J. Plaskett, R. Savage, N. Sawai, R. Sinclair, A. Wilson. GROUP/GROUPE: *"West '71".*

GOETHE INSTITUTE
35 O'Connor St.,
Ottawa, Ont.

ARTISTS EXHIBITING/ARTISTES EXPOSANTS:
P. Ackerman, L. Gerbrandt, G. Lambton.

GORDON GALLERIES
1362 7th Ave.,
Prince George, B.C.

ARTISTS EXHIBITING/ARTISTES EXPOSANTS:
P. Aspell, D. Baycroft, A. Bell, B. Boyd, G. Bricker, B. Garnett, I. Garrioch, T. Harrison, D. Jarvis, M. Johnson, B. Jones, J. Macdonald, C. Pomeroy, D. Rausch, Q. Robbins, M. Sjolseth, G. Smith, P. Zielke.

GRAFF (ATELIER LIBRE)
848 rue Marie-Anne,
Montréal, Qué.
P. Ayot

ARTISTES EXPOSANTS/ARTISTS EXHIBITING:
H. Agerup, P. Ayot, T. Beament, F. Bergeron, L. Bissonnette, G. Boisvert, P. Daglish, C. Daoust, G. Deitcher-Kropsky, R. Derouin, A. Dufour, M. Dugas, A. Dumouchel, V. Frenkel, R. Garneau, J. Hurtubise, D. Leblanc, M. Leclair, J. Lafond, L. Lemieux-Bourassa, G. Marcoux, G. Montpetit, D. Moreau, I. Nair, C. Pachter, N. Petry, S. Raphael, R. Rompré, P. Sarrazin, R. Savoie, F. Simonin, H. Storm, P. Thibodeau, S. Tousignant, J. Daoust, N. Ulrich, B. Van Der Heide, I. Whittome, R. Wolfe.

GRAND FALLS GALLERY
Grand Falls, Nfld.

ARTISTS EXHIBITING/ARTISTES EXPOSANTS:
W. Bachinski, J. Esler, M. Jones, R. Mikkanen, M. Panchal, M. Pavelic, H. Schmidt, G. Trottier, G. Wood, D. Wright. GROUP/GROUPE: *"Eight Canadian Printmakers".*

LE GRAND THEATRE DU QUEBEC
269 est, boulevard St-Cyrille,
Québec, Qué.

ARTISTES EXPOSANTS/ARTISTS EXHIBITING:
R. Brousseau, J. Marcel, H. Saxe.

GRAPHIC 8 GALLERIES LTD.
2107 4th St. SW,
Calgary, Alta.
Sonia Szabados

ARTISTS EXHIBITING/ARTISTES EXPOSANTS:
L. Compernol, B. de Jong, J. Esler, F. Gravel, K. Samuelson, R. Yuristy.

GREEN DOOR ART GALLERY
2254 Queen St. E.,
Toronto, Ont.

ARTISTS EXHIBITING/ARTISTES EXPOSANTS:
K. Butler, D. Fraser, T. Hinton, K. Lennox, H. Lyon, J. Maly, R. Robertshaw, J. Zetek.

GUTENBERG GALLERY
664 Yonge St.,
Toronto, Ont.

ARTISTS EXHIBITING/ARTISTES EXPOSANTS:
R. Burton, J. Gauthier, A. Klaussman, J. Leventhal, D. McCarthy.

H & S CANVAS ART GALLERY LTD.
2105 West 38th St.,
Vancouver, B.C.

ARTISTS EXHIBITING/ARTISTES EXPOSANTS:
J. Ackroyd, W. Dexter, P. Granieer.

HALLETT ANTIQUES & COLLECTORS GALLERY
27 Leslie St., Perth, Ont.
M. W. Hallett, Susan Saigal

ARTISTS EXHIBITING/ARTISTES EXPOSANTS:
V. Hallett, C. Mackenzie, J. Nieminin, M. Nieminin.

HARRISON GALLERIES
Vancouver, B.C.

ARTISTS EXHIBITING/ARTISTES EXPOSANTS:
G. Bates, B. Crawford, J. Eastman, J. Horton, R. Jackson, N. Kelly, D. Lam, J. Mackillop, J. MacLean, R. McVittie, R. Okey, S. Plant, M. Sjolseth, A. Sutherland, G. Traunter, K. Wood.

HART HOUSE GALLERY
7 Hart House Circle,
Univ Toronto,
Toronto, Ont.

ARTISTS EXHIBITING/ARTISTES EXPOSANTS:
A. Abdelmessih, M. Batty, S. Doobs, K. Glaz, M. Harpur, M. Hirschberg, J. Hurly, G. Iskowitz, P. Johnson, L. Jones, R. Kane, J. McEwen, M. McLoughlin, D. McWhirter, B. Musselwhite, R. Onasick, E. Paine, T. Paine, J. Plaskett, C. Ralph, A. Rao, C. Rappeport, D. Rifat, T. Sato, P. Seed, C. Senkiw, J. Spencer, A. Vallière, B. Varty, H. Viirlaid.

HEART OF ALBERTA ART GALLERY
Box 1622, Stettler, Alta.
John P. Kitsco

ARTISTS EXHIBITING/ARTISTES EXPOSANTS:
J. Acs, M. Biggs, D. Bodard, J. Dannewald, E. Eichner, M. Esau, A. Fischback, G. Fooks, G. Hallett, J. Kelts, J. Kitsco, M. McDonald, B. Payne, C. Schroeder, R. Schick, D. Schwenk, D. Seidlitz, Sister Reine, D. Sparks, P. Starling, C. Taylor, K. Taylor, G. Thieme, J. Thiessen, V. Wallace, E. Williams.

HERITAGE HOUSE GALLERY
Vancouver, B.C.

ARTISTS EXHIBITING/ARTISTES EXPOSANTS:
L. Englehart, R. Jackson, M. Muir, B. Sclater, A. Sutherland.

HOLY BLOSSOM TEMPLE
Toronto, Ont.

ARTISTS EXHIBITING/ARTISTES EXPOSANTS:
J. Hovadik, B. Penson, J. Stone, A. Weinstein.

HOT BED GALLERY
2071 Yonge St.,
Toronto, Ont.

ARTISTS EXHIBITING/ARTISTES EXPOSANTS:
A. Arthanic, C. Brady, J. de Santos, E. Fuchs, R. Kell, J. Shannon.

HOUSE OF CERAMICS
565 Hamilton St.,
Vancouver 3, B.C.
Hiro Urakami

ARTISTS EXHIBITING/ARTISTES EXPOSANTS:
N. Ashlie, K. Dodd, L. Epp, M. Ferretta, K. Hamilton, R. Hawbolt, B. Kingsmill, C. Kline, P. Marshall, D. McLaren, R. Meechan, C. Parthington, K. Parthington, L. Robson, L. Senior, K. Sumi, F. Tenendale, M. Wedeking.

HOUSE OF FINE ART
409 5th St. S,
Lethbridge, Alta.
Ilona Kajari

ARTISTS EXHIBITING/ARTISTES EXPOSANTS:
M. Lindstrom, O. Rapp, J. Schwartz, E. Wojtowicz.

IMAGES FOR A CANADIAN HERITAGE
1192 Burrard St.,
Vancouver 1, B.C.
F. W. Ellis

ARTISTS EXHIBITING/ARTISTES EXPOSANTS:
M. Brodie, E. Kornachuk, A. Sapp. GROUP/ GROUPE: "Indian Prints"; "Eskimo Graphics: Poveungnituck Collection"; "Eskimo Graphics: Holman Collection".

INNUIT GALLERY OF ESKIMO ART
30 Avenue Road,
Toronto, Ont.
R. Brownstone

ARTISTS EXHIBITING/ARTISTES EXPOSANTS:
Adamie, J. Akulatjuk, A. Aleekee, E. Alook, Angaktaquak, Anglosaglo, Annagtuusi, Apkilialik, G. Arlook, T. Ashevak, Atinah, E. Atoomowyak, S. Eevik, Iisa, Iksiktaaryuk, Ishulutaq, Ittuluka'naaq, Kavik, Kayuryuk, J. Kigusiug, Koodlarlik, Kootook, Kukiiyaut, Leesee, Mamnguqsualak, Maniapsik, Mannik, Meeka, Mosesee, Niungituq, W. Noah, T. Novakeel, Nowyook, Oitook, Olassie, Oonark, Peeah, L. Pitsiulak, Qarliksaq, Salee, Tagoona, Tookoome, Uqayuittuq.

ISAACS GALLERY
832 Yonge St.,
Toronto, Ont.

ARTISTS EXHIBITING/ARTISTES EXPOSANTS:
D. Burton, G. Coughtry, G. Curnoe, J. Greer, N. Kubota, W. Kurelek, L. Levine, R. Markle, G. Rayner, W. Redinger, J. Smith, D. Solomon. GROUP/GROUPE: "Theatre Arts Works".

JACK HAMBLETON GALLERIES
1829 Chandler St.,
Kelowna, B.C.

ARTISTS EXHIBITING/ARTISTES EXPOSANTS:
S. Black, H. Lyon, E. Oudendag.

JULIANNE GALLERIES OF FINE ART
Fairview Mall,
Toronto, Ont.

ARTISTS EXHIBITING/ARTISTES EXPOSANTS:
D. Armstrong, K. Hanke, P. Kulha, Taisia.

KAR GALLERY
131 Bloor St. W.,
Toronto, Ont.
Eugene Karniol

ARTISTS EXHIBITING/ARTISTES EXPOSANTS:
Y. Canu, A. Donato, M. Ferrières, J. Hamilton-Smith, H. Kohler, P. Kunz, T. Matas, J. Pepper, A. Pietrowsky, J. Richmond, L. Surcouf.

KITCHENER-WATERLOO ART GALLERY
43 Benton St., Kitchener, Ont.
Robert Ihrig

ARTISTS EXHIBITING/ARTISTES EXPOSANTS:
A. Bell, M. Hayden. GROUP/GROUPE: "Artforms '73".

KOOTENAY SCHOOL OF ART GALLERY
Box 480, Nelson, B.C.
E. H. Underhill

ARTISTS EXHIBITING/ARTISTES EXPOSANTS:
J. Allard, K. Anglis, A. Bell, B. Copley, B. Davidson, G. Farrar, C. Fletcher, T. Hasegana, A. Jack, J. Lawrence, T. Manarey, G. McEachern, N. Palmer, R. Pelby, M. Peters, S. Piroche, T. Priedinger, T. Stephens, M. Stevenson, G. Szilazi, J. Warpiuk. GROUP/GROUPE: "Artario '72"; "MAKE: Ontario Textile Exhibition"; "Cape Dorset Eskimo Prints"; "Master of Visual Arts '72".

LAMBTON GALLERY
4161 Dundas St. W.,
Toronto, Ont.

ARTISTS EXHIBITING/ARTISTES EXPOSANTS:
W. Chapman, S. Fulford, H. Hoenigan, N. McClellan, L. McGeach, J. Reid, R. Smith.

LAMM ART GALLERY
1223 1st St. W.,
Calgary, Alta.
Robert T. Hall

ARTISTS EXHIBITING/ARTISTES EXPOSANTS:
M. Lichter, M. Lindstrom, F. Schlager.

LEAFHILL GALLERY
47 Bastion Square,
Victoria, B.C.
W. J. Kent

ARTISTS EXHIBITING/ARTISTES EXPOSANTS:
N. Bradshaw, W. Crawford, R. Leadbeater, H. Lyon, W. Ngan.

LEAMINGTON ART GALLERY
Leamington, Ont.

ARTISTS EXHIBITING/ARTISTES EXPOSANTS:
C. Bice, L. Dubey, B. Ferrapo, C. Hofmann, T. Keck, E. Safra, K. Saltmarche. GROUP/GROUPE: "Univ Windsor Fine Art Faculty Show".

LEARNING RESOURCES CENTRE
666 Eglinton Ave. W.,
Toronto, Ont.

ARTISTS EXHIBITING/ARTISTES EXPOSANTS:
S. Butler, Chuck Stake Enterprizes (D. Mabie, W. Toogood), R. Katz, W. Overshot, E. Sugar, V. Wanke, J. Zellinger.

LEFEBVRE GALLERY
12214 Jasper Ave.,
Edmonton, Alta.

ARTISTS EXHIBITING/ARTISTES EXPOSANTS:
L. Beames, L. Kostiuk, R. Leadbeater, H. Wohlfarth.

LETHBRIDGE CENTRE
7005 De Maisonneuve W.,
Montreal, Que.

ARTISTS EXHIBITING/ARTISTES EXPOSANTS:
E. Brodkin, F. Richman, R. Venor.

LILLIAN MORRISON ART GALLERY
104 Cumberland St.,
Toronto, Ont.

ARTISTS EXHIBITING/ARTISTES EXPOSANTS:
R. Bolt, R. Chow, M. Cooper, J. Damasdy, K. Hamasaki, M. Hill, J. Leach, E. Manley, A. Thorn, M. Woodhouse.

THE LITTLE GALLERY
William Ganong Hall,
Univ New Brunswick, Tucker Park,
Saint John, N.B.
William Prouty

ARTISTS EXHIBITING/ARTISTES EXPOSANTS:
F. Coutellier, M. Donaldson, M. Macintyre, C. McAvity, P. Skalnik, E. Willar.

LONDON PUBLIC LIBRARY AND ART MUSEUM
E. P. Williams Memorial Bldg., 305 Queens Ave.,
London, Ont.

ARTISTS EXHIBITING/ARTISTES EXPOSANTS:
E. Bartram, A. Bell, A. Borowsky, R. Bozak, B. Brooker, B. Crawford, D. Dabinett, B. Dalton, J. De Angelis, R. Downing, M. Durham, C. Hodge, B. Jackson, S. Livick, I. MacEachern, T. Mosna, S. Raphael, M. Tingley, A. Weinstein, J. Wheeler.

GROUP/GROUPE: "Canadian Ceramics '71"; "Cape Dorset Eskimo Prints"; "Eskimo Graphics"; "Focus"; *"International Graphics"; "Ontario Society of Artists: 100 Years"; "Plastic Fantastic"; "Society of Canadian Painter-Etchers and Engravers Exhibition"; "Western Ontario Exhibition (33rd Annual)".*

MAISON CHEVALIER
5 rue Champlain,
Québec

ARTISTES EXPOSANTS/ARTISTS EXHIBITING:
M. Marois, A. Pelletier, M. Rousseau.

LA MAISON DES ARTS LA SAUVEGARDE
160 est, rue Notre Dame,
Montréal 127, Qué.
M. Jacques Toupin

ARTISTES EXPOSANTS/ARTISTS EXHIBITING:
S. Allard, B. Baxter, S. Brodkin, L. Côté, M. de Vaney, L. Dupuis, N. Elliot-Ledoux, P. Granche, M. Lemieux, P. Lemieux, P. Lim, L. Marois, C. Meunier, R. Nadon, Pedno, J. Poisson, B. Schiele, P. Thibaudeau, M. Tremblay-Gillon, C. Valée. GROUPE/GROUP: "Design 3D–2D"; "15 Attitudes".

MARLBOROUGH-GODARD GALLERY
22 Hazelton Ave.,
Toronto, Ont.
Mira Godard

ARTISTS EXHIBITING/ARTISTES EXPOSANTS:
R. Downing, M. Dugas, H. Dunsmore, J. Gouin, S. Haeseker, B. Hall, J. Hansen, B. Hepworth, C. Hoskinson, J. Hurtubise, C. Knudsen, M. Leclair, J. McEwen, J. Palchinski, W. Ross, R. Savage, W. Schluep, T. Tanabe, P. Tétreault, P. Thibaudeau, R. Van de Peer, E. Warkov. GROUP/GROUPE: "New Talent in Printmaking".

MARLBOROUGH-GODARD GALLERY
1490 Sherbrooke St. W.,
Montreal, Que.
Mira Godard

ARTISTS EXHIBITING/ARTISTES EXPOSANTS:
P. Ayot, D. Bentham, D. Bolduc, U. Comptois, Y. Gaucher, F. Jorgensen, W. Soto, P. Thibaudeau. GROUP/GROUPE: "17 Canadian Artists"; "10 Canadian Artists".

MARQUIS GALLERY
Univ Saskatchewan,
Saskatoon, Sask.
Bob Christie

ARTISTS EXHIBITING/ARTISTES EXPOSANTS:
D. Bentham, K. Hardy, M. Levine, A. McAulay, W. Redinger, R. Shuebrook, S. Spencer, M. Zora. GROUP/GROUPE: *"Master of Visual Arts '72";* "Regina-Saskatoon Ceramics"; *"Prairie Sculpture".*

MARY FRAZEE GALLERY
413 North Cordova,
Vancouver, B.C.

ARTISTS EXHIBITING/ARTISTES EXPOSANTS:
R. Bollerup, A. Dean, F. Henderson, N. Mohamed.

MAZELOW GALLERY
3463 Yonge St.,
Toronto, Ont.
Helen Mazelow

ARTISTS EXHIBITING/ARTISTES EXPOSANTS:
S. Edlich, W. Everton, G. Saward, H. Town, A. Yunkers. GROUP/GROUPE: "Pangnirtung Graphics".

McGILL UNIVERSITY MUSEUM
McGill Univ, Montreal, Que.

ARTISTS EXHIBITING/ARTISTES EXPOSANTS:
B. Egyedi, R. L. Studham. GROUP/GROUPE: *"Jeunes Peintres Québécois".*

McINTOSH GALLERY
Univ Western Ontario,
London, Ont.
M. Stubbs

ARTISTS EXHIBITING/ARTISTES EXPOSANTS:
H. Bervoets, J. Boyle, C. Breeze, R. Burke, G. Cantieni, K. Ferris, S. Greene, Hassan, K. Lochhead, B. Maycock, N. Oman, Parzybok, C. Pratt, H. Town, J. Wieland. GROUP/GROUPE: *"Artario '72";* "Canadian Society of Graphic Art (40th Annual Show)"; *"Painters Eleven".*

McMASTER UNIVERSITY ART GALLERY
Hamilton, Ont.

ARTISTS EXHIBITING/ARTISTES EXPOSANTS:
J. Cavael, K. Kranz, J. Wilkinson.

ME AND MY FRIENDS GALLERY
237 Queen St. W., Toronto, Ont.

ARTISTS EXHIBITING/ARTISTES EXPOSANTS:
A. Armstrong, B. Astman, M. Bentley, W. Darster, E. Evans, V. Fisher, B. Grison, S. Herman, R. Hoover, A. Ivan, B. Kort, D. Mabie, R. Mae, H. Schuster, A. Sgabellone, S. Spector, W. Toogood, B. Verlaine-Wright, E. Zajfman.

MEDICINE HAT GALLERY ASSOCIATION
Medicine Hat Public Library, 414 1st St. SE,
Medicine Hat, Alta.
B. Yuill

ARTISTS EXHIBITING/ARTISTES EXPOSANTS:
D. MacLean, M. Mann-Butuk, J. Van Belkum.

MEMORIAL UNIVERSITY ART GALLERY
Arts & Culture Centre, St. John's, Nfld.
F. Lapointe

ARTISTS EXHIBITING/ARTISTES EXPOSANTS:
J. Allsopp, W. Bachinski, A. Bell, P. Dobush, J. Esler,
E. Freifeld, M. Henrickson, T. Henrickson, J. Kashet-
sky, R. Kostyniuk, L. Levine, T. Manarey, J. Meanwell,
R. Mikkanen, G. Molinari, C. Pratt, M. Pratt, L. Poole,
G. Rackus, S. Raphael, E. Roth, R. Shepherd, C. So,
T. Tascona, J. Tiley, W. Townsend, G. Wood.

MENDEL ART GALLERY
950 Spadina Cres. E.,
Saskatoon, Sask.

ARTISTS EXHIBITING/ARTISTES EXPOSANTS:
D. Bentham, B. Berzin, W. Brownridge, L. Cutting,
N. Daltin, J. Esler, D. Evans, R. Ferguson, T. Fraser,
S. Greene, P. Hall, N. Harrington, M. Keelan, L.
Koehn, R. Kostyniuk, E. Lindner, B. McCreath, T.
O'Flannigan, B. Newman, H. Pfeiffer, A. Piper, J.
Plaskett, J. Poole, M. Rees, K. Romaro, S. Sparling,
C. Staigh, B. Warnock, G. Wozny. GROUP/GROUPE:
"Another Eleven Saskatchewan Artists"; "Cape Dor-
set Prints 1972"; "Holman Island Prints"; *"West '71"*.

MERTON GALLERY
68 Merton St.,
Toronto 7, Ont.

ARTISTS EXHIBITING/ARTISTES EXPOSANTS:
R. Anderson, E. Beck, D. Bentham, C. Birt, K. Chan,
M. Davies, D. Dunning, A. Fines, I. Garrioch, J. Gor-
daneer, M. Grant, K. Hayaro, T. Hodgson, J. MacKil-
lop, J. Martin, H. Norrington, J. Rosenthal, C. Shoni-
ker, L. Steen, J. Tiley, O. Timmas, V. Tolgesy.

MIDDLETON'S GALLERY
60 Middleton Dr.,
Vernon, B.C.
Holly Middleton

ARTISTS EXHIBITING/ARTISTES EXPOSANTS:
N. Churchill, B. Davis, Harley, Harris, P. Jones, H.
Middleton.

MIDO GALLERY LTD.
936 Main St.,
Vancouver 4, B.C.
Werner True

ARTISTS EXHIBITING/ARTISTES EXPOSANTS:
R. Adams, P. Bates, E. Brown, G. Class, A. Chung,
B. de Castro, J. Esler, H. Fawcett, B. Game, J. Grove,
T. Irving, P. Irwin, J. Jakebow, M. Jakebow, M. Jones,
J. Kidder, L. Kristmanson, R. Lewis, D. Marshall, E.
Mayhew, M. Minot, S. Montgomery, P. Ochs, N. Sawai,
H. Scholz, R. Swartzman, R. Wyndham. GROUP/
GROUPE: *"Contemporary Tapestry and Weaving Ex-
hibition"*.

THE MITCHELL GALLERY LTD.,
27 Prince Arthur Ave.,
Toronto, Ont.

ARTISTS EXHIBITING/ARTISTES EXPOSANTS:
M. Cassou, R. Gross, D. Haneguard, Jefferey.

MONCTON ART GALLERY
Univ Moncton,
Moncton, N.B.
Ghislain Clermont

ARTISTS EXHIBITING/ARTISTES EXPOSANTS:
J. Hansen, P. Skalnik. GROUP/GROUPE: *"Eight
Canadian Printmakers"*.

MOOSE JAW ART MUSEUM
Crescent Park,
Moose Jaw, Sask.
Austin T. Ellis

ARTISTS EXHIBITING/ARTISTES EXPOSANTS:
V. Cicansky, C. Gagnon, B. Newman, V. Sharma, S.
Sparling, B. St. Clair. GROUP/GROUPE: *"Artario
'72"*; *"Manitoba Mainstream"*; *"Watercolour Painters
from Saskatchewan"*.

MORRIS GALLERY
15 Prince Arthur Ave.,
Toronto, Ont.

ARTISTS EXHIBITING/ARTISTES EXPOSANTS:
K. Andrews, R. Bloore, Boughner, E. Brodie, Cameron,
L. De Niverville, I. Eyre, L. Fitzgerald, E. Freifeld,
Game, J. Gouin, B. Hall, R. Hedrick, K. Hunt, Jako-
vac, R. Letendre, E. Mazzei, H. Morden, P. Parkinson,
H. Schweizer, R. Sewell, W. Toogood, F. Vivenza,
Walker, J. Wieland, T. Whiten, Zingraff.

MOUNT ALLISON UNIVERSITY
Sackville, N.B.

ARTISTS EXHIBITING/ARTISTES EXPOSANTS:
W. Bachinski, E. Freifeld, J. Hansen, M. Henrickson,
T. Henrickson.

MORRISON ART GALLERY
221 Union St.,
St. John, N.B.
Joanne Morrison Melder

ARTISTS EXHIBITING/ARTISTES EXPOSANTS:
R. Campbell, T. Graser, C. Nicholson, D. Silverburg.
GROUP/GROUPE: *"December Choice"*; "Six Monc-
ton Artists".

MOUNT SAINT VINCENT UNIVERSITY
Halifax, N.S.
Margaret Cripton

ARTISTS EXHIBITING/ARTISTES EXPOSANTS:
W. Bachinski, T. Gallie, D. Nasby, L. Poole, R.
Swartzman, T. Tascona, F. Trainor. GROUP/
GROUPE: *"Eight Canadian Printmakers"*; *"Manitoba
Mainstream"*.

MUSEE D'ART CONTEMPORAIN
Cité du Havre, Montréal, Qué.
F. Saint-Martin

ARTISTES EXPOSANTS/ARTISTS EXHIBITING:
L. Archambault, R. Brousseau, M. Ferron, G. Guerra,
J. Hurtubise, E. Kowell, K. Kranz, R. Letendre, G.
Monpetit, M. Ristvedt, H. Saxe, B. Schiele, C. Tou-
signant, B. Vazan.

MUSEE DES BEAUX-ARTS DE MONTREAL
1379 Sherbrooke ouest,
Montréal, Qué.

ARTISTES EXPOSANTS/ARTISTS EXHIBITING:
C. Bates, D. Brayshaw, O. Caldaru, T. Forrestall, P.
Gaudard, L. Genush, R. Halliday, C. Hayward, J. Pa-
tel, J. Kyllo, S. Lake, P. Lefebvre, J. Leroux-Guil-
laume, D. Lukas, N. Moffat, G. Palladini, A. Pellan, S.
Peters, R. Piché, R. Proulx, G. Roach, M. Ristvedt, G.
Ross, R. Schorer, K. Speicker, J. Teff, B. Tenti, P. Thi-
baudeau, N. Ulrich. GROUPE/GROUP: *"Association
des Graveurs du Québec"*; *"Sculpture/Inuit"*.

MUSEE DU QUEBEC
Parc des Champs de Bataille,
Québec, Qué.

ARTISTES EXPOSANTS/ARTISTS EXHIBITING:
M. Ange, R. Arsenault, Canada Banners Co., M. Ca-
ron, C. Daudelin, A. Dumas, M. Ferron, A. Fournelle,
J. Hurtubise, C. Jirar, T. Keck, J. Légaré, D. Matte,
M. Mercier, A. Pellan, R. Poulain, M. Rousseau-Ver-
mette, E. Safra, A. Villeneuve. GROUPE/GROUP:
"Exposition des Sculptures Modernes"; *"Les Moins
de 35"*.

MUSEE REGIONAL DE RIMOUSKI
35 ouest, rue St-Germain,
Rimouski, Qué.
J.-Y. Leblond

ARTISTES EXPOSANTS/ARTISTS EXHIBITING:
Canada Banners Co., M. Chene Belzille, C. Rousseau.
GROUPE/GROUP: *"De Rêves et d'Encre Douce"*.

MUSHROOM GALLERY
Windsor, Ont.

ARTISTS EXHIBITING/ARTISTES EXPOSANTS:
H. Singh, B. Weir, E. Yerex.

THE NEW BRUNSWICK MUSEUM
277 Douglas Ave.,
St. John, N.B.
Robert M. Percival

ARTISTS EXHIBITING/ARTISTES EXPOSANTS:
J. Allsopp, E. Fielding, T. Forrestall, E. Freifeld, J. Hansen, J. Humphrey, C. Nicholson, N. Pliskow, G. Rackus, S. Raphael, T. Tascona, R. Venor, R. Vilder. GROUP/GROUPE: *"Eight Canadian Printmakers".*

NANCY POOLE'S STUDIO
554 Waterloo St.,
London, Ont.
Nancy Poole

ARTISTS EXHIBITING/ARTISTES EXPOSANTS:
A. Baker, S. Bailey, E. Cameron, H. Carter, J. Chambers, K. Danby, D. Dolman, J. Drutz, I. Gilbert, M. Greenstone, W. Gregory, G. Holdsworth, B. Jones, J. Kemp, B. Kloezeman, D. McLean, P. Moore, K. Ondaatje, V. Owen, M. Robinson, L. Russell, M. Smith, T. Urquhart, A. Varga, K. Verboom, T. Wilson.

NANCY POOLE'S STUDIO
16 Hazelton Ave.,
Toronto, Ont.
Nancy Poole

ARTISTS EXHIBITING/ARTISTES EXPOSANTS:
H. Aalto, E. Alexander, J. Boyle, H. Carter, J. Chambers, J. Drutz, L. Dupuis, I. Gilbert, M. Greenstone, W. Gregory, M. Keepax, B. Kloezeman, E. Lindner, P. Moore, K. Ondaatje, V. Owen, T. Urquhart, A. Varga, T. Wilson.

THE NATIONAL GALLERY/LA GALERIE NATIONALE
Elgin St., Ottawa, Ont.
Jean Boggs

ARTISTS EXHIBITING/ARTISTES EXPOSANTS:
P. Bourduas, B. Brooker, T. Davies, L. Levine, A. Pellan, J. Plaskett, M. Snow, J. Spencer, C. Tousignant, N. Yates. GROUP/GROUPE: *"Image Bank Postcard Show"; "Manitoba Mainstream"; "Sculpture/ Inuit"; "Toronto Painting 1953-1965"; "Watercolour Painters from Saskatchewan".*

NEW WESTMINSTER CENTRAL LIBRARY GALLERY
716 6th Ave., New Westminster, B.C.

ARTISTS EXHIBITING/ARTISTES EXPOSANTS:
H. Cragg, C. Hessay, M. Jakabow, L. Jensen, H. Kowallek, W. Lambert, K. Longden, M. McGill, K. Peterson, D. Portelance, N. Sawai, E. Storch. GROUP/ GROUPE: "New Westminster Arts Council".

NIAGARA FALLS ART GALLERY AND MUSEUM
Queen Elizabeth Way, Niagara Falls, Ont.
M. Kolankiwsky

ARTISTS EXHIBITING/ARTISTES EXPOSANTS:
T. Keck, E. Koniuszy, M. Kuczer, R. Nudds, W. Nudds, A. Ozols, L. Ozols, A. Pereyna, E. Safra.

NORMAN MACKENZIE ART GALLERY
Univ Saskatchewan, Regina, Sask.

ARTISTS EXHIBITING/ARTISTES EXPOSANTS:
M. Bates, D. Bentham, A. Caro, A. Colville, K. Eloul, J. Fafard, A. Gallus, T. Godwin, E. Lindner, R. Murray, D. Smith, M. Steiner. GROUP/GROUPE: *"Diversity".*

O'KEEFE CENTRE
Front St.,
Toronto, Ont.

ARTISTS EXHIBITING/ARTISTES EXPOSANTS:
H. Baillie, P. Faulkner, M. Hecht, H. Sabelis.

GROUP/GROUPE: "Art of the Dance"; *"Canadian Society of Painters in Watercolour";* "Media Probe".

ONTARIO ASSOCIATION OF ARCHITECTS
50 Park Road, Toronto, Ont.

ARTISTS EXHIBITING/ARTISTES EXPOSANTS:
E. Falkenberg, M. Kuczer, I. Lendvay, R. Lindson.

ONTARIO INSTITUTE FOR STUDIES IN EDUCATION
252 Bloor St. W.,
Toronto, Ont.

ARTISTS EXHIBITING/ARTISTES EXPOSANTS:
B. De Jong, P. Faulkner, P. Kavalik. GROUP/ GROUPE: *"Canadian Society of Painters in Watercolour (47th Annual Exhibition)";* "George Brown College Graphic Art Students Exhibit"; "Humber Valley Art Club Exhibit" "Manitou Art Association Exhibit"; "Ontario Department of Education Exhibition"; *"Ontario Society of Artists: 100 Years"; "Society of Canadian Painter-Etchers and Engravers (56th Annual Exhibition)";* "Toronto District Art Supervisors Association Exhibit".

OPEN SPACE GALLERY
Victoria, B.C.

ARTISTS EXHIBITING/ARTISTES EXPOSANTS:
H. Cragg, D. Holyoak, H. Kowallek, G. Simpson.

OPEN STUDIO
520 King St.,
Toronto, Ont.

ARTISTS EXHIBITING/ARTISTES EXPOSANTS:
B. Hall, R. Letendre, F. Vivenza, J. Wieland.

OWENS ART GALLERY
Mount Allison Univ,
Sackville, N.B.
Christopher Youngs

ARTISTS EXHIBITING/ARTISTES EXPOSANTS:
E. Fielding, K. Spital, R. Vilder.

PATMOS WORKSHOP AND GALLERY
561 Richmond St. W.,
Toronto, Ont.
James V. Marshall

ARTISTS EXHIBITING/ARTISTES EXPOSANTS:
J. Corcoran, E. Fielding, B. De Graaf, E. Hagedom, E. Kellogg, H. Krijger, H. Melles, J. Petkus, S. Van der Weele. GROUP/GROUPE: "Butterflies"; "Hodgepodge".

PENELL GALLERY
12 Hazelton Ave.,
Toronto, Ont.

ARTISTS EXHIBITING/ARTISTES EXPOSANTS:
A. Cowan, R. Charron, Katja, B. Langton, M. Saunders. GROUP/GROUPE: "Christmas Show".

PENTICTON ARTS CENTRE
Penticton, B.C.

ARTISTS EXHIBITING/ARTISTES EXPOSANTS:
B. Boyd, G. McEachern, S. Piroche, C. Pomeroy.

PETER WHYTE FOUNDATION GALLERY
111 Bear St., Banff, Alta.
Roger Boulet

ARTISTS EXHIBITING/ARTISTES EXPOSANTS:
R. Carmichael, D. Elliott, H. Feist, J. Plaskett, R. Sinclair.

PICTURE LOAN GALLERY
3 Charles St. W.,
Toronto, Ont.
George Rackus

ARTISTS EXHIBITING/ARTISTES EXPOSANTS:
R. McCarthy, B. Moss, E. Myers, M. Panchal, G.
Rackus, G. Sawyer, R. Sawyer.

PLUG IN GALLERY
90 Albert St.,
Winnipeg, Man.
Suzanne Gillies

ARTISTS EXHIBITING/ARTISTES EXPOSANTS:
T. Allison, L. Bako, J. Jonasson, W. Jones. GROUP/
GROUPE: "Canadian Arts Representation Open Cir-
cuit"; "Everyone Passes (Univ Manitoba School of
Art Show)"; "Red River Community College Student
Show".

THE POLLOCK GALLERY
356 Dundas St. W.,
Toronto, Ont.

ARTISTS EXHIBITING/ARTISTES EXPOSANTS:
A. Albers, J. Albers, R. Amisman, B. Caruso, G. El-
liott, E. Falkenberg, N. Ives, R. Langner, A. Marcos,
F. Massameno, N. Morriseau, R. Owens, F. Pollock,
C. Senitt-Harbison, L. Stokes, T. Van Alstyne.

REOS ART GALLERY
P. O. Box 11, R. R. 3,
Hamilton, Ont.

ARTISTS EXHIBITING/ARTISTES EXPOSANTS:
J. Cavael, I. Linton, R. Nudds, W. Nudds, S. Schnei-
der.

RICHMOND ARTS CENTRE
Richmond, B.C.

ARTISTS EXHIBITING/ARTISTES EXPOSANTS:
E. Addison, A. Baalam, A. Carter, E. Dirnfield, M.
Haigh, J. Hirota, E. Johnson, H. Sabelis. GROUP/
GROUPE: "C.P. Air Creative Artists"; "Island Ar-
tists"; "Richmond Artists Guild (Fall show)"; "Van-
couver Fabric Arts Guild".

RM GALLERY
460 Eglinton Ave.,
Toronto, Ont.

ARTISTS EXHIBITING/ARTISTES EXPOSANTS:
F. Boehmer, G. Eyer, T. Phillips.

ROBERT McLAUGHLIN GALLERY
Civic Centre, Oshawa, Ont.
Glen E. Cumming

ARTISTS EXHIBITING/ARTISTES EXPOSANTS:
C. Birt, J. Currelly, R. Downing, D. Gilhooly, Franz
Johnston, Frances-Anne Johnston, P. Kolisnyk, J.
Mance, P. Rodrik, J. Street, J. Tiley, H. Town, R. Vil-
der, S. Wildman. GROUP/GROUPE: *"Lithographs I".*

ROBERTS GALLERY LTD.
641 Yonge St.,
Toronto, Ont.

ARTISTS EXHIBITING/ARTISTES EXPOSANTS:
F. Arbuckle, L. Bellefleur, B. Bobak, M. Bobak, L.
Brooks, A. Casson, A. Collier, A. Dingle, T. Forre-
stall, J. Gould, P. Harris, P. Haworth, B. Howorth,
D. Houstoun, Frances-Anne Johnston, K. MacDou-
gall, W. McElcheran, D. Miezajs, W. Ogilvie, D. Par-
tridge, M. Pigott, M. Rakine, G. Roberts, W. Roberts,
C. Schaefer, J. Stohn, S. Wildman, S. Wildridge, Y.
Wilson, W. Winter. GROUP/GROUPE: "Artists'
Choice".

ROBERTSON GALLERIES
162 Laurier Ave. W.,
Ottawa, Ont.

ARTISTS EXHIBITING/ARTISTES EXPOSANTS:
S. Beaulieu, J. Houston, R. Savage, A. Tagoona.

ROMANOV GALLERY
12709 119th St.,
Edmonton, Alta.
Elsa Zajonz

ARTISTS EXHIBITING/ARTISTES EXPOSANTS:
F. Anders, L. Riopel, E. Vincent, P. Zielke.

ROSENBURG GALLERY
180 Waterloo Ave.,
Guelph, Ont.
Stimart Ltd. (W. Schmidt, Pres.)

ARTISTS EXHIBITING/ARTISTES EXPOSANTS:
Dzidra, P. Kunz, Maurillo, Wedor, P. Zazzetta.

SAIDYE BRONFMAN CENTRE
5170 Côte Ste-Catherine,
Montréal, Qué.
Georges Dyens

ARTISTES EXPOSANTS/ARTISTS EXHIBITING:
G. Cantieni, A. de la Porte, H. Franklin, S. Gersovitz,
S. Lewis, S. Raphael, W. Redinger, N. Tremblay, R.
Venor. GROUPE/GROUP: *"Les Moins de 35";*
"Staff Show".

**ST. CATHARINES AND DISTRICT ARTS
COUNCIL (RODMAN HALL)**
109 St. Paul Cres.,
St. Catharines, Ont.

ARTISTS EXHIBITING/ARTISTES EXPOSANTS:
H. Baillie, W. Cyopik, A. Dow, R. Downing, J. Fraser,
P. Haeberle, B. Hall, D. Vermeulen, M. Woodhouse.
GROUP/GROUPE: *"Artario '72";* "Six Canadian
Sculptors".

ST. LAWRENCE CENTRE FOR THE ARTS
27 Front St. E., Toronto, Ont.

ARTISTS EXHIBITING/ARTISTES EXPOSANTS:
L. Guderna, J. Hall, R. Hall, M. Hecht. GROUP/
GROUPE: *"NECAFEX: New Canadian Exhibition".*

ST. MARY'S UNIVERSITY ART GALLERY
St. Mary's Univ, Halifax, N.S.
R. Dietz

ARTISTS EXHIBITING/ARTISTES EXPOSANTS:
T. Batdorf, K. Bruneau, D. Duncan, J. Esler, N. Gray,
D. Haigh, S. Jackson, G. Rackus, R. Ridehout.

ST. THOMAS MORE GALLERY
Univ Saskatchewan,
Saskatoon, Sask.
Angeline Lucas

ARTISTS EXHIBITING/ARTISTES EXPOSANTS:
I. de Coursey, L. Dierker, W. Hathaway, R. Hoskins,
R. McCreath, Don Panko, Duane Panko, V. Sharma.

SARNIA PUBLIC LIBRARY & ART GALLERY
Sarnia, Ont.
R. T. Bradley

ARTISTS EXHIBITING/ARTISTES EXPOSANTS:
H. Ariss, M. Ariss, G. Brender à Brandis, I. Broeder-
mann, B. Brooker, J. Evans, G. Furoy, L. Grol, H.
Groves, J. Groves, J. Hanzalek, M. Horne, I. Miku-
nas, O. Mikunas, M. Saunders, S. Slahor, R. Van
Leeuwen. GROUP/GROUPE: *"Ontario Society of
Artists: 100 Years";* "Sarnia Annual Art Exhibition".

SASKATOON PUBLIC LIBRARY GALLERY
Saskatoon, Sask.

ARTISTS EXHIBITING/ARTISTES EXPOSANTS:
K. Angliss, R. Christie, R. Cross, V. Frenkel, M. Gib-
son, P. Hall, N. Harrington, C. Hume, L. Koehn, J.
Korpan, F. Lahrman, J. Pickering, V. Sharma, F. Steh-
wien, R. Symons, L. Walters, M. Wawra. GROUP/
GROUPE: *"A June Show"; "Nature Saskatchewan";
"Northern Saskatchewan Juried Show"; "Saskatche-
wan Arts Board Collection"; "A Summer Show".*

SCARBOROUGH PUBLIC LIBRARIES
c/o Cedarbrae District Library,
545 Markham Road,
Scarborough, Ont.
Helen Peterson

ARTISTS EXHIBITING/ARTISTES EXPOSANTS:
R. Anderson, M. Bentley, T. Bentley, M. Chambers,
H. Dunsmore, F. Henry, P. Hunt, L. Klausner, E.
Koniuszy, P. Leon, C. Morey, A. Perkins, R. Perkins,
J. Richmond, J. Rosenthal, D. Samila, B. Siegel, O.
Timmas, J. Walker, E. Willmott.

THE SCULPTURE STUDIO
Vancouver, B.C.

ARTISTS EXHIBITING/ARTISTES EXPOSANTS:
R. Hawbolt, M. Hewitt, L. Robson.

SHAW-RIMMINGTON GALLERY
20 Birch Ave., Toronto, Ont.
Marie Shaw-Rimmington

ARTISTS EXHIBITING/ARTISTES EXPOSANTS:
T. Chatfield, F. Gallo, P. Goetz, B. Huxley, J. Joel, J.
Kelley, W. Lew, N. Newton, E. Quan, R. Reichardt,
H. Rothschild, B. Shaw-Rimmington, J. Street, M.
Van Dam, I. Waller, B. Wilson. GROUP/GROUPE:
"Society of Canadian Artists Members Exhibition";
"Outdoor Sculpture Exhibition"; "Our Watercolour-
ists".

SHOESTRING GALLERY
147 2nd Ave. S.,
Saskatoon, Sask.
Marline Zora

ARTISTS EXHIBITING/ARTISTES EXPOSANTS:
W. Browning, R. Christie, L. Cutting, J. Fafard, M.
Forsyth, B. Warnock.

THE SIMON FRASER GALLERY
Simon Fraser Univ,
Burnaby 2, B.C.
J. W. Felter

ARTISTS EXHIBITING/ARTISTES EXPOSANTS:
A. Colville, A. Erickson, J. Esler, K. Lochhead, G.
Smith. GROUP/GROUPE: "Eskimo Graphics";
"Graff".

**SIR GEORGE WILLIAMS UNIVERSITY ART
GALLERIES**
1445 de Maisonneuve Blvd.,
Montreal 107, Que.
E. F. Cooke

ARTISTS EXHIBITING/ARTISTES EXPOSANTS:
F. Barry, T. Beament, R. Field, C. Gagnon, C. Hay-
ward, P. Laberge, P. Landsley, R. Langstadt, H. Leh-
man, C. Magnan, J. Miller, S. Raphael, R. Wilby, J.
Ziger.

STEWART HALL
Pointe-Claire Cultural Centre,
176 Lakeshore Road,
Pointe-Claire, Que.
Helen Judkins

ARTISTS EXHIBITING/ARTISTES EXPOSANTS:
M. Bertrand, C. Bourgeois, I. Desjardins, R. Dumais,
S. Girard, J. Hurtubise, C. Leonard, R. Poirier.
GROUP/GROUPE: "Image Bank Postcard Show";
"De Rêves et d'Encre Douce"; "Manitoba Main-
stream".

STUDIO 23 GALERIE
259 rue Principale,
St-Sauveur-des-Monts, Qué.
H. W. Jones, Pauline Jones

ARTISTES EXPOSANTS/ARTISTS EXHIBITING:
B. Aghajanian, V. Bourigaut, G. Caiserman-Roth, C.
Courchesne, P. Foxet-Studham, H. Franklin, P.
Gagnon, P. Gendron, H. Granson, M. Henaut, S.
Hudson, W. Krol, P. L'Abbé-Jones, P. Landsley, E.
Phillips, M. Prent, L. Studham, G. Tondino.

TATE GALLERY
46 Hayden St.,
Toronto, Ont.

ARTISTS EXHIBITING/ARTISTES EXPOSANTS:
S. de Verteuil, B. Mercer. GROUP/GROUPE: "A
Womens Show".

THEATRE IN CAMERA
736 Bathurst St.,
Toronto, Ont.

ARTISTS EXHIBITING/ARTISTES EXPOSANTS:
B. Allen, M. Bourgignon, A. Cetin, J. Kakegarnic, J.
Ladocha, G. Ranault, R. Tamaya.

THE THIRD GALLERY
Oakville, Ont.

ARTISTS EXHIBITING/ARTISTES EXPOSANTS:
P. Dion, B. Eakin, C. Eakin, Hikka, R. Kramer, L.
Shore, A. Steven, V. Teteris, A. Waywell.

TOM THOMSON MEMORIAL ART GALLERY
Owen Sound, Ont.

ARTISTS EXHIBITING/ARTISTES EXPOSANTS:
H. Baillie, G. Chu, J. Hanzalek GROUP/GROUPE:
"Annual Jury Show".

TOPHAM BROWN GALLERY
Vernon, B.C.

ARTISTS EXHIBITING/ARTISTES EXPOSANTS:
H. Middleton, S. Pirocha, C. Summerland.

TRAJECTORY GALLERY
381 1/2 Talbot St.,
London, Ont.
V. Jordan

ARTISTS EXHIBITING/ARTISTES EXPOSANTS:
R. Burke, M. Durham, P. Osicka. GROUP/GROUPE:
"Progress 7"; "Theatre Arts Works".

UNITARIAN CHURCH
175 St. Clair Ave. W.,
Toronto, Ont.

ARTISTS EXHIBITING/ARTISTES EXPOSANTS:
I. Cleland, K. Dick, B. Karzin, I. Mohr, H. Norring-
ton, L. Parker, L. Rowe, M. Wagler, R. Walker.

UNIVERSITE DE SHERBROOKE
Cité Universitaire,
Sherbrooke, Qué.

ARTISTES EXPOSANTS/ARTISTS EXHIBITING:
M. Audette, R. Bergeron, M. Bouthiller-Nantel, L.
Brookhouse, G. Cantieni, J. Dagneault, M. Ferron,
J. Plaskett, M. Rosengarten, T. Steinhouse.
GROUPE/GROUP: "De Rêves et d'Encre Douce";
"Pack Sack".

UNIVERSITE LAVAL
Québec, Qué.

ARTISTES EXPOSANTS/ARTISTS EXHIBITING:
D. Asselin, M. Bernatchez, C. Jiror, J. Weiss.
GROUPE/GROUP: "Masters of Visual Arts Exhibi-
tion".

**UNIVERSITY OF ALBERTA ART GALLERY &
MUSEUM**
Univ Alberta, Edmonton, Alta.
A. Dunlop

ARTISTS EXHIBITING/ARTISTES EXPOSANTS:
A. Bailey, P. Bartl, D. Bennetts, B. Bentz, R. Black-
more, D. Broderick, D. Cantine, J. Chalke, A. Darrah,
R. Douglas, J. Dow, J. Fafard, L. Fisher, V. Foster,
V. Frenkel, T. Gallie, M. Grayson, D. Green, D.
Haynes, K. Hughes, W. Jule, W. Jungkind, D. Lange,
J. Knowlton, A. McKay, L. Osborne, G. Peacock, J.
Risser, S. Roberts, R. Silvester, J. Taylor, M. Travers,
C. Westem, N. Yates. GROUP/GROUPE: "Master
of Visual Arts Exhibition"; "Young Alberta Weavers".

UNIVERSITY OF CALGARY FOYER GALLERY
2920 24th Ave. N.W.,
Calgary, Alta.

ARTISTS EXHIBITING/ARTISTES EXPOSANTS:
K. Bethke, L. Cromwell, A. Govers, M. Hobden, A.
Jackson, M. Jones, C. McConnell, R. Moppet, E.
Spiteri. GROUP/GROUPE: "Retrospective Bauhaus
and Today".

UNIVERSITY OF GUELPH
Guelph, Ont.
J. Nasby

ARTISTS EXHIBITING/ARTISTES EXPOSANTS:
W. Bachinski, E. Cameron, G. Chu, R. Downing, J.
Galt, Maurilio, J. Poklen, G. Weisman, J. Wieland, E.
Yerex, L. Zurosky. GROUP/GROUPE: "Realism:
Emulsion & Omission".

UNIVERSITY OF MANITOBA ART GALLERY
Winnipeg, Man.

ARTISTS EXHIBITING/ARTISTES EXPOSANTS:
T. Allison GROUP/GROUPE: *"Lithographs II"*.

UNIVERSITY OF NEW BRUNSWICK ART CENTRE
Fredericton, N.B.
M. Donaldson

ARTISTS EXHIBITING/ARTISTES EXPOSANTS:
M. Aitken, F. Bezeau, B. Bobak, G. Caiserman-Roth,
L. Coleman, E. Crowell, L. Fellows, C. Graham, M.
Gwiazda, L. Harris, H. Kashetsky, N. Pliskow, F.
Poyatos, G. Rackus, H. Swedersky. GROUP/
GROUPE: *"Eight Canadian Printmakers"; "Frederic-
ton Artists"; "New Brunswick Artists";* "Six Pewter-
smiths".

**UNIVERSITY OF TORONTO FACULTY OF
ARCHITECTURE**
230 College St.,
Toronto 5, Ont.

ARTISTS EXHIBITING/ARTISTES EXPOSANTS:
K. Eloul, I. Grossman, R. Letendre, L. Marcuzzi.
GROUP/GROUPE: "Symbols and Signs".

UNIVERSITY OF WATERLOO ART GALLERY
Univ Waterloo, Waterloo, Ont.

ARTISTS EXHIBITING/ARTISTES EXPOSANTS:
J. Bechtel, Z. Blazeje, D. Gilhooly, J. Hay, M. Hay-
den, T. Urquhart. GROUP/GROUPE: *"Art of the
Canadian Eskimo"; "Master of Visual Arts '72";*
"Student-Faculty Exhibition".

UPSTAIRS GALLERY
266 Edmonton St.,
Winnipeg, Man.

ARTISTS EXHIBITING/ARTISTES EXPOSANTS:
M. Bates, K. Jenkyns, J. Rudquist, T. Tascona, W.
Winter. GROUP/GROUPE: *"Baker Lake Drawings".*

VALHALLA INN
Burnhamthorpe Road,
Toronto, Ont.

ARTISTS EXHIBITING/ARTISTES EXPOSANTS:
J. Holbern Avery, P. Chen, N. Ducharme, D. Hayt-
Smith, Z. Nagy, R. Pitchke, O. Racknor, R. Robert-
shaw, M. Shack, G. Strudwick.

VANCOUVER ART GALLERY
1145 Georgia St. W.,
Vancouver, B.C.
T. Emery

ARTISTS EXHIBITING/ARTISTES EXPOSANTS:
J. Adams, M. Baden, D. Bailey, M. Bates, N. Best,
B. Bissett, A. Bonnet, T. Burrows, T. Chavez, C. Dahl,
J. Dine, D. Elliot, D. Ellis, J. Fafard, R. Foulger, B.
Jones, W. Laing, D. Mabie, S. McLaughlin, D. Potts,
R. Prince, S. Raphael, J. Reeve, D. Rimmer, D. Rot,
C. Samton, M. Snow, C. Tousignant, W. Toogood, R.
Vilder, A. Villeneuve, J. Wieland, J. Wild. GROUP/
GROUPE: *"Baker Lake Drawings"; "SCAN".*

VEHICULE ART INC.
61 Ste-Catherine ouest,
Montréal, Qué.

ARTISTES EXPOSANTS/ARTISTS EXHIBITING:
C. Bates, J. Bordelai, D. Brayshaw, T. Dean, M. Gou-
let, M. Henrickson, T. Henrickson, Insurrection Art
Co., J. Jason-Teff, C. Jirar, S. Lack, S. Lake, D. Lu-
kas, G. Nolte, G. Smith, B. Vazan. GROUPE/
GROUP: "Dessins"; "Kite Show"; "Sound as Visual—
Visual as Sound".

VICTORIA COLLEGE
Univ Toronto,
Toronto, Ont.

ARTISTS EXHIBITING/ARTISTES EXPOSANTS:
E. Bartram, D. Martin, M. Semak, S. Shaw. GROUP/
GROUPE: "Students' Work".

WADDINGTON GALLERIES
1456 Sherbrooke W.,
Montreal, Que.

ARTISTS EXHIBITING/ARTISTES EXPOSANTS:
M. Avery, I. Ballon, R. Briansky, C. Hayward, J. Hoy-
land, Kabubawokota, D. Knowles, F. Leger, H. Leroy,
J. Neuhof, W. Perehudoff, J. Ritchie, Towatuga, J.
Yeats.

WALLACK GALLERY
202 Bank St.,
Ottawa, Ont.

ARTISTS EXHIBITING/ARTISTES EXPOSANTS:
E. Evans, T. Roberts, H. Simpkins, R. Swartzman.

WALTER ENGEL GALLERY
2100 Bathurst St.,
Toronto, Ont.

ARTISTS EXHIBITING/ARTISTES EXPOSANTS:
G. Forgie, G. Hillman, E. Korda, H. Lucas, A. Lut-
kenhaus, W. Mason-Apps, S. Silver.

WELLS GALLERY
459 Sussex Dr.,
Ottawa, Ont.

ARTISTS EXHIBITING/ARTISTES EXPOSANTS:
I. Ballon, A. Bayefsky, L. Bederedge, J. Boyd, G. Can-
tieni, G. de Niverville, D. Pentz, A. Robinson, J. Stohn,
V. Tolgesy, W. Toogood, Wolf.

WINNIPEG ART GALLERY
300 Memorial St.,
Winnipeg, Man.
J. Konrad

ARTISTS EXHIBITING/ARTISTES EXPOSANTS:
J. Beardy, J. Busit, R. Carmichael, J. Fafard, T. For-
restall, B. Head, A. Janvier, L. Levine, E. Lindner, W.
Maltman, A. Newton, D. Odjig-Beavon, R. Vilder.
GROUP/GROUPE: *"The Legend of Assessippi"; "Li-
thographs I";* "Manitoba Society of Artists (47th An-
nual Exhibition)" ; *"Winnipeg under 30".*

WOODSTOCK ART GALLERY
Woodstock Public Library,
Woodstock, Ont.

ARTISTS EXHIBITING/ARTISTES EXPOSANTS:
A. Bevelander, M. Chambers, J. Hanzalek.

YORK UNIVERSITY ART GALLERY
4700 Keele St., Toronto, Ont.
M. Greenwood

ARTISTS EXHIBITING/ARTISTES EXPOSANTS:
Y. Cozic, J.-M. Delavalle, E. Fielding, C. Gagnon, D.
Gilhooly, T. Godwin, M. Hirschberg, R. Kostyniuk,
F. Thepot, N. E. Thing Co., M. Semak, R. Vilder, T.
Whiten.

YORKTON ARTS CENTRE
49 Smith St. E.,
Yorkton, Sask.
R. Vahala

ARTISTS EXHIBITING/ARTISTES EXPOSANTS:
B. Busch, B. Manchur. GROUP/GROUPE: "Cape
Dorset Prints".

ZAN ART GALLERY
A1 Nootka Court,
634 Humboldt St.,
Victoria, B.C.

ARTISTS EXHIBITING/ARTISTES EXPOSANTS:
P. Bates, J. Charnetski, J. Dobereiner, I. Garrioch,
D. Harvey, G. Smith, G. Tiessen.